Dr Caroline Shenton was Direct[...]
Archives at Westminster, where she worked for eighteen
years. Prior to this she was a senior archivist at the National
Archives, and she is currently a Fellow of the Society of
Antiquaries and the Royal Historical Society. Caroline has
written for the *Guardian, The London Review of Books*, and
reviewed books for *The Spectator*.

Praise for *National Treasures*

'Vigorously researched and highly entertaining'
Daily Telegraph

'An engrossing and uplifting story of how some of
the greatest treasures of Britain's museum, gallery
and library collections were protected and preserved
during the darkest days of WWII'
Richard Ovenden, author of *Burning the Books*

'Shenton has the archivist's unerring eye for detail and the
storyteller's instinct for what will make a compelling tale. It
is brought to life with energy and confidence'
Julie Summers, author of *Jambusters*

'Reveals the wonderfully inventive ways Britain's
great museums hid their priceless exhibits from
Hitler's bombs'
Daily Mail

'Entertaining, surprising and full of brilliant vignettes,
Shenton does justice to one of the great untold
stories of the Second World War'
Josh Ireland, author of *Churchill & Son*

Also by Caroline Shenton

The Day Parliament Burned Down
Mr Barry's War

National Treasures

Saving the Nation's Art in World War II

CAROLINE SHENTON

JOHN MURRAY

First published in Great Britain in 2021 by John Murray (Publishers)
An Hachette UK company

This paperback edition published in 2022

1

A CIP catalogue record for this title is available from the British Library

Paperback ISBN 978-1-529-38745-2
eBook ISBN 978-1-529-38746-9

Typeset in Monotype Bembo by Manipal Technologies Limited

Printed and bound in Great Britain by Clays Ltd, Elcograf S.p.A.

John Murray policy is to use papers that are natural, renewable and recyclable products and
made from wood grown in sustainable forests. The logging and manufacturing processes
are expected to conform to the environmental regulations of the country of origin.

John Murray (Publishers)
Carmelite House
50 Victoria Embankment
London EC4Y 0DZ

www.johnmurraypress.co.uk

In memory of Simon Gough
(1961–2020)
who would have done his bit

Contents

Cast

Titles and honorifics as they were at the period in which this book is set

Ashmole, Bernard, MC (1894–1988), Keeper of Greek and Roman Antiquities, British Museum

Bell, Idris, CB (1879–1967), Keeper of Manuscripts, British Museum and Council member, National Library of Wales

Beresford, John, CBE (1888–1940), Treasury civil servant and Secretary of the Standing Commission on Museums and Galleries

Blakiston, Georgiana (1903–95), writer and wife of Noel Blakiston

Blakiston, Noel (1905–84), Assistant Keeper, Public Record Office

Bradley, Leslie, OBE (1892–1968), Director of the Imperial War Museum

Buccleuch, 8th Duke of, Walter Montagu-Douglas-Scott (1894–1973), owner of Boughton House, Northamptonshire

Clark, Sir Kenneth (1903–83), Director of the National Gallery and Surveyor of the King's Pictures

Clayton, Muriel (1899–1956), Acting Keeper of Textiles, Victoria & Albert Museum

Craster, Edmund (1879–1959), Bodley's Librarian, University of Oxford

Curzon, Lady, Mary: see under Howe

Dashwood, Sir John (1896–1966), owner of West Wycombe Park, Buckinghamshire

Davies, Martin (1908–75), Assistant Keeper, National Gallery

de Normann, Eric (1893–1982), Assistant Secretary, Office of Works (from 1940 Ministry of Works), becoming Deputy Secretary, Ministry of Works in 1943

Digby, Adrian (1909–2001), Assistant Keeper, Ethnographic Collections, British Museum

Donisthorpe, Frances 'Donnie' (1870–1944), Gabrielle de Montgeon's housekeeper

Duff, Sir Patrick (1889–1972), Permanent Secretary, Office of Works

Edmunds, Charles (1869–1952), Land Agent at Mentmore, Buckinghamshire

Faudel-Phillips, Sir Lionel (1877–1941), owner of Balls Park, Hertford, Hertfordshire

Fincham, David (1899–1964), Senior Assistant, Tate Gallery

Flower, Cyril, CB (1879–1961), Deputy Keeper of Public Records, Public Record Office

Flower, Robin (1881–1946), Deputy Keeper of Manuscripts, British Museum (not related to Cyril)

Forsdyke, Sir John (1883–1979), Director of the British Museum

Forster-Cooper, Clive (1880–1947), Director of the Natural History Museum

Gibson, William (1902–60), Keeper, National Gallery

Gleichen, Lady Helena (1873–1947), owner of Hellens, Much Marcle, Herefordshire

Hake, Sir Henry (1892–1951), Director of the National Portrait Gallery

HM Queen Elizabeth (1900–2001), wife of George VI

HM Queen Mary (1867–1953), the Queen Mother

Hollings, Nina (1862–1948), companion of Helena Gleichen

Hollings, Herbert (1856–1922), her embarrassed husband

Howe, Mary, Countess (1887–1962), divorced first wife of the 5th Earl Howe (1884–1964) and chatelaine of Penn House, Amersham, Buckinghamshire

Ironside, Robin (1912–65), Assistant, Tate Gallery

Jenkinson, Hilary (1882–1961), Principal Assistant Keeper, Public Record Office

Kendrick, Tom (1895–1979), Keeper of British and Medieval Antiquities, British Museum

Lawson, Brigadier Edward Frederick, DSO MC (1892–1963), owner of Hall Barn, Beaconsfield, Buckinghamshire and, from 1943, 4th Baron Burnham

Lawson, Hon. Mrs Enid (1894–1979), wife of Brigadier Lawson, chatelaine of Hall Barn and, from 1943, Lady Burnham

Lee, Arthur, Viscount Lee of Fareham (1868–1947), art collector and owner of Old Quarries, Avening, Gloucestershire

Lees-Milne, James (1908–97), Secretary, Country Houses Committee, National Trust

Leveen, Jacob (1891–1980), Assistant Keeper, from 1944 Deputy Keeper, Department of Oriental Books and Manuscripts, British Museum

Llewelyn Davies, William (1887–1952), Chief Librarian, National Library of Wales

Mann, James (1897–1962), Keeper of the Wallace Collection and Master of the Armouries, Tower of London

Melchett, 2nd Lord, Henry Mond (1898–1949), owner of Colworth House, Sharnbrook, Bedfordshire

Montgeon, Mlle Gabrielle de (1876–1944), owner of Eastington Hall, Upton-on-Severn, Worcestershire

Morshead, Sir Owen, DSO MC (1893–1977), Royal Librarian

Morton, H. V. (Henry Vollum) (1892–1979), travel writer and journalist

Nicolson, Ben (1914–78), Deputy Surveyor of the King's Pictures

Norman, Lady Priscilla (1884–1964), owner of Ramster Hall, near Chiddingfold, Surrey

Peers, Sir Charles (1868–1952), Surveyor of the Fabric, Westminster Abbey

Plenderleith, Professor Harold, MC (1898–1997), Deputy Keeper of the Research Laboratory, British Museum

Popham, Arthur (1889–1970), Deputy Keeper of Prints and Drawings, British Museum

Pouncey, Philip (1910–90), Assistant, National Gallery

Rawlins, Ian (1895–1969), Chief Scientist, National Gallery

Robinson, Stanley (1887–1976), Deputy Keeper, Department of Coins and Medals, British Museum

Rosebery, 6th Earl of, Archibald Primrose (1882–1974), owner of Mentmore, Buckinghamshire

Rothenstein, John (1901–92), Director of the Tate Gallery

Rothschild, Miriam (1908–2005), naturalist and entomologist

Rutland, 9th Duke of, John Manners (1886–1940), owner of Belvoir Castle, Leicestershire, and Haddon Hall, Derbyshire

Rutland, 10th Duke of, Charles Manners (1919–99), son of the 9th Duke and subsequent owner of Belvoir Castle and Haddon Hall

Scholderer, Victor (1880–1971), Deputy Keeper, Department of Printed Books, British Museum

Senior, Elizabeth (1910–41), Assistant Keeper of Prints and Drawings, British Museum, working on secondment to the Treasury

Stopford-Sackville, Colonel Nigel (1901–72), owner of Drayton House, Northamptonshire

Tanner, Lawrence (1890–1979), Keeper of the Muniments and Librarian, Westminster Abbey

Vaughan, Charles A. (1885–), Manager of the Manod Slate Quarry, Merionethshire

Waterhouse, Charles (1890–1985), Draftsman and Illustra-
tor, Department of Greek and Roman Antiquities, British
Museum

Wheeler, Mortimer, MC (1890–1976), Director of the London
Museum

Author's Note

IN 1940, THE Office of Works was renamed the Ministry of Works and brought under full government control in order to expedite the requisitioning of property for war use. Due to wartime paper shortages, and also civil service habit, out-of-date letterhead continued to be used and letters to and from the Ministry, as well as third parties, continued to refer to the 'Office of Works' after 1940. Both names are therefore used interchangeably in this book.

Secondly, there are two men with the surname Davies in this book (somewhat inevitable in a story with a large Welsh component). To distinguish William Davies of the National Library of Wales from Martin Davies of the National Gallery I have used the name William Llewelyn Davies throughout for the former. He added his wife's family name to his own on their marriage in 1914 and, although he did not adopt the double-barrelled form, their daughter Melun used both names too.

Prologue

O N I SEPTEMBER 1939, the same day that Hitler's forces marched into Poland, Operation Pied Piper mobilised across Britain. One and a half million people from London and other major cities, mainly children, were moved by rail to safety in the countryside. Their tale is well known. But there is another mass evacuation story that needs to be told. At the height of the late summer heatwave of 1939 the time had finally come for the men and women of London's national museums, galleries and archives to mobilise, despatching what they could of their charges to safety in a gigantic but covert effort to save the nation's heritage.

Ingenious escape plans were devised by the capital's curators for their precious charges. Using stately homes, tube tunnels, castles, quarries, prisons and caves, a remarkable bunch of unlikely accomplices packed up the nation's most precious objects and, in a race against time, despatched them throughout the country on a series of top-secret wartime adventures. They, like so many in the Second World War, were ordinary people called on to achieve extraordinary things in the middle of a national crisis. From suave, high-profile public figures to diffident, self-effacing scholars, now they all came forward to do their bit, in what became their finest hour. And as with evacuated children in their new billets, those other evacuees met with an equally eccentric array of hosts; were greeted with open arms by some, with hostility and neglect by others.

Over the next few years of war these national treasures – collections and custodians alike – dug in or moved on. Previously used only to battling the hazards of moths, mice and mildew, now they faced first the threat of invasion, and then bombing, armed with no-nails boxes, stirrup pumps and brown paper, as the menace from the air stalked them to the very places where they were hidden and their chances of survival seemed ever slimmer. Back in London, many of their former homes were devastated. Yet the conflict also wrought personal transformations. Friendships were forged in the most unexpected places. New vistas of research opened up. Misfits found perfect niches. Those who had previously led lives of quiet desperation discovered in themselves the reserves of courage and resilience which had previously eluded them. Some found love. Two were killed. So here, with a cast of characters who could have stepped right out of an Ealing comedy, is a moment from our history when an unlikely coalition of mild-mannered civil servants, social oddballs and metropolitan aesthetes became nothing less than the heritage front in our fight against the Nazis.

To all those involved in the heritage evacuations of the Second World War, it would have been quite obvious why they were doing it. They would have been clear that their collections belonged to the nation, and were being saved for it. Future generations would thank them for their efforts in ensuring that the paintings, objects, books and records of their institutions had been packed up and hidden away from a malignant enemy, until they could once again go back on display for the public to admire and appreciate them. Today, we might take a different view of those certainties. Cultural artefacts looted by the Nazis are still being uncovered across the world and returned to those from whom they were seized in the great maelstrom of the Second World War. It is so tempting to think that the British experience is separate from that of continental Europe, and above reproach.

Yet for at least some of the objects which fled London in 1939, there is today a shadow over their status as national treasures. Which nation do they really belong to? And whose treasures are they really? Some of those wartime evacuees had come to this country as a result of acts of violence, sacking and bloodshed elsewhere; and some of the items fleeing the perils of bombardment, looting or confiscation in London had themselves once been acquired by damaging or obliterating other civilisations through just those same methods. Uncomfortable questions about the violent seizure of others' heritage to adorn our national institutions in the past are now confronting us in a way which would have been unimaginable to many of the people in this book. As ever, the study of the past is not a warm protective blanket, wrapping up history in nostalgia and securing it with a neat bow of tradition. It is more like a brisk rub down with sandpaper as varnished layers of sentiment and misplaced pride are removed from our certainties, and a rather different – but more realistic and ultimately more fascinating – view of what went on begins to be revealed . . .

PART I

Action This Day

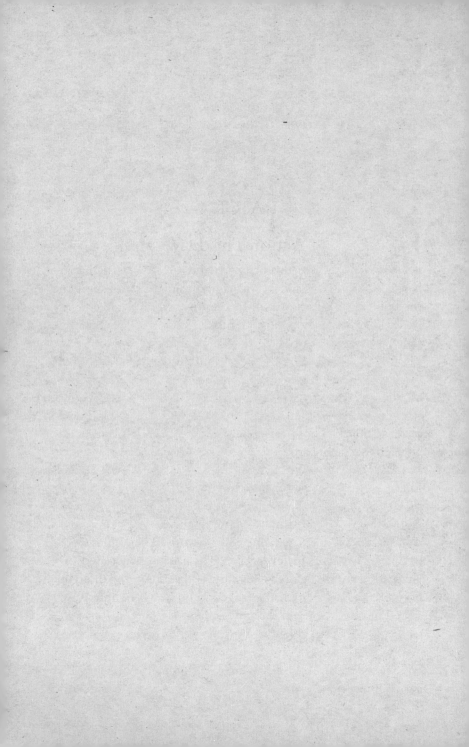

I

The Abyss of a New Dark Age

IN OCTOBER 1939 regular users of the National Library of Wales in Aberystwyth faced an odd and unwelcome development. It was distinctly irritating. All reader's tickets had been cancelled and it was announced that admission to the building in future was to be only by special arrangement, under an emergency permit. Similarly, students of the nearby University College of Wales returning after the long summer vacation also found that they were unable to use the National Library as before, unless they were postgraduate researchers or honours candidates, and only then if certified as needing essential access by their university tutor and after a good deal of form-filling. Those fortunate enough to be let inside discovered that large parts of the Library were now out of bounds and that the mess room, where they had previously consumed gallons of tea and piles of sugar-dredged welshcakes to sustain their scholarship, had closed down indefinitely.[1]

On the face of it, this was simply another of many new daily inconveniences which people across the country were having to get used to, ever since war had been declared on Germany a month before. They shrugged perhaps, and thought no more about it. Life had changed in hundreds of little ways since the summer, from the government taking control of all railways, ports and roads to the compulsory carrying of gasmasks by everyone, even babies. Any private property could be requisitioned at will, for war use. Whitehall and the police had unprecedented powers of censorship and internment.

Dancehalls and sports grounds had temporarily closed down. Cinemas, too: though Aberystwyth, confident of its isolation from bombing on the west coast of Wales, remained the last place in the United Kingdom where it was possible to watch a film in those early weeks of the war. Only the BBC Home Service could now be heard on the wireless. Petrol was being rationed, so there were fewer cars on the roads but a noticeable increase in military lorries. Those motorists who were out and about had trouble driving in the evenings since street lights no longer lit up at dusk. The blackout led to more road accidents, and eruptions of sandbags everywhere provided a hazard, both day and night. Householders now lived in dread of an Air Raid Precautions (ARP) warden reporting them to the authorities for a stray beam of light emerging from their houses.[2] Gardens were peppered with newly dug humps of soil concealing corrugated iron Anderson shelters beneath. And was it just people's imagination or did there seem to be fewer dogs and cats around to provide comfort and reassurance?

Yet that partial closure of the National Library, standing high on a hill above the town buffeted by wind and rain from the Irish Sea, was one of a series of largely unnoticed episodes taking place across the country during the early autumn of 1939 which, though individually unremarkable, combined to make up a very remarkable tale indeed. If, one night, an intruder had managed to break into the seemingly deserted building, they would have stumbled over a huge state secret. Shining a torch across the first floor they would have discovered an entire wing given over to the rarest and most precious books and manuscripts of the British Museum, evacuated in complete secrecy from London.

Untold intellectual and cultural riches lay there: too many to describe. One might open a box to discover the fourth-century *Codex Sinaiticus* inside, including the earliest complete text of the New Testament (bought with £100,000

of public funds by the Museum in 1933 from Stalin, the *Codex* having found its way from the Monastery of Saint Catherine, Mount Sinai to the Russian Imperial Library in 1869 by means of a disputed donation). Or perhaps opening the lid of a nearby stiffly hinged cardboard case, known as a solander, there might be the *Anglo-Saxon Chronicle*, the *Lindisfarne Gospels* or two of the original Magna Cartas from 1215 inside. There were stacks of illuminated manuscripts from across Europe; acres of charters; vast quantities of letters from royalty, writers, poets, musicians, artists and scientists; all of the royal manuscript collection given by George II. On the shelves were the British Museum's incunabula, first editions, fine bindings and *éditions de luxe*, five Shakespeare first folios, the world's finest collection of Caxtons, two complete Gutenberg Bibles, historic pamphlets, broadsides, early newspapers, eighteenth-century play collections, alongside the rarest maps, music and stamps. Hundreds of portfolios of prints and drawings included works by Raphael, Michelangelo and Leonardo, Blake, Cotman and Turner; and the finest Persian, Indian and Chinese artworks. Upstairs on the second floor, seven hundred paintings from the National Gallery, one of the greatest art collections in the world, silently lay on racks in the gallery awaiting a time when they could emerge from hiding and return to their home in London, out of danger.

Six years later, the Chief Librarian of Wales, William Llewelyn Davies, revealed in public the extent of his Library's wartime undertaking. The reason for all the disruption, he declared, was the service which 'it had been able and privileged to render to a large number of institutions and persons by providing a safe sanctuary – in the underground chamber and in the Library itself – for a huge accumulation of Britain's artistic and cultural treasures'. And it wasn't just the British Museum and the National Gallery collections which had been saved. In total, around a hundred smaller national, institutional

and private collections had also found refuge in the arms of the modest librarian of Aberystwyth.[3]

The seeds of this giant undertaking – and many others – had been planted over a decade before. Throughout the 1920s, the Committee of Imperial Defence – essentially a peacetime planning and advisory body – had been preoccupied with the likelihood of a future war. With enormous foresight, it set up an Air Raid (Precautions) Sub-Committee in 1924 to look at the impact of bombing on the civilian population, project the numbers of casualties and recommend possible means of protection. The memory of the 5,000 bombs dropped over Britain by Zeppelins and Gotha bombers during the Great War was still very fresh, and the horrifying possibility of them being combined with mustard-gas attacks in future was one which preoccupied the committee's members. But it wasn't only the human impact which needed to be considered.

On 14 July 1933, the National Socialist Party became the only political party permitted in Germany. Democracy there was dead, and some in London saw what was coming next. Within a week, in the conference room of the Office of Works in Storey's Gate near Westminster Abbey, a meeting took place under the auspices of the ARP Sub-Committee. The agenda was titled *Precautions for the Safe Custody of National Art Treasures*. Present were the directors of the British Museum, the National Gallery, the Tate Gallery, the National Portrait Gallery, the London Museum and the Wallace Collection, along with a smattering of civil servants and a squadron leader from the Air Ministry.[4]

The Office of Works was charged with the duty, it explained, of preparing a scheme for the protection of national treasures in time of war. The assumption was that the emergency would arise 'at very short notice' and that central London would be 'subjected to continuous heavy bombing by enemy aircraft'.

A tentative plan had been drawn up whereby museum and art collections would be transferred to Hampton Court pending their transfer to 'more suitable quarters in safer areas', meaning places north of a line drawn across England from the Bristol Channel in the west to King's Lynn in the east. Other possibilities included disused parts of the London Underground where a few collections had been sheltered towards the end of the Great War.

The directors present were not keen. They felt it would be wiser not to put all their eggs into one basket, but to spread out the clearing houses. Some removals could be done directly by rail or road to their final destinations anyway. The Office of Works undertook to draw up a list of recommended country houses, 'having regard *inter alia* to the non-proximity of military objectives', while the directors agreed to draw up lists of objects to be removed based on their existing emergency salvage lists. The museums and galleries agreed to do the packing, while the Office of Works would supply the packing materials. It was unclear, if underground railway tunnels could be pressed into use, how immovable treasures might be protected and what 'the effect of poison gases' would be on certain types of art. All went away with much to think about.

By the following January, the draft list of suitable venues was ready. In preparing it, the Office of Works had chosen places that were 'large and substantially-built country seats in areas comparatively safe from aerial attack'. Such houses should be remote from railways, large towns, aerodromes or military establishments, reasonably free from risk of fire, with strong floors to carry cases of exhibits, 'and should be continuously maintained by a permanent staff of servants'.[5] That stately homes were considered as suitable destinations was not a surprise. The boards of London's museums and galleries were stuffed with aristocrats and gentry, some more educated than others, and they were the first port of call for the Office of Works when

approached about the problem. If they couldn't help, then it was likely that one of their friends or relations would.

Thus the list of locations initially compiled ranged through Buckinghamshire, Northamptonshire, Hampshire, Bedfordshire, Wiltshire, Dorset and Berkshire – all of them counties, in fact, distinctly south of the advisory line between the Severn and the Wash. Properties belonging to the Astors, the Rothschilds, the marquesses of Lansdowne, Bath and Ailesbury, and the earls of Ilchester and Selborne, and Earl Beatty made it onto the list, as well as houses owned by senior military figures and Justices of the Peace. These plans were simply preliminary designations. And there they rested as the situation on the Continent grew gradually more and more desperate, not just for certain people, but also for certain museum and art collections.

Novels of the 1930s reflected the national obsession with Prime Minister Stanley Baldwin's gloomy prediction that 'the bomber will always get through'. H. G. Wells imagined it in *The Shape of Things to Come* (1933) and so did Leslie Pollard in his sci-fi potboiler, *Menace: A Novel of the Near Future* (1935). In it, the hero wanders dazed through a destroyed Westminster:

> As he reached the Chelsea Embankment he met a wild, bedraggled figure moaning ... 'To think that all those flying inhuman monsters have demolished that wonderful building and all that it contained, all that it meant to England.' 'Yes,' agreed John. 'Parliament will never sit there again.' 'Parliament!' shouted the man. 'Who in hell cares about Parliament? That is what I'm talking about,' and with a wave of his hand pointed to the ruins of the Tate Gallery.[6]

Even mothers and fathers reading Tolkien's *The Hobbit* (1937) to their children at bedtime might have paused to consider how Smaug, a monster inspired by the dragon in *Beowulf*, had

a resonance for their own times, when they reached the part where he descends upon his hapless victims without warning, his tail crashing through the skies, breathing a furnace of deadly fumes down on the undefended Lake-town.

The Spanish Civil War gave a real taste of what such fiery devastation meant for art and historical collections. The bombing of the Prado in Madrid by fascist forces in November 1936 made real the long-held fears of many in the European museum world. Originally stored in parts of the building thought to be safer than others – away from outside walls and on lower floors – the most important of the collections were then hastily packed up from the shattered gallery and sent in convoy overnight to Valencia, where the Republican government had fled. A year later they were on the move again to Catalonia, and the great Velázquezes, El Grecos and Goyas finally ended up close to the border with France from where they were rescued by an international coalition led by the League of Nations, which put them all on a twenty-two-car train to Geneva, where they went on display. 'The conflagration is not far from bursting upon us,' wrote the Parisian art dealer, Réne Gimpel.[7]

But destruction by bombing was only one of the grisly fates which might befall the nation's collections as a result of war. Should the Nazis be victorious, other equally appalling possibilities were likely; possibilities which Britain, along with the rest of Europe, had watched emerge gradually over the years since Hitler took power. The widespread availability of published gallery and museum catalogues allowed for the easy identification of works which a hostile power might want to appropriate. Similarly, they also allowed for the potential identification of proscribed works. Libraries could expect to be subject to book-burnings, such as had been organised in May 1933 by the *Deutsche Studentenschaft*, the students declaring a national *Säuberung*, or 'cleansing', to expunge 'un-German'

works from Berlin and thirty-four university towns across the country.

In the firing line were liberal, democratic texts support-ive of the Weimar Republic; Marxist and Communist literature; books by Jewish authors; pacifist texts; the works of non-German authors critical of the new Germany; history books which challenged or undermined the state-sanctioned line on the cultural, sexual or racial purity of the *Volk* and so on. The same might occur in Britain if the country was invaded, with the five national legal deposit libraries (which under the 1710 Copyright Act could claim a copy of every book pub-lished in the country and which collected much else from across the world) being most at risk: the Bodleian Library, Oxford; Cambridge University Library; the National Library of Scotland; the National Library of Wales; and above all, the British Museum Library in London.

In Nazi Germany, museum and gallery directors who were 'non-Aryan' were dismissed. Over twenty lost their jobs in 1933 alone. Artists who refused to join official groups over-seen by the new *Reichskulturkammer* were censured, while others were dropped from membership of various academies, including major figures such as Paul Klee, Oskar Kokoschka, Mies van der Rohe, Otto Dix and Käthe Kollwitz alongside many others. Then in July 1937, the infamous *Entartete Kunst* exhibition opened in Munich, comprising 650 modernist paintings, sculptures, prints and books culled from over thirty German public collections. Two million visitors attended the exhibition over the next four months and a further million viewed 'Degenerate Art' over the next three years as it travelled through the German-speaking world.[8]

Its aim was nothing less than to mobilise popular and pop-ulist opinion in favour of the Third Reich's views on art and artistic representation. Hitler's preference was for Old Masters, and for nineteenth-century Bavarian and Austrian landscapes,

still-lifes, figurative portraits and genre paintings in oil. Above all he admired hyper-realistic works, those 'almost as good as photographs'. Bronzes of classical nudes, portrait busts and animals were particular favourites.[9] Nothing deemed challenging, anti-war, ambiguous, distorted, disfigured, indistinct, sexualised or industrial was permitted within the Nazi canon of taste. All such art was deemed un-German.

As a result, a huge slew of late nineteenth- and early twentieth-century art, as well as the contemporary, was immediately suspect. Expressionist, Cubist, Futurist, Bauhaus, Surrealist, Dada-ist, Post-Impressionist and even some Impressionist artists all came under attack. The degeneracy of 'Jewish art Bolshevism', the exhibition explained, could be recognised in nine ways: formal deformation; insult to religious feeling; call to class war; depictions of wartime atrocities; depictions of moral decay; 'non-Aryan' ideals of race in portraits; art related to the mentally ill; art by Jewish artists; and a final useful catch-all: art demonstrating 'complete insanity'.

Yet only six of the 112 artists represented at the exhibition were actually Jewish. *Entartete Kunst* played with a willing audience's inclination to find modern art elitist and impenetrable, and in particular its purchase by public institutions (naturally acting under the malignant influence of Jewish art dealers) a deeply insulting waste of hard-earned taxes at a time of hyperinflation and economic depression.

To underline the point, across the road the *Haus der Deutschen Kunst* (House of German Art) was displaying the first *Grosse Deutsche Kunstausstellung* (Great German Art Exhibition). Launched by Hitler just a few days before with the words, 'the end of the mockery of German art and thus of the cultural destruction of our people has begun. From now on, we will wage a pitiless, purifying war against the last elements of our cultural decay', the exhibition featured the inevitable heroic portrait of the Führer, canvases depicting his

favourite episodes from Nazi party history, bronzes of muscular male bodies, busts of stern politicians and mystical scenes of Germany's destiny, all installed in cool airy halls where visitors felt compelled to whisper as if in church.[10] Those attending conveniently forgot the scene when the *Haus der Deutschen Kunst* at the new Crystal Palace itself had been opened, and the hammer Hitler was using to lay the cornerstone had broken. His subsequent very public tantrum had to be expunged from the propaganda film reel.[11]

In 1937, more than 16,000 'degenerate' works of art owned by public collections were confiscated by Goebbels' propaganda machine. Museums in Germany had been full of contemporary German art, collected by a vibrant cadre of expert curators, but they also contained many Impressionist and Post-Impressionist works by foreign artists, among them Monet, Manet, Renoir, Van Gogh, Cézanne and Gauguin, and contemporary masters including Chagall, Munch, Kandinsky, Matisse, Mondrian and Picasso.[12] This act of mass 'safeguarding' culminated in the notorious sales of these works in 1938 at Schloss Niederschönhausen outside Berlin, and at the Hotel National, Lucerne in 1939.

Göring had already had his pick of the Cézannes, Munchs and Van Goghs, which he sold privately to pay for his own choice of Old Masters. At the Lucerne auction, former owners and international dealers knew that to bid would increase the coffers of the Nazi party, but on the other hand *not* to bid would result in the 126 masterpieces being flung into the abyss. The prize item, Van Gogh's self-portrait of 1888 dedicated to Paul Gauguin, formerly on the walls of the Neue Staatsgalerie in Munich, fetched 175,000 Swiss francs, 30,000 more than the asking price. Despite the rescue of some of these works by the international art market, 1,004 unsaleable paintings and sculptures and 3,825 drawings, prints and watercolours from the 16,000 confiscated in 1937 were burned in

the open air in a fire practice outside the Berlin Fire Department that spring.[13]

The assault on art did not stop with public collections, but extended to private ones too. On 12 March 1938 came the *Anschluss* of Austria. Hitler, born in the sleepy border town of Braunau am Inn, was ecstatic. The same day, the stupendous private collections of the Rothschilds in Vienna were looted by the SS, as were those of many other Jewish families. Those who subsequently tried to flee had goods confiscated at the borders, or had to sell them to raise funds to pay for an exit visa. Hitler, while waiting for an embarrassing tank breakdown to clear the road to Vienna, met with the Director of the Linz Provincial Museum to discuss plans to redesignate it as one of four new German ceremonial cities, and to realise there a long-held ambition, his *Führermuseum*. Over the next eighteen months, 80,000 Jews left Austria and were stripped of their possessions, often including decorative and fine art. The cream of these artefacts, declared ownerless and forfeit under a series of retrospective laws, went to form the *Führervorbehalt*, or Führer Reserve, destined for the enormous new art museum in Linz displaying the personal collection of the Leader.[14] No longer would his home town be subject to the slur: 'Linz ist Provinz'.

Seeing all this, London's curators became increasingly anxious. A small group of directors of the major London institutions was formed in late 1937 to get on with making decisions more quickly than the lumbering ARP Sub-Committee. The general principles for their protection strategies were clear: remove valuable exhibits if possible from London; provide reinforced storage space onsite for the rest; use the Underground tunnels in certain cases.[15] But the specifics were still very vague.

It was even worse outside the capital. The President of the Museums Association – the archaeologist Mortimer Wheeler,

also Keeper of the London Museum – following a confer-
ence of his members in early 1938, wrote a worried letter to
the Secretary of the Standing Commission on Museums and
Galleries in Whitehall, John Beresford:

> Little or nothing has been done to safeguard our principal
> provincial collections in case of emergency, and there was a
> general feeling of ignorance as to the nature of the precautions
> which are at the same time most urgent and most feasible.

His advice for the present was to recommend shelters – gas-
proof, splinter-proof and fire-proof, on the premises or nearby,
or in 'a private mansion or other building in a country district'.
But beyond that, no one had thought.

What classes of objects were susceptible to damage from
known poison gases? Did pictures suffer from exposure to
them? What about textiles and silver? What was the simplest
and most economical type of shelter which could be con-
structed in a basement?[16] To answer these questions, Wheeler
was put in touch with three men who might be able to help.
They were Eric de Normann of the Office of Works, the con-
servation scientist Professor Harold Plenderleith of the British
Museum Research Laboratory and a physicist called Ian
Rawlins in the employ of the National Gallery.

Together these men produced a small pamphlet with a
bright green cover, called *Air Raid Precautions in Museums, Pic-
ture Galleries and Libraries*, published by the British Museum the
following year and available for ninepence. Its jaunty appear-
ance belied the serious nature of what was inside. The authors
covered how to fight fires and put out incendiary bombs; how
to decontaminate people and equipment; how to deal with
casualties; how to sandbag buildings and protect windows and
doors from blast; and how to build shelters and make them
gasproof. They assumed that 'Exhibition Galleries and Read-
ing Rooms will be closed to the general public at the outbreak

of hostilities, in order that the staffs may give their whole attention to protecting the material in their charge.'

The little green book laid out in the starkest terms what the danger to collections and curators might be. 'Incendiary bombs are of various kinds, and range in weight from 1 to 25 kilos,' it told its readers. Filled with magnesium, and with a primer which ignited it, they would burn for up to twenty minutes, their sole aim being to set off larger fires wherever they landed:

> One large bomber could carry between 1,000 and 2,000 of these bombs. They would be released from containers holding 10 or 20 and the contents of several containers can be released simultaneously ... the kilo bomb has poor powers of penetration, being designed to pass through an ordinary roof of slates, tiles etc., but to remain on the floor immediately below, thus starting fires in places which are difficult of access.

Training to put the flames out was of the utmost importance, 'to prevent an incipient fire becoming a general conflagration'. Water served only to accelerate the magnesium's combustion, so sand, earth, ashes or slag was needed to smother incendiary bombs. For high-explosive bombs, nothing could prevent direct hits but sandbagging could provide protection from blast and splinters.[17]

And then came the Munich Crisis. On the very day that Chamberlain signed on the dotted line for 'peace in our time', 30 September 1938, Picasso's *Guernica* arrived in England. Those who had not seen the great anti-war painting at the 1937 Paris International Exposition now had the chance to view it in England, first in London, and then in Leeds, Liverpool, and – finally and rather unexpectedly – in a car showroom in Manchester.[18] *Guernica* was a primal scream of rage and fear at General Franco's bombing of that historic Basque town, carried out by the Luftwaffe and Italian air force. Three-quarters of the town was completely destroyed and – at the time, though subsequently revised – several

thousand civilians were estimated to have perished. Nothing could have been a more powerful warning for London curators and art-lovers than seeing the great Cubist master's apocalyptic canvas in their own city. Herbert Read, art critic and editor of the *Burlington Magazine*, told his readers, 'Not only Guernica but Spain; not only Spain, but Europe, is symbolised in this allegory.'[19] The writing – or rather, the paint – was on the wall.

The day after that 'faraway country of which we know little' (despite the fact that Czechoslovakia's western borders were considerably closer to Britain than Berlin) was abandoned to the tender mercies of Nazi Germany, a short column appeared in the *Daily Telegraph* entitled 'Guard on Art Treasures: Plans for Removal Ready'.[20] 'Comprehensive plans for protecting the nation's treasures have been completed by all the London museums and art galleries,' it announced. 'Experts are standing by to set these plans into operation immediately an emergency is declared.' This was surely the last thing which the museums and galleries wanted publicised. And in fact all was not going well, during what became known as 'the Emergency', for the handful of places which had managed to mobilise in good time.

There had been no clear, single signal to begin evacuation, leading to false starts and uncertainty all round, so it was agreed that next time – and there would be a next time – the Home Office would be responsible for giving the order 'Go!' to each institution.[21] Transport arrangements had also been somewhat chaotic that September. Many of the museum and gallery directors felt that going by road would be unsafe, 'in the stress of general evacuation of urban areas', unless the lorries had military guards, 'or were otherwise marked as inviolable Government vehicles'. Lorries for transporting the crates to the railway stations and the Underground had been plentiful, but it had proved impossible to get crucial details of the vehicles' size, type and equipment beforehand. Meanwhile, the V&A had found its arrangements to use Brompton Road tube station severely

disrupted by other plans made by the army. The station was due to close that year, so the V&A had signed a lease over the summer to fill two disused tunnels with collections. Yet right in the middle of the Munich Crisis the Museum, to its horror, discovered that the War Office was installing a telephone centre inside the station's lift shaft which rendered the tunnels inaccessible. This double-booking, in the view of the museum and gallery directors who met shortly after to review what had gone wrong, had 'quite reasonably destroyed our confidence in all such provision, and here again the National Museums must have security of tenure of the accommodation allotted to them'.

The exception to this muddle had been the National Gallery which – typically – had made its own separate, and much more effective, arrangements. Container vans had been provided by the rail company, had been fitted and packed by the Gallery, then slung and roped on the trucks, and finally precisely positioned in ordered fashion on specified trains. This was 'the proper way to do things', thought John Forsdyke of the British Museum, 'and we must make up our minds whether each Museum is to do so for itself or get the Office of Works or the Ministry of Transport to act for all of us.'[22]

War could not now be far off. By the beginning of 1939 the Office of Works was keeping a fleet of lorries on permanent standby, ready to make the great escape with those collections due to travel by road.[23] But still the national institutions continued to make their own arrangements largely independent of one another. John Beresford, Secretary of the Standing Commission, explained to a colleague how, in trying to corral all the plans and personalities involved,

> my principle has been to cling like grim death to the one departmental rock (for this particular purpose) in a weary land, namely the Office of Works, and we have received most

helpful assistance from de Normann . . . Any Treasury objections at this stage would frankly tempt me to throw in an almost unspeakable sponge![24]

Little did Beresford know that some collections would need to be moved multiple times over the next years – as had those of the Prado – to guarantee their safety. The exasperated civil servant had never had to cope with 'a more tiresome problem or more thankless task; even now I doubt we are out of the wood owing to the lack of unity in the National Museum and Gallery world. However, I shall hope for the best.'[25] There were proposals that museum warders should be enrolled as special constables to give them extra powers and permit them to carry firearms; and that any wartime convoys moved out of London should be escorted first by armed Metropolitan Police and then by county forces. The most trusted warders at each property would be trained to shoot revolvers by local gunsmiths.[26] As the inevitability of what was to come approached, these very un-English suggestions indicated that at stake in the plans was nothing less than the country's cultural identity and historical memory.

2

Before Us an Ordeal of the
Most Grievous Kind

I AN RAWLINS LOVED trains. There was nothing he liked
more than to spend hours peering short-sightedly at railway
timetables, memorising the routes of tracks and freight across
the country and working out which junctions led where.
'Ian is blest with an individuality that defeats classification,'
was the view of long-time professional colleague, the British
Museum's Harold Plenderleith, one of his co-authors of the
little green ARP pamphlet. Living in a world of his own,
Rawlins was 'essentially an introvert, he is content with simple
comforts, disdaining luxury of all kinds save in scientific appa-
ratus, and only then when the equipment can be shown to do
something effective'.

He was certainly very much a loner. But, observed
Plenderleith,

> growth in isolation has resulted in self-reliance, great faith and
> courage, and a desirable continuity of mental development
> based firmly upon history, and in particular upon the history
> of science, to which he is as devoted as to mathematical physics
> and philosophy.

His friend also noticed that in his own specialist field he
spoke with justifiable confidence and authority. But when
it came to topics beyond his narrow interests, 'he seems
to tread warily, making assessments based, wherever pos-
sible upon physical measurements or upon the theorems of

the pioneers.' Others observed that while he wrote fluently in scientific papers, when he spoke he was hard to follow, repetitive and stumbling.[1]

Not all were as sympathetic to Rawlins as his friend Plenderleith. Immensely tall – well over six foot four – bespectacled, with pale skin, a greasy auburn comb-over, and unfeasibly long fingers, Rawlins was regarded by his boss, Kenneth Clark, Director of the National Gallery, as a faintly absurd figure. But the awkward and intense Rawlins, whose daytime job was Chief Scientist in charge of the Gallery's conservation laboratories, was about to become the first of our unlikely wartime heroes.

He was born Frances Ian Gregory Rawlins – 'Fig' to his few close friends – in a smart neighbourhood of Marylebone in 1895, the son of a barrister. That he was educated from an early age at home by a live-in governess called Margaret Peachey, who was still tutoring him when he was fifteen, was perhaps the first sign that Ian's parents recognised he had particular needs and would not have flourished in the rough and tumble of Eton, where both his father and two elder brothers had been educated. He was nineteen at the outbreak of the First World War, but there is an intriguing gap in his story at this point. Stuart, his eldest brother and a career army officer, served with distinction in the Great War: ten times mentioned in despatches; awarded the DSO, Belgian and French *Légion d'honneur*; by the end attaining the rank of Colonel. Evelyn, his middle brother, broke off a diplomatic career in the Middle East to serve first with the Allied Headquarters in Salonika and then in the Royal Navy. But Ian stayed at home. Whether kept there by overprotective parents or, more likely, unfit for service, for whatever reason he never joined up.

In 1920, at the advanced age of twenty-five, he finally headed off to university. There, he would not have stood out as plenty of young men who survived the slaughter took up their places later than expected; and any eccentricities might

have been put down to shellshock. It is no coincidence that earlier in the year his father had died, and his eldest brother inherited what was by then the family home, a small country house called White Waltham Grove, near Maidenhead in Berkshire. The upheaval of that time for someone as sheltered as Ian must have been immense, but nevertheless he set off into the outside world.

Instead of a more traditional choice of university for someone of his class, he was educated at the Sir John Cass Technical Institute in East London, a forerunner of today's London Metropolitan University. This was a college which focussed on training for the scientific and technical professions, with practical courses such as navigation, engineering – and physics. For two years he studied, gaining 72 per cent in his final exams and joining the Institute of Physics in the summer of 1922. Then, fast catching up on his scientific and social education, he was accepted as a graduate student by Trinity College, Cambridge, where both his father and his brother Evelyn had studied (his father had even been a Fellow in Law there, for a short while).[2]

But before he took up his place, he spent a year at the Phillips-Universität Marburg, one of Germany's premier scientific universities and its oldest Protestant one, which had boasted Robert Bunsen and many other famous scientists among its teaching staff. Given that the Armistice with Germany had been signed just four years before, this seems a bold move indeed for such a seemingly vulnerable creature as Rawlins, but gives an early indication of his fearless ability for crossing the invisible lines of tradition and social expectations, perhaps oblivious that they even existed. He emerged from Trinity in 1926 with an MSc on 'The absorption spectrum of aragonite and strontianite in the near infra-red', and then spent the next few years in Cambridge, teaching at Fitzwilliam House.[3]

Taking the post there was in keeping with Rawlins' round-about route into academia: Fitzwilliam was at that time a hall of residence for male students who could not afford to attend a college but who wished to study and take exams at the University. Rawlins began building his career by teaching crystallography and the Natural Sciences tripos at much the same time as the far more brilliant Alan Turing was studying maths as an undergraduate at King's College.

The break that was to change Rawlins' life came in 1934. In that year, Kenneth Clark approached him (they were both members of the Athenaeum, Rawlins no doubt as a result of his father's contacts) to form a scientific department at the National Gallery, funded by the profits of art postcard sales.[4] X-ray crystallography was an expanding new scientific field in the 1920s and 1930s, and its particular application to art was that it made possible the analysis and identification of paints and pigments, salts and other corrosives, and of conservation materials such as the fillers, glues and colorants found in old paintings, sculpture and museum objects. Armed with this knowledge, conservators could then set about repairing damage, reproducing fixatives or matching colours. X-rays were also starting to be used to visualise paintings beneath their surface and to resurrect *pentimenti* – abandoned designs or pictures which the artist had overpainted. Rawlins was the man to introduce these analyses to the new conservation laboratory of the National Gallery. He would not be directly employed, but instead would be paid a retainer as its Scientific Adviser.

Rawlins found that his new boss was his polar opposite. Clark, the Oxford-educated heir to an enormous Paisley textile fortune, and his glamorous wife Jane, a fashion designer, were the high-society hosts of a sparkling salon at their London townhouse in Portland Place, and Clark's meteoric rise to prominence in the art world (he was only thirty at the time he

took on the National Gallery job) continued when later that year he was also appointed Surveyor of the King's Pictures.

Elegant, patrician Clark immediately rubbed the scholarly curators of the National Gallery up the wrong way on his arrival, and his parallel royal appointment – followed swiftly by a knighthood – only worsened the atmosphere at Trafalgar Square. Clark was a broad-brushstroke sort of man: impatient, a womaniser, uninterested in management and budgeting, but visionary and determined in his approach to popularising art. 'Whenever he gave praise one felt that God Almighty had himself conferred a benediction,' thought James Lees-Milne. 'He would also have made an admirable dictator, had he turned his talents to politics.'[5] Clark regarded Rawlins as

a kind, good man, but one of the most relentless bores I have ever encountered, who fussed to me interminably over the most trivial details. I am no friend of a fusspot, and I am afraid I sometimes treated him brusquely.[6]

Clark was becoming hugely distressed by events in Germany. Jane was reading *Mein Kampf* aloud to him while he shaved in the mornings, and he told a friend in the government 'what a horrible and terrifying impression it was making on us'. On meeting Neville Chamberlain and pointing out some unpleasant facts about the Nazis, his concerns were dismissed as propaganda by the Prime Minister. Clark loathed appeasement.

We realised at last that the pandering of successive governments to the peace-loving inclinations of the country in which, for once, materialism and idealism were united, had left us impotent. No one, not even Mr Churchill, knew exactly how weak we were.[7]

Clark, who regarded himself always as a connoisseur rather than an art historian, still less a civil servant, was viewed with

intense suspicion from the start by most of his curators, a situation which deteriorated further when he unwisely purchased some paintings he was convinced were by Giorgione against their unanimous advice. When the works turned out to be by a much lesser artist, a faction led by the Assistant Keeper Martin Davies locked him out of the Gallery library in protest against his attempts to widen its appeal. Clark later quipped that it was because they found his ties offensive.[8] Clark had made innovative decisions such as opening the Gallery at 7 o'clock in the morning to allow those attending the FA Cup Final in London (Manchester City v Portsmouth) to visit before kick-off at Wembley, pioneered late night openings, introduced electric lighting, and advertised it all on the Underground.[9]

Martin Davies simply could not bear the vulgarity of it all. Possessed of a long quivering nose, badly spaced teeth and the large ears of an inquisitive vole, he was a confirmed bachelor, 'obviously descended from a long line of unmarried English clergymen', according to the great Jewish-German art historian Erwin Panofsky. (Panofsky was, incidentally, one of those who had fled to the USA after being sacked from his post at Hamburg University when the Nazis had come to power.) No one could have been more irritated by the urbane Clark than his Assistant Keeper.

Known as 'Dry Martini' to his colleagues, Davies lived an austere life, and cut a fastidious, shy, unworldly figure as he walked through the West End, carrying at all times a string bag full of library books and oranges.[10] 'The only strong emotion which he experienced', recalled a colleague, 'was hatred. Intense and lasting hatred of Kenneth Clark.' Clark revolted him. For Davies, the primary purpose of a gallery and its staff was scholarship, not its role in public entertainment or education, and for this revolutionary approach he never forgave his boss.[11]

But the thought of evacuating the National Gallery for all of them was overwhelming. How could it possibly be done? Founded in 1824, with thirty-eight pictures bought for the nation from the estate of Russian-born John Julius Angerstein, a wealthy marine insurer, and installed in a new building in 1838 in Trafalgar Square, throughout the nineteenth century the collection was expanded by the purchase of further acquisitions and by the donation of some remarkable collections, including those of wealthy horse dealer Robert Vernon in 1847 and J. M. W. Turner's own bequest, which arrived in 1856. When, in 1889, the sugar refining magnate Henry Tate offered his own collection of British art to the Gallery, it was so much bigger than the premises could hold that it was hived off to form the 'National Gallery of British Art', under the overall management of the mother institution but better known by its more familiar name of the Tate Gallery (today, Tate Britain).

By the 1930s the National Gallery itself contained around 2,000 oil paintings comprising some of the greatest masterpieces of European art. Its foundation collection had been enriched with paintings by medieval masters such as Duccio and the artist of the Wilton Diptych, and with Piero della Francesca's *The Baptism of Christ*. Other masterpieces included *The Arnolfini Portrait* by Jan Van Eyck, Vermeer's *Young Woman Standing at a Virginal*, Botticelli's *Venus and Mars*, Leonardo da Vinci's *Virgin of the Rocks*, Titian's *Bacchus and Ariadne*, portraits by Rubens and Rembrandt, landscapes by Poussin and Claude, one-third of Uccello's *Battle of San Romano* (the other two parts being in the Louvre and the Uffizi), Holbein's *Ambassadors* and the stunning *Christina, Duchess of Milan*, Caravaggio's *Supper at Emmaus*, Velázquez's *Toilet of Venus* (better known as the Rokeby Venus, stabbed by a suffragette in 1914): the list of endless glorious wonders created by the hands of the Old Masters went on.

Then there were much loved works by canonical British artists including *The Fighting Temeraire* by Turner and Constable's *Hay Wain*; and a smattering of more modern art, which might in Germany have been classed as *Entartete Kunst*: Van Gogh's *Chair*, *Wheatfield with Cypresses* and one of his many *Sunflowers*; a few Monets and Manets; Renoir's *Umbrellas*; and Degas' *Ballet Dancers*. But it wasn't just their age and value that put them at risk. Some paintings were huge – including Van Dyck's *Equestrian Portrait of Charles I*, which stood nearly twelve feet high by over nine feet wide in its stockinged feet – and just how on earth might that be removed to a place of safety?

Davies, Clark and Rawlins: three more different men it would have been hard to imagine. But pooling their varied skills together they masterminded the evacuation of their collections – and ultimately provided a safe haven for many others. Clark did the politics, Davies the curating and Rawlins the logistics. Clark had already ruled out using the Earl of Rosebery's massive country house at Mentmore in Buckinghamshire, where some other national collections were going. As he recalled later, he took a breezily optimistic view of the challenge before them:

> England is full of large houses, and I thought it would be easy to find a proprietor who would have welcomed the quiet occupation of his house by famous pictures rather than by rowdy and incontinent evacuees. But in practice the difficulties were great.[12]

His advice from the Air Ministry was that the north-west of Britain would be safest, and so the Gallery 'decided to request the hospitality of Wales', as Dry Martini put it, being as far away from enemy aircraft and their devastating bombs as possible. Everything would have to move. To save only part of the collection 'would have been a mistake', Davies thought.

'A selection, even a generous selection, would inevitably have excluded pictures that some admirers of the Gallery think are good; to avoid criticisms that would be hard to prove were unjustified, the removal of all pictures was planned.'[13]

So, in September 1938, just as the Munich Crisis was developing, Davies had taken a tour of properties in North and West Wales to see which might provide suitable housing for the Gallery's paintings. This had the immense benefit of getting him away from Clark. He was already pretty sure that two institutions – the National Library of Wales (NLW) in Aberystwyth, with a brand-new extension to its building, and the premises of Bangor University – would provide shelter. But those two places could not take everything, so he started looking further afield.

Under the Defence Act of 1842 the state had been given powers to seize private property for the defence of the nation in an emergency. So in 1937 the Office of Works had created a central register of buildings which could be requisitioned at any time in wartime for military, civilian or government use. Unlike the Office's 1934 schedule of destinations for national treasures, the listings in the 1937 general register would not be subject to negotiation. They would be compulsory. The details of the properties earmarked for seizure were kept a closely guarded secret, for fear of panic. With that uncertainty hanging over them, canny owners of country houses boasting more than four bedrooms (the threshold for consideration) who suspected they might be targeted sometimes offered up their homes spontaneously in the hope of bagging a more acceptable guest than if the decision were forced on them.[14] Schools were considered better than barracks, and art collections better than schools.

Thus, Colonel G. W. MacNaghten of Chew Magna Manor in Somerset was just one of many owners bombarding the

government in early 1939 with letters offering a safe haven for the nation's heritage:

> I wish to offer this house as a repository for works of art and other articles from Museums in London which it may be desired to house in the country in the event of war. It is not, I think, a very suitable house for billeting children or evacuated adults.

The Office of Works immediately sniffed out the Colonel's real motive: 'he feels works of art will be better behaved tenants in such a house than human evacuees and wants to make sure he doesn't get the latter.' A month later, the Colonel was back, helpfully pointing out that the kitchen pump which had drawn water from a well for the past 400 years would make the house unsuitable 'for any considerable number of children billeted in a large house'. He got nowhere. 'Our arrangements for the custody of national treasures have been completed,' replied the Office of Works, disingenuously.[15] Meanwhile, Granville Proby, owner of Elton Hall near Peterborough, quite shamelessly declared, 'I think we ought to have the Old Masters. After all, we do know that girls can be produced at any time by the processes of nature; but Old Masters are quite irreplaceable.'[16]

At the Rothschild mansion of Waddesdon – a Loire chateau confected in the Buckinghamshire countryside in the 1870s – Baron Ferdinand's spectacular collection of decorative and fine art (including snuffboxes owned by Marie-Antoinette) had itself to make way for over a hundred nursery-school children from Croydon. The dangers of keeping the family art in the wrong conditions became evident very quickly when the Old Masters consigned to wooden crates in the cellars were inspected a fortnight into their dingy sojourn. They were covered with a 'blue haze' of mould and had to be rehoused above ground in well-aired racks in

a spare drawing room. The Reynolds, Gainsboroughs and Romneys were restored, but permanent damage was done to three paintings by Watteau. In the wake of that disaster, Dorothy Rothschild took the pragmatic view that 'the danger of Hitler's bombs falling on Waddesdon was less than the known peril of Waddesdon damp.'[17] That view wasn't one shared by Martin Davies.

The owners of the properties who welcomed in the diffident, donnish and slightly rodent-y figure they found on their doorstep did not realise that they, as well as their homes, were being inspected. Alongside details of the dimensions of the rooms, doorways, light levels, the likelihood of damp and approaches to their houses, Davies made waspish notes about the potential custodians as well. 'Owner: not inspected. Takes trouble with his letters'; 'A gentleman and efficient'; 'A lady, & most obliging. Probably would not inhabit the house in wartime.' But also, 'The owner is nice, ruled by his wife, a tartar, anxious to have NG pictures instead of refugees or worse'; and 'Owner not inspected but seems obliging in a haughty way.'[18]

At last, a mile or two outside Bangor, Davies found what he wanted: Penrhyn Castle, a neo-Norman pile built for the 2nd Baron Penrhyn in the 1820s and 1830s, out of the profits of enslaved Africans working on his Jamaican estates and the slate mines of North Wales. It was also home to a great art collection of its own. 'The building as a whole is extraordinarily massive,' wrote Davies in his notebook. This was what he needed, because although he had seen many buildings whose rooms were big enough for the Gallery's biggest picture, up until then, none of them had had doors or windows colossal enough for the paintings to pass through. 'This building is on a magnificent scale. The courtyard, originally planned for the reception of numerous carriages, contains at one end a garage with no less than six doors of enormous size.' With another

small garage which had a massive door, and the Castle's dining room, all of the Gallery's outsize pictures would be accommodated comfortably.[19]

Clark called what happened next 'a dress rehearsal for the big move'. He had not believed that Chamberlain and Halifax would let themselves be cheated into an agreement, and he therefore decided to close the Gallery section by section so that the pictures could be taken down and packed. 'To close the National Gallery would be a political act, and (since the Gallery reports directly to the Treasury) I had to get permission from the Chancellor of the Exchequer, Sir John Simon.' Things did not go quite as planned at their meeting. With a faraway look, Simon murmured about 'your great summer exhibitions when, without fear or favour, you show all that is best in the art of the present day'. Realising that the Chancellor had mistaken him for the President of the Royal Academy, Clark seized the moment and asked, 'Well, can I do it, then?' Simon dreamily replied, 'Yes, of course, my dear fellow, do what you think right.'[20]

Clark was so fully engaged in the preparations during that 'miserable period' that he was able to forget his terrible sense of foreboding for a while. In anticipation of the oncoming need, an extra goods lift large enough to take the biggest paintings was added between the main Gallery mezzanine and the ground floor, and the route out to the street was made more efficient by a shuttered loading bay to which vans could drive straight up if needed.[21] The sheer weight and volume of the paintings was a challenge, so Davies and his team had tried to reduce both since 1937. The glazing was removed from most of the larger paintings with ease, as it had been fitted many years before in a way that would make cleaning straightforward.

The glass sheets were not fixed to the frames themselves but instead were bolted to 'flats': projecting wooden slats which were easily removed, leaving the empty frames in place still hanging on the walls. 'A depressing and wearisome business,'

thought Clark, but he did regard himself as having one secret weapon: Rawlins.

> He was a railway-train addict. His idea of a holiday was to visit Willesden or Crewe and he read Bradshaw every night. So when we came to plan the removal of the pictures to large, empty country houses in what we took to be safe areas, he could tell exactly what lines were available and what hours were free for a special train. He could also find the right vans and have them lined with Sorbo rubber [shock-absorbent sheeting].[22]

Rawlins' professional colleagues knew about his craze for anything to do with railways as well. Harold Plenderleith joked about

> the otherworld of delight into which he enters in studying Bradshaw, a compilation which he already knows inside out. For of trains and railways he is a veritable *amateur*. Parachute him anywhere in England or Scotland (he is 12.5% Scottish), by day or night, and it is alleged that after sniffing the breeze he will unerringly make for the nearest railway station and long before reaching it will have worked out the simplest route home to King's Cross![23]

In the months leading up to the Munich Crisis, the curators, gallery porters and volunteers had been practising, and when the time came to send off the first two vanloads of paintings to the railway yard, loaded into crates and buffered by thick brown paper wrappings at the corners, Davies and Clark drew on the experience of one of their young assistant curators, Neil MacLaren, who had been at the Prado during its evacuation from Madrid in 1936. As planned, they closed the Gallery in sections and took pictures not heading off to Wales to their newly fitted-out 'bomb-proof' basement. The 'agonising' discussions at Berchtesgaden lasted longer than Clark

had anticipated, and the first railway containers containing medium-sized pictures had arrived at Bangor station before their conclusion. 'Then, as we were emptying the last room, came the news of the Munich agreement. I suppose that a sense of relief was inevitable, but very few people I talked to, except for hardline appeasers, were deceived.' The Bangor stationmaster, clad in top hat, frock coat, gold watchchain and buttonhole met the consignment from London only to tell MacLaren and his handlers that 'peace in our time' had broken out after all and that they were to return to London, with their precious caravan still intact.[24]

Clark was never afraid to make himself unpopular in the interests of a cause he believed in and that included with the men from the Ministry too. He had, it was acknowledged, undertaken the best evacuation during the Emergency, but had definitely not played by the rules, as carefully constructed by the Standing Commission on Museums and Galleries. The Gallery had joined in the country-house scheme and reserved lorries for evacuation by road to the Home Counties but 'all the time they had been working out an alternative rail scheme'.[25] Their arrangements, it was grudgingly admitted, worked perfectly, 'but they were rather naughty: they got the Office of Works to earmark lorries for direct transport to country houses; they then changed their plans (without notifying the O.W.) and used rail – getting their lorries from Paddington direct'. This was hardly the way 'for one Government Department to treat another', John Beresford sniffed, in the Treasury.[26] But it was Clark's turn to be astonished when he received the rail companies' bills: 'all the special services which they gave us for the protection of the pictures have been given free and they have simply charged us as if the pictures were sacks of coal.'[27]

In later years, Clark recalled the year after Munich as largely 'a blank in my mind', except for one episode. Snooping round

the National Gallery cellars for spots which could be made into air-raid shelters for staff he found,

> in a small and remote vault, some twenty rolls of canvas, thick with grime, which I took to be old tarpaulins. I was just about to tell the head attendant to throw them away when curiosity prompted me to ask him to bring them upstairs and unroll one of them on the stone floor of the office entrance. It disclosed what seemed to be a layer of soot-smothered paint. I sent for soap, a brush and a bucket of water and to the general amusement, went down on my knees to scrub the filthy surface. Out came an unquestionable Turner. I had just enough strength of mind to stop scrubbing, and have the grimy rolls taken to the restoration department. They are now among the most admired Turners in the Tate Gallery.[28]

After Munich, more sophisticated flats, or wooden carcasses, were built which could hold entire canvases safely without their ornate frames or glazing, saving even more labour, time and space, and Davies ensured that 'frequent practices in 1938 and 1939 had taught the men on the Gallery staff exactly what to do.' Rawlins put his unusual brain to work on the 'formidable matter of transport'. It was imperative, he said, 'to make certain that the load would in fact be able to leave London amidst the turmoil inseparable from the outset of war'.[29]

By early 1939 Rawlins had made himself indispensable to the cultural preparations for war, yet his oddness was such that no one actually wanted to employ him directly. But he was keen to help and put his expertise to some use. In February he wrote to the Office of Works that

> you were good enough to say that my name might be borne in mind to cover your Department in [sic] emergency after such evacuation work here was finished. Things being what they are, I feel pretty sure I might be a little more use thus

employed than in returning to work in a laboratory under such circumstances.

One mandarin appreciated his value and wrote to another: 'He has apparently made himself an expert on the protection, disposal and evacuation of works of art.'[30] Rawlins had found the perfect niche, after years of being a square peg in a round hole. His diplomat brother Evelyn was working at the British Embassy in Berlin and he cannot have been ignorant of the full enormity of what was going on in Germany at the time.[31] All were waiting for the starting gun to go off.

Finally, on 23 August, it did. The trigger was the signing that day of the Molotov–Ribbentrop Pact which secured a non-aggression treaty between Nazi Germany and Soviet Russia. The invasion of Poland was imminent. Whitehall mobilised. All galleries and museums were ordered to evacuate immediately. The majority of the National Gallery paintings were destined for the Prichard-Jones Hall of University College, Bangor (its Registrar, E. H. Jones, declared in public by Davies to be very pleasant, but described in his secret notebook as 'stupid but apparently bullyable'). A smaller number of canvases went to the National Library at Aberystwyth under the care of the Chief Librarian, William Llewelyn Davies ('helpful and sensible', stated the notebook), while the most outsize pictures departed for Penrhyn Castle and its aristocratic owner.[32]

The first container from the National Gallery left Trafalgar Square for the goods yard in Camden that very afternoon, to be followed by many more. Pictures heading to Bangor and Penrhyn Castle would go via Crewe and Chester on the London, Midland & Scottish Railway (LMS), and those to Aberystwyth via the Severn Tunnel thanks to the good offices of the Great Western Railway (GWR).

With war imminent, Rawlins took the pessimistic and almost universal view that there was 'no reason to assume that the whole evacuation would be completed without attack from the air'. Nearly everyone believed that as soon as war was declared bombers would descend upon the capital. Ever a stickler for detail, Rawlins' scheduling with railway officials ensured that the amount of time getting the items aboard the freight containers from the railway vans was reduced to a minimum and that long periods of waiting or remarshalling at junctions was avoided. Railway engineers constructed a special sloping ramp at Bangor to deal with the biggest paintings alighting at the station: a considerable headache then and in the many moves to come.[33]

Looking back, years later, all Clark could remember of that sultry August was 'the turmoil and fatigue of evacuation'.[34] He was also worried about his family. Some years before he had become friendly with Viscount Lee of Fareham, an elderly politician who as former chairman of the Gallery's trustees had pressed hard after his retirement for Clark to become its Director. He had co-founded the Courtauld Institute of Art in 1932 and, using the considerable fortune of his rich American wife Ruth, had not only given their former home Chequers, with all its contents, to the nation as an official country residence for the Prime Minister but had also created an extensive art collection of his own. This Clark privately scorned, realising that 'he was genuinely fond of me, but also hoped that I would be his stooge.' Lee, or 'Uncle Arthur' as the Clark family called him, had built a gallery for his paintings at his home, Old Quarries, in the Gloucestershire village of Avening near Tetbury.[35] The Clarks, looking for somewhere to move to, were persuaded by Uncle Arthur to relocate near him.

Jane and the children (including eleven-year-old Alan, future MP and outrageous cad) left their country home

Bellevue in Lympne on Romney Marsh – very close to the Kent coast and an obvious landing place for any invader – and rented an attractive but run-down seventeenth-century house just four miles from the Lees, while Clark spent his time 'in the relatively easy task of evacuating the National Gallery pictures. Thanks to my railway addict everything went on time, and the last container rumbled away to Aberystwyth on the afternoon before war was declared.' The family was joined by Clark's mother and some evacuated friends and always hoped to return to Lympne once the war was over, 'but it was damaged by a bomb and the beautiful barn completely destroyed. We never had the heart to go back there.'[36]

Early in 1939 Uncle Arthur had been asked by Clark to take in 200 smaller paintings at Old Quarries if war broke out, 'the only private occupied house which would be honoured in this way', its custodian boasted.

Needless to say I welcomed with pride this unique responsibility and at once set to work designing special racks and fittings which could be made locally, and which would secure the maximum of security and safe atmospheric conditions for such a galaxy of famous and irreplaceable 'guests'. The plan had to be treated as a profound State secret and, with the sole exception of Ruth, not even my own household had any idea of what was in the wind.[37]

Lee received the code word from the Gallery by telephone on the evening of 24 August and

our respective teams 'jumped to it' and by 10.30 the next morning the great vans were arriving at Old Quarries and my specially designed storage racks were in position waiting to receive them. It was a strange spectacle; first the long process of odd-size bundles of coarse brown felt, tied round with

string but without labels or any indication of what they con-
tained; then, the cautious unwrapping of each in turn, and
the appearance to our startled eyes of one after another of the
Nation's greatest possessions, looking fantastically out of place
on the floor of a Cotswold rectory. There was no order of
precedence; indiscriminately there emerged, a round dozen
of Bellinis, four or five Raphaels, Velázquez's *Philip IV*, Van
Dyck's *Cornelis van der Geest*, Rembrandt's self-portrait, all
the Vermeers, Metsus, Antonellos and Van Eycks (including
the *Arnolfinis*); to say nothing of such oddments as the Wilton
Diptych and the King's famous Duccio. There were some
230 in all, and when I looked round our little gallery that
night and went to bed somewhat dazed by my responsibil-
ities, I dreamt that I was now the owner of the great-
est private Collection that the world had ever seen! It was
also however the worst displayed, as most of our own best
pictures had to be removed from the walls and stacked away
in the dining room, whilst the bulk of the Gallery master-
pieces were hung on specially designed racks which looked
more like sheep-pens at the Cirencester market. It was all
very safe and business-like, but undeniably ugly, and the con-
gestion was so great that it would have been quite impossible
to keep the pictures on view, even if sightseers had been
permitted by the authorities.[38]

In total, 1,800 paintings were sent away from London, each
consignment accompanied by senior railway controllers, and
Rawlins ensured that 'officers of the Gallery were present at
the loading stations each night, travelling when possible with
the pictures until the train was clear of the main London
area', only to return to the Gallery to continue packing once
the trains were on their way through the darkness. Each one
was powered by the strongest steam locomotive available,
bristled with armed guards and displayed the headcode 'X'
indicating a non-stop royal train. Control points were tele-
graphed along the route to ensure that other trains were halted

and level-crossings cleared, as they rumbled through the night on their top-secret mission to the sanctuaries of Wales and Gloucestershire.[39]

Among the fragile cargo was the great wedge-shaped, tarpaulined 'Elephant case' containing the gigantic *Equestrian Portrait of Charles I*, one of a dozen made for the biggest paintings in the collection so that they lay angled within their specially designed Office of Works wooden crates when passing through tunnels and under bridges on their way to Wales. This was not the first time the Van Dyck had been moved. In fact it was one of the best-travelled paintings in the entire Gallery. Painted for Charles I in 1636, the twelve-foot-high monster masterpiece had been sold in the great auction of the King's art collection on his execution thirteen years later. It passed through the hands of a Mr Pope in 1652, then resurfaced mysteriously in Antwerp in 1698 when it was bought by Maximilian II Emanuel, Duke of Bavaria, regent of the Spanish Netherlands. He took it home to Munich at the turn of the eighteenth century where it lodged in the Wittelsbachs' vast art collection at the Alte Residenz.

Seized by Maximilian's brother-in-law, the Emperor Joseph I, as part of the booty associated with his bloody occupation of Munich during the War of the Spanish Succession, it then passed in 1706 from the Emperor to his ally, John, 1st Duke of Marlborough. Marlborough undoubtedly knew of its shady past. When it arrived back in England, after nearly fifty years' absence, it was housed first at Sarah Duchess of Marlborough's residence, Holywell House near St Albans, then at her town house in London, then finally at Blenheim Palace in Woodstock, Oxfordshire, where John's descendant, Winston Churchill, was born in 1874. The painting was sold to the National Gallery by the 7th Duke in 1885, but its wanderings were far from over.[40] Now its latest home was about to become Penrhyn Castle.

Ten days later, on 2 September 1939, after a gargantuan effort, the evacuation was complete. Clark had found himself intensely moved by the process but not in the way many would expect. He told radio listeners on the BBC Empire Service:

> Pictures which I have known for years have only come to life for me the first time during these last days when I have seen them being wheeled in and out of shafts of sunlight and finally buried in the darkness of a railway container.[41]

For while it could no longer be a secret that galleries and museums were on the move, the means and destinations were still completely confidential. As for Davies, he had achieved his aim of emptying the whole gallery, 'with the exception of some thirty or forty useless works, and some examples already out of London on loan'. The glass sheets were stacked together as they were taken off and sent on later to be reaffixed once the pictures were safe in their new homes.[42] After waving off the last van that afternoon, Clark and some staff from the Gallery went to St Paul's Cathedral to pray and be with others, fearful of what the next hours held, but found themselves shooed out by the vergers because they arrived just at closing time.[43] The next day war was declared.

At that time, Rawlins lived in a terraced house in Hampstead, looked after by his elderly housekeeper Edith Wing, and with a vicar for a lodger, an old Cambridge acquaintance. For the next eighteen months he regularly made the journey to and from Wales, checking and advising on the respective environments in which the pictures now found themselves.[44] Davies breathed a sigh of relief, departed his house in Chelsea, and all seemed set for him to spend the war motoring at leisure between Bangor and Aberystwyth (once he could organise a petrol allowance from the ministry). He could finally get down to researching a detailed

catalogue of his favourite works which he now had the time and opportunity to do, freed from the red tape of London (and Clark) even if he had to put up with Rawlins' eccentricities now and again. How wrong he was. None of the three men suspected that within a year, all their plans would be turned upside down and a frantic search for a new safe house for their paintings would begin.

3

We Shall Defend Our Island
Whatever the Cost

ALL ACROSS LONDON'S museums that August, cur-
ators were rallying to the call. Victor Scholderer was one
of them. He had worked for the British Museum's Depart-
ment of Printed Books for thirty-five years and was one of
the world's most brilliant incunabulists – that is, an expert on
fifteenth-century printed books. As his name might suggest,
his parents Otto and Luise were German, his father a well-
known artist of the Frankfurt School who was a friend of
Manet and had connections to the Paris art world, who had
emigrated to England with his wife following the outbreak of
the Franco-Prussian War. Victor, their only son, was born in
Putney. Though his parents moved back to Germany when
he was nineteen, he studied Classics – 'Greats' – at Oxford
and for a time lived in Paris. So, armed with complete fluency
in English, German, Ancient Greek, Latin and French, he
joined the British Museum Library (known today as the British
Library). In 1913 he had married Frida Semler, the daughter of
a German Railways executive, an event which he regarded as
'one of the most lustrous blessings shed upon me by my star'.
Frida had narrowly missed being interned as an enemy alien in
1914, though, as Victor later explained,

> we escaped the worst attentions of the hysterical Germano-
> phobia of the war . . . but the situation was a severe trial for my
> wife, which she stood up to with a steadfastness that was the
> admiration of all who knew her.

45

Victor, as a first-generation German immigrant, had seen what was coming from early on, and observed with dread the spiral of evil into which his parents' beautiful and cultured country was descending:

> From the very beginning I had felt in my bones the menace of Hitler. The futility of appeasement and all wishful devices for keeping him at arm's length was always evident to me and I was daily forced to acknowledge the insight of Heine's remark that the German fool pursues his folly with a grisly thorough-ness of which a superficial French fool (or British, for that matter) has no conception.

In 1932 he and Frida had stayed in Germany for a few days on their way to Sweden, and he recalled it forever after with a shudder.

On the day the Munich Agreement was signed – the rape of Czechoslovakia, as he called it – he was walking despond-ently down Victoria Street, 'and feeling as a well-whipped dog must feel I saw in a shop-window a small blue-and-white china lion priced at 5/- and the sight of it solaced me so much that I went in and bought it'. Compiling his memoirs over thirty years later, he noted that 'it stands before me as I write and I still feel actively grateful to it – let the psychoanalysts explain.'[1] Victor was approaching sixty by the time war finally broke out and might otherwise have looked forward to spending his final years before retirement quietly tending his collections at the British Museum at its great building in Bloomsbury and engaging in scholarly dis-course with his European counterparts. It was not to be, for the war set him off on a different, but remarkable, path westwards.

At the time, the British Museum's library holdings made up the greater part of its collections, a fact reflected in the title of its 'Director and Principal Librarian', Sir John Forsdyke. But Sir John was only the second man who was not a librarian to hold the post in the Museum's almost 200-year history, and

he had – up until that point – shown no particular interest in the Museum's vast and precious printed and manuscript collections. Forsdyke, indeed, was an unpromising person to be leading the whole of the British Museum.

His was a life which had descended into a rigid mediocrity after some early promise. Born the son of a commercial traveller in Bermondsey, by winning a place at Watford Grammar School and then a scholarship to nearby Christ's Hospital in Hertford he had been able to gain the education needed to obtain a scholarship to Keble College where he read Greats (he and Scholderer missed each other at Oxford by three years). In 1907 he became an Assistant Keeper of Greek and Roman antiquities at the Museum, where he stayed for the rest of his life, though he was no great scholar. Among staff he was unpopular, not least because of his sharp tongue. Possessed of watery blue eyes, a ruddy complexion, large ears and a rather petulant mouth topped with a bristly toothbrush moustache, he insisted on being painted in full civil service court dress for his official portrait by Gerald Kelly – a painting which still hangs in the British Museum. But there were other reasons beyond his pomposity for his staff to dislike him. He was blamed by them for the scandal which had engulfed the Museum in the late 1930s when the Elgin (properly, Parthenon) Marbles suffered a conservation disaster that permanently damaged them, adding yet another chapter to their controversial history. The man brought in to sort out the mess with the Marbles was Bernard Ashmole MC: distinguished numismatist, expert in classical sculpture, Professor of Archaeology at University College London, historical adviser to Charles Laughton's 1936 film, *I, Claudius*, and, most of all, a safe pair of hands. Ashmole described the situation he found at the Museum when he arrived. The sculptured panels looked 'unnaturally white' he thought, and Forsdyke subsequently made an 'alarming revelation'.

Lord Duveen, the world's richest and most famous art dealer (and also its most overbearing), had offered to donate a new gallery for the Marbles. In Ashmole's words, Duveen

> had in effect bribed the chief mason, who happened to be a drinker and therefore not all that trustworthy, to clean a number of the marbles drastically so as to make them more showy for his new gallery; the mason had removed the patina, which is that change, mainly in colour, of the surface which tends to occur with age.

According to Ashmole, it was the absence of the Keeper of the Greek and Roman Department due to long-standing illness, and the Senior Assistant Keeper's unwillingness to inspect the conservation studios in favour of burying his nose in his research, which had created the situation in which 'the mason carried on his evil work undetected', cleaning the Marbles with copper chisels and the gritty polisher known as carborundum, rather than a neutral solution of medicinal soap and ammonia, as recommended by Harold Plenderleith. Though the two curators involved eventually resigned (hung out to dry by Forsdyke, thought some), the Museum sank into a pit of unedifying mudslinging whose lingering stink followed Forsdyke thereafter, who was blamed for not having kept a closer eye on the department. He then compounded the mess by instructing the unflappable Ashmole to continue to play down the matter with the press and in Parliament, as he himself had done. Ashmole viewed the whole situation with distaste.[2]

Unknown to most of his colleagues at that time, Forsdyke had recently lost his wife Frances – a woman whose existence he had kept firmly in the shadows. He failed to mention her in his entry in *Who's Who* and the rumour was that he had dutifully married her in 1910 only after promising a dying friend, whose mother she was, to take care of her.[3] At that time he was twenty-six and she was almost fifty. She died in

the summer of 1938, shortly before Forsdyke first reported to the Trustees of the Museum the trouble with the Marbles. The couple had no children but lived with his very elderly mother (who was just a few years older than her daughter-in-law) and his spinster sister. Theirs was a large house in secluded Asheridge, a small hamlet near Chesham in Buckinghamshire where this other part of his life could be safely hidden away at the end of the Metropolitan underground line.[4]

But the world kept turning beyond the little universe of Bloomsbury and soon the prospect of war pushed the cleaning scandal from the forefront of most people's minds. By early 1939, the overriding concern became how to save the Marbles from utter obliteration, along with the other fantastic collections of the Museum from across the world; some bought, some donated, others acquired under dubious circumstances or simply grabbed during colonial occupation, all since 1753. The tables were turned as the Museum sought to protect those same treasures from a new generation of ruthless raiders who might stop at nothing to obtain them for the Fatherland.

Forsdyke was of the view that 'our experience of air attack in the First World War, and the expectation of much heavier bombing in any future conflict, made preparations for the removal of valuable objects a necessary part of Museum and Library technique.'[5] The main obstacles in planning for a large-scale evacuation at an undetermined future time, he found, were not scholarly questions or antiquarian niceties, but the very practical dilemma of storing the huge number of boxes which would be required for packing. The logistics were daunting. Thousands of bulky empty crates would take time to transport to Bloomsbury and an even longer time to get into the building. Once inside, they would have to be stored in basements, stairwells and corridors much to the inconvenience of staff and visitors. They would be highly visible and might even cause comment among an already unnerved public. The

answer to this dilemma proved to be surprisingly nearby: just two miles from the front gates of the Museum, in fact.

The London offices of No-Nail Boxes Ltd were in Victoria Street (the very same street where Victor Scholderer had bought his china lion). Along with its Bootle branch, this new company had recently invented a novel kind of packaging for all sorts of retail products from margarine to paint, boot polish to soda syphons. 'May we make you a test pack of YOUR product?' 'The No-Nail Box is the modern improvement on accepted methods in case-making!' blared its smart black and teal advertisements. This is familiar to us today as flat-pack storage, but at the time it was a new innovation. No-Nail's invention was made of four pieces of smooth plywood, riveted together by steel strips to create a single, long, hingeable sheet. When needed, the sheet was folded up into a cube and, with the addition of two further sheets gripped in place down each side, became a sturdy wooden box, considerably lighter than a battened and nailed wooden crate which was rough and took up space. They were so 'extraordinarily simple' to put together without tools that – astonishingly – 'in many instances female labour is now being employed from the time of assembling the case to its final closing'.[6]

What it did for the transport and storage of chilled fish and Bakelite wirelesses is unknown, but for those planning the defence of the British Museum's collections, the company's product was transformative. After Munich, Forsdyke ordered 3,300 of them, until production for civilian use was stopped by the Admiralty, which had cottoned on to their usefulness and now diverted their manufacture to its own ends. No-Nails were easily stored in the basement of the new Duveen Gallery intended for the Parthenon Marbles until, as one member of staff put it, 'you could see nothing else, they were crammed floor to ceiling'.[7] The sides of the boxes could easily be stencilled with identification codes as they were filled, corresponding to

the Museum's departments: B&M for the British and Medieval collections, G&R for Greek and Roman, E&A for Egyptian and Assyrian, OA for Oriental Antiquities, and so on. To these codes would be added an inventory number so that each box's contents could be identified from a separate packing list, and then the final destination was marked on the outside. Easier to obtain at short notice were ordinary millboard cases 'for small or non-fragile objects' and Forsdyke was ready to order them as soon as needed. Six hundred alone were required to hold the Museum's C&M – Coins and Medals – drawers, all secured with riveted steel bands as the final step.[8]

The Munich Crisis had been, as with the National Gallery, a wake-up call. Forsdyke had been faced with what he called, 'salutary reminders that arrangements for removal must be absolutely complete before an outbreak of war'. They had to be ready to run like clockwork as soon as the order to evacuate was received from Whitehall. Like many museums, galleries, libraries and archives, there had long been a list of priority items at Bloomsbury to be saved in case of fire, so Forsdyke considered that already covered. But then there was the question of the removal arrangements: where the collections should go and how they would get there.

Early in 1939, the Office of Works had presented the Museum with a final shortlist of five large country houses which could offer refuge for some of its collections. They were all at least two miles from towns, factories, camps, aerodromes and 'other likely points of danger': Boughton, Deene, Apethorpe, Drayton and Lilford.[9] Furthermore, all were in Northamptonshire – that flower of south midlands English counties – which was still largely a rural idyll despite its ironstone quarries, the shoemaking heritage of its towns and the burgeoning industrialisation of the village of Corby, fast becoming a centre for steel manufacturing. The attraction of Northamptonshire was not only that was it in the centre of England, relatively far

from the threatened south and east coasts, but that its towns were serviced by the London, Midland and Scottish railway line from St Pancras, just a mile north of Bloomsbury: the obvious point of departure for precious freight from the capital.

The two houses Forsdyke settled on by the end of March 1939 were Boughton and Drayton which, close to Kettering station, would 'be enough for our purposes', he told the Office of Works, in a letter which gives a small taste of the autocratic style that proved to be so useful in wartime, where it had been a disaster in peace. He declared:

> We must however be prepared to make full use of these simultaneously and immediately on the outbreak of war, and it would be necessary to billet members of staff in them for the reception, disposal and invigilation of material throughout the period of war . . . For reasons of safety also, particularly protection from fire and theft, it is essential that unknown or irresponsible persons should not have access to these houses while we are in occupation, and I regard it as essential that their use should be secured exclusively for the British Museum.[10]

So Northamptonshire it was, a county sprinkled with gorgeous aristocratic country houses dating from the seventeenth and eighteenth centuries, set amid fields of wheat and barley and gentle river valleys. Boughton House was the main English residence of the Scottish Dukes of Buccleuch and Queensberry. It was a country paradise. 'Boughton always reminds me of cuckoos and the cawing of the rooks in the spring; summer days, warm and peaceful,' recalled Alice, daughter of the 7th Duke, of her childhood. She later became Princess Alice of Gloucester and thus at the time of this story was George VI's sister-in-law.

> Wildflowers – bluebells, fritillaries in profusion. We were allowed to roam at large, nobody seeming to worry that we

might drown in the lily-pond or the river running through the park. We loved the birds and chasing the butterflies. We loved Boughton – but because it was English we could never admit to it.[11]

When Boughton was scheduled as a home for the British Museum, the family at first suspected it was because, when the 7th Duke died in 1935, the Inland Revenue had crawled all over the house valuing it for death duties with the help of museum experts and that details had been retained nefariously for ARP planning.[12] But Boughton had been on the Office of Works' radar since at least early 1934.[13] And actually the connection between the Buccleuchs and the Museum went back even further, as far back in fact as its very origin.

It was their Montagu ancestors who had in 1759 sold the family's ancient London home, Montagu House in Bloomsbury, to the trustees of the new British Museum (founded 1753) to house its growing collections. That building was then demolished when the collections vastly outgrew it and the building which was there in 1939 had been constructed to the designs of Robert Smirke between 1823 and 1857. Things at Boughton were not quite as perfect as they seemed however. The 8th Duke (1894–1973), Walter John Montagu-Douglas-Scott, Lord Steward of the Royal Household (an honorary position), was overfriendly with fascists. He had met up with Ribbentrop in London in 1939, and intended to go to Hitler's birthday celebrations that April until instructed by Buckingham Palace on arriving in Germany to stop his jaunt immediately. The fact that they might be putting the British Museum's treasures into the hands of a possible Nazi sympathiser seems to have passed both the Office of Works and Forsdyke by. The King however noticed the Duke's predilections and, the following year, Buccleuch was quietly excluded from his position close to the royal family.

Just a few miles further east of Kettering was Drayton House, home of the Stopford-Sackville family, whose ancestors had lived there since the thirteenth century. As early as March 1934, the owner, Colonel Nigel Stopford-Sackville, declared himself 'glad to undertake the safe custody of any of the national treasures should the necessity arise at any time. Whatever spare room is available in this house is entirely at the disposal of those persons responsible for making the necessary arrangements.'[14] Secluded from the world, in a large landscaped park, it was sufficiently hidden away to be invisible to the casual passer-by despite its elaborate towers topped with Baroque cupolas. Only its grand iron gates gave a clue to what lurked within the grounds behind the ornamental park railings, and its large medieval hall, decorated with marble panelling and a painted ceiling, was ideal for the storage of large crates from the Museum.

Forsdyke and the Office of Works then thrashed out the logistics of the moves with the railway companies. Multiple boxes would be

> conveyed in door-to-door container-vans, which would be locked and sealed at the Museum, escorted on the trains by members of the Museum staff as well as by railway inspectors, and met at the local stations by members of the reception parties billeted in the country houses.[15]

From there, the containers would be transferred onto 'mechanical horses': the name given to the three- or four-wheeled vans with articulated trailers used by the railway companies to drive the containers to Boughton and Drayton.

Not everything however was small enough or light enough to be easily moved to Northamptonshire. All the sculpture at the British Museum was heavy and some of it was gigantic. For these collections other solutions needed to be found. The London Passenger Transport Board had confirmed that 'there

are lots of odd bits of tunnel left in our system' which could be put to good use. The British Museum had in fact once had its own tube station – closed in 1933 – but that had already been commandeered for top-secret military use pending the outbreak of war. Aldwych, a lightly used station on the deep Piccadilly line with one closed tunnel which had housed the defunct Holborn shuttle service, was relatively close to the British Museum, just as the Brompton Road station (closed in 1934) was well placed for the museums of South Kensington. But there was a problem. The interconnecting lines under the streets of central London meant that a high-explosive bomb could wreak not just immediate damage on a target, but set off a major flood within the maze of tunnels if a water main were breached or, worse, the Thames or one of London's many underground rivers found its way through a damaged wall.[16] It was a risk which had to be taken.

At the very end of the Great War, the British Museum had sent a handful of its most precious books and manuscripts to the National Library of Wales to escape the danger from Zeppelin raids. 'Gallant little Wales' had come to the rescue; and their reception – 'courteous, businesslike, prompt and able' – had not been forgotten.[17] It therefore seemed obvious that the National Library should be approached again during that first phase of air-raid precautions planning in the early thirties. Back in January 1934, the Secretary of the British Museum had written to the Chief Librarian of Wales in the following terms:

> May I ask whether your Court would be prepared to provide again the hospitality which they provided during the War of 1914–1918? At present I can readily believe your spare capacity is much less than it was then, but your new building plans . . . probably give you, at any rate for a time, considerable accession to spare space. The deposit would consist of books, manuscripts and prints and drawings, and not, of course, of antiquities, for which other repositories are being sought.

Within two working days, London had its reply from Aberystwyth. 'I have no doubt in my mind that, if the necessity arises, this hospitality will be gladly given.'[18] So the four great Library departments of the Museum – Printed Books, Manuscripts, Oriental Printed Books, and Prints and Drawings – could move to the west coast of Wales, over 200 miles away, if a sanctuary were ever needed again.

William Llewelyn Davies, the man who had made the offer, was born the son of a gamekeeper in Pwllheli on the Llŷn Peninsula just a few years after Forsdyke, and was modest, polite and generous. A native Welsh speaker, he had two degrees in Welsh literature from the University College of Wales at Aberystwyth and, after a stint teaching and time in the army education service, in 1919 had joined the young National Library of Wales.[19] In appearance he was unremarkable, and not at all the image of a knight in shining armour. With a thin kindly face, alert curious eyes, thick-rimmed glasses and hair centre-parted and slicked to his bony skull with copious amounts of Brylcreem, he could have been mistaken on Aberystwyth's High Street for a bank clerk, cinema projectionist or optician's assistant. But beneath his mild-mannered exterior beat the heart of a passionate visionary. By 1930 he had risen to the very top.

During his time in charge he transformed the institution. The National Library had only been established in 1907, and was given legal deposit privilege in 1911, allowing it to claim all printed publications in the United Kingdom for free. Llewelyn Davies aimed to make it not just the National Library but the national archives of Wales as well. Throughout the thirties, a huge acquisition programme took place, taking in manuscript collections from Welsh families, churches, businesses and estates, as well as expanding its printed holdings. He launched the Library's own academic journal and wrote its official history.[20] In 1937 came the opening of the central block of the building whose foundation stone had been laid twenty-six years before.

Huge excitement attended the expansion of the Llyfrgell Genedlaethol Cymru. When the royal train arrived at Aberystwyth George VI and Queen Elizabeth were mobbed by the locals, before being whisked up Penglais Hill, a windswept bluff above the town, to unveil the plaque over the Library entrance. Designed by the architect Charles Holden, its upper storeys of dazzling white Portland stone – brighter even than those scoured surfaces of the Parthenon Marbles – were, and still are, huge and visible from across Cardigan Bay, over the heads of the seals and dolphins which swim there.[21]

In the wake of the Spanish Civil War Llewelyn Davies had become extremely worried about reports that modern high-explosive bombs could penetrate through eighteen feet of concrete, and at the start of 1938 began to express his concerns publicly. Never a man to delay, by mid-February he had persuaded his trustees to approve a plan to create a secret storage cave 'under the high rock which is in the field between the Library and the Librarian's house'. Reading his daring scheme, the Secretary to the Council exclaimed, 'you take my breath away!' By March the Treasury in London had been contacted about whether it would be prepared to defray costs of up to £3,500 towards the building of the shelter, 'to which it is proposed to transfer, in the event of danger from air raids, some of the more valuable literary and historical treasures which this Library holds in trust for the Welsh nation'. Whitehall was not keen. 'We could scarcely give the National Library of Wales, a grant-aided body situated in a pre-eminently safe position, the perfectly bombproof shelter which we have denied to the great national museums and galleries.'

A mandarin called Usher then foolishly decided to ask Forsdyke to fob off the Welsh by means of what he called 'your little committee' working on the green ARP advice pamphlet. But this ruse spectacularly backfired when Forsdyke, no man to be patronised and with the Chief Librarian's promise of

1934 on file, immediately saw the potential of the chamber for
the British Museum Library itself. The crestfallen Usher had to
tell Eric de Normann, storage supremo of the Office of Works,
'that the result has differed considerably from my hopes'. It
turned out that Forsdyke was right behind the idea of a 'com-
pletely bomb-proof shelter somewhere for highly valuable and
perishable property', outside London, and for his part Llewelyn
Davies kept up a campaign of persuasion with Whitehall:

> in the event of an emergency arising the National Library
> would be prepared to house some of the most important
> manuscripts in the British Museum. It will be recalled that the
> national library was able to take care of some of the most valu-
> able collections of the British Museum during the last war.[22]

At this point in his battle with the Treasury, Forsdyke
wheeled out one of the most powerful weapons in his arsenal:
the expert Harold Plenderleith. 'No safe repositories have been
constructed for the protection of any national property (works
of art, literature or records) against high-explosive and incen-
diary bombs,' Plenderleith warned. The thirty-five-year-old
Scot, already Professor of Chemistry at the Royal Academy (and
whose undergraduate study at St Andrews had been interrupted
by service on the Western Front, resulting in the award of a
Military Cross at the age of nineteen), knew of what he spoke.
For several years he had been testing out his new theory in rela-
tion to museum preservation, namely that the best conditions for
the storage of art, archives and other perishable museum collec-
tions were a steady temperature of 60° F with a relative humidity
of 60 per cent: what he called the 60:60 rule.[23] Basement storage
on site at Bloomsbury for books and manuscripts was just not
going to be good enough, he told the Treasury.

> The National Gallery has a newly finished shelter which it
> describes as bombproof, but the Office of Works tells me that

it is not so. In fact the Office of Works has told us all from the start that the provision of safe storage on the premises is impossible.[24]

He had to point out – again – that tube tunnels were damp and in some cases actually wet, with Aldwych being sixty-six feet and Holborn fifty-five feet below the river at high tide. The London Underground would only be suitable for the British Museum's non-organic objects made of stone or metal – ceramics, gems, vases, terracotta, marble, granite, alabaster and most coins. There was thus, he submitted, no provision, apart from the country houses under consideration, for books, manuscripts, prints, drawings, wood, textiles, fur and feathers, partially corroded or patinated bronzes, Egyptian and Assyrian antiquities, or anything painted: that is, organic materials which would rot away or be permanently damaged. In his efforts to force a decision on Llewelyn Davies' plans, Plenderleith even took a swipe at the Office of Works' strategy of employing country houses, 'which may or may not be damp- and fire- and burglar-proof'. Finally, forwarding a report from his research chemist, he reiterated that the Underground simply 'would not do for books and manuscripts'.[25]

Still unmoved by the double onslaught from Bloomsbury and Aberystwyth, the Treasury turned down the proposal in July 1938. Llewelyn Davies was not deterred. He forged ahead with his plans regardless, and the contractors began blasting successfully through the layers of hard shale in the hill that summer. But he did not abandon his attempt to get funding from London either. At the height of the Munich Crisis Llewelyn Davies was approached on a visit to the capital by representatives from the British Museum, the National Gallery, Dulwich College and the RIBA, 'all of them anxious to send materials to the National Library if a state of emergency should arise'. Could the British Museum perhaps

make another approach to the Treasury on behalf of Wales, to exert further pressure, he then asked Forsdyke? 'We are proud of the fact that the youngest of the national libraries was able to afford safe custody to some of the nation's treasures from the British Museum and elsewhere during the last war.'[26]

From this point, Forsdyke delegated much of the negotiation with Llewelyn Davies to Idris Bell, the Museum's Keeper of Manuscripts whose own speciality was papyrology. Bell was ideal for the task because he was also an accomplished editor and translator of Welsh literature, being Welsh on his mother's side and having taught himself the language as an adult. And he was already a member of the National Library's Council.[27] By October 1938, the architect Charles Holden (also responsible for the University of London's Senate House and many art deco tube stations) was being briefed on the British Museum's requirements. Meanwhile Forsdyke had become so impressed with Llewelyn Davies' daring plan that he was minded to stump up the cash required from savings in the Museum's budgets and suggested that Plenderleith go down to take a look at the site.[28] The Treasury remained obdurate, so Forsdyke took the plunge. By the end of the month, the Museum had formally declared its intention to join with the Library in sharing what was becoming known as 'the ARP chamber' or 'the Tunnel' and to pay for an extension. This would bring the cost to some £6,000, of which the Museum would pay two-fifths for a discrete storage space all of its own, though 'we are still a little worried about the problem of damp'.[29] He would find the money internally, somehow. The race was now on to complete it before war broke out.

Ten months later, in the late evening of Wednesday 23 August, Forsdyke was telephoned by the Office of Works with a message from the Home Secretary, as was Kenneth Clark. Evacuation should begin as early as possible the next day. All the Museum's senior staff were immediately contacted by

telephone or telegram, and told to get their packing and despatch teams ready for work.[30] The following morning, Junior Assistant Keeper (Second Class) Adrian Digby, of the Department of Ethnography and Oriental Antiquities, had been listening to the news of the Molotov–Ribbentrop Pact on the wireless at his home in the north-west London suburb of Hatch End and was still eating his breakfast when the phone call summoning him to Bloomsbury came, cutting short his summer leave. For the next fortnight he got up at 5 o'clock every morning and caught the earliest train he could into Euston station, walked to the Museum, wolfed down a hearty fry-up in the staff canteen, and began a marathon of packing. Ever since Munich, the staff had been listing and prioritising their collections by importance and rarity. During those ten months they had also taken part in various salvage and fire-fighting exercises and had undergone a mock poison gas attack using tear gas, which was so unpleasant they never forgot to carry their gasmasks afterwards.[31]

Stacks of No-Nails, stencils and packing materials were awaiting Digby and all the other curators in the galleries. The boxes took two minutes to assemble and most objects were packed in wood wool. Cotton wool was reserved for the most fragile items. The rest were packed in cheaper Kapok which floated through the air and stuck to their clothes so that all the packers looked like giant fluffy chicks at the end of the day. So much packing went on that supplies ran out; the team ended up using a huge stash of *News of the World* (motto: 'all human life is there') which they found at the back of a cupboard. Apart from the principal treasures from Digby's department, including the Benin bronzes, Mexican turquoise mosaics and Hawaiian feather-work cloaks which were dealt with separately, everything was packed. The highest priority 'ETH' (Ethnographic Collection) boxes were stencilled with a red star (save everything) or red square (save individually labelled

items inside). Green stencils indicated lower priority boxes. A hand-painted 'P' for 'Perishable' (the Director's Office had forgotten to include a P stencil) indicated boxes of collections to go to Drayton and not to the Tube.[32]

Elsewhere in the building, Bernard Ashmole found that everyone in Greek and Roman Antiquities was

> wonderfully helpful, and day after day we packed, making an inventory, case by case, of the thousands of objects. Particularly tricky were those in the Gold Room, many of them small and extremely delicate. Every one had to be detached from its setting in the show-case, listed, laid in cottonwool, and then packed in such a way that it would not be crushed.

His team packed up the precious exhibits from the room of Greek and Roman life, 'the best of the ancient glass, and all the more important Greek vases', to go into the Tube.

The basement vaults of the Museum were very large, and brick-vaulted, so all of the lesser sculptures and hundreds of second-rank vases were moved there, in the hope that this would provide at least some protection against light bombing or fire. Ashmole saw to it that the Parthenon Marbles were, 'as a preliminary measure', taken down and set as close to the wall of their gallery as possible between the pedestals from which they had been removed, and then roofed over with a 'thick sloping roof of sandbags supported on steel sheets and joists'. Later on, Forsdyke ordered the interior frieze panels to be shifted into the Aldwych underground, while the heavier pediment statues and the *metopes* (the sculptured blocks from the exterior portions of the frieze) were moved to the museum basement and once more sandbagged under the galleries' stone floors for protection.[33]

For Forsdyke, the threat of war was a liberation. It set him free from the mediocrity into which he seemed destined to slide

further had things turned out otherwise. His weaknesses were transformed by crisis into strengths. The *dirigiste* had become the meticulous planner. The caustic tongue had become decisive. Unyielding formality had become gravitas. And in the process he became just the leader the Museum needed. He ran the evacuation like a military operation, having served as a captain in the Royal Field Artillery in the Great War. The first batch of LMS Railway containers, known as BKs, were already on site, having been requested by him some days earlier to ensure a quick start when the balloon went up.[34] Once a box was packed and stencilled with its destination, it was wheeled in a barrow down to the colonnade outside the building by a gallery warder. Routes through the enormous building had been specially drawn up by Forsdyke to avoid congestion. There were seven loading points on the colonnade, six destined for the railways and one for the Aldwych tube tunnel.

Each box was then officially sealed with steel tape by Mr MacIntyre, the Assistant Secretary of the Museum, and was left at the relevant department loading point. There, a two-horse dray pulling a railway container would drive up, the boxes loaded with their lists inside to be checked at their destination. The Museum forecourt was bustling with activity like 'a busy railway goods yard', thought Digby, the BKs trundling to and fro with a policeman sitting beside each driver. The barrows streamed out of the Museum doors and their contents were loaded into the containers by the sweaty, red-faced staff. One BK became so overloaded with heavy sculpture that its wheels sank into the tarmac forecourt in the burning sunshine, and all the boxes had to be unloaded again. Forsdyke rebuked the Assistant Keeper responsible and was lambasted in return. Surprisingly, he overlooked it.[35]

Inside the Museum, lower priority items were being moved to the reinforced basement. Others were simply too big or

too awkward to move. Massive Assyrian and Egyptian mon-
umental sculpture had to be protected in place, their stone
eyes staring blindly down emptied galleries. They were sand-
bagged in, based on photographs of what had happened at
the end of the Great War. Three of the old-timers remem-
bered doing it before.[36] The Queen Charlotte Island totem
pole had to be left on the colonnade, unable to be moved
further and at the mercy of the pigeons. Two smaller poles
went into a basement passage. A Solomon Island canoe,
thirty feet long, was left in situ in the Ethnographical Gal-
lery, and some of the images of native gods – including the
ten-foot wooden statue of the Hawaiian war god Ku-ka'ili-
moku from the late eighteenth century – gave Digby 'a lot
of trouble, in some cases as if they were incarnate'. The
next day Forsdyke called him in and instead of receiving a
dressing-down the junior curator found that he was invited
to lunch and asked to accompany the Director to Drayton
the next day to discuss final arrangements with Colonel
Stopford-Sackville. On the train journey through the
countryside, passing by ripe wheatfields dotted with poppies
wilting in the sun, Forsdyke quietly said, 'That reminds me
of the poem *In Flanders Fields*.'[37]

Bernard Ashmole had viewed the 1936 Olympics in Berlin
as 'a blatant piece of political propaganda' and was heart-
ily sceptical about an international conference which the
German Archaeological Institute in Berlin put on in the sum-
mer of 1939. He had decided not to go himself, but instead had
sent just one of his Assistant Keepers so as not to offer the
Museum's wholehearted support. 'This was wiser than I knew;
the Congress broke up on the eve of the war and some of our
delegates, hurrying homewards, felt themselves lucky not to
be interned.'[38] Others too had been caught unawares. Digby's
boss was at a conference in America.

For Victor Scholderer, who had not gone across the Chan-
nel that summer, perhaps with fears for his own safety, the
decision to stay in London was itself to turn his life upside
down.

> The August crisis was becoming daily more acute when one
> evening I was rung up after supper by the Keeper of Printed
> Books: Henry Thomas, the senior deputy keeper, was delayed
> abroad, so would I take charge of the valuables of the depart-
> ment due for safe deposit in the National Library of Wales
> at Aberystwyth? – Yes. – Then be at the B.M. at half past
> eight tomorrow morning. So curtly was my life re-directed for
> seven years to come. Robin Flower, in charge of manuscripts,
> travelled down to Wales with me that day, our treasures were
> duly deposited at the National Library and we ourselves lodged
> in the Bellevue Hotel; my wife followed shortly, as did more
> museum personnel.

Included among those other colleagues were Arthur Popham,
Deputy Keeper of Prints and Drawings, and Jacob Leveen,
Assistant Keeper of Oriental Printed Books and Manuscripts.[39]
Llewelyn Davies was about to have under his Welsh roof some of
the top library curators in the English-speaking world.

All, however, had not gone to plan with the ARP Tunnel.
After the removal of eighty feet of 'very solid rock' the
contractors had encountered a problem. An engineer's report
found that the shale further into the hillside was unstable,
while Mr Jones, the blasting contractor, described it as being 'as
difficult as any he had encountered in his experience', in a land
whose geology and landscape were riddled with man-made
mines and quarries. The flat concrete roof for the chamber
originally planned would not be strong enough to withstand
the likely rock falls from above; an additional brickwork lining
would be needed, as for a railway tunnel.[40] To speed things
up, the figure-of-eight design originally planned was reduced

to a U-shaped construction, with the National Library and the British Museum taking one side each, to be separated by a grille in the middle at the bend of the figure, and with independent entrances beyond a single front gate at each end for security, so that one institution's staff could not access the other side's collections.

Over the summer progress had slowed even further because of the growing shortage of construction materials, which by now were being diverted to military and naval preparations. The curved asbestos sheeting needed to fire-protect the roof vault failed to appear. On 24 August, the same day that the Museum mobilised, Llewelyn Davies wrote to his suppliers. 'We must urge you', they were told, 'to expedited [sic] delivery . . . We would emphasise that this is Government work of national importance and is entitled to priority and therefore we feel that there should be no delay in completing this order.'[41]

The British Museum Library's collections were already on the move when Llewelyn Davies cancelled his asbestos order in favour of a local, though less-tailored, supply. But even with the fire protection in place there was still much to do. Electricity had to be installed, asphalt laid on the concrete room to waterproof it, the humidifiers and heaters needed to be tested, and steel security doors were still awaited. The plan had been that the British Museum's most precious manuscripts and printed treasures would be stored in the Tunnel, with the remaining evacuated books and manuscripts being shelved in the Library building. Now the treasures were going to have to be stored in the main building until the Tunnel was ready.

Ten tons of books and manuscripts were sent off to Aberystwyth that first day of the evacuation, and crates of sculpture and metalwork began to be transferred to the Aldwych. Twelve and a half tons of coins and medals and another twelve tons of antiquities set off for Northamptonshire. That is not to say there were not hiccoughs, often verging on the farcical.

At Boughton, one curator borrowed a housemaid's bicycle in the early hours to meet the first consignment due at Kettering at 6 o'clock in the morning and was stopped by a policeman patrolling the park in the middle of the night; Forsdyke had forgotten to alert the Chief Constable to their arrival. At Drayton, the specially ordered low-wheeled lorries managed to get through the arch of the entrance gateway, but once the containers were off the back the suspension bounced back; one particularly highly-sprung vehicle got stuck under the park's ornate gateway as a result.[42]

By day three, all the C&Ms were in the butler's pantry at Boughton and all the top-priority items from other collections had been evacuated. Within another week, 100 tons of the Library collections were at the National Library of Wales (some 12,000 books, and the same quantity of manuscript volumes, plus three-quarters of the prints and drawings), yet this was only the rare and historic, a fraction of the total Library collections. The rest had to be left in the stacks around the Museum's Round Reading Room to take their chance. It had taken eight days to shift the greater part of the Museum's contents. Moves of sculpture and other antiquities to the Tube continued for some weeks, with transfers of the heaviest sculpture continuing throughout the war.[43]

The day war was declared, 3 September, was a Sunday. Digby, driving up to Hampstead Heath to view the shelter trenches that were being dug there, noticed a rush of cars heading northwards out of London. Then the first air-raid siren went off, and they were stopped and directed to the nearest shelter.[44] Churchill's Private Secretary, Jock Colville, puzzled how

> ever since war was declared the sun has shone with unremitting
> splendour, and there is nothing about the gaily dressed, smiling

crowds in the streets to remind us of this great catastrophe — except perhaps for the gasmasks slung across their backs and the number of men in uniform.

But within a week 'there was a feeling of autumn in the air'.[45] And a winter chill was about to hit Forsdyke. Unbeknown to him, due to a disastrous lack of communication from the Air Ministry to the Office of Works, the precious collections at Boughton and Drayton had been evacuated a few miles from a planned military airfield at Grafton Underwood, and would turn out to be directly under the Luftwaffe's flight path to Coventry.[46]

4

You Ask What is Our Aim? It is Victory

A<small>T THE TATE</small> gallery, John Rothenstein was beginning to wonder about the motives of his deputy; and more importantly, whether he was being made to look a fool, yet again. Rothenstein was quite new in the job and still finding his way. It was, to begin with, unfortunate that he had been appointed in the wake of that embarrassing diplomatic incident perpetrated by his predecessor. James Bolivar Manson had disgraced himself at the opening of an exhibition of British art at the Louvre organised by Kenneth Clark the year before. In the supremely grand surroundings of the Hôtel George V, Manson had got horribly drunk during the reception, become abusive to the VIPs over luncheon, made increasingly raucous cock-a-doodle-doo noises during the speeches and, in a spectacular finale, had loudly promised to show the British Ambassador's wife 'something not on display at the Tate Gallery' the next time she was in London. Then, having drained the dregs of the British delegation's many glasses – they had walked out in embarrassment – he passed out. Clark secretly thought it hilariously funny yet contained his amusement until he had been able to roll around on a park bench in the avenue d'Iéna, but Manson was forced to resign by his trustees on his return home.[1]

Rothenstein had other reasons to be suspicious. Though he worshipped his father, the artist and cultural supremo Sir William Rothenstein, at the age of thirty-eight John still struggled to break free from his smothering influence. Although

William's work had fallen out of fashion during his own life-time — something which caused great pain to both him and his son — he remained enormously influential in the art world, counting among his friends many of the most prominent artists and writers in both London and Paris. John's appointment to the Tate job in 1938, just a few years after William stepped down as a Gallery trustee, meant that hints of nepotism followed him around, especially as John knew his father had phoned the Chairman of the trustees in advance of his interview. The selection panel included Kenneth Clark, who anticipated having 'a reasonable being at the Tate who does not envisage the relations of the Tate and the National Gallery as a continual guerrilla warfare'.[2]

Casual antisemitism was rife among the educated classes in Britain in the 1930s, and John Rothenstein was particularly sensitive to it. His paternal grandparents, who were Jewish, had emigrated from Germany to Bradford in the nineteenth century. His father had drawn on this in some of his most successful paintings depicting synagogue scenes in Brick Lane, though he himself did not practise the faith of his forebears.[3] But John was deeply uneasy with this aspect of his family heri-tage. Just before he was twenty-five he converted to Roman Catholicism, and took pains to play down his background, stating that 'it included Protestants . . . Catholics, as well as members of the race to which belonged both the glory of giv-ing birth to Christ and the responsibility for his rejection and death.'[4]

Osbert Sitwell, supposedly a friend and after the war a trustee of the Tate, quite openly and unashamedly declared that the life of Jews was 'one round of pretence, of pretending to be Europeans, Christians, Englishmen, English Gentlemen, Peers and Viceroys'. At the height of the Tate Affair, a scandal which hit Rothenstein in the 1950s over the mismanagement of the museum's staff and its trust funds (some of which, at least, was

cooked up by his enemies in the art world), Sitwell said, 'Some of my best friends are Jews: I just can't stand a Japanese Jew.'[5] This was an allusion to Rothenstein's striking appearance, which was decidedly not 'English' by the standards of the day. All this added to his uncomfortableness with the world in general, as he sought to step out of the long artistic and intellectual shadow which Sir William cast, while at the same time trying to erase the fact that his paternal grandparents were Jewish, and (perhaps equally embarrassing in his view) the fact that they had settled in Bradford and were *in trade*.[6] He made up for this with dandyish suits and a flowery written style.

Touchy, and occasionally over-sensitive to the point of paranoia, Rothenstein junior had previously run galleries in Leeds and Sheffield. After what he regarded as an inadequate education at the progressive public school Bedales, he had scraped into Oxford at the third attempt and three years later by all accounts was lucky to scrape out again with a third-class degree in Modern History.[7] He used his father's contacts and family friends to forge a career in the art world, before he began to find his own feet as an art historian and successful writer. He enjoyed and was good at his new-found profession. One thing he was not, however, was an administrator. He was temperamentally unfitted to lead staff or manage them effectively and this, combined with an occasional streak of laziness, meant that too often he overlooked or ignored situations which in a national institution should have demanded his attention, until things had escalated to the point of no return. He was regularly addressed by the Office of Works as 'Dr' Rothenstein, too: an error he never troubled to correct. He often made the wrong decision when it really mattered, and constantly found himself in the wrong place at the wrong time.

So it was that, when the order to evacuate from the Home Office came, he was not at home to take it. He was in Glasgow.

ACTION THIS DAY

The call was picked up instead by his Assistant Keeper, David Fincham, a long-serving curator on the Tate's small staff and a great friend of Manson. Rothenstein drove back to London in his car as fast as he could, arriving on 24 August. He found the Tate Gallery bustling with visitors, and though anxious not to alarm them by removing the paintings from under their noses, at the same time he did not want to delay in case of an air attack. At lunchtime that day he closed the Gallery. As the final visitors left he wondered 'how many years would pass before these doors were opened to admit a member of the public? Books were obtainable almost everywhere; music could be broadcast, but these doors (and those of the National Gallery, which were closed about the same time) were shutting out people from the visual arts.'[8]

This was not Fincham's recollection of the state of things when he came to write an official account of the Tate evacuation for the Office of Works. Fincham cast himself in the role of saviour and action-man and made out that all the paintings on the Tate's priority 'A List' had been taken away to their new homes before Rothenstein had even arrived back. 'I have to tell you that I cannot accept this as an authoritative account,' Rothenstein told Eric de Normann at the Office of Works later, 'it conflicts at a number of important points with well-established facts . . . this report was furthermore written without my knowledge or authority.'[9]

Whatever the truth, pre-prepared adjustments to their picture frames, as had been made at the National Gallery, meant that the evacuation of the first tranche of the Gallery's paintings was speedy. The canvases of Hogarth's *Marriage à la Mode* ('six of our most important pictures') were deframed and slid into a special, ready-made case in just two and three-quarter minutes. By the following afternoon, all 230 items on the 'A List' were on their way by train to their secret destinations.[10]

★



Three houses had been selected for the Tate's storage. Muncaster Castle in Ravenglass, Cumberland, owned by Sir John Ramsden, was the first. Rothenstein was pretty confident this was a sound choice. Ramsden, though helpful, was not in residence, and the building was largely closed up, looked after by just a couple of staff. The only problem there were the erratic ballcocks of the estate's water supply. But then there was Hellens, near Much Marcle in Herefordshire, owned by the formidable Lady Helena Gleichen; and Eastington Hall at Upton-on-Severn, in Worcestershire, occupied by her friend, Mlle Gabrielle de Montgeon. Later on, after things had gone wrong, Rothenstein claimed that the first two properties had been selected by Fincham before he himself had arrived at the Tate and that, in the case of Eastington, 'all negotiations in connection with the selection of this repository were carried on without the knowledge of the Director'.[11] It appeared there was a lot going on behind his back.

Was Fincham, he wondered, executing some sort of elaborate joke at his expense? He had not enquired too closely, but the domestic arrangements at both Hellens and Eastington seemed, not to put too fine a point on it, decidedly rum. Lady Helena, on the face of it, had an impeccable pedigree. She was the daughter of Prince Victor of Hohenlohe-Langenburg, whose mother had been Queen Victoria's half-sister, but the family had patriotically abandoned their German titles in the First World War. Lady Helena was no longer afforded the title of Countess, but she still had a studio in St James's Palace. Now in her sixties, she was a minor artist of landscapes, horses and dogs, with connections across the art world (her sister and father were notable sculptors) and – obviously – to the royal family.

Living with Lady Helena in the rambling brick manor house surrounded by perry orchards was her friend, Mrs Nina Hollings, a widow eleven years her senior. Had Rothenstein

explored further, there was quite a tale to be told. Nina's elder sister was Dame Ethel Smyth, the distinguished composer, writer and, also, notorious lesbian ('like being caught by a giant crab,' said Virginia Woolf). Nina was Ethel's favourite, and as musical as Ethel, but her life looked set to be much more conventional. She had married the local squire Herbert Hollings, barrister, JP and pillar of the local Conservative Association, and dutifully produced three children: Jack, Richard and Hildegard. But in Ethel's view,

> she was one of those people who habitually go dead straight for any end that attracts them, no matter how fantastic. And once Nina started no one could stop her, least of all her husband, Herbert, who as so often happens in these cases, was of an orthodox and methodical turn of mind, averse by nature from improvisations, from wild statements, and from still wilder expenditure ... he was powerless to deflect Nina by one hair's breadth from her course, and could only periodically breathe a hope that she was 'not going to do anything to make herself conspicuous'.[12]

Herbert's hopes were dashed. Nina was very conspicuous indeed, especially in rural Surrey at the turn of the twentieth century. She was a superb and fearless horsewoman and later in life became 'an intrepid car driver with a passion for charging up perpendicular Welsh hills'. At Frimley Fair one year she soundly rang the bell with a sledgehammer on the Strongman High Striker where 'several brawny youths' had failed, and once blew up a flower bed with gunpowder to entertain one of her sons who was convalescing from a serious illness. And like her sister, she had relationships with women.

She played cricket and hockey, and, according to Ethel, when she took up golf in 1899, 'under the charm of the then lady champion, she at once entered for an International Competition and was in the final'. Nina's obsession came to a head

in Ascot week when instead of hosting a grand dinner she went off and spent the night with her 'latest *culte*' (in Ethel's words) to the exasperation and embarrassment of the long-suffering Herbert.[13] This was not the first time, Ethel observed, that Nina had had a female pash, but around 1905, Ethel became aware of a 'new *culte*' in Nina's sights who was to become her companion for the rest of her life. It was Helena Gleichen, and the two women became inseparable.[14] Indeed, reading Helena's memoirs it would be easy to think that Nina had no husband and children at all, and only occasionally does Helena let slip that her companion is *Mrs* Hollings.

But family obligations did intrude when Nina's eldest son Jack was killed at the first Battle of Ypres in 1914. It proved a turning point. She was fifty-two and determined to contribute to the war effort. Herbert had long since acquiesced in anything his wife wanted to do. So she and Helena raised the funds and kitted out a mobile ambulance unit of their own. Off the intrepid couple went, all the way to the Italian Front, and, having trained themselves up, became joint commandants of the 4th Radiographic British Red Cross Unit near Gorizia (taking X-rays of wounded soldiers, thus enabling surgeons to identify where exactly bullets or shrapnel had lodged in the body prior to extraction). For this extraordinary feat they were both awarded the *Medaglia di bronzo al valor militare* for gallantry by the Italian government and Helena was made an OBE and also a Lady of Grace of the Order of St John of Jerusalem.[15]

In Radclyffe Hall's groundbreaking novel on lesbian love, *The Well of Loneliness*, she describes a similar unit on the Western Front as 'a battalion formed in those terrible years that would never again be completely disbanded. War and death had given them a right to life, and life tasted sweet, very sweet to their palates.'[16] Helena Gleichen herself described her and Nina's relationship as 'a friendship which has nearly equalled

that of the Ladies of Llangollen', drawing a comparison with the Lady Eleanor Butler and the Hon. Miss Sarah Ponsonby, a well-known eighteenth-century couple. They discovered that they both loved dogs ('a perversion of the maternal instinct,' Ethel had read), horses and hunting, and in Nina she found 'a first-rate companion, always good-tempered and cheerful, very quick on the uptake, very energetic and highly amused at everything'.

Nina had

> much more dash and go, I have been born with a large bump of caution and had been trained to dogged work, so the combination was a good one and neither of us could have done without the other. But she was twelve stone and I was nine, so when it came to a physical tug-of-war she had me beat.

Nina's other son died tragically soon after the war of TB; Herbert left her a widow in 1922 but in any case she had been living openly with Helena for at least a year before then at Llanbedr in Wales. Nina became a poultry farmer while Helena painted and then, in 1931, according to Helena, 'it took us sometime to find the house of our dreams, but we found it at last.'[17] That was Hellens, where the Tate paintings were due to be housed.

Rothenstein didn't care to enquire too closely about goings-on at Eastington Hall, either. Its chatelaine Gabrielle de Montgeon was glamorous, fur-swathed, and nearly six feet tall, the only daughter of a French aristocrat and his American wife, who had inherited her father's considerable fortune at just six months old. Mlle de Montgeon had bought the property near Upton-on-Severn in 1911, in her mid-thirties. At that time it was a large half-timbered Tudor manor house, with a gorgeous medieval hall. Over the next three years, and using only a portion of her considerable fortune, she doubled it in size and it became her main home – almost an arts and crafts palace. There, she bred Belted Galloway cattle, white show horses and

her champion Labradors; chain-smoked Turkish cigarettes; rode to hounds; employed two chauffeurs to ferry her around when she tired of driving her own expensive motor cars; and served her ten servants the same top-class food as herself, as well as accommodating gamekeepers, grooms, gardeners and farm workers in the many cottages on her estate, and employing two daily charwomen from the village.[18]

In London she owned a smart mansion flat in the Brompton Road, Knightsbridge, which was lived in by her childhood friend Miss 'Toupie' Lowther, jujitsu enthusiast, international tennis player and champion fencer. During the First World War Gabrielle, like Lady Helena, had volunteered to provide medical support wherever it was needed. But rather than running a Red Cross X-ray unit, she joined a front-line first aid service known as the Hackett-Lowther Motor Ambulance and Canteen Unit which had been set up by Toupie. This was a private organisation, which had the benefit of bypassing the official British Army First Aid Nursing Yeomanry (unfortunately known as FANY), which imposed an age limit of twenty on its women drivers, thereby disqualifying most. A number of older well-off independent women from Britain set up their own units, and went off to engage in some derring-do. The Hackett-Lowther unit worked with the French Army on the front line near Compiègne, and Toupie was eventually awarded a Croix de Guerre for her bravery. Gabrielle donated an entire ambulance to the all-female Hackett-Lowthers and joined the team herself as a driver, becoming a *sous-commandante* under Toupie.

Working alongside her as the other *sous-commandante* was Leicester-born Frances 'Donnie' Donisthorpe, who had driven an ambulance unit in Serbia until Russia withdrew from the war in 1917. The two women were lovers, and after the war Donnie moved to Eastington, ostensibly as Gabrielle's housekeeper – though it was well known locally that they were a

devoted couple. Toupie herself was the model for Stephen Gordon, the lesbian protagonist of *The Well of Loneliness*, who also ran an ambulance unit and also won the Croix de Guerre, and the unit was made notorious in the obscenity trial which followed the publication of the novel.

What is less well known is that *The Well of Loneliness* was actually written at Eastington Hall in the mid-1920s. Gabrielle was part of cosmopolitan lesbian society and had no doubt been introduced to Radclyffe Hall by Lowther. She also became friends with Helena and Nina, to whom she was so similar, both personally and professionally, and they were less than twenty miles' drive away. Gabrielle gave regular dinner parties for local gentry neighbours and together she and Donnie raised prize pigs on their farm. Every year they would shoot grouse in Scotland together.[19] Eastington was very probably suggested to Fincham by Helena when he was looking for a third refuge for the Tate Gallery – and Gabrielle accordingly offered up her ground-floor drawing room, the smoking room and the corridor between them as her contribution to the war effort, no doubt to avoid worse billetees.

For the time being, though, work continued at the Gallery to complete the evacuation. A few items were moved to Green Park tube station. A further 3,800 paintings were despatched to plan, the last on 12 September. The King paid a visit as the final consignment was being prepared for removal out of the capital. 'I thought I'd have a look at them before they go,' he said cheerily, 'although if it weren't for those labels of yours, I wouldn't know one from another. Would you?' Rothenstein took this comment on the chin, and thought that since the King was completely uninterested in art, he 'gave this brief leave-taking of the Tate collection a touchingly symbolic significance'.[120] Heavy sculpture was moved with machinery stored on site by the Office of Works, and only five 'very heavy pieces' remained in situ, boarded up and further protected by

flame-retardant paint. At this point, Kenneth Clark swooped in, also unannounced and dressed as elegantly as usual in Savile Row's finest. Rothenstein, whose old pullover and flannels were covered with dust after all the moves, apologised for his appearance. 'But I too', Clark said seriously, 'am wearing my oldest suit.'[21]

Once everything had been secured, the biggest remaining worry was possible flooding of the Gallery: either from the bombing of the Thames Embankment just outside, or the bursting of a water main or sewer in the street. Seventy-two windows and doors were protected with custom-made flood barriers and sandbags, to prevent a repeat of the damage of 1928 when the water rose to over five and a half feet at street level. Fincham thought the auction value of the evacuated items might be as much as five million pounds, and he was happy to confirm to the Office of Works that 'all cases and bundles of uncased pictures have arrived at their destinations, as far as we can tell at the moment, undamaged.'

Previously diffident curators had steeled themselves and shown qualities of leadership which surprised all around them. Secretaries had come in from sick leave. Warders had cancelled their holidays. 'I cannot express sufficient admiration for my staff, many of them men between fifty and sixty, who were prepared to work from 10 a.m. to 10 p.m. in very arduous and exacting circumstances,' Rothenstein told his trustees. Fincham, 'had showed the most exceptional initiative, energy and diligence' with regard to all the evacuation arrangements. He could hardly say otherwise, since Fincham signed his report for him, after Rothenstein had headed off to the USA. Once he had taken his American wife and small daughter to his parents-in-law in Lexington, Kentucky, for safety, Rothenstein embarked on what he described as 'a long-standing engagement' in North America, lecturing, networking and dining with the transatlantic art world, while London braced itself for

attack. Left in charge of the stored collections were the Junior Assistant Curator, Robin Ironside, and Mr Fagg, the Official Gallery Lecturer. Once unpacked and checked for damage in their new billets, Rothenstein intended that all the canvases would be measured, and a new and accurate catalogue begun.[22] Fincham looked set to be seconded to another department on account of his knowledge of Germany. In retrospect, Rothenstein was unwise to leave the country.

'Somewhat colourless.' That was Kenneth Clark's opinion of all other heads of London's museums and galleries, including Rothenstein, with one exception. For him, Sir Eric Maclagan of the Victoria & Albert Museum was 'one of the most civilised men in London, and an excellent director'.[23] Rothenstein himself recalled Maclagen as 'a man who in spite of the sallow chilliness of his looks and a manner that could easily become contemptuous had many endearing traits', but who had no ambition and as a result 'accomplished so little'.[24] Someone who did have ambition, and was working in the Textile Department of that great national museum of art and design in South Kensington, was Miss Muriel Clayton. Maclagan thought highly of her.[25] But Muriel Clayton was that terrible thing, feared above all other social phenomena in the interwar years. She was a *surplus woman*.

Before the Great War there had already been three-quarters of a million fewer men than women in the country due partly to greater mortality rates among males and partly to the number of men permanently relocating overseas to work in the Empire. Between 1914 and 1918, war had tragically added 700,000 lost men to those figures. When the overall impact of this was revealed in the 1921 Census results, the press went crazy and 'Britain's problem of two million superfluous women' hit the headlines. It was suggested that the female 'surplus' – spoken of as if they were some unwanted

agricultural by-product – should be exported as sexual and domestic fodder for hungry colonial husbands.[26] The Women's Freedom League and other campaigning organisations protested:

> Marriage is not the only profession which women want. If there is a problem of surplus women, it will be solved not by sending women to exile in the Dominions to which they don't want to go, but by giving them in their own country equal opportunities with men to work. If more professions and industries were opened out to women, and if the tops of such professions were not reserved for men by men, we should hear little of the surplus woman problem. If it is a problem, it is a problem created by men, which should be solved by men. To call any woman 'surplus' simply because she is not married is sheer impertinence.[27]

Furthermore, of the 1.6 million wounded men, some were so seriously maimed both physically and mentally that they were unlikely to be on the lookout for a wife (although many women of that generation did marry such men, taking on the role of nurse-companion). Self-help books such as *The Technique of the Love Affair* (1928), *The Bachelor Girls' Cookery Book* (1931) and *Live Alone and Like It. A Guide for the Extra Woman* (1936) abounded.[28] These women haunted British interwar society, and well into the 1960s and 1970s everyone knew of a 'maiden aunt' or a spinster neighbour who had lost a fiancé or sweetheart in the war and never found love again. Every woman born between 1885 and 1905 was considered to be affected by the surplus woman problem. Muriel Clayton was born in 1899. There were plenty of women around like her who would have been prepared to receive a proposal from bachelors, even ones as unlikely as Ian Rawlins or Martin Davies. But for whatever reason, neither of those two men ever took the plunge.

Thus, single women curators, who had only begun to fill professional jobs in museums, galleries, libraries and archives in the 1920s, suddenly came out of the shadows on the outbreak of war. Young male curators were swiftly called up or joined the intelligence services (especially if they had expertise in obscure ancient languages: perfect for decoders). This allowed their female contemporaries to flourish and prove their mettle. It wasn't so long ago that the first 'lady curators' had been banned from wearing dungarees when doing dirty tasks, for fear of undermining discipline among the lower grades, as had happened at the Public Record Office.[29] Now Muriel rolled up her sleeves to play a prominent part in organising the V&A moves and to protect the collections once offsite.

Muriel's mother was English, her father Irish. Her older brother William had fought in and survived the Great War. Muriel was fortunate to be clever; very clever. For spinsters such as she, academia was one way out of a life of quiet desperation: a way leading to autonomy, self-respect and personal fulfilment. At school she had won national medals for her performance in Greek examinations and in 1920 she became a scholar at Trinity College Dublin, reading Classics.

This was a time when Oxford University had only just permitted women to graduate fully and Cambridge was to hold out against allowing its female students to graduate for another twenty-six years. Of these three ancient Anglican universities, Trinity had been a beacon of progressiveness since 1904, taking in women students on the same terms as men, and awarding women from Oxbridge their degrees if they had passed their exams in their home universities. The students who went to Dublin to take up this offer were known as 'the steamboat ladies'. Muriel proudly graduated during the winter of 1922, in the middle of the Irish Civil War. By February 1923, she had registered for a postgraduate Master's at University College London, and later that spring she had moved to study there in

earnest. Her next graduation was delayed by her father's death in 1925 but the following summer she gained her Master's degree based on her thesis, 'The story of the Argonauts in Greek literature and art', a degree which was also recognised by Trinity.[30]

It wasn't too clear to Muriel what she should do next. She tried her hand at writing, and she published a collection of short stories around this time which included 'A Gust of Wind', a poignant little tale of wish-fulfilment about how a romance blossoms when a man's hat blows into the garden of a house occupied by an elderly lady and her spinster niece, Constance, who shares his interest in music and engravings. One thing leads to another and soon they are engaged. 'His friends in the city all said that "John was cut out for a bachelor" and could not imagine him married. But it is always the unexpected that happens.'[31] Writing, however, was not enough for a bachelor girl to live on and so, in 1926, following her interest in art history, Muriel became one of the first women to be employed at a professional level in a great national museum. The bar on women in the civil service had been lifted in 1919, and starting as an 'Assistant in the Department of Engraving, Illustration and Design' she began a career at the V&A, teaching herself curatorship on the job.[32]

She was hugely industrious, studying the collections and publishing on what she discovered there. Within a couple of years – really from a standing start – she had co-authored pamphlets on ivories and Ottoman mosaics, and then in 1929 published a popular book all of her own: *The Print Collector*. Muriel dedicated it to her boss, Martin Hardie, Keeper of Prints and Drawings, 'without whose encouragement and assistance this book would not have been written'. She intended the book, not

for the advanced student, but for the amateur collector, who wishes to find out more about the wide prospect before him,

and would like to know what hills to climb, what marshes to avoid, and what short cuts there may be.[33]

With Hardie's benevolent mentoring (he was twice her age), she had written a classic in the field, which was released in an American edition the following year.

At the same time her restless pen produced a new edition of the V&A's catalogue of brass rubbings and incised slabs which remained in print as the standard work well into the 1980s. Through the 1930s she published regularly in the *Burlington Magazine*, the major journal of art history and connoisseurship. In 1938 she was promoted to Acting Keeper of Textiles, overseeing the museum's spectacular collections of tapestries, carpets and embroideries from across the world. Of her private life we know little. But an official V&A portrait photograph of Muriel from around this time suggests that she was very far from needing to be pitied. She gazes steadily out at the camera, her hair neatly waved, her well-cut black dress business-like and set off with a large gold brooch. She looks unused to the flummery of having an official photograph and anxious to get back to her collections and publishing.

Looking back, Muriel realised that Munich had provided the museum with the opportunity for 'virtually a full dress-rehearsal', though it was a very real operation at the time. Items on the museum's 'A List' were put into the V&A's bombproof stores, which had been under construction for some months. These were steel-reinforced vaults under the Architectural Courts with armoured doors which 'would provide reasonable security against the effects of blast, splinters, gas, fire and flood, but it was impossible to give protection against a direct hit.' The museum had prepared four lists of its individual holdings worth £5,000 or more. 'A List' items were to be removed instantly, 'at any time of the day or night', into the reinforced strongrooms being built in the basement. 'B List' items could

go into the museum's offsite art stores or into the Tube if they could cope with the damp. 'C List' items were 'perishable and fragile objects of considerable size': furniture, tapestries, carpets and pictures, to be moved by lorry to safety at a location in the countryside. 'D List' items were large and immovable objects which could only be protected in situ. These were to be sandbagged, then cased in corrugated metal sheeting packed with slag wool and other fireproof material to stand the effects of blast. On the 'D List' were the famous Raphael Cartoons, the Desiderio mantelpiece 'which should take precedence above all others', the Luca della Robbia roundel, Ferrucci altarpiece, Buon relief and the Sérilly Boudoir.[34]

It had been a struggle for the V&A to find suitable accommodation outside London for its 'C List'. Somerley House, Hampshire, and Longford Castle, Wiltshire, were the original 1934 suggestions from the Office of Works. Longford was finally selected. Then, in the middle of the Emergency, it was suddenly realised that it was too close to Salisbury Plain, the largest military training area in the UK and an obvious target for bombing. Shirburn Castle in Oxfordshire was suggested, and turned down. Finally the V&A alighted on Montacute House, a beautiful but unloved Elizabethan mansion in south Somerset, acquired by the National Trust in 1931, stripped of all its contents except paintings.[35] The Trust was swiftly contacted and gave its consent. All was packed and ready for the evacuation of the 'C List' when the 'stand-still' order came from Whitehall. Chamberlain was returning from Munich convinced of 'peace in our time'.

There were queries over the next year about whether Montacute was suitable, given the Westlands aircraft factory only two miles away in Yeovil. But it remained the V&A's chosen country house, although West Wycombe Park in Buckinghamshire, owned by Sir John Dashwood, was brought in for the overspill. Evacuation was already underway there in 1939

when the Dashwoods suddenly changed their minds. Lady Dashwood had returned home with the family unexpectedly, and the stables, squash court and cellars were no longer available. The collections of carpets, tapestries, ivories and books which had already been unloaded had to be sent back to South Kensington the next day. The curator Mr Bedford reported that what Sir John Dashwood had really hoped for was that the Museum should take over the whole house, and in the process pay the bill for the Dashwoods' failing hot water system, 'thereby ensuring proper care for his own pictures'. The remaining dispersal to the Museum's basements, the Underground and Montacute continued to 31 August when Muriel became certain that war was imminent. The V&A was, as she put it, 'stripped for action'.[36]

5

For Without Victory There is No Survival

S IR WILLIAM ROTHENSTEIN had been an official war
artist during the Great War and many of his works had
found their way to the Imperial War Museum. This was
housed in the incongruous setting of 'Bedlam' – the Georgian
hospital building in Southwark, south of the Thames, which
had previously been occupied by the Bethlem Royal Hospital.
Its Director since 1938 was one Leslie Ripley Bradley, a meek
and childlike character who, though described as someone
who had been an 'immensely industrious' researcher, was
about to become overwhelmed by the threat to his museum.
Even in old age he was remembered as 'very slight and boyish
in figure, he seemed younger than his years. He was curi-
ously indifferent often to the opinion of others and in many
ways was unconventional, having a complete disregard for
his own appearance.'[1] Bradley had been invalided out of the
army during the Great War and, after a lengthy search, found
a job sorting and listing the war posters which had been ac-
quired for a brand-new 'National War Museum', established
by legislation in 1920.

The Imperial War Museum (IWM), as it became known,
was the brainchild of Sir Alfred Mond, the Jewish industri-
alist, financier, MP and philanthropist who, having founded
the great chemical conglomerate ICI, became the first Lord
Melchett. In 1917 he put forward to readers of *The Times*
his idea for a museum which would 'reconstruct for future
generations the story of the stirring times in which we are

privileged to live', and which would memorialise the every-day experience of those bound up in the Great War, whether at the front or at home.[2] The collections included some sig-nificant paintings, photographs, ephemera, a reference library and, of course, materiel, some of it extremely large and heavy. But it was still very much a poor relation in terms of national museums and had only just found its permanent London home, after three moves in twenty years.

Although the IWM had been included in the Office of Works air-raid plans from 1933, its trustees were mainly mili-tary men and from the first they had taken an alternative view of how any evacuation plans should proceed. Unchallenged by the somewhat feeble Bradley, they agreed not to hinder the evacuations of other museums and galleries; that the number of items to be sent away 'should be kept as small as possible'; and 'expense should be kept to a minimum'. Two of the non-military trustees, Earl Howe and the second Lord Melchett (Henry Mond, the son of Alfred Mond who had died in 1930), did however offer up their own homes as safe houses: Penn House and Colworth Park respectively. Melchett had better reason than most to care about the museum's collections. The grandson of Jewish industrialist, Ludwig Mond, Henry was not only worried about the fate of his own and his family's art collection in general (his grandfather had bequeathed twenty-four paintings to the National Gallery, and his uncle a major collection of Egyptian antiquities to the British Museum) but also the war paintings by Paul Nash, Stanley Spencer, William Orpen and John Singer Sargent acquired by the IWM under his father's chairmanship of the museum's board of trustees. By 1939, a third trustee was on board as a host for the collections, namely Lady Norman of Ramster Hall in Surrey.[3]

Priority was given to the Museum's art and photographs, and Bradley thought that 'elaborate schemes of packing should be dispensed with: the Museum's several migrations had led us

to think that pictures travelled best in their frames.'⁴ This was quite unlike the approach taken elsewhere. The IWM seemed to lack much in-house conservation expertise and consulted the Tate Gallery about the best methods of transport, but went its own way in the end, simply interleaving hessian between paintings and sticking gummed tape to the glass. Fortunately nothing untoward occurred as a result of Bradley's passive approach to the moves. Only three exceptions were made with regard to protecting the IWM art, one of which was Sargent's famous twenty-foot-long canvas, *Gassed*, showing a line of maimed and blinded soldiers in the aftermath of a mustard-gas attack − which needed to be rolled.⁵ Yet there was one thing that worried Bradley. Fearful of mob violence which might follow the outbreak of war, he 'intended to arm the men riding with the load with trench clubs'.

The Museum had faced the Munich Crisis equipped only with five rolls of brown paper and forty-eight electric torches. A year later Bradley and his staff were slightly better armed, with seven helmets and sets of protective clothing plus gum-boots, some civilian respirators, six beds with bedding, and a little first-aid equipment to deal with the coming onslaught. Somewhat typically, Bradley was on holiday at the time the call came; and throughout the war he seemed be caught on the hop. It took just two afternoons to load the collections onto three lorries which in five journeys drove the cream of the IWM's paintings and photo albums to their new billets in the home counties. Even that became muddled when the men loading the vans ignored the lists provided and put pictures into them by size rather than destination, a mistake which had to be rectified when discovered on their unloading. The top floor of the museum was cleared of remaining collections which were brought downstairs; negatives were packed away and, later on, film reels from the Great War

were sent to the British Film Institute in Aston Clinton in Buckinghamshire.[6]

The Wallace Collection – the exquisite town house collection of the marquesses of Hertford, bequeathed to the nation in 1897 – was being despatched to a seventeenth-century house called Hall Barn near Beaconsfield, the home of Brigadier Edward Frederick Lawson, DSO, MC. His family were the Levy-Lawsons, barons Burnham and owners of the *Daily Telegraph*, founded in the nineteenth century by his Jewish grandfather. In peacetime, Fred Lawson was general manager of the paper and his wife, Enid, was in charge of their lovely home in its handsome landscaped park, purchased by 'the Guvnor' in 1880. The Hon. Mrs Frederick Lawson was an enormously capable woman: high up in the local Red Cross and St John's Ambulance, and first District, then County, Commissioner of the Buckinghamshire Girl Guides. Both husband and wife were keen to help. As Fred was at work during the week in Fleet Street, from the first he left it to Enid to liaise and manage the relationship with (and provide copious, delicious working lunches for) the Wallace Collection representatives, predicting correctly that 'in the event of the emergency arising in the next ten years, I shall probably be elsewhere.'[7]

This was not the first time that the collection had to defend itself against aggression from Berlin. In 1870, it had been in Paris, housed in Lord Hertford's two homes there. It was a great accumulation of fine and decorative art from eighteenth-century France, and much more besides, not least a spectacular array of historic arms and armour. During the 1871 siege of the city during the Franco-Prussian War, trenches were dug outside Hertford's principal residence, the Château de Bagatelle in the Bois de Boulogne, to protect its contents, and on the declaration of the Paris Commune everything was shifted to Hertford House in London. Then, the whole

collection had been packed up again over the course of eight months in 1918 to protect it from Zeppelin raids, when it was taken to the empty new Post Office tube line at Paddington. That rather desultory operation had taken eight months. It was now about to take eight working days.[8]

Balls Park in Hertford, the home of Sir Lionel Faudel-Phillips, was another destination for the Wallace Collection. Sir Lionel was a trustee of the museum and a cousin of Fred Lawson: two good reasons why his hospitality might have been welcomed. The Faudel-Phillips family were Jewish, owners of Faudels Ltd, a textile and sewing-machine company, and Lionel was involved in many good causes, as well as being both Chairman and Treasurer of the Bethlem Royal Hospital. While Hall Barn had been scheduled for use by the Collection since those early investigations of 1934, Balls Park had only been identified at the end of 1938.

There had been a hiccough when the *Evening News* sniffed out a story in the spring of 1939 that the Lawsons had appealed for a billeting exemption and published a story about an 'Art Treasures Evacuation Plan', but that seems not to have caused a stir. Shortly afterwards, when Italy invaded Albania at Easter, objects packed the previous summer during the Munich Crisis were packed into crates once again, but this time they were kept in their boxes as the Keeper of the Wallace Collection, James Mann, was convinced 'the threat of a general European war is now constant'.[9]

Mann was a level-headed and highly intelligent Scot, with an Oxford education and a research degree in historic armour. Previously Deputy Director of the new Courtauld Institute, in 1936 he had become Keeper of the Wallace Collection, where he had worked earlier in his career. He was an accomplished manager, an expert in his field and much in demand as an 'effective committee man'. In August 1937 he had taken the opportunity to visit Spain at the invitation of the Republican

government to look at how art was being protected during the Civil War, so he was already well prepared for what might be needed in the coming conflagration.[10] He was also prodigiously well-organised, as the meticulous notes and inventories of the Wallace Collection's moves attest.

From 1939, he combined his position at Hertford House with being Master of the Armouries at the Tower of London, a role which included not just historic weaponry, but custody of the Crown Jewels themselves. Sadly, the story that Mann became an adviser to Laurence Olivier for his 1944 propaganda film of Shakespeare's *Henry V* is apocryphal.[11]

With such sympathetic and practical owners as Enid Lawson and Sir Lionel, and with the unflappable Mann at the helm, the Wallace Collection's evacuation proceeded smoothly. Beginning on the morning of 24 August 1939, two lorries each lined with 'Sorbo' and containing not only virtually all the Collection but an Assistant Keeper and 'four able-bodied men ... equipped with truncheons' as well, set off from Manchester Square just north of Oxford Street heading west and north. As quickly as the safety of their precious cargo would allow, they drove *The Swing* by Fragonard, *The Laughing Cavalier* by Hals, the Boucher portrait of Madame de Pompadour and many other paintings, Boulle furniture and gorgeous *objets d'art* carefully to their destinations in the home counties, taking a total of twenty-eight journeys in the days up to 4 September.

Four loads of pictures, Sèvres porcelain, majolica and miniatures went to Balls Park. The other two dozen, which included the furniture and sculpture, went to Hall Barn. 'It is more important for a few objects to be safely packed than for a large number of breakable items to be inadequately packed,' cautioned Mann to the evacuation teams.[12] The Lawsons had rushed back home from a family wedding on the Isle of Wight to prepare the house for the incoming refugees. A few days later, Enid Lawson was startled to find a strange woman

coming up the stairs one evening as she was heading down to supper. On asking if she could help, she discovered that it was Mary Mann who, unknown to her, had moved in with the collections and would be living in the bachelor's wing with her husband, for the duration.[13]

One man who knew more than most about the history of Jews in England was Hilary Jenkinson, Assistant Keeper at the Public Record Office in Chancery Lane. The site of the archive had once been the *Domus Conversorum*, a home for Jewish converts in the Middle Ages. He was an expert on the medieval records there relating to Jews and in later life became one of the few gentile presidents of the Jewish Historical Society of England. Jenkinson had deeply annoyed his boss Cyril Flower when, in 1938, he had produced an inventory of records to be evacuated so long that it included half the entire holdings of the office, instead of a short list as originally requested.

Jenkinson was prickly and tactless, not really a people person, while Flower was in denial about the fact that it was a question of 'when', not 'if', there would be war. When Flower got the top job that year – Deputy Keeper of Public Records (the statutory Keeper being the Master of the Rolls) – their relationship deteriorated further. Jenkinson believed that he had an equal claim to the post. But he got his revenge in a small way because, in stepping into his new role replacing Flower as Principal Assistant Keeper, he was able at last to render his name in the official publications of which he was now in charge as Hilary Jenkinson, not C. H. Jenkinson. This the other man had always flatly refused to do lest anyone believed Jenkinson to be a woman.[14]

The PRO (today, The National Archives) held the records of government since the time of the Normans: a treasure house of history and national identity. Various schemes had been put forward since 1933 to solve the challenge of storing

miles and miles of historic archives in the event of war, and had been abandoned. Two stately homes in Bedfordshire were deemed not suitable. The London Underground was too wet. Even a Heath-Robinson-style wheeze to store them in railway carriages in remote sidings, to be shunted elsewhere if things got too hot (both literally and figuratively), was suggested in desperation. Though Flower thought highly of it, the government office co-operation needed to effect that plan was not forthcoming, which was just as well.

Part of the problem was the very particular needs of archival storage. The Public Record Office building in Chancery Lane was built along the lines of a Victorian prison, except that the cells along each corridor contained slate-shelved racking and pipe rolls instead of iron beds and felons. It was therefore entirely appropriate that, in the end, some of the homes found for its wartime *evacuanda* (as Jenkinson called them, in typical fashion) were places of incarceration too. The Prison Commission came to the rescue and offered the disused women's wing of the empty Shepton Mallet prison in Somerset; and the Ministry of Health came up with part of the workhouse at Market Harborough. The great benefit of both these locations was that the buildings were essentially industrial, with floors robust enough to bear the heavy loading of records expected: they needed to be five or six times stronger than ordinary houses. Paper, parchment and leatherbound volumes were very weighty indeed.

So 300 tons went to Shepton Mallet, along with the treasure items from the PRO's museum. Special arrangements were made for these, the cream of Britain's historic records. The latter included Domesday Book, Britain's oldest public record, the 1086 survey commissioned by William the Conqueror into the wealth and landholdings of his new kingdom; several Magna Cartas; Shakespeare's Will; Guy Fawkes' confession; the logbooks of HMS *Victory* and much else.

All were driven down to Somerset in an anonymous van with an armed guard riding shotgun. Such was the care taken in preparation that the consignment arrived early. So naturally the men went off to have a cup of tea at the local café in the market square, unfortunately leaving the doors unlocked.[15] Luckily no one noticed.

Another 140 tons went to Market Harborough.[16] But there was still much to be moved, and Flower was extremely fortunate that, over the summer and autumn of 1939, a member of the House of Lords approached him and

> freely offered two of his seats in succession for the reception of records. His offer was gratefully received; and as he was a Fellow of the Society of Antiquaries and a working archivist, he was made an unpaid Assistant Keeper.[17]

This was not quite the whole story. The member of the House of Lords was the reclusive 9th Duke of Rutland who, as he got older, had increasingly retreated into researching into his family's history and medieval records to make up for his shame at not having served at the front in the Great War (his mother having persistently lobbied generals to keep him out of the trenches). Now was his time to shine. At that time, it was a sacrosanct principle that public records should never leave official custody in order to protect their integrity as genuine records under the law and to prevent accusations that their contents had been tampered with in some way. At Chancery Lane this meant that every night an assistant keeper slept overnight in the great building in a small bedsit furnished for the purpose, a practice which continued well into the 1980s. When the records were evacuated this meant that an assistant keeper had to be in charge at the new destination, and it wasn't enough – as with the museums and galleries – for junior staff to live on site with their more elevated bosses in comfortable

billets nearby. A senior archivist needed to be there; but there weren't enough to spread across all the evacuation locations.

The solution to this dilemma was suggested by the Duke himself. He was a member of the Historical Manuscripts Commission, the national body tasked with documenting private archive collections, including those in aristocratic houses. He knew Jenkinson well. One thing led to another and thus Belvoir Castle in Leicestershire and Haddon Hall, Derbyshire, took on a total of 575 tons of brimming archive boxes, kept safely on the ground floors. Rutland remained in residence at Belvoir and was made honorary Assistant Keeper for his trouble there, a post of which he was immensely proud.[18]

Records from the PRO were packed in cardboard boxes then sealed with steel tape to keep the heavy contents immobile. One assistant keeper, the appropriately named Mr Slingsby, a diminutive recipient of a Military Cross in the Great War, got the back of his trousers tangled up in the banding apparatus, prompting a less than sympathetic colleague to pronounce that there was no need to emulate the Nazis' 'Strength through Joy' programme by introducing 'Rupture by Rapture' at the PRO. In the end more than 88,000 boxes of the nation's memory were packed up and moved to seven different repositories out of the city up to 1942.[19]

A third country house in Buckinghamshire provided sanctuary to yet another national museum. At that time, the county's leafy charms on the edge of the Chiltern Hills seemed sufficiently far from danger, but still well connected by road and rail to London. The house in question was Mentmore Towers, and its owner was the cricketer, horse breeder and politician Harry Primrose, 6th Earl of Rosebery. He was the son of the Victorian prime minister whose wife Hannah had inherited their monumental Jacobethan pile from her father, the banker and fine art collector, Baron Meyer de Rothschild.

Henry Hake, Director of the National Portrait Gallery (NPG), had inspected various properties in 1935, alongside the National Gallery which at the time controlled its budgets. Although the National Gallery eventually dropped out of the negotiations when Kenneth Clark, as the new Director, settled on Wales, Hake kept up relations with Mentmore and had been particularly impressed by his dealings with Rosebery's friendly and practical land agent, Charles Edmunds, who lived with his family in the nearby village of Wing. 'When the Munich Crisis was on us I rang up Mr Edmunds and asked him if he could provide a refuge for a few of our more important pictures. This he said he could do.'[20] As easy as that. While Kenneth Clark felt that Hake was an unremarkable figure on the London art scene, it was thanks to him the National Portrait Gallery's wartime evacuation to Mentmore proved to be the most amicable sojourn of all the collections sent out of London.

A priority list of sixty leading portraits was drawn up, while the basement of the building in St Martin's Lane just off Trafalgar Square was fitted out with a strongroom capable of holding 600 deframed pictures. This became known as 'The Dug-Out'. Over the winter of 1938/9, Hake's staff experimented with packing paintings using old student practice canvases and different paddings, even on one occasion going so far as to leave a parcel of sample canvases wrapped in waterproof paper out in the snow for a fortnight to see what would happen. 'Most important of all,' as far as Hake was concerned, 'we made the pictures in the collection more easily moveable by fitting the panels with narrow guard frames and substituting spring catches for the nails holding the pictures in the frames', though there was not time to do this to all the larger paintings. By relying on hook–and–eye wall fixings rather than tangly cords, removals were made even speedier and would make 'it possible to disengage the pictures in less than half the time' when the starting gun went off.

The unflappable Edmunds offered the NPG one of a group of outbuildings at Mentmore known as 'the gas-house', which was nowhere near as alarming as it sounded. The building was of brick with a concrete floor and tiled roof, which the NPG renamed 'The Refuge', long since out of use as the location of the estate's gas and electricity generation plant. It was racked up in the spring of 1939 by the museum's in-house carpenter, and four low-temperature electric pipe heaters were installed. Having booked their trusted removals contractor to be on standby over the summer, and with teams of men also ready to spring into action at short notice, Hake then ordered everyone in the museum to take a month's holiday and be back on duty by 1 September.

The call, as for all the other museums, came on the evening of 23 August. By 2 o'clock in the afternoon of, the following day, those top sixty paintings were on the road with an escort and two guards; the van's arrival at The Refuge telephoned through to Hake at home by Edmunds at 6 o'clock that evening. Evacuations continued to Buckinghamshire in the days following. The NPG basement took the secondary pictures, pastels and delicate drawings the Gallery did not think worth sending to Mentmore. The nicknames 'Dug-Out' and 'Refuge', with their echo of Great War trenches, indicated starkly what Hake thought was before the NPG, and every other London museum and gallery. But they would all have to wait to find out whether their worst fears would be realised.

On 1 September, Hitler invaded Poland. By this time, most collections had already been evacuated or otherwise protected. Britain and France declared war on Germany two days later.

PART II

We Must Just KBO

6

We Shall Fight in the Fields
and in the Streets

AND SO BEGAN the Phoney War, that period between early September 1939 and April 1940 when the whole country was on standby, each day expecting a lightning attack to begin. Rooms in London's museums and galleries were largely empty and silent, while in the country houses, owners got used to their newly evacuated guests. Arthur Box-Bender was one of them. A fifty-six-year-old MP with three daughters and a son in the army, he owned a townhouse in Belgravia, and liked to boast to his brother-in-law about how expertly he was playing the system with the onset of war. His female offspring had been sent across the Atlantic to stay with a business contact in Connecticut, while his wife Angela had gone back to their home in Gloucestershire to arrange for the arrival of furniture removed from Lowndes Square which was being shut up for the duration.

For his own part, the smug Box-Bender planned to decamp to share with two other MPs in a brand-new luxury flat whose rent had fallen through the floor with the outbreak of war. 'The cleverest of his dodges', though, was 'to get his house in the constituency accepted as a repository for "National Art Treasures". There would be no trouble there with billeting officers, civil or military.' Mr and Mrs Box-Bender's Cotswold idyll was a 'small gabled manor in a sophisticated village where half the cottages were equipped with baths and chintz'. But they were in for a horrible

shock, as Angela explained to her brother Guy. The entire drawing room and dining room were crammed to the ceiling with wooden crates. 'Such a disappointment, darling,' she wailed, 'I thought we'd been so clever. I imagined us having the Wallace Collection and luxuriating in Sèvres and Boulle and Bouchers. Such a cultured war, I imagined. Instead we've got Hittite tablets from the British Museum, and we mayn't even peep at them, not that we want to, heaven knows.'

Arthur and Angela are, of course, the fictional creations of Evelyn Waugh, straight off the pages of his 1952 novel *Men at Arms* based on his wartime diaries; their surname a nod to the No-Nails receptacle.[1] The Box-Bender experience was not so different from that of the real-life custodians of the evacuated collections. 'If there is any threat of evacuees,' one chatelaine told the National Trust's James Lees-Milne later in the war, 'I shall spread out the art treasures and furniture into more rooms.'[2] But for those hosts who believed that receiving Constables and Turners to adorn their ancestral piles would be preferable to the flea-ridden and bed-wetting children from the slums of the East End, or regiments of boisterous squaddies learning to shoot or practising tank manoeuvres in their landscaped parks, the reality of housing a national collection often turned out to be less than idyllic.

At Boughton House, where the Duchess of Buccleuch was still in residence, exhibits from the British Museum were being supervised by the gentle, stammering numismatist Stanley Robinson, Deputy Keeper of the Coins and Medals Department. He was living there with a motley team of eight warders deployed to guard and monitor all the museum evacuees.[3] Quantities of 'E&A' wooden crates filled the Great Hall, crammed in, Box-Bender style. They completely obscured the wall panelling and fireplace to shoulder height, while

the tapestries peered down on the stately warehouse, uncon-
cerned. Other 'E&A' crates occupied – appropriately enough –
the Egyptian Hall.[4]

Meanwhile the Duke's young agent, Frank Wycherley,
was becoming concerned about a number of things. Firstly,
the road to the house had been damaged by the mechan-
ical horses trundling backwards and forwards delivering the
collections.[5] Secondly, the Duke had offered Boughton rent
free but there was still the matter of fuel to be seen to, and
also the services of an odd-job man to be paid for by the
BM.[6] And then there were the men billeted in the house.
'The housekeeper and the head house maid are exception-
ally nice, efficient, obliging women, who seem to have
been thoroughly imposed upon,' he grumbled. Instead of
the two meals on offer to the museum warders, four had
been demanded, including afternoon tea *and* a hot supper
instead of just a high tea. The housekeeper – sporting the
magnificent name of Donaldina Gunn McLeod (clearly a
Scot, as befitted the household) – received no thanks, only
complaints, for producing thirty-two meals a day, and was
'simply chained to the kitchen cooking and washing-up'.
Her health was suffering from lack of fresh air and exercise
and she could not see to the care of the Duke's own treas-
ures in the house, including regularly turning the rugs and
tapestries to prevent moth.

The men never offered to do their own washing up,
despite having facilities in the still room they used for their
sitting room. 'Another treasure', the head housemaid, Ethel,
had become so disgusted with the way the men kept their
bedrooms that she had stepped in to do the cleaning. 'Now
she only gets complaints from the men that their beds are
not properly made and so on, which is quite absurd as she
is a most competent and efficient woman.' The men clock-
watched and were bored, and even then, in Wycherley's

view, 'did not have sufficient to do even to occupy a child, let alone able-bodied men.' When asked to chop wood for the fire, they set about it 'in the most dilatory possible way, taking a book down to the stick house to read while they are doing it', and Mrs McLeod the housekeeper had to go and beg for logs to keep the house warm. He wished they would be self-sufficient, like in the army, and volunteer to do something on the estate such as cutting nettles or thistles to increase grazing for stock. Although Boughton was getting twenty-one shillings a week per man to cover billeting costs, Mrs McLeod was having 'great difficulty making ends meet' and was having to employ a second cook to help out.[7]

Down the road, Forsdyke's evacuation plans were also starting to fray at the edges. Adrian Digby spent two and a half years of what he called his 'vigil', confined to Drayton. Initial orders to the British Museum staff were that they should stray no further from the house than the sound of a whistle. Drayton played second fiddle to Boughton, in terms of staffing. Digby realised that he must be 'a very tiresome junior' to Robinson because of his boss's lack of knowledge of the particular conservation challenges the ethnographic collections posed. Unlike at Boughton, at Drayton there were moth and other insects, and problems with humidity and light. Harold Plenderleith from the conservation laboratory came down to help; Robinson, being a metals man, found it difficult to appreciate the problems with organic collections.

At Drayton too, the Museum staff shared the house with the whole family and a full complement of servants. Things were often awkward. The Museum staff were there on official business, could not always do as the family wanted and were regarded as inconvenient guests. Colonel Sackville was helpful but only came back when on leave. The resident

servants looked down their noses at Digby and the others, taking pains to emphasise their own status as employees of the gentry while their compulsory visitors were simply 'a lot of cockney evacuees'.[8]

Many of the collections, including the feather images and wire baskets, were in the Long Library underneath the roof. Textiles were hung on bars made by the estate carpenter. All were regularly sprayed with Lethane insecticide from flit-guns. The standard boxes were on the ground floor but raised up on wedges to avoid any water from hoses in case a fire broke out. The wooden figure of the war god Ku-ka'ili-moku ended up in the chapel. The Museum staff occupied themselves with security patrols, checking environmental conditions and fire protection.

The greatest hardship was being confined to the park and not being allowed out without a replacement from Boughton. Afternoon tennis and bowls failed to catch on. Keeping chickens and decorating the accommodation was more popular, and practising fire-fighting with stirrup pumps, and later a trailer pump, was good for team building, Digby found. However, he had failed to take into account that he, a keen yachtsman, was used to heights, while others were not and on hearing the drills he was putting the staff through, Forsdyke shot off to Drayton to stop him making the team practise dangerous manoeuvres using a bosun's chair across the roof. 'Damned dangerous,' thought Plenderleith. It helped that one of Digby's men, Mr Eldred, was a fully trained auxiliary fireman who gave much assistance. This they badly needed because 'holding the hose with the pump going flat out was like holding a python'. Another time a 'wet but happy morale-boosting afternoon' was spent clearing some ill-advised brushwood camouflage from the estate pond (for fear it drew attention to the fact there was something interesting about the house and its park). Some

wives moved to nearby Lowick, and were permitted to visit their husbands in the afternoons. Digby's wife Nick also moved into rooms in the village.[9]

The Stopford-Sackvilles and their retainers proved to be inconvenient for the Museum's operations at Drayton, preventing rooms being locked where collections were stored. Gradually the staff were reduced to a butler, housekeeper and a single maid, making controlling them easier, but one day the maid and housekeeper started a chimney fire in their shared sitting room. This was put out by Eldred with a stirrup pump, flooding the kitchen to a depth of two inches, but Digby felt the real risk was not the minor fire in the chimney itself but the attention which it might draw from enemy aircraft flying overhead.

Humidity recordings – or 'stupidity reports' as they were known – were a constant worry as well, with the portable hygrometer sent down by Plenderleith from Bloomsbury regularly getting broken when the heavy-handed assistants, more used to whirling football rattles, spun it round their heads to take readings. In the end they constructed a homemade one, forever after known as 'Mr Digby's Rattle'. Then the introduction of Valor Perfection paraffin heaters was a risky strategy to try to stabilise the temperature and humidity, which would never have been allowed back in Bloomsbury for fear of a fire.[10] As for Plenderleith himself, he and his wife spent the war living in Forsdyke's official residence (the two men had always got along well), Mrs Plenderleith taking charge of cooking for the 'Commissariat' based there.[11]

After several months at Drayton, the location restrictions were eased and the warders were able to leave the site, one at a time. Digby bought himself a little moped which he used to travel backwards and forwards to Boughton for meetings; to the timber or coal merchants; to the Estate Manager; or to

cash pay-cheques at the bank for the men. There followed a bitterly cold winter. Fire drills on the roof were suspended and two foot of snow covered the surrounding countryside. The enterprising Digby bought a pair of skis and used them to undertake his trips to the bank and the agent. His wife, now pregnant, was installed in a comfortable private hotel in Barton Seagrave near Kettering, with her mother, and Digby would make the seven-mile round trip to spend an hour with her.

On one occasion, travelling further afield to Northampton wrapped up in a frosted balaclava, tarpaulin jacket and leather gauntlets, icicles hanging from his eyebrows and moustache, he stopped in Wellingborough for a hot rum. 'Blimey, 'ere's a ruddy Finn!' roared the drinkers in the pub, who had heard of Finland's resistance to Russia in the Winter War. In February Nick and her mother returned to Hatch End to await the arrival of the baby, which was born a month later and christened Helen.[12]

As with Boughton, food and feeding at Drayton became a battleground. Shortages started to bite in January 1940 when sugar, bacon and butter were rationed, followed shortly after by other meat in March.[13] The Museum staff ate with the servants in the Servants' Hall, but friction was constant. The butler listened in to all the Museum's calls back to London. In return when it was discovered that the butler drank methylated spirits one of the Museum attendants, seeing him about to light up a cigarette, joked, 'Be careful, mate, or you'll go off pop!' Better for his employer that he did that than that he should help himself from the cellar, was Forsdyke's dry response on being told the story. Digby himself found he had nothing in common with the Stopford-Sackvilles. The atmosphere, he found, was 'always polite but hardly cordial' and he spent most of his time tucked away in the small sitting room which was his office.

Conversation at dinner was a strain. On mentioning a column in *The Spectator* one evening, the dowager turned to him and declared, 'that's a horrid middle-class paper'.[14] In February, the food having become intolerable, the cook (a kitchenmaid out of her depth) and most of the housemaids handed in their notice to find better-paid factory work.[15]

All the family moved out by the start of April 1940, except for the Colonel's mother, and the three remaining servants devoted themselves only to her. The Museum staff were given the run of the enormous kitchen heated by a huge range and began to do their own cooking, but much of the house no longer in use was closed up. The men moved to a single room rather like a barracks dormitory. Digby was shifted to the former housekeeper's bedroom and sitting room – very cramped when Nick and the baby joined him there. One of the men, Mr Hudd, turned out to be an excellent plain cook. He, and subsequently Mr Lee, the Museum's window cleaner, kept everyone going on the rations and what they were able to grow at the house. The food situation improved measurably. But Digby was becoming increasingly irritable, not helped by the lack of sleep, and the fact that he thought he 'ought to be doing something better than guarding a lot of boxes'.[16]

He bought a car, a very old Austin 7. When the Chinese painting of a thousand geese and the Mexican turquoise mosaics were needed back at Bloomsbury, to be hermetically sealed into metal boxes for security, he drove them to Kettering station. Nick went with him, but no police guard despite their cargo being some of the most valuable items in the collection. Nobody, he thought, would suspect a young couple in a shabby old banger of carrying such precious objects. They waited for the pickup in the station buffet, drinking tea with an anonymous box of treasures under the table. The items were safely moved to London. But the car was destroyed shortly

afterwards when a lorry backed into it outside the bank in Thrapston and squashed it flat.[17]

As for Aberystwyth, it was proving to be a positive idyll for the fifteen or so British Museum librarians and conservators. Jacob Leveen, the Museum's Jerusalem-born Hebraist with a first-class degree in Arabic to boot, was in charge of the Oriental Books and Manuscripts section there. He was delighted that all of his and the other departments' holdings had survived the journey to Wales so well, thanks to the care taken in packing and loading. The Library collections evacuated from the British Museum were so vast (even though they were only a fraction of the entire holdings) that at first the Bloomsbury curators wondered how they would ever be accommodated in their new home. But Llewelyn Davies had thought of virtually everything.

Robin Flower – the British Museum commanding officer, as it were – was given a private office of his own in the President's Room. The Department of Printed Books and the Department of Prints and Drawings were allocated the entirety of the NLW's long, airy Print Room. 'Not only did this room accommodate the collections,' noted Leveen, but Scholderer, Popham and the rest could work in it 'under ideal conditions of light and freedom from dust'. Additional shelving was put up speedily where required by the NLW carpenter and his assistant. The Department of Manuscripts filled more of the President's Room, the Old Mess Room, the Summers Room, with its papyri stored in an old but clean and dry lift shaft. Leveen himself and his collections occupied one end of the public Readers' Room. This was why the Library had closed its doors to so many readers; it had, in some respects, become Bloomsbury-on-Sea.[18] In addition to all the Western European treasures, thousands of books and manuscripts in over fifty languages from the Middle East, Africa and Asia had been evacuated there and

all, to the delight of Leveen and his colleagues, could be researched and catalogued 'without the numerous interruptions to which so many Museum officials are subject in the course of their duties at Bloomsbury'.[19] It was not just a refuge for them all. It was a paradise.

Scholderer too considered himself 'phonily well off' during this period in his enforced exile by the sea. The NLW staff he found to be excellent new colleagues, and 'none more so than the Librarian himself . . . who went out of his way to give us all help and favour possible'. For the Welsh librarians, it was a pleasure to have back in the country the collection of Welsh manuscripts and records donated a century before by the Honourable Society of Cymmrodorion, the London-based society of Welsh antiquaries founded just a few years before the British Museum itself. New friendships were made and existing ones reinforced as they all found themselves in the same boat. Soon there were sociable coffee parties taking place at the Belle Vue and, after the academic year commenced, regular 'morale-sustaining' chamber concerts took place at the University. Nocturnal patrols of the Library were routine, and the building being so new meant that even those inclined to believe in ghosts or things that go bump in the night were not spooked.

But this did not extend to the top floor where the National Gallery paintings were stored and which was off limits to the British Museum contingent, even though the staff of both institutions mingled together elsewhere. Scholderer had been intrigued by the thousand or so heavily wrapped canvases when they arrived, 'so close to hand yet invisible'.[20] He, Leveen, and the other British Museum staff immediately set up a rota so that there was always one of them in charge of the collections, day and night. Every senior curator did a week's night duty and two armed police patrolled the building inside and out outside working hours. The

NLW, British Museum and National Gallery shared the cost of ARP equipment and together they learned how to use the stirrup pumps and sand buckets, respirators, axes, ropes and asbestos sheeting.[21] All took their duties seriously, even in a place apparently so far from danger as Aberystwyth. The local police angrily phoned their constables in the National Library on more than one occasion to report that all the lights were on and the blackout breached, only to find that the cause was the light of a full moon being reflected off the building's many windows.[22]

By the end of October, the ARP Tunnel at the bottom of the hill under the Library was holding up well in tests. Extinguishers and sand buckets were at the ready. Forsdyke travelled to Aberystwyth with Idris Bell, in spite of wartime restrictions, to meet Llewelyn Davies in person. It was a great success. 'First of all, let me thank you and your wife again for your kind and welcome entertainment,' he wrote,

> I am glad to have this pleasant memory of my first real visit to Aberystwyth and the National Library. The journey up seemed less agreeable than the journey down, perhaps because of the last three hours in darkness. The trains (1st class) were surprisingly empty and fairly warm, if tiresomely slow; there was however very little waiting for connections, none at Welshpool and only enough at Shrewsbury to get a hot drink. The ham sandwiches did me splendidly.

On his way back to the station he realised that he had left behind his gasmask and a taxi was sent back to pick it up. No payment for the fare was required, joked Llewelyn Davies, but if he insisted then the money would go into the Library's building account, which was heavily overdrawn.[23] Forsdyke did suggest a solid metal door outside the entrance, for 'any person wishing to do malicious damage might throw a bomb through the present grille gate'.

Llewelyn Davies finally took possession of his cherished Tunnel early in November. He was buoyed by Forsdyke's reaction. 'They both went away very satisfied with all that they saw. They realised that we have given them more space and more facilities than they ever thought was possible.' But a fortnight on and the humidity readings from the Tunnel had deteriorated. Llewelyn Davies was close to despair. They had come so far and yet were still so far away. 'Unless the damp comes from the water still incorporated in the structure I fear that it will be impossible ever to use the tunnel for the storage of books and manuscripts'. Drying out carried on over Christmas and the New Year.[24] By January, while some damp was still visible on the lined walls and the gutters needed clearing, the architects confirmed that the ventilation apparatus could maintain a consistent environment inside during winter conditions.[25]

Back in Bloomsbury, however, things were better than expected for those strange nine months. The Library reading rooms remained open, though as time went on, readers were restricted to those doing war work or work of public value. As it slowly became clear that the expected air strikes were not coming, Forsdyke began to wonder whether the gallery clearances had really been necessary. He felt confident enough to put on an exhibition of items from the Library collections not in Aberystwyth, and photographs of some treasures from a spectacular new acquisition were displayed in the Entrance Hall.[26]

The trustees had just approved 'the most magnificent single gift ever made to the Museum in the lifetime of a donor', namely acceptance of the treasure from the Sutton Hoo Anglo-Saxon ship burial in Suffolk. Mrs Edith Pretty, the landowner concerned, was assured that the utmost care would be taken to ensure the safety of the artefacts dur-

ing the war.[27] The extraordinary story of their discovery in the spring of 1939 is well known. Charles Phillips, the Cambridge academic who had taken over the excavation from Basil Brown of the local museum, met Tom Kendrick, the British Museum's Keeper of British and Medieval Antiquities at Woodbridge station and with awed excitement pulled out of his pocket one of the gold and garnet shoulder clasps for a warrior's cloak. They both knew this was one of the most dramatic finds of the century, and certainly one which would define their careers. The site excavation had been completed just nine days before war was declared, and a coroner's inquest followed soon after.

The inquest determined that the find was not treasure trove, so Mrs Pretty was deemed to be the owner, and Kendrick – who had sat next to her during proceedings and thought he had been charming her – whispered to a colleague, 'I think I've got it, I think I've got it.' But in fact fifty-six-year-old Mrs Pretty, a widow and devout believer in spiritualism, had not been persuaded by Kendrick. It was her dear-departed husband who had made clear from 'the other side' that his preference was for the find to go to the British Museum.[28] So 263 objects, including gold buckles, coins, weapons, silver cutlery, and the iron and bronze helmet, having lain undisturbed in the sandy Suffolk soil for thirteen centuries, only saw the light of day for a few weeks before having a reburial, this time deep in the Aldwych tube tunnels where they joined, among other things, the Lewes chessmen. For Kendrick this was particularly ironic. He avoided the London Underground at all times because of his claustrophobia, a legacy – along with his locked knee and stiff gait – from his time in the First World War trenches, where he had been severely injured.[29]

In the spring of 1940, the journalist H. V. Morton was given privileged access to the Aldwych store. Without mentioning

his location, he described how, after a tortuous journey and 'the sound of many withdrawn bolts', he found himself deep underground:

> And I turned to examine the boxes, which contain some of the most priceless treasures of the British Museum: Egyptian gods, Greek bronzes, Etruscan metalwork, marble statues of Pharaoh and Caesar, Roman rings, and gold and alabaster vases from ancient tombs – the most amazing Aladdin's Cave ever seen.

In the middle of all this was a matchboard shed, with a bed-room, office and electric stove. Two warders from the Museum were always there, isolated from the world above. 'It is doubtful if they would hear very much of a raid. They are alone in a treasure cave eighty feet below ground – the two safest individuals in London.' Far overhead, buses, taxis and Londoners were hurrying along without the slightest idea that beneath them

> was a gigantic Tut-ankh-Amen's tomb ... and is it not perhaps even stranger to reflect that many of the treasures now hidden away for the duration of the war had once, centuries ago, slept in the tomb beside Pharaoh and Caesar, and have returned again to the secrecy of the earth?[30]

The closed galleries of the Museum, he found, were an eerie sight. Labels were still in place but the cases were empty and 'bare as a bankrupt draper's store'. The occasional exhibit loomed out of the darkness in the Eygptian galleries: 'several huge stone heads of vainglorious monarchs, and the two immense Assyrian winged bulls from Khorsabad, each of which weighs as much as a couple of tanks.' The vast column drums of the Temple of Artemis from Ephesus were 'now so well sandbagged and protected with wood and iron that they would survive the fall of the building'. The Parthenon

Marbles were 'so embedded in sandbag pies that not one fragment of arm or leg is visible'.[31] Of the evacuation of women and children the country is rightly proud, he told his readers, 'but nothing has been heard of the more difficult task of moving mummies, statues, priceless glass, fragile vases and pottery, of detaching huge stone objects from their pedestals and of moving them all to safety.' That was the last of his 'London in Wartime' columns for the *Daily Herald*. He was giving too much away. By the time it was published on 17 April, the Phoney War had ended.

7

We Shall Fight in the Hills

S INCE THE DAY war broke out, Kenneth Clark, Martin
Davies and Ian Rawlins of the National Gallery had
gone their separate ways. Davies found his new role at
Penrhyn Castle in North Wales highly congenial, not
least because he hardly saw Clark who, with his revolting
neckware, was mainly preoccupied with other work in
London. The storage situation was, he considered, satisfac-
tory. Inspecting the paintings was not too difficult: 'in point
of fact they behaved quite well after their journey and in
their new surroundings.' Local guards had been recruited
and some men from the Gallery were stationed there and
at the Prichard-Jones Hall in Bangor. Official photog-
raphers occasionally came up: two ladies called Miss
Rickeard and Miss Severn. The 700 smaller pictures on the
top floor of the National Library in Aberystwyth he had
left in the capable hands of the Assistant in charge of Prints
and Drawings, Philip Pouncey, and eleven warders.[1] All
seemed well.

The Director himself was highly satisfied with his
arrangements:

Thanks to the efficiency of our scientific adviser, F. I. G.
Rawlins, and an admirable railway man called Inspector
Bagshaw, the pictures arrived safely at Penrhyn Castle, and
as soon as possible I visited them. Penrhyn cannot have been
a cheerful setting for ordinary life, and with its dark walls

covered by large, dark canvasses it was exceptionally dismal. The pictures, far from decorating the walls, appeared only as areas of discoloured varnish. I had already decided that this would be a good occasion on which to carry out a programme of cleaning.

Mr Holder, the contract conservator most often used by the Gallery, agreed that his war work would comprise living and working on the paintings on site at Penrhyn, for a tiny payment. Holder, 'the gentlest of men', thought Clark,

> had shown ominous signs of balancing some inner distress with the help of the bottle, and exile to the rather dismal atmosphere of Bangor might have pushed him further down the same slope. Kill or cure: in fact it cured him; throughout the war, in even more discouraging circumstances, he never showed a trace of addiction.[2]

Clark was particularly sympathetic to Holder's weakness for alcohol, thinking of his father and his wife Jane's drink problems. By the time war broke out Jane was also addicted to her cocaine inhaler, prescribed by a Harley Street doctor to cope with her mood swings and Clark's affairs.[3] He greatly admired Holder's work:

> a restorer of the old, pre-scientific school. Delicacy and vast experience were his merits. To see him touch the surface of a painting with his swab of cotton wool was like watching a keeper pick up a baby partridge. The other restorer we had employed was the pioneer of scientific restoration in England, Helmut Ruhemann.[4]

Ruhemann, a German émigré conservator who had been dismissed from his job at the Kaiser Friedrich Museum in Berlin, had found a safe haven with several other German- and Austrian-Jewish conservators at the National Gallery.

On the outbreak of war he had transferred to work at Aberystwyth. Like Rawlins (who was dividing his time between London and the Welsh properties), he was an expert in the use of X-ray photography to investigate paintings and this is perhaps how the initial connection was made. Clark sponsored Ruhemann's application for naturalisation, which must have helped to prevent him from being interned as an 'enemy alien' in 1940. That was the fate that had overtaken Sebastian Isepp of the Kunsthistorisches Museum in Vienna who had fled Austria in 1938 to protect his Jewish wife. Clark had found him a perch at the Gallery too, and he was working with the paintings at Aberystwyth when he found himself detained briefly at Huyton Camp near Liverpool.[5]

But Clark was quite capable of being unpleasant about Jews. The Jewish artist David Bomberg tried repeatedly to get a commission from the War Artists' Advisory Committee, which Clark had created and was now chairing (on top of a role in the Ministry of Information which Uncle Arthur had obtained for him). 'Like so many of his race,' said the man who had supported Ruhemann and Isepp, 'his work looks artificial and done for effect, which is the last thing we want our records to be.'[6]

The empty National Gallery back in London became the location of a daily lunchtime concert, beginning on 10 October, with the pianist Myra Hess (like Muriel Clayton, 'surplus' to requirements) who played her own piano transcription of the chorale setting of Bach's cantata BWV 147 – better known as *Jesu, Joy of Man's Desiring* – and Beethoven's Piano Sonata No. 23 in F minor – the 'Appassionata'. It was no coincidence that the performer was Jewish and the music German. 'In common with half the audience, I was in tears,' wrote Clark later. 'This was what we had all been waiting for – an assertion of eternal values.'

Hess went on to organise a daily concert in an almost unbroken series to the end of the war. She played at them herself twice a week, including a cycle of all twenty-three Mozart piano concertos in chronological order, and used her contacts to programme the rest. Competition from the bells of St Martin-in-the-Fields and noisy regimental bands in Trafalgar Square notwithstanding, these quickly became a London institution, and attracted the cream of British musicians including Kathleen Ferrier, Sir Henry Wood, Benjamin Britten (before he left for America) and Michael Tippett.

Government restrictions on numbers for public gatherings were lifted and audiences of around 1,300 attended, from the Queen to servicemen on leave, all paying a shilling each. The refreshment counter served around 1,500 sandwiches at each performance (honey and raisin the bestseller), along with – according to Joyce Grenfell who regularly attended – 'dozens of buns, rolls, slabs of fruit cake and chocolate biscuits'. Clark himself even conducted a performance of Haydn's *Toy Symphony* on New Year's Day 1940. Having been coached by Sir Thomas Beecham, he was immensely put out when Hess – who had a mischievous sense of humour – deliberately sent him up during the performance. The year after, she was made a Dame.[7]

Cracks in other arrangements, however, were starting to show. The V&A at Montacute had a permanent staff of six warders on site, and a rota of curators from London who would spend a week at a time in the house dealing with official and supervisory matters. After a period of sick leave for back problems following the outbreak of war, Muriel Clayton returned to work in November 1939. Some historic textiles, early vestments and opus anglicanum were transferred to Montacute in January 1940. During her stint at Montacute that month, she was horrified to discover that, whilst the

furniture, prints and drawings were in good order, all the car-
pets and tapestries were still lying on the floor where they had
been since their evacuation, rolled up but covered with dust.
They hadn't been touched. On her next visit in February she
took some additional men down with her to help vacuum
them, roll them up and wrap all of them in double layers of
brown paper, sealed with paper tape.[8]

Muriel Clayton got to work with typical grit and deter-
mination. Her background made her undaunted by hard
work and setbacks. She had been born and brought up
in County Down and went to the top girls' school in
Belfast – Victoria College – where she had been a star pupil.
Her father Edward Clayton, a Kildare-born Protestant in
the Royal Irish Constabulary, reached the level of county
inspector, equivalent in rank to a lieutenant-colonel in the
army, in 1910 when Muriel was eleven. During the Easter
Rising he was working in East Galway, and between 1917
and 1920 in East Cork and Cork City, one of the most
explosive areas in the run-up to the Irish War of Independ-
ence. By 1920 he was Divisional Commander (essentially
Brigadier-General) in charge of the whole of Munster.[9]
Civil unrest and political violence then erupted into all-out
warfare.

It was just at this time that Muriel began her degree at Trinity
College Dublin, a bastion of the Anglo-Irish education system
which found itself in the middle of the war zone, increasingly
isolated from its loyalist and unionist networks, and with RIC
members coming under frequent attack. Women made up a
quarter of the students, but there were only thirty-one women
scholars between 1914 and 1920. Muriel was one of them.
Female students were not allowed to stay on the main site in
the city centre after 6 o'clock in the evening and women dons
were not permitted to eat in the dining hall with their male
counterparts.

Trinity College could be a dangerous place in other ways. In June 1921, a woman finalist called Kathleen Wright – whom Muriel probably knew – was shot dead by a stray bullet in College Park, when gunfire was aimed at a visiting military cricket team. And during the running street battles in Dublin in late June and early July 1922, the main site was taken over by Free State troops demanding food, while the women students kept themselves safe inside their suburban single-sex residence, Trinity Hall.[10]

So a few moths were certainly not going to defeat a woman who had seen all this; who had lived her teenage years with a father whose life was increasingly in danger and whose family was at risk of becoming a target. Edward Clayton was pensioned off in 1922, as part of the phased disbandment of the Royal Irish Constabulary. He died in a hotel in Saint-Jean-de-Luz, near fashionable Biarritz, three years later: though whether he was on holiday or had retired there – no longer welcome on either side of the newly partitioned Ireland – is not clear.

Some hosts were also proving to be a major headache for other museums. At Fawley Court, in Oxfordshire, where the Natural History Museum's entomology and botanical specimens had been sent, hundreds of cases ousted elderly Major MacKenzie and his spinster daughter Margaret from their dining room and drawing room. With butterflies in the basement too, they were refusing to give up the library which they claimed was their only remaining living room. A suggestion from the Museum that the family could find more space if they rearranged things more radically was greeted with horror by Miss MacKenzie, because they 'cannot mix furniture of different periods'.[11]

The IWM collections were lodged in their trustee Lord Melchett's cocktail room, ballroom and lounge at Colworth

Park in Befordshire, with fire protection being provided by two 'extincteurs' and the luxury swimming pool outside. They spent a happy and contented war there, even after parts of the house became a rest home for nurses.[12]

But not all was well at the IWM's other choice of home. Penn House near Amersham in Buckinghamshire was the main seat of the earls Howe, a red-brick Georgian mansion heavily enlarged in the Edwardian period for country house parties. In fact, the 5th Earl steered clear of the house and had handed it over to his heir, Viscount Curzon, in 1938; it was lived in by his ex-wife, his son being away on naval service.

Mary, Countess Howe, or 'Lady Curzon' as she was known by the Office of Works, had once been dubbed 'England's most beautiful peeress'. She had divorced her rackety husband and first cousin in 1937, no doubt fed up with his adultery and mad motor-racing escapades. Earl Howe, who seems to have modelled himself on Toad from *The Wind in the Willows*, incurred at least twenty-one convictions for speeding during the first eighteen years of their marriage and finally took up motor-racing professionally after a weary magistrate suggested that it would be a way of channelling his poop-poop enthusiasm for the open road. He was married three times and divorced twice, and was President of the British Racing Drivers Club for thirty-six years.[13] As a member of the House of Lords, the Earl had campaigned for decades in Parliament for the removal of the 20 mph speed limit.

Society photographer Cecil Beaton declared, 'there is no more charming spectacle than Lady Howe, either at the opera or taking the Pekinese for an airing in the Park, or at home, at tea time, blowing out the silver spirit-lamp and eating toast and honey.' By the time of her divorce at the age of fifty, however, the features of the erstwhile 'Queen

of Beauty' had hardened, though she had managed to retain the dog and an interest in eighteenth-century history. Mary now spent her time at Penn House entertaining friends and minor royals from across Europe, serviced by a large staff who looked after her, the buildings, the gardens and the shooting estate.[14] Howe had confirmed his offer of Penn House to the Office of Works in 1937 without consulting his ex-wife, and there are indications that from the first the IWM collections were unwelcome guests, resented by the Countess and given short shrift by her land agent.[15] Accordingly, the paintings were stored in the large centrally heated brick garage which had once housed the racing Bugattis of the Earl.[16]

Even at the comfortable Belle Vue Hotel in Bangor (all Welsh seaside towns seemed to have a hotel with this name) where Martin Davies and his colleagues were billeted, there were rumbles of distant thunder. He had been taken by surprise one day while labelling and arranging the new arrivals at the Castle when 'Lady Penrhyn marched smoking into the garage and very nearly ordered a picture to be turned round for her to see'. A month later he and Rawlins were becoming concerned about the conditions: the 'appalling dust' and fluctuating temperatures. 'Naturally', he told the Gallery's Keeper, William Gibson, the man in charge of administration back in London, 'I am taking no precautions against high explosive bombs here until they start to fall on the west of England', but he was thinking of pasting brown paper strips across the picture glasses to protect them, just in case of a shock explosion in the neighbourhood. Half a mile of tape would be required.

Getting around by car was becoming more difficult and Davies regularly pleaded for more petrol tokens from Gibson. Some creature comforts were still possible, however: 'the

Stilton has arrived and is much appreciated; please let me know how much I owe you.' By November, paranoia had started to creep in among the Gallery staff, waiting daily, even hourly, for the sound of enemy bombers. One of the guards told Davies that he had tuned into a German radio broadcast which mentioned that there was immensely valuable government property at 'Penreen' and Bangor, and that bombs were on the way, though not as big as for Scotland Yard now in Llandudno. Davies was sceptical, but passed the story back to London anyway.[17]

As winter came on, increasingly there were fuel shortages and the weather proved to be harsher than expected. Due to a shortage of staff, Rawlins found it difficult to heat the Hall at Bangor sufficiently with the coke-fired boilers.[18] Back at colossal Penrhyn a few miles away (its interior modelled on Durham Cathedral), the humidity in the dining room and garages was fluctuating wildly – by about 20 per cent over twenty-four hours – risking the cracking of panel paintings and canvases as they gradually expanded and then shrank back again. Rawlins measured the air circulation and found it was nearly stagnant: an ideal situation for mould and mildew. In the garages, the largest paintings were showing a variation in temperature of 5 per cent between the top and bottom of the canvases, putting potentially fatal strain on the organic fibres which made up the pictures. Rawlins managed to reduce this by half, thanks to the judicious use of small electric fans and airing the spaces on dry fine days. By contrast, the situation with the Gallery's collections at Aberystwyth was stable and worry-free.[19]

Rawlins was occupied in advising not only the National Gallery on its storage conditions but other galleries as well, and was in frequent contact with his opposite number at the British Museum, Plenderleith, about the challenges their collections

were facing. On one trip he travelled to Mentmore to take a look at the humidity levels at The Refuge for Henry Hake.[20] Four attendants from the National Portrait Gallery were now permanently stationed there and Hake was keen to ensure that they, as well as the paintings, were as comfortable as possible in their new berths. They had begun with two home-made camp beds and a few cooking pots. Within a week of arrival, they had an electric stove wired into their kitchen/living room in the outer portion of the building, and wooden sleeping bunks had been installed. These were shortly afterwards joined by a coke stove for heating, and the roof was insulated as the cold weather came on.

All the attendants slept overnight in The Refuge and at least two were on duty during day shifts. One man, who was Buckinghamshire-born and bred, enjoyed the role so much that he volunteered to be the permanent housekeeper and cook. Soon a vegetable garden sprang up at the request of Hake ('I think this would be desirable as an occupation for them and would also be of some national importance. We should of course pay for seeds, manure and provide our own tools') and thanks to Edmunds ('I will try and get a bit [of ground] quite handy for them'). In the spring, tomato seedlings were planted against the sunny brick walls of The Refuge. Then chickens were obtained for eggs, and deckchairs for use after each day's routine checks were completed. Hake made regular visits to check on his men, and to catch up with Edmunds.[21]

At the Tate, John Rothenstein remained inexplicably away in the USA on his extended tour. In his absence, Fincham delighted in telling anyone who would listen, including the Tate trustees, that the Director's whereabouts were hazy and his return date unknown.[22]

William Rothenstein saw the danger of his son's poor judgement in staying abroad and the risk to his reputation,

even if John did not. With the concerts at the National Gallery and the tentative exhibitions opening to the public at the V&A, the British Museum and elsewhere, the closure of the Tate was beginning to look awkward. Clark was beginning to dominate wartime London's cultural life. 'I doubt whether you realise how much the need of providing both for artists and the public is being catered for,' he wrote to his son. 'My own feeling is that you should be here: it is the feeling of others, less kindly disposed, also.'[23]

At Hellens, Lady Helena was unhappy with the arrangements and took her concerns to the top. She wrote to Sir Patrick Duff, the Permanent Secretary of the Office of Works, and demanded the fire extinguishers promised her before the pictures arrived:

> I think you ought to know that there is no proper protection for the State Property from the Tate Gallery which is stored in my house . . . I have repeatedly applied to Mr Fincham of the Tate Gallery representing the danger were a fire to break out or an incendiary bomb to fall but nothing has materialised.

Duff arranged for the equipment to be sent down post-haste and Lady Helen was most grateful, admitting, 'it is extremely unlikely that any bomb will come near here but in such a fantastic war one never knows what to expect!'[24]

An air-raid shelter had been constructed in the cellars at Hellens to Nina's specifications.[25] Lady Helen was devoted to the house but there were constant money worries, as she and Nina had spent every penny they had on buying it. For 'nine blissful years', they had lived there. But now 'comes a new war, when only young people can be of use and old experience counts for nothing. Everything has to go into the melting-pot and Hellens must join the rest.'[26]

Paintings were one thing, but Lady Helena refused to have any man permanently billeted there. There were two guestrooms, but a man was only to sleep in the house on shifts, 'the question of laundry and wear and tear of bed-linen' being one which Lady Helena was threatening to contact Fincham about.[27] Two brothers called Higginson were among the warders guarding the collection at Hellens. In March, Lady Helena wrote to Fincham asking for them to be replaced: 'No. 2 Higginson . . . has not been at all satisfactory in the house for a long time.' He had got off to a good start when, unasked, he had taught the small houseboy to clean the silver, but since then he had stubbornly refused to lift a finger with anything else, even when asked by herself or the maids. She claimed never to have demanded anything, only occasionally requesting help with moving heavy furniture. When she told 'No. 1' Higginson that she was replacing his brother he threatened to leave too, and 'as you are asking for trouble I shall see that you get it'. Lady Helena threw him out of the room, 'as I will not be spoken to like that'. She demanded that Fincham withdraw them both, 'as after this most disagreeable interview I should not care to have either of them here'.[28]

Kenneth Clark initially found that he much preferred visiting his collections in West Wales rather than the north, with its congenial atmosphere and scholars from the London museum and art world (and no Davies, of course). For him, Aberystwyth was 'a happy escape from the joyless atmosphere of London and the grim discomfort of Bangor'. There he was able to spend time with his friend Arthur Popham, Deputy Keeper of Prints and Drawings at the British Museum, who in his best Blooms-bury tones would airily reply to those who asked what war work he was doing at the National Library: 'making a catalogue of drawings by Parmigiano.'[29] Yet over time the North Wales

WE MUST JUST KBO

landscape started to pull on Clark's imagination. The country-side around Bangor he began to regard as 'sublime. I usually profess indifference to hills, but at the moment I feel like the Psalmist.'[30]

Also in Aberystwyth was Dr Johannes Wilde, formerly the Keeper of the Kunsthistorisches Museum and an old friend. He had fled Vienna because – like his colleague Isepp – his wife was in danger. The *Anschluss* had made life intolerable for them both, and when Wilde had the chance to go to an exhib-ition in Amsterdam in April 1939 the couple had made an escape to England together. The Clarks had welcomed them both to their house at Lympne (the wife 'a very boring Jewish lady', according to Clark – actually she was the Hungarian art historian Julia Gyárfás).

Wilde had been deeply traumatised by their experi-ences but found solace in learning English from the Clarks' young son, Colin. Their escape had been engineered by the Austrian aristocrat and art collector Antoine Seilern, who then sent Wilde along with his own collections to the National Library for safety. Wilde was then introduced to Popham by Clark, and ended up devoting his time to cata-loguing the Italian drawings of the British Museum as well as the Italian paintings belonging to the National Gallery. It looked as though he had turned a corner and life was about to get much better.[31]

Back at Penrhyn, Martin Davies was enjoying the calm before the storm. Clark noticed that in those early months his Assistant Keeper was 'in very good form reading the Italian classics and working indefatigably'.[32] He was also learning to manage the relationship with the Penrhyns. By the beginning of 1940, and after what Davies called 'a series of underground plots', he agreed to allow Lady Penrhyn to show off some of the pictures stored in the Castle to her friends, providing he was there and had been given a few

hours' notice to put on a little show.[33] Although the 'many minor problems' at Bangor and elsewhere were an irritant for Davies, the storage of paintings in North Wales 'might have been an uneventful task', he wrote. 'The Fall of France altered things.'[34]

8

We Shall Fight on the Beaches

O N 9 APRIL 1940, Germany invaded Norway and Denmark. Suddenly mention of a Phoney War ended, to be replaced by talk of fifth columnists and Quislings. It was rumoured that coded graffiti was popping up on walls and carved into trees; that nuns with distinctly masculine hairy hands had been spotted on public transport and near airfields; and that spies masquerading as blind men had been seen reading newspapers.[1] Once Nazi forces were in the country, so it was said, they would be aided by enemy agents disguised as maids. But many such women were refugees, such as the sister of the Rothensteins' German-Jewish cook, working as a housemaid in their home at Hampstead. The cook had begged Rothenstein to help her sister, a lawyer, flee Germany in 1939 and then the parents came too. John and Elizabeth were delighted to help and before they left for America had installed the entire family on the top floor of their house.[2]

On 3 May, Rothenstein finally returned to London, after an anxious journey on a small boat across the Atlantic, during which he had helped to scan the sea at night for German submarines. Not only had the situation back home persuaded him to return but warnings had come from friends that his personal position was now in danger, with no one in the art world knowing why he was still in the States, and replacements for him being openly named.[3] A week later, on 10 May, German forces launched their assault on the Dutch, Belgian,

Luxembourg and French borders. The War Cabinet met three times that day, and by the evening Chamberlain had resigned and the country had a new Prime Minister.

Three days after that, the call went out for men between the ages of sixteen and sixty-five to join a new domestic force, to be known as the Local Defence Volunteers, later renamed the Home Guard by Churchill. A quarter of a million came forward within the week.

The Netherlands surrendered a few days later, after the dreadful bombing of Rotterdam. When Tyler Kent, a cypher clerk at the American Embassy, was arrested in his Bayswater flat on 20 May and found to have nearly 2,000 secret documents in his possession, including decryptions of correspondence between Churchill and Roosevelt for passing to Berlin, fears about traitors at the heart of the establishment became real. The next day, Churchill's chiefs of staff told him that Hitler had the invasion of Britain 'worked out to the last detail'. On 22 May, the War Cabinet agreed to an extension of the 1939 Defence Regulation 18B, which allowed for the detention without trial of British citizens. Oswald Mosley and other leaders of the British Union of Fascists (BUF) were interned.[4]

The ripples from this tidal wave of precautions were felt even in the gentle waters of the British Museum. Suspicion fell on a number of staff. Under the Defence Regulation, spreading rumours or engaging in other activity designed to lower public morale or provoke disaffection with the government or war effort had become a criminal offence. A museum telephonist from Neasden was spotted by a female colleague hiding a copy of *Action*, the newspaper of the British Union of Fascists, under a copy of the *Daily Mail*. He then drew her into conversation on the government's ill-treatment of veterans of the Great War and she had come away 'with the definite impression that he was trying to rouse discontent'. A gallery attendant was said to be an outspoken pro-Nazi,

a member of the BUF and a subscriber to *Action*. He was seen consorting with a regular user of the Museum Library's Reading Room with a German-sounding name, 'who has recently disappeared', and 'expressed jubilation at Hitler's success'. A porter was also said to be a member of the BUF and to hold extreme views. The British Museum wrote to the Treasury asking what to do. 'The expression of their views and of pleasure, or something like it, at national disasters, is causing ill-feeling among their colleagues,' and Forsdyke considered it 'unsatisfactory that men holding these political views should be employed in Government service where they might have an opportunity of subversive action'.[5]

Back at his desk in the Tate, Rothenstein noticed that the perennial thorn-in-his-side Fincham kept leaving the building for long periods during the day. After having his questions evaded for some time, eventually Rothenstein demanded to know what was going on. Fincham claimed to be working for Military Intelligence, 'keeping fascists under observation in Chelsea public houses'. Clearly this was a blatant piece of insolence.

> A few days later I told him that the Director of Military Intelligence disclaimed any knowledge of him, but that he was at liberty to transfer to some other Department for the duration of the war. This he undertook to do. His pose as a secret service agent, more especially as one assigned for duty in places to which he had long been notoriously addicted, seemed to me so farcical that I discounted him as a joke.[6]

At Hellens, Lady Helena had pre-empted Churchill with her precautions for the village. In March she had set up her own personal army, the 'Much Marcle Watchers', who were scanning the skies above her acres of pear trees for enemy parachutists. Each of the eighty tenants and staff she had enlisted had been given an ink-stencilled calico armband with the name of

their troop on it. They were drilled by her in the daytime in the grounds of Hellens, while in the evenings they had to sit through her talks on tactics. True to form, her shooting skills were formidable: in her younger days she had felled a rampaging bull with a single shot.

But there was a problem. Where to find guns for her men? Determined to obtain rifles and ammunition for her 'parashots', she strode into the Shropshire Light Infantry Headquarters in the nearby market town of Ross-on-Wye and demanded some, adding 'I could do with some machine guns too, if you have any to spare.' Undeterred by the rejection of her request by the Battalion Commander, she returned home and armed her Watchers with the ancient pikes and halberds decorating the walls of Hellens, as well as pitchforks and other sharp implements from the farm.[7]

The German armoured divisions pushed the British Expeditionary Force (BEF) and the French forces back towards the Pas de Calais, taking Boulogne on 25 May as the Allies retreated to Dunkirk. Between 26 May and 4 June, some 190,000 British soldiers and 140,000 French were evacuated across the Channel to safety. Among them was Brigadier Fred Lawson of Hall Barn, later decorated for rallying the defence of the St-Omer canal against German mortar fire to protect the Nieuwpoort bridgehead, and promoted afterwards to Major-General. The BEF was reduced by 68,000 due to deaths, injury or capture and left behind nearly all its stores, ammunition, artillery, vehicles and over 400 tanks. In total 100,000 Allied troops were taken prisoner; 92,000 French were killed and another 200,000 wounded. It was a desperate, humiliating, shocking defeat. Church bells in England were silenced, now only to be rung in the event of parachutes falling from the sky.[8] Some of the traumatised artillerymen were billeted in Aberystwyth, for rest and recuperation. As a result, the British Museum staff at the Belle Vue Hotel were moved out to a much less

congenial hotel to make way for them, and eventually into rented lodgings scattered across the town. 'Yet we were still to be envied,' Victor Scholderer recalled. 'There were no air-raids, only an occasional mine washed up on the beach, which could be allowed for, and rationing was not nearly so irksome as in the great centres.'⁹

Bernard Ashmole, of the British Museum Greek and Roman Department, volunteered for the Home Guard after Dunkirk. He knew his way around a gun all right. He had been awarded a Military Cross in the Great War and, aged only forty-six, he would have been unexpectedly competent for a curator in a tight corner. 'We kept watch from the top of our water-tower at Amersham for possible German parachutists, with one rifle and the few rounds of ammunition that the force possessed.' Eventually he was commissioned into the RAF Volunteer Reserve and saw service in Britain, Greece and the Middle and Far East as a wing commander.¹⁰ Not too far away at Mentmore, Henry Hake had decided that he needed a base to be closer to the paintings of the National Portrait Gallery. Edmunds offered the visiting grooms' quarters in the hunting stables, so that from June 1940 Hake and his wife could use them whenever they needed to get out of London.¹¹

By the end of May, there were ructions at Hellens. Lady Helena's sister Valda and her nephew, Roger Machell, badly wounded in the BEF retreat, were due to arrive any day – and the cook was threatening to leave. Lady Helena's favourite meal was a plate of caviar, smoked salmon and the anchovy paste known as Gentleman's Relish, all washed down with half a bottle of champagne. Her cook quailed at the difficulty of feeding a household of four with such expensive tastes on rations.¹² Furthermore, after a string of complaints from Lady Helena, the chief warder, Sergeant Chappin, was sent down from London to take action and see to his unruly team. It was a sorry tale. All the men had been wandering off during

duty and going to the local pub. They were now banned from leaving during their shifts, and encouraged to join the Home Guard out of hours provided that, in the event of invasion, they would not dive into the local hedgerows with pitchforks to lie in wait for the enemy but would remain at Hellens to protect the paintings.

One of them, whom Lady Helena had refused to have in the house as he 'cannot be trusted', was immediately sacked as he had been fighting with villagers and had been thrown out of the Home Guard. Another was 'more or less under the influence of drink' and his clothes badly needed replacing, but he was civil and obliging, and had taken to sawing logs for the fire and 'driving out cows from swamp at bottom of garden' which, owing to his being up to his knees in mud, 'rather takes the crease out of clothes'. Lady Helena quite softened towards him when he offered help to the convalescing Roger who 'needs a man's help at times' and for whom she intended 'to do all that we can'. The Higginson brothers – Nos 1 and 2 – had 'undoubtedly been rude and rough in answering her Ladyship'. They weren't sacked but Chappin tore them off a strip.[13]

It did the trick. A few days later, under Chappin's influence, peace appeared to break out. 'I must tell you', wrote Lady Helena to Rothenstein,

> the two Higginsons last night offered to valet my nephew who is unable to do much for himself. They tell me they have both been valets and they were most anxious to be obliging. We shall be very grateful for their help.

Rothenstein declared himself 'pleased and not a little amused' at the Higginsons' 'sudden revelation of prowess as valets'. It was a short-lived truce. A month later, tensions arose again when Lady Helena roundly abused one of the Higginsons 'in front of her three young maids' for not helping out with the harvest.[14]

★

As the evacuation at Dunkirk continued, the rattled National Gallery trustees began to push Kenneth Clark to consider evacuating certain pictures to Canada. He was deeply uneasy about it, 'not only the risk but also that . . . the Americans would always claim that they had saved the National Gallery for us'.[15] Reluctantly Clark wrote to the new Prime Minister. On 1 June, despite the extraordinary events going on across the Channel, he received a reply. Churchill, wrote back Anthony Bevir, his snuff-snorting private secretary, was 'not prepared to agree to the evacuation of any pictures, which he feels would be quite securely placed if there was adequate protection for them – if necessary, under ground.' Clark in turn wrote to his administrator, Gibson, at the Gallery: 'It is a load off my mind. The Prime Minister's actual words were "Hide them in caves and cellars, but not one picture shall leave this island." Will you please inform Davies?' Jock Colville noted in his diary:

> Very busy all the morning, especially when the P.M. returned from Paris with a box full of straggling papers. His minute on the paper in which Tony had asked about sending the National Gallery pictures to Canada was 'No, bury them in caves and cellars. None must go. We are going to beat them.'[16]

But keeping the Gallery's paintings where they were was becoming ever more perilous too. At Penrhyn, things were going from bad to worse. 'For your most secret ear,' reported Martin Davies to Gibson on 5 June, the same day that German tanks began heading south from the Somme:

> one of the troubles at Penrhyn Castle is that the owner is cele-brating the War by being fairly constantly drunk. He stumbled with a dog into the Dining Room a few days ago; this will not happen again. Yesterday he smashed up his car, and, I believe, himself a little – so perhaps the problem has solved itself for the moment.[17]

Three days later the Germans launched their attack on Paris and, the day after that, Italy joined in the conflict, declaring war on France and Britain. Norway finally surrendered after two months of stout resistance to German invasion on 10 June. The French government declared Paris *ville ouverte* on 13 June and fled to Bordeaux. On 14 June, German forces paraded down the Champs-Elysées towards the Place de la Concorde. Eighty-four-year-old Marshal Pétain took over as President on 16 June and signed the armistice with Germany on 22 June. Hitler arrived in the French capital for a tour of his newly conquered neighbour the day after.

In rural parts of Britain, fields were being filled with railway sleepers and abandoned vehicles to prevent parachutists from landing safely; improvised roadblocks were rolled into place; village signs and fingerposts were grubbed up; and place names scrubbed off shopfronts to disorientate any enemies who did get through. Cars and trains were immobilised when not in use. Barrage balloons floated overhead in London. The Public Record Office hastily closed its Canterbury outstation, moving forty-five lorryloads of records to the PRO's other safe houses.[18]

At Montacute, Muriel Clayton arranged for the redistribution of boxes and exhibits from the upper floors to downstairs. 'Somerset', she worried, 'was now within easy bombing range of the French coast' and Yeovil aerodrome not far away. She organised teams to stick coloured labels on all the boxes, prioritising what 'should be rushed outside' in an emergency, and pinned up guidance around the house. She had also been battling a major moth invasion for weeks. The fabulous Ardabil carpet, the oldest dated in the world and one of the V&A's prize objects, was riddled with eggs and others had been extensively chewed. Moths were spotted flying lazily through the Great Hall. The tapestries and carpets open to

the air which were regularly vacuumed were not the problem though. It was those which remained rolled in brown paper. The unseen infiltration had taken place the previous autumn when the carpets had lain unattended without her, just as she had feared. Beaten, sprayed and left out on the terrace in the sun, the carpets were the battleground where Muriel spent her days fighting her own offensive against a deadly enemy. When Maclagan contacted his superiors in the Department for Education for additional reinforcements to help her, he received a single verse in reply:

> I'm sorry that at Montacute
> The moth's at work with teeth acute
> But if your people work with zest
> They'll soon eliminate the pest.[19]

Muriel's response is not recorded.

After Dunkirk, it appeared to Adrian Digby at Drayton that

> the whole world thought our position was hopeless. Hitler seemed to think we would surrender. But in fact everybody was surprisingly cheerful. People went about saying that we were in the final and it would be fought on the home ground. The position was desperate but we did not want to believe it.[20]

Ten miles away at Boughton, first Canadian then some British home forces took over parts of the grounds for billeting and manoeuvres, in the process damaging fields, crops and the estate roads further, as well as a stone bridge and the entrance gates.[21] Overenthusiastic ARP exercises by the Museum's staff on the roof, spurred on by the rising apprehension, led to a water leak through a painted ceiling below.[22]

After Churchill's call to arms, the Museum staff at Drayton talked about joining the Home Guard, even equipping

themselves with bows and arrows in the absence of proper weapons. Digby and the other staff felt gripped by 'a kind of madness or hysteria' which had infected everyone across the country. Forsdyke banned them from joining. Instead, if Drayton was overrun by the Nazis, Digby was told to find the German officer in command, tell him British Museum collections were inside and that the British government would hold him responsible for their safety. Digby found it a relief to have some definite orders.[23]

So which of London's galleries and museums would be targeted on the invasion? The *Informationsheft Großbrittanien* (the Great Britain Information Brochure, a poorly researched but nevertheless revealing handbook put together in early 1940 by the Gestapo to prepare the incoming occupiers for governing the country), gives a taste of what was planned. 'England', it declares,

> has some of the largest museums in the world. Art treasures and cultural valuables have been collected or stolen for decades. They also contain documents and works of art from German history, in which the German Reich must have a special interest. The biggest collections are to be found in the British Museum in London, which is organised with an international perspective and exhibits collections and treasures from all over the world, generally the very best that could have been obtained or stolen. Its valuable manuscript collection, with some very important historical documents, has to be particularly emphasised. The building's central block contains a giant library for all sections and collections.

It described the V&A as holding 'valuable art objects and items from Europe, including wood-carvings, woven articles and embroideries, the world's most beautiful and precious pieces of ivory, iron and most of all gold and silver'. Conflating the National Gallery with the National Portrait Gallery, it noted

'among 4,000 paintings many portraits of English personalities, as well as a series of Jews'. And 'apart from these museums some churches possess considerable treasure vaults.'[24]

These handbook entries are, at the same time, both bizarre and chilling. It is clear that despite their random and often half-digested nature the intention of the entries (stitched together from pre-war guidebooks and gazetteers) was to highlight collections which could be stripped of art or arte-facts of Germanic, pseudo-Germanic or 'Aryan' origin; to expunge collections of all Jewish or Bolshevik influence; to appropriate items of high intrinsic value such as those made of precious metals or gems, perhaps for melting down or to use as financial collateral; and to punish anyone whose credentials suggested that they would be likely to form part of any resistance. Reading between the lines, the seem-ingly anodyne description of the home of the government archive is lightly laced with menace: 'The Public Record Office in Chancery Lane, London WC2, was founded in 1838 and is of great interest. It has had its own museum since 1902.'[25]

And it was not only institutions which were in the Gestapo's sights. Individual museum directors were some-times named and several outside London alleged to be Nazi sympathisers. An annexe known as the *Sonderfahndungsliste G.B.* – the infamous 'Black Book' – gave an alphabetical schedule of 2,820 persons to be rounded up immediately on the country's occupation. They included politicians, writers, artists and intellectuals of all kinds. A number of prominent Jewish figures were listed. Henry Mond, Lord Melchett (providing shelter for the IWM at Colworth Park) was spe-cifically singled out:

> The chemical industry is dominated by Imperial Chemi-cal Industries Ltd, which has succeeded in acquiring more

and more chemical businesses, and perpetually increases its prominence and influence. Imperial Chemical Industries was founded in 1926 by the Jew Sir Alfred Mond ... [his] son sits on the board of ICI under the name Lord Melchett.

So were the Rothschilds. The Minister of Aircraft Production was described thus: 'The *Daily Express*, *Sunday Express* and *Evening Standard* are part of Beaverbrook Press. Lord Beaverbrook who owns this group, is a close friend of the Jew Melchett and is completely pro-Jewish.'[26] No doubt characters like Osbert Sitwell would have regarded Brigadier Fred Lawson as one of those unsatisfactory Jews pretending to be Christian, Englishmen and gentry even though his grandfather, Edward Levy-Lawson of the *Daily Telegraph*, had converted to Anglicanism. Certainly, the Black Book took this view, as Fred appeared in it: singled out for his newspaper connections, his daughter thought, though it is also just as likely he was targeted because of his Jewish ancestry.[27]

Victor Scholderer, too, only found out after the war that he was also in the Black Book, described as 'a "Jew and Director of the British Museum" – characteristically two 100% untruths; I still wonder who caused them to be wished on me.'[28] When the list came to light in 1945, Noël Coward received a telegram from Rebecca West, 'My dear – the people we should have been seen dead with.'[29] But at the time, it was no joking matter. What, one wonders, would the Nazis have made of the radio play *Gestapo in England*, written by Graham Greene and – startlingly – Kenneth Clark, intending to illustrate 'what might happen here if Germany won the war', which was broadcast on the BBC Home Service in 1942?[30]

It was not difficult to predict, either, what would become of some of the Anglo-Saxon and early Norman treasures that had been secured in England. With Domesday Book imprisoned in Somerset, similarly elaborate precautions had been taken in

France, but to no avail. The Bayeux Tapestry had been rolled onto two spools, sprinkled with naphthalene and crushed peppercorns to prevent moth, then laid in a padded wooden case lined with zinc and locked in a secure concrete shelter in the cellars of the Hôtel du Doyen in Bayeux. Beginning in late September 1940 and continuing through the autumn, the local *Propagandastaffel* unit established by Goebbels demanded to see the Tapestry, and that led to a series of viewings by the occupying forces.

The Tapestry also caught the attention of Himmler, and not only because it portrayed the story of a successful invasion of England. Himmler's monstrously hubristic personal project was to restore – with the enslaved labour of concentration camp inmates – the castle of Wewelsburg in Westphalia as a mystical cult site for ancient Germanic heritage. As far as his *Ahnenerbe* was concerned (the SS unit identifying and seizing from other nations, among other things, historical artefacts which 'proved' the racial superiority of 'Aryans'), the Tapestry celebrated 'the story of the battles and victories of a Germanic Prince' and was an outstanding object of Viking culture, the Normans having indeed originated in Scandinavia.[31]

Despite the delaying tactics of the Bayeux mayor, by June 1941 the Tapestry had been moved to the Abbey of Juaye-Mondaye in the Calvados region where it was unrolled, and over the course of six weeks closely examined and minutely photographed under powerful lights in front of senior military officers and *Ahnenerbe* scientists. Parts of its fragile structure were unstitched so that the cameras could intrude right inside the gap between the embroidery and its backing, then sewn back up again, before being briefly returned to Bayeux. A few days later it was on the move again, this time to crate A in room nine, one of the cellars of the Château de Sourches in the Loire Valley. This contained the most important paintings from the Louvre including the

Mona Lisa and Delacroix's *Liberty Leading the People*, furniture from Versailles and private collections confiscated from prominent Jewish families. Painted in large white letters on the chateau's lawn was 'Musée Louvre' to deter casual bombing from the RAF flying overhead.[32]

That autumn the Tapestry was aiding Goebbels' propaganda efforts, with William Joyce – Lord Haw-Haw – broadcasting that it would form a travelling exhibition around neutral countries, boasting of the forthcoming invasion of England – as those Germanic Vikings had managed in 1066 – and stating that it was already in Germany. The *Times* leader the day after scoffed:

> the famous Tapestry will outlive the tawdry resurrection, under the name of the 'new order', of that paganism of the Dark Ages which the dawning chivalry of Norman and Saxon alike had left far behind by 1066. This is the 'propaganda' our Bayeux Tapestry really gets over, let the Goebbels minions do with it what they will.[33]

But it would be very hard indeed to keep up such a defiant tone if the Sutton Hoo treasure or Domesday Book found their way into the hands of the enemy. Happily the tour did not happen, and prior to the D-Day invasion orders were given to move the Tapestry to Paris where it was stored in the Louvre itself, despite the danger, eventually to be retrieved by the Allies' Monuments, Fine Arts and Archives unit (the MFA&A) – the so-called 'Monuments Men'.[34]

Hilary Jenkinson of the PRO – shortly to become a Monuments Man himself – was fully aware of this new and insidious menace. Curators, librarians, archivists: all were on a front line of their own, defending not just the physical integrity of their collections, but also sandbagging the authenticity of their treasures as protection against those who sought to misinterpret them for their own twisted ends. The defences put up by

this unlikely heritage front were bulwarks against the invasion of the past by a vile and malignant force. 'In an age in which untruthfulness is not only increasingly condoned but in certain quarters and by certain powers elevated to the status of a science and prescribed as a rule in the conduct of affairs,' Jenkinson wrote, 'in such an age our profession may, I venture to submit, have a part to play the importance of which it would be difficult to exaggerate.'[35]

On 16 July Hitler gave the direct order for Operation Sealion – the codename for the invasion of Britain – to commence preparation. The Battle of Britain began. At the Natural History Museum in South Kensington, the newly formed Special Operations Executive (SOE) took over some of the empty galleries and turned them into sabotage workshops and a demonstration room known as Station XVb. It was here that the SOE's most picaresque invention – the exploding rat – was dreamed up. The creatures' skins were removed in one piece and then stuffed with explosive and a fuse. It was intended that booby-trap rodents would then be left by agents in the fields near German army boilers so that when shovelled into the furnaces they would then cause devastation. The plan failed in its original objective when the very first consignment to cross the Channel was intercepted by the enemy, but it succeeded in the end because the *Wehrmacht* spent so much time thereafter engaged in trying to find and then detonate a presumed but non-existent infestation of rodent-bombs that it achieved the aim of disrupting operations.

On the other side of London, some of the weapons in the IWM collection still in the museum itself were pressed back into service. Naval and army guns, veterinary and optical instruments were sent away to be reused. Other items were taken for training purposes. A small number of steel helmets from the Great War were handed over to the Home Guard

and some trench clubs sent away to be copied.[36] The sirens began, and not just in London. At Montacute, the first bombs in the area dropped ten miles away.[37]

Martin Davies was fatalistic about invasion, and saw no point in worrying. 'If the Germans [overran] any of the National Gallery depots, there was nothing very much to do beyond hoping the pictures would survive.' Bombers loomed larger in his mind as a danger than parachutists. Ever since the Germans gained control of airfields in Normandy and Brittany, he had begun noticing many more planes in the skies above Bangor, ominously heading towards Manchester, Liverpool and Chester. He was fearful of bombers jettisoning their loads, when 'chased away from the industrial centres to the East. It was therefore quite possible that a bomb would fall near Prichard Hall or Penrhyn Castle.' Even if the paintings were not damaged or incinerated in the event of such bad luck, the buildings they were in might be set on fire or rendered useless. The paintings would be homeless and supremely vulnerable.[38]

He wasn't the only one in Wales who was anxious. At much the same time, Llewelyn Davies the Chief Librarian contacted the Chief Constable for advice. All at once, the sparkling white stone of his art deco building overlooking Cardigan Bay seemed an enormous liability. What was more, danger came not only from the north-east but also from the west. Rawlins was worried about this too.[39] Just forty-five miles across the Irish Sea was Éire: neutral, but liable itself to be invaded or bombed.

When war had broken out the Head of the Art Department of the University had approached the Librarian suggesting they camouflage it with a lot of painting assistance from the junior staff. Llewelyn Davies had managed to put off what seemed then an excessive proposal. But things were ratcheting up, and he and the National Gallery's Philip Pouncey, having gone out onto the roof of the Library, had concluded that

the only possibility in the case of the leaded roofs is the use of nets. The white walls of the Front and of the South Wing, however, present a very difficult problem – a problem, in fact, which to me appears incapable of solution, as the Library buildings form such a prominent landmark. Nevertheless I shall be glad if you will give me the benefit of your advice.

'Personally,' replied the Chief Constable,

I think this should be done ... similar buildings in London have been camouflaged partially by painting, partially by screening with nets on which something to represent Ivy is placed. This breaks the outline and would prevent the structure standing out on the horizon as it now does. I think that partial camouflage of the roof by nets would prove effective.

Llewelyn Davies then contacted an acquaintance at the Air Ministry:

in the strictest confidence do you have any aerial photographs of the Library showing how the building appears from the air or is this information which you are not able to give me? My feeling is that the appearance of the lead roof might, perhaps, be hidden with the aid of nets, but I really cannot see how we can hide the white walls without incurring heavy expenditure. Is there a friend of yours there to whom you can refer these awkward questions?

Two hundred sandbags were ordered to protect the four observation points being constructed outside the Library, and he wondered about moving the Library's air-raid shelter in the basement as it was now directly under several floors of books which might collapse in on it in the event of a strike. The lower floor of the nearby University swimming pool was thought better for readers to go to, 'as a place of retreat, at any rate, during the summer months'.[40]

Meanwhile Johannes Wilde, whom Kenneth Clark regarded as 'one of the sweetest and gentlest human beings in the world', had just been offered the chance by Arthur Popham of cataloguing the Michelangelo drawings of the British Museum. But returning from the National Library on Hangman's Hill in the blackout one night that June, the fragile Wilde was spotted with a lit torch shining out of his pocket. Arrested and accused of signalling to German submarines off Aberystwyth, the unhappy Wilde was interned and, despite the protests of Clark and others to the authorities, deported to Canada. He only managed to survive the camp through the help of fellow Austrian internee, the art historian Otto Demus. Clark was incandescent with rage, describing the episode as 'one of those revolting incidents which characterizes a frightened bureaucracy in any country and which we loudly condemn in others'.[41]

There was a piece of good news for Llewelyn Davies among all the anxiety. At long last, the ARP Tunnel was ready for action. It had taken ten months to install the electrics and fans, dry it out and test that the humidity and temperature were right for the books and manuscripts, and fill it with racks of steel shelving. On 2 August, the most precious of the British Museum's rare books and manuscripts were moved from the Print Room down the cliff to their new home. There, in wooden boxes, they occupied one side of the Tunnel, while the National Library of Wales used the other. Each side was separately secured and accessed through locked inner doors. Three weeks later the nerve-racking transfer was complete.

A rota was set up so that Plenderleith's hygrometers in the Tunnel were inspected day and night on a regular schedule to ensure that the relative humidity of the air did not rise above 65 per cent: a sure harbinger of mould and mildew. Space released in the Print Room was soon filled to bursting by yet more arrivals from Bloomsbury.[42] Scholderer, who celebrated his

sixtieth birthday that year, was determined to play a full part. Walking up the hill to the Library from the town was already something of a trial, and added to this was the rota of monitoring the environmental conditions in the Tunnel several times every twenty-four hours when he was on shift, sleeping overnight in the Library. It was physically exhausting. Scholderer recalled how, 'on nights of rain, frost and snow the scramble downhill in the small hours with the keys, the checking and the climb back might be said to constitute a "hardship".' But that summer, the determined and tough sixty-year-old found that there was the sublime pleasure of watching the sun rise over the lush green hills to the east.[43]

Martin Davies' initial response to the new danger was not camouflage or burying things underground, but redistribution. Having so much of the National Gallery in and around Bangor was a risk, so he removed twenty important pictures ten miles south-west, to the lowest floor of the Eagle Tower at massive Caernarfon Castle with its hugely thick stone walls. Edward I's greatest castle was once again in use, but this time as a refuge against hostile forces, rather than the military headquarters of a brutal coloniser, as it had originally been. Another twenty masterpieces went to a country house, Plas-y-Bryn, in Bontnewydd, three miles further south; and seventy more to Crosswood, nine miles from Aberystwyth. But these changes brought with them their own difficulties. The area under Davies' control had just increased six-fold and the number of guards had doubled. Regular checks were becoming ever more time-consuming and, with increased petrol rationing, often difficult to achieve.[44]

Rawlins however found that while conditions at Bontnewydd and Caernarfon could be stabilised with standard electrical heaters, Crosswood was more of a challenge. So many properties by then had been requisitioned that the Gallery was left with a bit of a pup. There, the library, which was

the room used to house the pictures, was dangerously dry – a consequence of the antiquated hot-water pipes running under the floor. After considerable head-scratching, Rawlins ordered that as many old blankets and as much felt as possible should be found in the house, dipped in a nearby stream until soaked through and hung in the room to humidify the air on a regular basis.[45] The smell of wet wool must have been quite rank.

The National Gallery now had its collections dispersed across seven locations, but Clark worried particularly about those stored with Uncle Arthur – Lord Lee – at Old Quarries in Gloucestershire. 'I feel we have too great a concentration there,' he wrote to Gibson.

> It is relatively safe from bombing, as you know, but surrounded by flying fields and so would be vulnerable if the Germans chose to land troop-carrying aeroplanes. I think that Lee will be relieved if some of the more precious pictures are taken away from him.[46]

The overbearing Lee had certainly become increasingly anxious about his storehouse once the initial euphoria of the pictures' arrival wore off. 'It was essential for safety's sake', he recalled in his memoirs,

> to maintain complete secrecy as to the whereabouts of these several million pounds' worth of irreplaceable treasures, and consequently our whole house was scheduled by the Government as 'reserved premises' to which neither visitors not billetees could, under any circumstances, be admitted. This had the advantage for us that we were guaranteed the privacy of our home, but at times the sense of responsibility became oppressive.[47]

It was rapidly becoming clear to Davies and Rawlins that storing collections in historic properties above ground, however widely spaced, would no longer do. Bombing was fast

spreading beyond London and the south-east and invasion was expected within days. 'The proper precaution', they had determined, 'was to go underground.'[48] But where and how it could possibly happen, with the nation on full alert, was a mystery.

In August 1940 an additional display of British and medieval antiquities was mounted at the British Museum. The exhibits were duplicates, plaster casts and reproductions which could easily be sacrificed: 'bygones,' Forsdyke considered, 'which were soon to justify their name in every sense.' The so-called 'Suicide Exhibition' replaced the display of originals, which were hastily removed to safety early the next month. It was just in time. On 7 September 1940 the chiefs of staff issued the code word 'Cromwell': invasion was imminent, and the Blitz began.

9

Blood, Toil, Tears and Sweat

FOR SEVENTY-SIX CONSECUTIVE nights the capital was bombed. Londoners naturally sought the refuge of the London Underground in the blackout. But this sense of safety was misplaced. A month into the Blitz, Balham station in South London (designed by the very same architect as the NLW and its ARP tunnel, Charles Holden) received a direct hit. Sixty-eight people were killed, not by the explosion but by the surge of water, sewage and debris which breached the tunnel walls and burst through the enclosed platforms.

If people had had a choice, which of course they didn't, then they would have chosen Aldwych during an air raid. Aldwych was regarded as the best of refuges for Londoners, not because of its depth at over ninety feet below street level, but because of its relative comfort. In addition to being equipped with portable toilets, bunk beds, refreshment stalls and medical posts, as most stations were, Aldwych had a library, and those sheltering in it – oblivious to the stacked treasure of the British Museum hidden nearby – were entertained with regular lectures, films, plays and variety performances.[1]

All the major London museums and galleries, along with landmarks and public buildings, positioned fire-watchers on their roofs during air raids, with their own firemen on standby. John Rothenstein found that the first two nights of the Blitz 'brought raids of such intensity and violence, and so much destruction was caused in the areas around the Tate that I decided that I ought to spend my nights as well as my

days there'. The Tate had now remained obdurately shut to the public for a year. His wife Elizabeth arranged for their beds to be moved into the Gallery but even while they were packing, their house shook with the impact of the anti-aircraft guns starting to fire from nearby Primrose Hill.

On arriving at Millbank with their puppy Jake they found 'an almost ducal suite' had been set up for them in one of the galleries, enclosed by screens and,

> with carpets laid, bedside tables in place and flowers in a vase ... there was nothing between us and the huge glass roof and, before the night was over, at many points there was nothing between us and the sky.

Worried about offending the staff who had gone to so much trouble, they stayed put that first night but 'one night with glass and shrapnel rattling down was enough. Next day we moved below.'[2]

For the next week they slept in the Tate's ARP shelter in the basement, where neighbours also sought safety. A family came in, traumatised after their grandmother was decapitated. She had poked her head out of the window to look at the enemy aircraft flying overhead just as a falling bomb dropped past. At 2.30 in the morning of 17 September Rothenstein was woken by 'an explosion of unbelievable violence and duration to feel the massive building continuously shaking'. The puppy had disappeared, blown to the other end of the shelter. There were screams, and the lights failed. Someone struck a match in the darkness to a scene of chaos. The Gallery had taken a direct hit.

The glass roof had completely shattered and Rothenstein felt an icy wind coursing through the building as he went to investigate while the raid continued. Masonry and glass continued to cascade down as he stumbled through the galleries with Sergeant Chappin to see what had happened. Outside,

'hugging close to the wall for shelter', they spotted moderate damage on three walls of the Gallery but the fourth 'put me in mind of one of Paul Nash's pictures of the Western Front in the First World War'. The east wall of the Tate had collapsed and there was a huge crater between it and its devastated neighbour, the Royal Military Hospital, lit up by the flash of guns and bombs and fires, with a pale grey dust falling continuously. Huge shards of glass from the shattered roof had embedded themselves in the lawn, 'a dense harvest of dragon's teeth' as high as a man, and whole paving stones were found on top of what remained of the roof.[3]

Damage was occurring elsewhere to the nation's other treasure houses. A turret of the Public Record Office in Chancery Lane was destroyed on 19 September by a high-explosive bomb, with the roof and some windows shattered; and the museum room where Domesday Book had been displayed was hit by fragments. On several nights, Jenkinson and Flower noticed it was possible to read a newspaper 'in the glare of neighbouring fires'. On one night alone, twenty-three incendiaries were put out on the roof.[4] Jenkinson, however, retained a sense of humour. In addition to the sixty staff doing ARP duties at Chancery Lane, his annual report for that year listed a dedicated 'rat officer' who had joined the PRO on the outbreak of war 'from another unit unidentified'. It was furry, and 'black with white patches'.[5] Rats were an increasing problem in damaged buildings, and for any collections or staff left behind promised all kinds of damage and infection. At the National Portrait Gallery, a schedule of 'Rats Killed and Trapped' was begun, their location carefully noted and their methods of despatch recorded (boots, shovels, brooms, planks and, even, 'with great excitement', a poker).[6]

On 23 September, the King's Library at the British Museum was hit. This was the room in which the book

collection created by George III, subsequently sold to the nation by George IV, was housed. Some items had been sent to Aberystwyth, but most had stayed put. The high-explosive bomb incinerated thirty feet of shelving and set more on fire, destroying some 400 volumes. Plenderleith set up a huge drying operation to salvage the charred and soaked remains, opening them out along the length of the floor and blasting them with fans.

Plenderleith's own laboratory at 39 Russell Square was badly damaged on 14 October and two days later, in the early hours of the morning, an oil bomb went through the dome of the British Museum's Reading Room. The crumpled shell plunged right into the middle of the floor but its fuel load had already splattered across the copper roof – to be put out in seventeen minutes. To Forsdyke it seemed 'like a Christmas pudding flickering and burning'. If it had remained intact the whole room would have gone up.[7] For the rest of the war Plenderleith and a single assistant operated an emergency repair service out of the basement of the Museum.[8]

Another lucky escape came when a thousand-pounder dropped through the ceiling of the Prints and Drawings Room on the top floor, luckily ripping off its tail and detonator in the process, so that it then sailed on down through four more concrete floors to bury itself in the basement, unexploded. Smaller bombs dropped into the King's Library again and Duveen's new Parthenon Gallery, making a terrific mess but not obliterating the rooms entirely. While the main building was fortunate that autumn, the British Museum Newspaper Library at Colindale was not. Thirty thousand volumes of newspapers were destroyed in the bombing of 20 October, almost a third of the Museum's entire collection, the closely packed stacks confining the blast to inside the building. In all, the Museum was struck six times that

autumn, which Forsdyke considered below average for that part of London.[9]

Throughout the Blitz, Adrian Digby was on alert with the rest of the British Museum staff at Drayton, though it was 'still a rest cure compared with almost any city in England'. Kitted out with wellingtons, a steel hat and gasmask, he used to take the first watch of the night, but there was often nothing to do. Occasionally an enemy plane would drop its unused bombs at random on the way back from the industrial Midlands, 'then you would see a row of twinkling lights break out in the distance and burn for a short time'. The nearest the bombs got was half a mile away at Lowick. For a month from mid-November Drayton witnessed the planes flying over to carry out the Coventry Blitz. One night a bomber flew so low that it passed between the two cupolas on the towers of the house. Digby, terrified, ducked behind a low wall on the roof and was able to look down into the cockpit at the pilot as it flew past: it was British.[10] He comforted himself by establishing a regular routine: morning was reserved for administration, dealing with staff and checking each storage room, especially the oil heaters. Lunch with Nick was followed by afternoons of ARP exercises or research. He had made friends with the local vicar and doctor, who varied his company. Digby chafed at the restrictions and cramped conditions, and was frustrated not to be joining his contemporaries: 'while most people were directly aiding the war effort in some way it was rather galling to be carrying on with ordinary Museum work.' His happy domestic life was some consolation.[11]

Now Forsdyke was becoming ever more concerned about Boughton and Drayton, with their ancient timber construction. The start of the Blitz had changed his view on whether it had been wise to remove there. And rumblings about the creation of aerodromes and army camps close by were rising

to a crescendo that he could hear even back in Bloomsbury. In October 1940, the Air Ministry finally served notice on Boughton that they had long intended to build an emergency landing ground at Grafton Underwood, barely a mile away. When it emerged that what was planned was a full-scale aerodrome, Station 106, involving the demolition of one of the estate farms and huts close to the house for staff and the air force, it became clear that the Museum's days there were numbered.[12] The same was true of Drayton, only six miles further east.

The Tate suffered increasing damage by night, but each morning Rothenstein hailed their survival as 'a tiny victory for England and a tiny defeat for Nazi Germany'. Awkward incidents continued to plague him though, such as when a passer-by reported to the police that they had seen a Japanese paratrooper entering the Gallery: but it was only the Director, hidden behind his gasmask and tin hat.[13] Churchill telephoned him personally to ask for a changeover of the Tate paintings on loan at 10 Downing Street. And Charles de Gaulle left his calling card one evening when Rothenstein was out fire-watching. Rothenstein took these gestures as a vote of confidence in the Tate and in future victory. Yet a few weeks into October, with repairs impossible, heavy night raids continuing and rain pouring through the roof, Rothenstein and most of his remaining staff decamped to Eastington. They took over three rooms, a barn and an unfurnished cottage where four additional warders would be billeted. The Gallery paid the heating costs, but Gabrielle de Montgeon offered the lighting and rent for free.[14] Fincham was despatched to Muncaster, on the edge of the Lake District and well out of the Director's hair. There was plenty of time in the deserted castle to repent at leisure about his goading of Rothenstein, even though he was safe from the Blitz. 'I would give a good deal to

be back in London,' he admitted, crestfallen. 'I am not cut out by temperament to be a glorified caretaker whatever its compensations!'[15]

A small office was kept as a base in the shattered Tate, with a couple of secretaries. Rothenstein and the junior Assistant Curator he trusted, charming and sophisticated Robin Ironside, joined the Home Guard in Upton-on-Severn. They spent lonely nights guarding the bridge over the river, checking the papers of passing cars, or trying to sleep under thin blankets in the chilly Drill Hall, waiting for the enemy. Rothenstein and Elizabeth had found basic if damp lodgings in the town, but he felt ill-prepared. Ammunition was short and one practice had ended with the Hall ceiling being shot through by a runaway machine gun. 'If the balloon does go up – well, I just don't know,' admitted their Home Guard captain.[16]

In the middle of that month, a man known to all of the museum directors was killed, bringing home to them the very real dangers they all faced if they stayed at their posts in London. John Beresford, the Secretary of the Standing Commission on Museums and Galleries, who had played such a major part in co-ordinating the arrangements for the evacuations, was in the Treasury when an air raid took place on Whitehall on 17 October. An entire portion of the building was levelled. His decomposing body was only found ten days later in the wreckage where he had probably been fire-watching on ARP duty.[17]

It was a wretched month for the National Gallery and for Kenneth Clark too. The Hamptons furniture store right next door took a direct strike on 12 October and was completely destroyed, with collateral damage at the Gallery serious enough for the lunchtime concerts to be moved. On 17 October – the same day that Beresford was killed – an unexploded bomb fell right into the building. A squad of

Royal Engineers was called in to make it safe. On the fifth day of defusing, they allowed volunteers from the canteen to take a good look, despite being forbidden to do so by the administrator Gibson, and then it exploded twenty minutes later while they were all at lunch, destroying the Old Board Room and most of the Library. On that occasion, the concert-goers both heard and felt the explosion but carried on with their Beethoven quartet anyway. The response to Gibson's complaint to the Commanding Officer of the Unit was so 'insolent and scandalous' that Clark took the view that it was 'typical of what one would suffer under a military dictatorship'. The number of onsite warders was increased to prevent unwanted visitors in the damaged portions.[18]

At the same time, the National Gallery's stay in North Wales was looking ever more precarious. Lord Penrhyn now wanted to let the property, and while the garage and guardroom the Gallery occupied were self-contained and could be protected from intruders, the dining room was not. He had blocked an attempt by the Office of Works to requisition the Castle for the Royal College of Art, and had prevented the rest being used by the military, citing the National Gallery's occupation, which suddenly became convenient once again. The Office of Works was not impressed by 'the so-called "generosity" of the owner in letting us use a portion of the house which anyhow is almost entirely useless to him'.[19]

In South Kensington, the V&A was hit throughout the Blitz by high-explosive bombs and incendiaries, and by late spring there were hundreds of holes in its glass roof caused by flying shrapnel. It experienced its worst pummelling when a bomb in Exhibition Road blasted the west side of the Museum, wrecking the masonry, while blowing in doors, windows and grilles,

shattering glass and leaving the roofs open to the elements.[20] The pockmarked stonework can still be seen, engraved, in 1985, with the words:

> The damage to these walls is the result of enemy bombing during the Blitz of the Second World War 1939–1945 and is left as a memorial to the enduring values of this great museum in a time of conflict.

Muriel was marooned at Montacute House on her regular visits to Somerset, and now battling the damp and cold over the winter of 1940 that menaced the V&A's vast collections of prints and drawings. It wasn't much fun and she was largely deprived of intelligent conversation, with only the caretaker's family and the V&A warders for company.[21] She did find one oasis of sociability, however, and that was at the second biggest house in the village, where the Keep family lived.

Local ARP was the responsibility of Captain Stuart Keep who was Muriel's main contact with the Yeovil headquarters on matters to do with the protection of the house and collections. Born in Australia, he grew up in England, and having been invalided out of the army in 1916, he transferred to the Royal Flying Corps, gaining his wings a few months later. He had flown in the RAF bombing raids on German cities along the Rhine and won the Military Cross. After the war, a dashing and moustachioed war hero, he joined Westland Aircraft in Yeovil as a test pilot.

Then in 1924, newly married to Marjorie, while he was trialling the new Dreadnought postal monoplane, Keep's machine had suddenly nose-dived and crashed into the ground. Critically injured, he was taken to Yeovil Hospital where both legs had to be amputated to save his life.[22] It was a miracle that he survived at all. Nevertheless, he recovered

yet again, and two years later the couple's daughter, Ann, was born. Keep carried on working for Westland, becoming its Technical Manager and eventually Managing Director. He retired in 1935 in his mid-forties and the family continued to live at The Old Rectory, now with the addition of an evacuated schoolboy.

In the middle of the evening on 22 November 1940, six bombs exploded close to Hellens, dropped by a plane involved in the eleven-hour Blitz on Birmingham. All the windows were blown out at the front of house. Lady Helena yelled 'Bombs!' Nina – in bed at the time – jumped out and cried, 'Action at last!' And the Much Marcle Watchers thought, 'Hellens has had it!' Another bomb fell nearby an hour later. The ARP turned up, as did the local special police, to consult with 'The Lady'. Sergeant Warder Beasley, who had replaced Chappin, moved some vulnerable paintings, covering them with the emergency tarpaulins supplied by the Office of Works, and hung some more over the windows to protect against rain getting into the house.[23]

When Rothenstein drove over to inspect the damage, Lady Helena took him aside to tell him that her friend and fellow Great War veteran Gabrielle was bitterly upset. According to her, Ironside had been discourteous and threatening about the extra rooms needed at Eastington, and the Tate accommodation had been forcibly taken over at the Hall without her permission. Lady Helena declared that all of Upton was up in arms about it. Rothenstein dashed off a letter to Mlle de Montgeon:

> Of course I am well aware that to install a Government office and a picture store in a private house is by no means an easy matter ... but that you were under the impression that you had been very badly treated I never for an instant suspected.

He had always found Ironside 'exceedingly courteous' and so had Lady Helena. Rothenstein affected puzzlement, but in private told Ironside, 'you will see I confine my letter to what can go on an official file!'[24] As far as he was concerned, the women owners of Hellens and Eastington were becoming unbearable.

Henry Hake was now dividing his time between the National Portrait Gallery three or four nights a week, and the grooms' quarters at Mentmore where his wife was living. But Mentmore, like Hellens, was not immune to the Blitz either. That autumn six bombs were dropped on the park and two parachute mines detonated a mile away.[25] Notwithstanding those alarms, shortly after the Hakes moved to Mentmore, the Office of Works asked if the NPG would object to sharing storage with what they cagily described as 'various pictures, tapestries and valuable furniture in the possession or custody of this Department'. News had got back to Whitehall that Mentmore was proving to be a good choice of billet, despite the odd explosion nearby.

In fact, the refugees were from Hampton Court Palace where Clark was Surveyor of the King's Pictures: the state beds of William III, Queen Anne and George I with all their hangings, twenty-two rollers of tapestries, the Grinling Gibbons carvings, and an array of seventeenth- and eighteenth-century furniture.[26] There they were joined by the dismantled organs from Hampton Court and the Queen's Chapel at St James's Palace.[27] Gradually Mentmore filled up. George III's gold state coach from the royal mews spent the war parked, appropriately enough, in the coach house. Paintings from Speaker's House at Parliament arrived. They spilled over into the hall, billiard room, the laundry and even the studfarm looseboxes, which the ever-obliging Edmunds had made available. Hake, however, made it very clear that while the 'Hampton Court dump in the laundry'

was an entirely suitable home, no one from the NPG could 'be responsible for more than a daily look'. The Ministry of Works, newly renamed, wrote back archly that it was confident 'it will be a <u>look</u> and not a <u>glance</u>.'[28] The Ministry would come over to make a full inspection every two months. At the Gallery itself, the Luftwaffe 'broke a lot of glass and scored two hits', as Hake put it. But he was lucky that there were no casualties and the damage did not affect important parts of the building.[29]

After months of wrangling about payments for the coal for the Hellens boiler and fireplaces, it being impossible to extricate Tate usage from the normal house usage, Lady Helena once again turned to the man in charge at the Office of Works. 'I wonder if you would help me in a rather tiresome matter,' she asked Sir Patrick Duff.

> I have asked the Tate Officials, Mr Rothenstein and Mr Ironside, to settle the matter for me but with no result. Could you do something about it for me? It is so unpleasant having to apply to minor officials who apparently have no power to settle things ... I know a word from you would put everything right.[30]

The ongoing row between Helena Gleichen and the Office of Works about the cost of coal finally ended, to her advantage.[31]

Back at Eastington where, he admitted, 'things are not happy', Rothenstein asked the Chief Constable to ensure that they got the yellow as well as red air-raid precautions from the local police due to some bombing in the area. His request went all the way to the Ministry of Home Security who turned him down, mystified as to what additional action could possibly result from yellow alerts. But all was not lost. Where Rothenstein failed, Gabrielle de Montgeon succeeded, storming into the local police station at Upton to obtain satisfaction.[32] When a few stray bombs

did actually fall at Upton, the Tate Gallery Board decided to discuss the future of both not-so-safehouses.[33] This was Rothenstein's long awaited chance to be rid of Hellens and Eastington's troubling – and troublesome – owners for good. Space, heating and access were problematic, he explained at the January 1941 meeting, and he set about finding alternatives immediately, contacting friends of friends and a host of acquaintances who might have space to spare.[34]

For the moment, Forsdyke had received an offer from the Marquess of Northampton to use his home Compton Wynyates in Warwickshire to help out with the British Museum's emerging crisis in Northamptonshire. Despite the Air Ministry expressing its doubts about the position of the house amid wireless navigation signals, Forsdyke regarded it as 'very remote from military and industrial objectives and exceptionally well equipped with fire-fighting facilities'. Uninhabited Skipton Castle in North Yorkshire he also obtained through the Ministry at the beginning of 1941. But by then he had become convinced that 'deep underground storage would be the best kind of protection if it could be provided on a large enough scale.'[35]

Unless and until this was found, two-thirds of Boughton were scheduled to move to Compton Wynyates, in the teeth of fierce opposition from Sidney Smith, the Keeper of Egyptian and Assyrian Antiquities. Still furious with Forsdyke for the Parthenon Marbles debacle and determined to be as awkward as possible about everything, he announced that only eighty-five out of his 748 boxes, including papyri, cuneiform tablets and mummies, were fit to be displaced again. 'From our point of view the best thing that can happen now is for the Hun to immobilize everything; which is, I fear, precisely what will *not* happen.'[36]

It was just as well that he did not know what Harold Plenderleith had discovered concerning some of the mummies now residing in the basement back at Bloomsbury, after water had got in following fire-fighting. Finding them green and stinking, he had set up some camp beds from the first-aid stores, laid a mummy on each, blasted them with fans, brushed off the mould and then sprayed them with para-nitrophenol. 'In the end they were very little worse,' the scientist confessed.[37] The move from Boughton began on 25 March 1941. Everything but the tomb paintings, soft stone sculpture and very heaviest boxed items left. Smith washed his hands of it. The Duke in turn was vastly relieved to be rid of them: 'in the blackout one stumbled over mummies of incredible rarity.'[38]

Of course, not all national collections were inert. Despite its many bombings, London Zoo's occupants at Regent's Park suffered no fatalities in the Blitz. However, the Director did report that when the zebra house was hit, twenty-year-old Johnson 'escaped from the Gardens and ran for half a mile' before being rounded up in Camden Town. A troupe of Indian rhesus monkeys roamed wild for several days after the monkey hall burst apart. But nothing ruffled the camels, who responded with withering contempt – in the eternal manner of camels – to the damage, and stayed put.[39] The Zoo had closed its doors the day war broke out but reopened a fortnight later, rather depleted. Just as domestic pets across the country had been put down in huge numbers by worried and tearful owners at the start of the war, many venomous zoo animals had been killed for fear they would escape during bombings; yet somehow the rare but deadly Komodo Dragons, pythons and alligators were spared. Those animals which were destroyed at least avoided the terror which primates suffered at the Zoologischer Garten in Berlin, who were taken

back to the houses of their keepers in the last days of the war, so distressed were they by the bombardment of the advancing Russians.

H. V. Morton visited the Zoo for his 'London in Wartime' columns early in 1940 and was delighted to find it much as it always had been.[40] The monkey house was

> as energetic as ever: the lions and the tigers have not become evacuees; the bears still prowl with optimistic expressions round their pits; the host of other creatures, great and small, hairy, feathered and scaly, are present in bewildering variety; and all delightfully unconscious of the war. Indeed, the Zoo is the only place in London where you can spend a happy afternoon talking to other living organisms without mentioning the word Hitler.[41]

The Zoo's Bedfordshire outstation at Whipsnade had taken the valuable large animals including the giant pandas, an ostrich and the two mating elephants. Some yak calves, deer fawns, two baby brown bears and a black pet lamb belonging to the princesses Elizabeth and Margaret had also been evacuated there for safekeeping.[42]

Two 'revolting black spiders' from South America, along with certain poisonous snakes and venomous insects, had been destroyed. A couple of sealions were sent to the USA but one died on route; the other just made it to Washington DC Zoo before expiring. As for the famous aquarium, 'that brilliant sea garden has been drained of water, and the strange, mouthing, multi-coloured fish, brought with such pains from the far rivers, lakes and oceans of the world, have been destroyed.' The keepers felt they had no choice as the breaking of the huge tanks would have endangered humans as well as killing the fish. Protecting the remaining animals from raids, and Londoners from escapees, had resulted in the creation of the Zoo ARP, whose members were armed with rifles.

It was going to cost the Zoo £12,000 a year to provide feed for the animals, so a public adoption scheme had been launched: elephants at Regent's Park could be sponsored for one pound a week, or a giant panda at Whipsnade for ten shillings (the bamboo shoots being sent from gardeners across the country). The cheapest animals were hummingbirds and porcupines, who sipped and gnawed through a modest shilling a week respectively. The carnivores were switched to a diet of horsemeat. Hardest to get was fish for the sealions, penguins and other birds, but some fruit-eating mammals were reported to be thriving on vegetables, particularly carrots – a great favourite, according to the Zoo's Director. The monkeys missed their peanuts. And the reptile tanks were now used for breeding rabbits for food.[43] The llamas and camels were put to good use transporting feed around the site due to the fuel shortages, and the keepers started to grow their own feed onsite.

As for the 'dead Zoo' of the Natural History Museum, that was a different matter. Alongside the expanding art storage at Mentmore lived more than a hundred evacuees with whooping-cough; Lord Rosebery's Derby winner, Blue Peter; and his cousin, Miriam Rothschild, entomologist and conservationist, who was working at nearby Bletchley Park.[44] The brilliant and energetic Rothschild had been working furiously in the years before the war with organisations plucking Jewish children to safety from Germany and Austria, a number of whom she gave sanctuary at her own home, Ashton Wold, in Northamptonshire. Many of her relatives in Hungary had already been sent to the death camps and, like Helena Gleichen, 'I decided that I would arm the village, because I had quite a lot of guns and rifles, and that I'd die with a rifle in my hand.'

Miriam Rothschild was an expert in the lifecycle of flat-worms, as befitted a woman whose own father was a

distinguished entomologist and whose uncle Walter, the first Jewish peer and recipient of the Balfour Declaration, had set up an extraordinary natural history museum at his mansion at Tring and bequeathed it to the Natural History Museum on his death.[45] Tring Park contained several thousand stuffed mammals, reptiles, birds and insects collected by him over a lifetime, including a number of animals which had become extinct. Before the war, his niece had been given the brush-off by the Director of the Natural History Museum when she enquired what he intended to do with the collections if the worst came to the worst.

'Dear lady,' said Dr Forster-Cooper, a man plagued by painful sinusitis and a chronic case of tweedy complacency, 'since there will be no war – let us talk of something more interesting.' He dreamed of launching great expeditions to the tropics once again to collect specimens, as he had in his youth, and was unable to face up to the reality of protecting from destruction a fiendishly difficult-to-house collection which was mainly kept in glass bottles of alcohol; and which had as its two most famous skeletal exhibits an eighty-two-foot, 4.2-ton blue whale and the 105-foot cast of a Diplodocus donated by Andrew Carnegie.

Dismayed by this response, Rothschild took matters into her own hands and rallied several country house owners she knew, who had plenty of space in their homes as well as shooting brakes suitable for the removals, and 'found them enthusiastic and most cooperative'. She put together her own proposals for the Museum, and submitted them to the Chairman of the trustees 'who replied in his own hand-writing, thanking me for my suggestions, but voicing the opinion that no plan was necessary at the present time'. When a year later war was declared, absolutely nothing had been done about the evacuation of these priceless collections, not even during the Phoney War. When the bombs

started falling, and the Museum and its collections were hit, Rothschild rushed to point out to Forster-Cooper that her pre-war plans were still useable, but she found that 'the director was obviously in a state of deep shock and he could not or would not reply.' Instead he was focussing on his growing collection of bomb splinters, which he would pick out of the ground after each attack, in a vain attempt to collect them for war salvage.

Eventually she and a curator called Theresa Clay, a specialist in bird lice, persuaded another Rothschild cousin, James (a government minister), and the Archbishop of Canterbury (one of the British Museum trustees) to step into the breach. The following day the evacuations of collections began to the Museum's outstation at Tring Park, where Walter had once been driven around the grounds in a coach pulled by four zebras.[46] The dinosaurs were dismantled and packed into the basement in South Kensington. And she herself gave refuge to the Museum's extensive collection of preserved parasitic worms, known as Helmmiths, at Ashton Wold, 'where they spent an uneventful war in a dry cellar.' Fossils were despatched to Tattershall Castle in Lincolnshire, where James Lee-Milne spotted them later in the war, neatly stacked and filling the rooms: 'the whole place stinks of mothballs' (though why mothballs would protect fossils is unclear).[47]

By mid-November 1940 all forty-eight oil paintings of the IWM which had been stored at Penn House had been removed.[48] It had become impossible to keep them and the photo albums and watercolours there any longer. Relations deteriorated to such an extent that the land agent at Penn gave three days' notice to the Museum to depart, backed by the family solicitors. As with Lord Penrhyn's scheme to let his Castle which was alarming the National Gallery,

Viscount Curzon had discovered that renting out Penn to a prep school from Dorset would provide more income than his non-paying IWM guests ever would. The school naturally did not want to have responsibility for the art in the garage, but it was clear that the IWM had been there under sufferance from the start and against the wishes of Lady Howe and her son. It was ridiculously short notice to find transport and fuel, let alone a new home. Before instructions could be given about how to protect the pictures from damage, the schoolmasters had begun to use the garage for their own cars: fumes, oil and all.

Salvation came in the person of the wealthy second wife of Sir Henry Norman, the MP and journalist who had made his name with scoops about the Dreyfus Affair. Now a widow, Lady Norman still lived in their home at Ramster Hall, near Chiddingfold in Surrey. A no-nonsense trustee of the Museum, she knew exactly what she wanted. Some IWM items had been at Ramster's 'Long Hall' since 1939 – actually a sixteenth-century brick barn with a timber-framed roof converted in Arts & Crafts style. 'I will take 50 oil paintings and can arrange to take them all into the house with a little rearrangement,' she briskly agreed.

> I want all the Sargents and Orpens put in the Brick Hall (by an external door) as this is a nice temperature in winter, and the less interesting canvases can go in a small room opening directly outside where in case of fire they can be got out also . . . PS the size of the pictures does not matter to me, the great thing is to try and keep them from getting <u>damp</u> in the winter months – heating is expensive now.[49]

There they sat alongside Stephenson's *Rocket* from the Science Museum which Lady Ramster had agreed to house after other arrangements fell through.[50] Strange bedfellows of this kind became increasingly common as those

institutions which had been tardy in their evacuation arrangements scrambled to find safe havens at the height of the Blitz.

There was more on the minds of the IWM trustees, how-ever, than just its collection. Ever since the Blitz began, its building had suffered grievously. Its position close to the Thames and major railway stations made it inevitable that it would be damaged. But no one quite expected how much. A ten-foot UXB buried itself in the lawn outside in November 1940 and took a week to extract, and the staff remaining onsite suffered greatly during that winter, work-ing in terrible conditions. By mid-January the Director Leslie Bradley was canvassing ideas from his trustees as to where the library – still in situ – could be evacuated when yet another devastating raid took place. At lunchtime on 31 January 1941, two bombs exploded in the grounds, another two very near the building, and one destroyed the Naval Gallery in a direct hit.

'The damage is very great,' reported Bradley to his trustees. Almost all the naval exhibits had been destroyed, there was extensive gallery and roof damage, the windows were blown in, the heating and hot-water system incapacitated, and half the building and its contents left open to the skies. Almost all inside at the time suffered from shock. Despite sandbagging and screens, major damage was done from blast, and 'to what degree my negligence and the inefficiency of the precautions I had taken were responsible for this disaster', Bradley asked his trustees to decide.[51]

A few days later, the Financial Secretary at the Treasury described himself as 'rather shocked to find this museum has evacuated practically nothing'. Bradley was very upset, but Forsdyke – an ex-officio trustee as Director of the British Museum – tried to soothe him by saying that the decision had been that of the trustees and that he should not blame

himself.[52] But unlike Bradley, Forsdyke and other museum and gallery directors had forcefully driven through their own plans and taken their trustees with them. Bradley penned a series of increasingly scattergun letters to anywhere he could think of which might house the IWM library books, which he had now fixed on as a priority.

His attempts ranged far and wide: Oxbridge colleges, Taunton and Winchester castles, public libraries in Winchester and Hertford, manor houses in Wales and Shropshire, stately homes such as Althorp, Chatsworth, Knebworth and Panshanger, and many other locations: all long since filled up with civilian and military evacuees. His desperate attempts so late in the day were greeted with incredulity. Lady Leconfield at Petworth House in Sussex replied:

> I am sorry to say there is nothing we can do to help you here. I think perhaps you do not realise that this place is only just behind the front line, in other words is really in the invasion area.[53]

In the meantime, the Ministry of Works had decided not to repair the heavily damaged IWM building, leaving it to its fate and confining the forty remaining staff and collections to a single wing where the rain regularly poured in.[54]

Eventually, a Miss Daphne Drake of the North Devon Athenaeum in Barnstaple came to the rescue. If they cared to accept her offer of four rooms, 'and could lend us a small vacuum cleaner', the deal was done. The 447 cardboard cartons of books were moved at the end of June, and Miss Drake asked if she might inform the local press. Bradley had to say no: 'Any hint that books from the Imperial War Museum had been deposited there should be scrupulously avoided since the anxiety of the Nazis to obliterate any record of Germany's defeat in the last war is well-known,' he fluttered.[55] Bradley was perhaps thinking of the fate of

the *Wagon de l'Armistice* in Compiègne – the carriage where
the Germans had signed the Armistice with France in 1918
– which had been used by Hitler to receive the French sur-
render the previous June and was then removed to Berlin
(and ultimately destroyed); the glade where it stood as
a memorial, obliterated. The day after the books left, the
library ceiling at the IWM collapsed.[56]

10

All That We Have Loved and Cared For

T HERE WAS, OF course, another kind of national treasure
which needed top-secret protection: the Monarchy. The
royal family were not just flesh and blood, they were the very
embodiment of the nation's constitutional heritage. The cap-
ture or death of the Head of State, his Queen and his heirs,
Elizabeth and Margaret, at the hands of the enemy would be
an enormous, possibly fatal, defeat for national morale. So the
Windsors themselves, as well as all the other London collec-
tions, had to be safeguarded from imprisonment by invading
forces, or destruction by bombing.

This was not a hypothetical threat. From the late spring
of 1940 royal heads of state were falling across Europe. King
Haakon VII of Norway and his heir Crown Prince Olav,
along with the Norwegian Cabinet, narrowly escaped being
seized in April 1940 by hiding first in snowbound woods and
then in a log cabin near Tromsø, as their own country was
bombed then invaded. They had made their way at great peril
to London to form a government in exile in opposition to the
fascist regime headed by Quisling. They were swiftly joined
by Queen Wilhelmina of the Netherlands and the Grand
Duchess of Luxembourg in May 1940, following the Battle
of Belgium, and at the end of April 1941 by the kings of
Yugoslavia and of Greece.

As soon as war broke out, George VI and Queen Elizabeth
had raised their concern, rather nervously, with the Home
Secretary that Buckingham Palace offered an excellent target

from the air, and had wondered what might be done to camouflage it.[1] Their fears were realised just over a year later. At 11 o'clock in the morning on 13 September 1940, Buckingham Palace received its first, deliberately targeted, direct hit from high-explosive bombs. One royal servant was killed and three others injured; many of the building's south and west windows were blown out; and the royal chapel and several portraits in the collection were damaged. The King and Queen were having their morning tea at the time and it was after this attack that the Queen made her famous remark, 'I am glad we have been bombed. It makes me feel I can look the East End in the face.'

Churchill later admitted that he had not at the time realised how close they had come to being killed. 'Had the windows been closed instead of open, the whole of the glass would have splintered into the faces of the King and Queen, causing terrible injuries.' The royal chef, who was French, was stoical. There had just been 'un petit quelque chose dans le coin, un petit bruit'. He was 'perfectly unmoved', observed the Queen, 'and took the opportunity to tell me of his unshakeable conviction that France will rise again!' To her mother-in-law she wrote, 'Dear old B.P. is still standing and that is the main thing.'[2] In all, the Palace itself was hit nine times; the grounds a further six.

Just as if they were another heritage collection, secret evacuation locations had been identified early in 1939 for the royal family in case of an emergency. They were, in effect, human Crown Jewels. If it ever became impossible for the machinery of government to remain in London, Parliament would move to the auditorium of the Royal Shakespeare Theatre in Stratford-upon-Avon. Hindlip Hall and Spetchley Manor, close to Worcester and around twenty-five miles from Stratford, would house the Cabinet and Prime Minister respectively. The King would need to be nearby for constitutional

reasons and therefore, in the final days of August 1939, a property known at the time only as 'Establishment A' had been selected.

This is thought to have been Croome Court, today in the hands of the National Trust.[3] Fred Corbitt, a junior member of the Royal Household, was sent there to gather information on the local shops and he had met the village butcher, poulterer and fishmonger, warning them that they might be descended on by 'some VIPs at some distant date without much advance notice', who would require a lot of feeding. Mrs Ferguson, the Buckingham Palace housekeeper, had arrived to help with the installation of extensive bedding, furniture and pantry supplies, including many glass jars of turtle soup and huge quantities of sugar lumps.

Croome then seems to have been abandoned early in 1940 due to a security breach, and instead Madresfield Court, home of the 8th Earl of Beauchamp, stepped into the breach as a new royal refuge in the west of England if ever needed. It was given the codename 'Harbour'. Boasting a double moat and 162 rooms, hidden on the edge of the Malvern Hills, with an escape route down the Severn or into Wales, Madresfield had been considered ideal. The Countess, who was Danish, had a standing booking at a Malvern hotel in case the Windsors turned up at short notice, but had found it difficult to explain to friends and neighbours why her huge home had not yet been requisitioned by a school or the military. It was

> very difficult. Everybody was so curious. They asked me all the time questions about it. Why are you all alone in that big house, with your 54 bedrooms? So first I tell them that it was going to be a convalescence home. But then the army, they made big defences here. So I said, you mustn't say to anyone, but the treasures from the Tower of London are coming.[4]

In fact quite different arrangements had been made for those.

Should the royal family need to head north from the capital, in order to hide or escape via Scotland, then another property was put on standby from July 1940, near the A1. This was Newby Hall in Yorkshire, codenamed 'Security', where the owners, Captain Edward and Mrs Compton, were old friends of the Queen. They appear, however, not to have known the identity of their potential mystery visitors. Their agent was instructed to prepare for 'housing and accommodating a high government official under certain circumstances', and to be able to be ready at six hours' notice. Six servants' rooms would be required and the cook was told to be ready to obtain, among other larder items, a whole ham and an entire stilton, cream crackers, a dozen bottles of hock or Chablis, whisky, sherry and soda.

Two other lesser bolt-holes were prepared in Shropshire, presumably for escape via North Wales or Liverpool: 'Refuge' (Pitchford Hall) and 'Peaceful' (Burwarton House).[5] At this time, the royal family itself was protected by a secret team of crack bodyguards drawn from the Coldstream Guards headed by Major Jimmy Coats, former stockbroker, crack shot and champion Cresta Run skeleton racer: flamboyant but deadly. As a last resort, the princesses would be evacuated from a Scottish hideaway to Canada, far away from the reach of the enemy. The King and Queen would stay.[6]

Queen Mary the Queen Mother had been moved on the orders of the King to Badminton House. Sandringham was too close to the east coast and its occupants vulnerable to bombing or even kidnapping.[7] And so, the day after war was declared and much to her annoyance, she had decamped to the home of her niece, the Duchess of Beaufort. It had taken eight and a half hours to drive her from Norfolk to Gloucestershire, with a stop at Althorp for luncheon with the Spencers, followed in convoy by a retinue of sixty-three servants and their dependants: 'quite a fleet', Queen Mary acknowledged.[8]

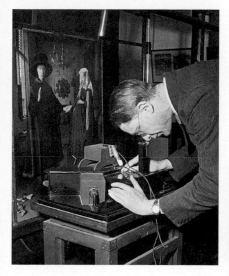

Ian Rawlins, Scientific Adviser to the National Gallery, examining Jan Van Eyck's *Arnolfini Portrait* with a tintometer.

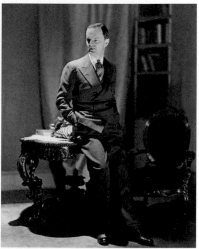

Sir Kenneth Clark, Director of the National Gallery, hated by a number of his curators for his popularism and – allegedly – his taste in ties.

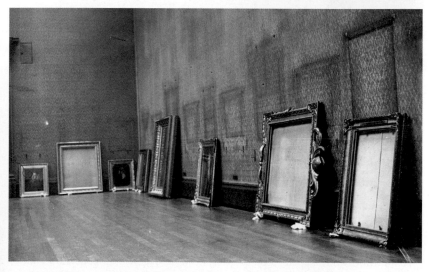

Frames removed from paintings at the National Gallery on 25 August 1939, the day after the signal to evacuate.

John Forsdyke, Director of
the British Museum.

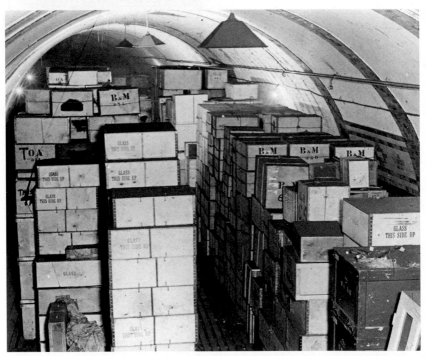

Some of the many No-Nails boxes from the British Museum stored in
the Aldwych underground tunnels. The hand-painted 'T' designated a box
for the Tube, while stencilled on the outside were department collection codes:
'B&M' for British and Medieval antiquities; 'OA' for Oriental antiquities
and 'G&R' for Greek and Roman.

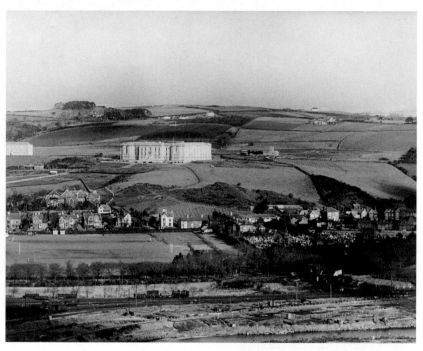

The National Library of Wales on Penglais Hill above Aberystwyth, overlooking Cardigan Bay. The ARP Tunnel entrance can be seen at the bottom corner of the dark slope, below the right-hand side of the building.

William Llewelyn Davies, Chief Librarian, National Library of Wales.

John Rothenstein, Director of
the Tate Gallery.

Muriel Clayton, Acting Keeper of Textiles,
Victoria & Albert Museum.

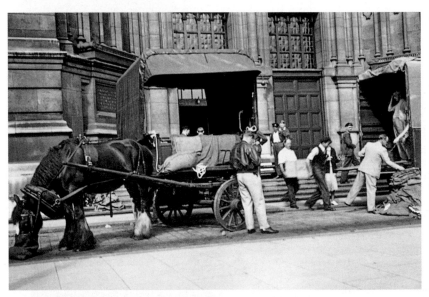

Despatching the contents of the Victoria & Albert Museum to the
London Underground. The half-hidden woman with a clipboard
by the tailgate may be Muriel Clayton.

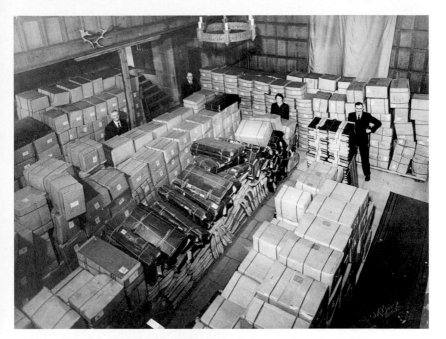

Some of the hundreds of tons of national archives from the Public Record Office stored in the Banqueting Hall at Haddon Hall, Derbyshire.

Parts of the National Portrait Gallery in store in the Battery House at Mentmore Towers. Note the shelf lists of paintings at the end of the racking, the asbestos sheets over the shelving as fire protection, and the paintings wedged up on the floor to protect them from water leaks.

National Portrait Gallery warders taking a break outside the Battery House, their morning duties complete.

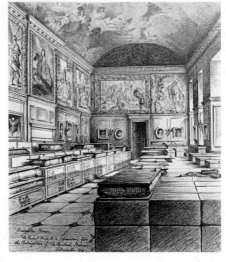

Charles Waterhouse's illustration of British Museum Egyptian and Assyrian crates in the Great Hall at Boughton House, Northamptonshire, 1941.

Sir Charles Peers, Surveyor of the Fabric at Westminster Abbey (right), admiring the bronze tomb effigy of Henry III in a loose box at Boughton House.

Martin 'Dry Martini' Davies, Assistant Keeper of the National Gallery, relaxing off-duty in North Wales, far from Kenneth Clark.

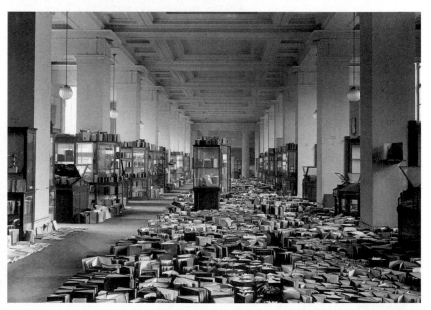

Some of the fire- and water-damaged rare books of the British Museum Library laid out to dry in an empty gallery on the instruction of Harold Plenderleith, following bombing in 1941.

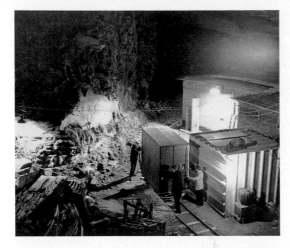

Unloading National Gallery paintings from hand-wheeled wagons into Ian Rawlins' environmentally controlled storage repositories inside the Manod Mawr slate mines.

The elephant case containing Van Dyck's *Equestrian Portrait of Charles I*, making its way up the mountain road to Manod Mawr, having survived its encounter with the Hen Capel bridge outside Blaenau Ffestiniog.

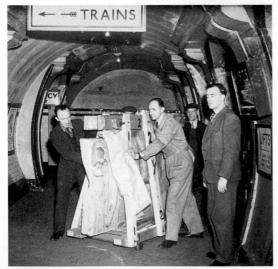

The Parthenon Marbles emerge from their sanctuary in the London Underground in 1945.

The Duchess was less sanguine:

When I first saw her arrive I was scared *stiff* – more than fifty of them descended on me one afternoon and I was all alone. Master [everyone's nickname for the Duke] was away. You've never seen anything like that arrival in your life.

Badminton was subject to fairly regular air-raid warnings, but the first one was a shock for the Duchess:

there I was in the middle of the night, with my hair all anyhow and in a filthy old dressing gown; and there in the shelter sat Queen Mary, perfectly dressed with her pearls, doing a cross-word puzzle . . . on the other side of the Queen was her maid gripping her two jewel cases grimly. I never did that again, I just couldn't compete.[9]

The princesses, Elizabeth and Margaret, had been at Birkhall (the family holiday home in Aberdeenshire) with their holiday governess, a nanny, equerry, chauffeur and a policeman when war had broken out, and Queen Elizabeth soon joined them, meeting the evacuated mothers and children of the Glasgow slums who had been billeted elsewhere on the Balmoral estate. Shortly afterwards, she returned to London and her place was taken by Marion 'Crawfie' Crawford, the princesses' usual governess, and their French teacher Madame Montaudon Smith, who had continued the girls' lessons. Princess Elizabeth maintained her coaching in constitutional history with the Provost of Eton by correspondence. The Queen felt

desperately sad that all that ghastly waste was starting again at the bidding of a lunatic . . . Humanity must fight against bad things if we are to survive, and the spiritual things are stronger than anything else, and cannot be destroyed, thank God.[10]

Queen Mary had found life in the country a complete change ('so *that's* what hay looks like') but soon – like Helena Gleichen, her distant cousin – she became the self-appointed *commandante* of the local voluntary war effort. In other words, she was a complete menace. Her activities were based, the Duchess of Beaufort was convinced, on her being, 'fundamentally very very German – the two things she liked most were *destruction* and *order.*'¹¹ At Sandringham she had been a determined enemy of ivy on the estate and at Badminton she continued her campaign against it, inspecting the gardens and poking any offending growth with her stick and parasol.

First, she had created an 'Ivy Squad' to pull any sight of it from the Beauforts' walls, and then had expanded this into a 'Wooding Squad', comprising her four despatch riders and the soldiers who guarded her, whom she paid in cigarettes while smoking herself as they toiled away chopping things down. Unsuspecting guests and friends were roped into help with the carnage whenever possible. Conscious of fuel shortages, Queen Mary had initially ridden to de-wooding sites on a horse-drawn farm cart, mounted with two basket chairs for her and her lady-in-waiting. 'Aunt May, you look as if you were in a tumbril!' her niece had objected. ('It may come to that yet, one never knows,' was the reply.) No tree was safe from Queen Mary's desire for *ordnung*. Her south-facing bedroom at Badminton was overshadowed by a huge cedar and the dowager Queen alleged she had been plagued with the insects which nested there and dive-bombed their way through her windows. But on her demanding that it be felled, the Duchess – pushed beyond endurance by her aunt – declared, 'It will come down over my dead body, Ma'am,' and so it escaped execution by the Wooding Squad.¹²

As time went on, Queen Mary switched to travelling the estate in her green Daimler, with her tree-felling equipment strapped to the back. Soon, salvaging tins, bottles and scrap

metal in the neighbourhood with evacuees from Birmingham (also billeted nearby) had taken on the same importance for her as ripping down trees.[13] 'There was nobody in the whole of England who went in for austerity to such a degree as Queen Mary,' declared Crawfie.[14] This was on top of her descents upon local factories, workshops, hospitals and canteens (where she served tea); her weekly visits to London; plus cataloguing the archives and paintings (in her own style) in the house.

Queen Mary was, in her own way, a great champion of the Royal Collection. She was an acquisitive and dogged collector of former royal *objets d'art*, furniture and jewellery which were no longer part of the Royal Collection, and bought back many items herself, as well as leaning heavily on their current owners to return them to their royal homes. Single-handedly she had turned Frogmore House at Windsor into a museum of royal family souvenirs. And one of her major hobbies was relocating and cataloguing the stunning contents of the royal palaces, all carefully labelled in her own hand. George V had stuck doggedly to his stamps.

So what arrangements had in fact been made for what today is called the Royal Collection, the largest private art collection in the world, mainly scattered across various current and former royal residences in London? Windsor Castle was still very much a castle, with a great keep, thick curtain walls and huge, spacious state rooms. It was the obvious place to retreat to and consolidate vulnerable art and artefacts. Before war broke out fifty-seven paintings from Buckingham Palace had been identified as needing to be shifted to Windsor, and most of the precious Sèvres, Meissen and other sets of porcelain used for decorative and banqueting purposes were to be sent there for safety. But Sir Hill Child, Master of the Royal Household, was worried. When preparations were underway, he had told the Office of Works that it was

a mistake to put all our eggs in one basket. I don't imagine the Royal residences would be specially selected for bombing, but if they were, Windsor Castle on the bank of the river would be a very tempting target.

Accordingly, a lorryload of porcelain from Buckingham Palace had been destined for the Underground. 'There would of course be some vibration from the passing trains, but I imagine that careful packing would overcome any risk,' reassured Sir Patrick Duff of the Office of Works.[15] Though it took some time for a space to be found for it (the Aldwych and Dover Street tube tunnels being already packed to the gunnels), the royal porcelain finally came to rest in Knightsbridge underground station.

Historic contents were cleared from the Tower of London. Half of the Royal Armouries went into Knightsbridge Tube station and the other half to Hall Barn to sit alongside the Wallace Collection.[16] Clearly James Mann, Director of both museums, had decided to put all his considerable eggs into that very reliable basket. The Tower, 'awakening once again, has become a sinister fortress', wrote the journalist H. V. Morton. 'Its gates have been shut. The public is not admitted. What goes on there in wartime is one of the mysteries of London.' He wondered when it would be open again. An elderly yeo-man warder replied, 'When Hitler has got what's coming to him. Good-bye.'[17]

But the main focus was on securing the Crown Jewels. Not only were they priceless, but of the greatest imaginable symbolic value. It was well known that, at the time of the *Anschluss*, Hit-ler had ordered the removal of Charlemagne's imperial regalia from the Vienna Hofburg to Nuremberg where they went on display, appropriating their heritage and sacral importance in order to bolster the Third Reich's claim to be the legitim-ate successor of the Holy Roman Empire. After war broke out they were hidden in the Historischer Kunstbunker under Nuremberg Castle. An unthinkable consequence of the fall of

London would be if the Crown Jewels end up being used as a vehicle for Nazi propaganda in some way (say, through the coronation of a puppet king, with Edward VIII installed on the throne in the plot known as Operation Willi): a fate to be avoided at all costs. But not all realised the danger. 'What a dreary spot!' grumbled H. V. Morton on visiting the Jewel House after its evacuation.

> Instead of the flash and the rippling fire of diamonds that once met the gaze of every holder of a sixpenny ticket, there are only plate glass cases whose tremendous fortifications protect – nothing. The Jewel House to-day looks like the scene of a robbery.[18]

In 1940, the King and Queen wondered whether not only some of the best pictures from the Royal Collection should be sent to Canada, but also some of the Crown Jewels ('for instance the crown which the King wears in India, and certain other "duplicates"') so that they could be used for a coronation overseas if the worst came to the worst. It would have halved the risk of capture, but 'on the other hand the ship might have been sunk, and the moral effect would have been undesirable had it become known – as no doubt it would have.' Churchill had been consulted on this plan and his reply – as with the National Gallery – was an emphatic 'NO.'[19]

The core of the Crown Jewels was the coronation regalia, dating back to the reign of Charles II: gold, silver-gilt and platinum, studded with some of the most ancient and fabulous gems in the world, some of which had been acquired in the most dubious circumstances. A top-secret operation had taken place, beginning on 26 August 1939, to transfer them in stages to a 'previously selected and approved position' in Windsor Castle. This had the capable James Mann at the helm, assisted by the Lord Chamberlain's Office, the

Commissioner of Police, and Garrard's, the royal jewellers. It was an operation which, typical of Mann, 'worked with the utmost smoothness', and the changeover was complete by 26 September 1939. Keys to the strongroom had been handed to 'Wiggy' Wigram, formerly Private Secretary to the King and now Deputy Constable of the Castle.[20] Even the uniforms and equipment of the Yeomen of the Guard, including the ancient costly doublets worth over £3,000, were despatched to safety in the store of the royal uniform company in Witney, Oxfordshire.[21]

The secret strongroom destination of the Crown Jewels was a vault under the office of the Royal Librarian, Sir Owen Morshead. He had kept Queen Mary up to date with preparations at Windsor before she had left for Badminton:

> Here we are busy sandbagging the windows on the ground-floor along the North Terrace, and timbering them inside, and fitting gas-proof doors. The frames of certain of the more valuable pictures hang empty, their canvases having been removed into safe custody. The Crown Jewels came down from the Tower on Saturday evening. Otherwise all is quiet, the more so since from to-day the State Apartments are closed to the public.[22]

Queen Mary had asked that some of her most precious jewels and valuables also be stored safely at Windsor. 'What a lot of trouble and expense that hateful fiend has put us to ... how I hate the Germans!' she complained, ignoring the fact that – though she was born and brought up in England – her father was a Württemberg and her mother a Hanover and a granddaughter of George III.[23] There was also the embarrassment that her husband's first cousin (and her sister-in-law's brother) was the Eton-educated Charles-Edward, Duke of Saxe-Coburg and Gotha (formerly Duke of Albany and Earl of

Clarence of the United Kingdom), an enthusiastic, prominent and unrepentant Nazi.

Morshead – like a number of the middle-aged men and women involved in protecting national collections in the Second World War – had an extraordinarily distinguished record of bravery in the Great War, having been awarded the Distinguished Service Order, Military Cross, *Légion d'honneur* and *Croce di guerra* for his bravery. In 1926 he had been appointed Royal Librarian, having long been known to George V. He had served with the Prince of Wales (the future Edward VIII) during the war, and had been up at Magdalene College Cambridge with the Duke of York (the future George VI) and the Duke of Kent ... and so was *sound*. This was not a completely inappropriate piece of royal patronage, as Morshead did have some scholarly credentials – he had after all been a Fellow of Magdalene and Pepys Librarian before moving to Windsor.

Tall, slender, handsome and cheery, with an American wife called Paquita, he struck up a warm, gossipy and life-long friendship with the dowager Queen Mary whom – in his own words – he regarded as 'more like a beloved aunt'. He was extremely popular with the rest of the royal family too, Queen Elizabeth describing him as 'such a charmingly "accessible" librarian . . . we are most thankful that we have in you an informed and interesting expert and thank God a lover of beauty and all that means.' In return, he thought the Queen 'a perpetual tonic with her sunny and buoyant nature'. It was in fact Morshead's own influence which had secured for Kenneth Clark the post of Surveyor of the King's Pictures in 1934, and on Clark – known to his friends as 'K' – attaining the Directorship of the National Gallery he had sent a telegram: 'Happy and Glorious. Not too uproarious, God save our K.'[24]

Being so heavily occupied with the move at the National Gallery, 'K' himself had handed over responsibility for the paintings in the royal palaces to his deputy, Ben Nicolson,

a gentle and rather unconfident but keen art historian, who
lived in the shadow of his famous parents, Harold Nicolson
and Vita Sackville-West. Correspondence flew backwards and
forwards between Windsor and Trafalgar Square. 'I send you
my list of pictures to be moved from their places in Windsor
Castle,' Nicolson wrote to his boss, as war loomed.

> Of course it is inadequate, and there are masses of pictures
> I feel tempted to add to the list – but it is already too long.
> Almost all will fit with ease into the vault where the Bucking-
> ham Palace pictures now are: the Holbeins and the small Van
> Dycks. The two pictures which are not on the list and should
> be are the 'Charles I on horseback' and 'Charles I and his
> family' in the Van Dyck room. These would be the devil to
> move, and being straight opposite the large windows would
> be very vulnerable to splinters of glass. I therefore arranged . . .
> that they should be placed in some adjoining room where no
> flying glass could reach them and where they would be safe
> except from a direct hit.

He was worried about what to do with the Waterloo Cham-
ber at Windsor as well. This was the huge vaulted hall with
a glass and iron roof in which hung many great portraits by
Thomas Lawrence of the victorious allied monarchs, statesmen
and military commanders who had defeated Napoleon in 1815,
its eastern wall dominated by a great oil of the Duke of
Wellington. Clark came up with the answer:

> The pictures in the Waterloo Chamber cannot all be stored,
> but I would suggest taking them down and standing them
> round the walls and covering them with some thick material
> i.e. old carpet. This would save them from being cut if some
> of the glass fell through the roof.

Eventually the two Van Dycks – among the painter's most
famous works – were stored in the wood-panelled Charles II

Dining Room, decorated with murals by Verrio of a banquet of the gods, one of the Castle's safer, windowless rooms. By the end of the month, all the most important objects of furniture from Buckingham Palace had been sent down to the basement, so 'you can imagine the place looked pretty gloomy this morning!'[25]

A month later, in September 1939, Morshead wrote to Queen Mary at Badminton:

> Life here has settled down to a plane of peace and quietude, remote from any suggestion of war: these still autumn days reveal the Castle in its fullest beauty, and all the gardens are ablaze with flowers. There are no tourists, which is a relief. The works of art in the Castle are almost wholly dismantled and I only hope that they will emerge from their interment undamaged. The frames hang empty in the walls, the two tapestry rooms are stripped, all porcelain and bronzes are removed, and such furniture as remains is turned face-to-the-wall, or stacked in a corner . . . I now have the whole of the Crown Jewels in my sole care, together with the personal jewellery of The Queen and most of the Ladies of the Royal Family; and the responsibility for these irreplaceable Drawings, if the Germans should start dropping bombs hereabouts.

With Clark now occupied by Wales and with the Ministry of Information and the War Artists' Advisory Committee; Nicolson manning an anti-aircraft battery in Chatham; and he too old to join up, Morshead the former war hero confessed, 'I do feel that I am doing better work here watching over the Arts of Peace (and defence) than guarding a gas-works with a Japanese rifle of 1912.'[26]

The two princesses had been moved from Scotland to Sandringham for Christmas 1939, then the following February they shifted again to Royal Lodge in Windsor Great Park – a less

vulnerable aerial target than the Castle. But on 10 May 1940, as the Wehrmacht overran the Netherlands, Luxembourg and Belgium, and began its assault on the borders of France, Crawfie received an urgent phone call from the Queen telling her to get the girls into the Castle, 'at least for the rest of the week'. There they stayed for the rest of the war, in 'a fortress, not a home', as Crawfie put it.[27] With the fall of France, Morshead ended up in charge of the Windsor Castle Home Guard. The King was brushing up his shooting prowess, gained on the moors at Balmoral, and the Queen – who as a Scottish aristocrat was no mean game shot herself and had once despatched a nine-foot crocodile on safari – was taking revolver lessons each morning: 'I shall not go down like the others. I should die if I had to leave.'

If invasion came, the princesses would not be a liability, Churchill reassured the King. The Queen chimed in, 'the children could not go without me, I could not possibly leave the King, and the King would never go.' She and the King spent their days at Buckingham Palace and usually travelled back to Windsor each night, though sometimes they stayed overnight in town. The Queen thoroughly disliked the air-raid shelter at Buckingham Palace, a former housekeeper's room in the basement, decorated with furniture from upstairs and Dutch landscapes from the Collection, which made her hate similar paintings forever after.[28]

Some months into the Blitz, fears arose about another national treasure in a different royal palace. A number of letters appeared in *The Times*, including one from the art critic Clive Bell, Bloomsburyite and brother-in-law of Virginia Woolf: 'Sir, I believe you and some of your readers will be shocked to learn that the ceiling of the Banqueting House is still unprotected.'[29] There was a rumpus. The matter reached the House of Commons where a written question was tabled for the Ministry on 15 December 1940: 'What steps are being

taken to protect the Rubens paintings in the banqueting hall at Whitehall?' Four days later the answer came: 'Steps were taken before the outbreak of war to protect this ceiling from incendiary bombs. A short while ago work began on the dismantling of the ceiling, and the panels are to be removed to safe storage.'[30] No detail was gone into. In fact, it was one of the most radical and dangerous art removals of the entire war.

The Banqueting House ceiling in the Palace of Whitehall was one of Rubens' greatest masterpieces, made up of nine painted and gilded compartments in the manner of Baroque ceilings, commissioned by Charles I in 1629. Its centrepiece showed his father James I lifted into heaven by Justice flanked by Piety and Religion and about to receive a triumphal laurel wreath: a celebration of the divine right of the Stuart kings. Surrounding the central painting were eight other panels, depicting James' achievements: the Union of English and Scottish Crowns, Peace and Plenty, Reason overcoming Discord, Abundance triumphing over Avarice, and the defeats of Rebellion and Envy. It was installed in 1636. Thirteen years later Charles I stepped out of a window from the Hall under the gaze of his father and onto the scaffold for execution; but the ceiling survived. As part of its pre-war planning, the Office of Works had decided to keep it in situ.

> We are providing protection against light incendiary bombs for the ceiling and presumably it will be reasonably safe from blast and splinters. This is a logical policy, the same as we are adopting for the Raphael Cartoons [at the V&A]. I think it will have to suffice as the work and transport required for removal of the ceiling would be extremely difficult to obtain in an emergency.[31]

Following conservation work in 1908, the nine canvases had been glued firmly to rigid plywood panels, each battened and framed behind for strength, then hoisted back into place sixty

feet above the floor, hung on steel hooks. As a result, 'there should be no difficulty in reversing the process and in lowering them,' thought the Office of Works. The nine painted panels included two that were eighteen feet high and the oval *Apotheosis* centrepiece which was twenty-one feet high. Some of the rectangular panels were forty feet long. 'The most certain method of providing for their safety would consist of removing them from the building to a distant pre-arranged place of security,' agreed the Office of Works.

But there was a problem. 'It should be noted that the tallest windows in the Banqueting House are 11ft. high.' If the sashes were removed from one of the high windows then the corner panels and the narrower rectangular ones could pass through easily. But the others could not. The canvases could no longer be rolled, being stuck to their wooden panels, and it was impossible to peel them off without destroying them. Desperate times required desperate measures. Whitehall was coming under sustained bombardment every night. There was only one thing for it:

> to cut the large central panels along the lines of canvas joints so that each section would be of a suitable size to pass through a window. The panels, if cut in this way, could always be permanently re-jointed and the joints could be stopped in and re-touched with colours so they would be indiscernible.[32]

On 12 December one of the corner panels was tested, with hoists being fixed to the steel hooks from above through the ceiling boards, and at 10 o'clock that morning the lowering of the first panel was successfully completed. A second one was authorised, and then the rest. The larger panels were sawn into three or four pieces each of about twenty feet by nine feet and weighing nine hundredweight. As far as possible the canvases were cut following

old canvas joints, but some fresh cutting had to take place. 'In no case, however,' the Ministry of Works tried to reassure those concerned, 'have these cuts run through any of the important features of the paintings such as heads.' Unlike Charles I, then.

The dissections took place with the large panels detached and raised a few inches above the ceiling, in conditions 'very awkward and extremely uncomfortable'. Each panel was lashed to wire and rope slings in case of a fall, and then, once sliced up, the partitioned panel was lowered to the ground. Two accidents occurred through haste or inattention, when the workmen omitted to tie the slings in place for two of the panels before lifting them prior to cutting. The unsupported but heavy central Apotheosis itself swung round just before it got to the floor and crashed onto a display case owned by the Royal United Services Institute Museum which occupied the Banqueting House at the time. Luckily – very luckily – only the painting's woodwork was damaged and a small amount of the painted canvas. Similar damage was done to the final rect-angular panel when being lowered on 19 January 1941, also breaking a glass case.

In total, twenty-one sawn-up sections were passed through the window and onto a Pickfords lorry which travelled to and from Hall Barn, no doubt suggested by James Mann.[33] 'How grateful we are to you for all the help you have given us,' the Ministry of Works told Enid Lawson. 'We should have had difficulty in finding a place for it if you had not come to the rescue. It is most kind of you.'[34] The Lawsons were indeed terrifically generous with their home. They had converted the gun room into the family sitting room, and had kept the din-ing room (also with a new sitting area in it) but had handed over much of the rest of the house. The Wallace Collection was already occupying the ballroom and Long Parlour (both with two men sleeping on camp beds overnight). This housed

most of the paintings, furniture and *objets d'art* in cases, plus a room on the first floor given over to the Collection, with more in the garage, which housed the trailer pump as well. On the top floor were the clerical assistant and shorthand typist's offices, along with three bedrooms and two sitting rooms for the Head Attendant and the administrative staff. There was one bedroom for two men in the basement, and a mess room for the men had been fitted up in the stable tack room. The house's stillroom was used as a conservation and repair studio for the furniture restorer. Fifteen warders were accommodated in total. On top of all of this, the Tower armoury collections were keeping the horses company in the stables.[35] The library and front hall, and upstairs linen cupboards, were stacked with hampers of bandages, towels and hospital bedsheets from London, since Enid Lawson was President of the Buckinghamshire Red Cross, and had agreed the house could be used as a depot for the Central Hospital Supplies Service.[36] Prepared for anything, it comes as no surprise to learn that she eventually became England's Chief Commissioner of Girl Guides.

The Rubens ceiling was stacked in a long gallery known as the South Hall, reported Mann,

> the only part of the house with a door large enough to take the panels, and it is here that we have put the two large Bouchers from Hertford House which were too large to go into the Ballroom or long parlour where the rest of the Wallace Collection material is stored ... it will not be possible to store the panels in the stables where the Tower armour is kept as the doorway is only 6'6" and in any case, the conditions there would not be suitable.[37]

Despite all precautions, a small fire broke out in Mrs Lawson's sitting room in January 1941, after a cigarette was left smouldering on an armchair. It was quickly seen to, although

the Wallace Collection's Head Attendant was unimpressed with the local police and firemen – 'proper yokels', he called them. After this, an extra trailer pump was ordered just in case, given the extraordinary contents of this Beaconsfield ark.[38]

As the bombing in London intensified, Mann's friend 'K' sent a further seventy-two paintings from Hampton Court to the National Library of Wales. A shelter was built on site at the Palace for the Mantegna paintings which were too large to fit into any railway container. This made a move out of the question, on grounds of cost alone.[39] Further up the Thames, the Blitz changed everything at Windsor Castle too. 'I didn't tell your Majesty about the New Strong Room which Their Majesties are having made for the greater safety of the most valuable treasures,' wrote Morshead to his friend Queen Mary in January 1941.

He described a room in the south buildings of the Upper Ward where, descending through a trap door and down a ladder, one found oneself in a steep underground brick passageway, originally leading to the Castle moat and about seventy or eighty feet long, running under the yew trees flanking the South Terrace. There, at a cost of £1,200, two chambers were being tunnelled out of the chalk rock, left and right, about two-thirds of the way along the shaft. Each was '12 foot long by 8 foot wide, with 35 feet of head-cover, and their floor, ceilings and walls thick concrete and steel rails'. A vertical shaft, eight-foot square, was sunk into the grass above by the huge yew tree,

> and up this by means of a crane and a large steel tub [come] huge quantities of chalk-rock, of startling whiteness. This piles up into two great stacks, like those mine-tips we passed on the way from Edinburgh to Glasgow (how long ago) and these are kept within reasonable bounds by lorries that remove the spoil bit by bit. At night the humps of chalk will be filled up again when they have done.[40]

Later that spring, Crawfie and the two princesses were let into a great secret. 'Windsor Castle was a wonderful place on wet days,' the governess recalled.

> There was so much of it to be explored, so many odd nooks and crannies where we had never been before. One day the King's Librarian, Sir Owen Morshead, took us right down into the vaults under the Castle. 'Would you like to see something interesting?' he asked us. We said we would. He showed us a lot of rather ordinary-looking leather hatboxes which seemed at first sight just to be stuffed up with old newspapers. But when we examined these, we discovered the Crown Jewels were hidden in them![41]

London continued to be pulverised, but Morshead had still not managed to move Queen Mary's personal treasures down to the new 'Sally Port dug-outs' because the tunnels remained damp.

> We have got the Crown Jewels down there (from the Tower of London), but some of the leather cases are showing signs of mildew. The Office of Works are experimenting with various devices to reduce the condensation of moisture, and I hope they may succeed, for there are a lot of papers and drawings which ought to go down there.[42]

This was something of an understatement. The 'papers' included the correspondence and diaries of Queen Victoria in the Royal Archives, and the 'drawings' the extraordinary collection of Leonardo da Vinci anatomical studies and the Holbein chalk-and-ink portraits in the Royal Collection.

Then Morshead made an extraordinary confession to Queen Mary about what he had done to the Imperial State Crown and Queen Elizabeth's Crown, when they had arrived from the Tower in 1939.

At the King's personal wish I did take one bold step. I got down with Mr Mann, and we took out perhaps a dozen of the most important jewels – the Cullinan fragments, the Koh-i-noor, the Black Prince's ruby; and some others, to which the Queen [Elizabeth] added that fat ruby the size of a frog, which is mounted in a necklace. All the stones I mention came out easily, being merely clipped in; with one exception. Speaking from memory I think it was a portion of the Cullinan; at any rate it was set fast in the forehead-circlet of the crown the King normally wears, and we had to sever the four attachments, 'springing open' the circlet until the stone is replaced at the end of the war. These stones I wrapped in cotton-wool and placed inside a tall glass preserving-jar with a screw-top & rubber washer, placing in it a note signed by the King to say that it had been done at his personal direction, and that it was at his wish that nobody had been told. I then packed the glass jar inside a Bath Oliver biscuit tin, which fitted it to perfection; and sealed the two with surgical tape. That tin is at present with the Crown Jewels, which are under my key. Nobody has any particular reason to apprehend that the Germans would ever succeed in raiding so far into the country as this; but at the same time it is only sensible to prepare. In such a case the roads might become congested: the Crown Jewels are bulky and heavy, and the lorry containing them might not be able to get along. This tin is easily portable; betrays no indication of its contents; is easily disposed of at the shortest notice – even buried or sunk. And it contains the nucleus for a new set of Crown Jewels if the worst should come to the worst. Which God forbid – as I think he will.[43]

Clark and Morshead had together persuaded Queen Elizabeth to commission John Piper to paint views of Windsor Castle, thinking that a record was needed, just in case. Cheerily optimistic Morshead did not like the dark and brooding watercolours which emerged from Piper's brushes

('You don't seem to have had much luck with the weather, Mr Piper,' said the Queen on first viewing); but the louring black clouds with the grey and acid yellow tones of the buildings strikingly evoked the impending doom cast over the Castle and the royals.[44] Contemplating the destruction of the City's medieval Guildhall and the devastation being wrought on London, Queen Mary the Queen Mother declared, 'I did not realise that I could really *hate* people as I do the Germans, tho' I never liked them.'[45]

11

The Whole Fury and Might of the Enemy

T HE WORST NIGHT of the Blitz was 10/11 May 1941.
Seven hundred tons of bombs killed 1,500, injured
another 1,800 and started 2,200 fires across London. The
sirens began wailing at 11 o'clock. Jock Colville was about
to go to bed when the raid began and he descended to
the shelter under Whitehall to sleep, rocked by the explo-
sions on Horse Guards Parade under a full moon: 'on every
occasion I awoke about five seconds before the bomb
actually exploded.'[1] It was a year to the day that his boss had
become Prime Minister. At St James's Palace, close by, eight
rooms connected to Helena Gleichen's apartment had their
doors and windows blown off.[2]

Sir John Forsdyke now faced his greatest challenge. No
longer was he derided or despised by most of his curators.
The 'B&M' curator Tom Kendrick had been impressed by
the 'fine and inspiring part' Forsdyke was playing and his
'brave and able leadership'.[3] But the Director was about to
have the darkest hour of his whole life. Up until that night,
the Museum's ARP wardens and auxiliary firemen had dealt
with small quantities of incendiary bombs which, according
to Forsdyke, had 'given very little trouble'. The fire-watch-
ers at the opposite corners of the museum roof could easily
see flames through the top-floor windows when a single
burning stick had dropped through the glass or copper of
the roof, and would telephone the watcher at the nearest
firepost who would go out and smother it with a sandbag.

This time it was different. Dozens were falling. Though they heard the ominous 'cracking sound' some half an hour after the sirens began wailing, the staff spotted only those on the roof of the new Parthenon Gallery and adjacent 6a Bedford Square.

Unknown to them too, an incendiary canister had burst open just above the south-west angle of the building, dropping the empty husk of its case on top. But dozens of the deadly magnesium sticks inside had lodged, hidden, between the roof cavities and the plaster ceilings of other rooms, so that the flames there were not evident until the fire had spread and taken hold. The first sign of this was when the ceiling plasterwork of the Roman Britain Room fell in and the fire began spreading westwards towards the Coins and Medals section. The blaze became too much for the ARP so, for the first time during the Blitz, the London Fire Brigade was called to the Museum, arriving at a quarter to one. Eight pumps were sent but Forsdyke – wearing his usual tin hat emblazoned with 'D' for 'Director' – soon realised that 'no concentration of pumps and men could have prevented the roofs from burning out. It was rather a matter of putting them out when they fell to the floor.'[4]

Fifteen minutes after the fire brigade arrived with their turntable ladders, the south-west quadrant of the so-called 'Iron Library' was on fire. This was one of the four great book repositories of the Museum, arranged around the circular Reading Room where Karl Marx, George Eliot, and many thousands of other readers had studied and written. Despite the arrival of another engine, to Forsdyke it seemed that 'books were burning like a blast-furnace, and no amount of water could have any effect.' There was in any case a severe shortage, as so much mains supply was being used all over the city. Extraordinarily, Harold Plenderleith crawled into the burning bookstack to take a

look at what was happening 'like a snake, for the air was clear for a space of about a foot above the floor. You could see right along and you could see the flames coming from the books – it was the leather bindings which caused all the smoke.'

A quarter of a million volumes perished that night. It was one of the great cultural losses of the war. For decades after, serious researchers in theology, art, architecture, archaeology and medicine were familiar with calling up a book or periodical at the Library only to find their order slip returned, marked 'destroyed in the war'.[5] The roofs of the Roman Britain Room, the Central Saloon, the Prehistoric Room, the main staircase, the Greek and Roman Life rooms, the Medal Room and Coins and Medals offices, the Greek Bronze Room and the First Vase rooms were all destroyed, and their interiors devastated, leaving behind burned-out shells and twisted girders. A Clazomenian sarcophagus lid was pulverised and the Suicide Exhibition incinerated.[6] Amazingly, the great glass-roofed Reading Room survived.

Killed on that devastating night in her flat at 17b Canonbury Square was thirty-year-old Elizabeth – Betty – Senior, Assistant Keeper in the British Museum's Department of Prints and Drawings since 1934. Senior was the first ever female antiquities curator at Bloomsbury and had beaten fellow young art historian Alec Clifton-Taylor to the job. A graduate of Newnham College Cambridge and the Courtauld, she was also the first qualified professional in the department (her colleagues being history or classics graduates), highly intelligent and lively, and involved in a variety of academic and publishing projects in the years leading up to the war. A year spent studying history of art in Munich in the early thirties had made a profound impact on her. Once installed at the Museum, she had become

deeply involved in helping Jewish art historians who had fled Germany, among them Ernst Gombrich, Yvonne Hackenbroch, Edith Hoffman, Ernst Kitzinger and Fritz Saxl-Kitzinger.

Using her position at the heart of the British Establishment, Senior determinedly set about helping to find homes, employment and publishing opportunities for her émigré friends and their families, transforming lives for the better. On the outbreak of hostilities, Senior had been seconded to work at the Treasury in Whitehall (perhaps on work related to the Standing Commission on Museums and Galleries) and had risen rapidly through the ranks. Ernst Gombrich offered a generous acknowledgement to Senior in his most famous work, *The Story of Art*. It would never have been written without her 'warm-hearted encouragement', he wrote, and her 'untimely death . . . was such a loss to all who knew her'. The manuscript of this classic work and Senior's translation of it, along with a letter of support for the Gombrichs to government officials, was found in the wreckage of her flat.[7] In fact, it was probably through Senior that John Forsdyke met Gombrich's sister, Dea, a concert violinist: they married the following year.[8]

Plucked to safety from the debris at Canonbury Square by an ARP warden was Senior's unscathed ten-week-old daughter Sally, who was found under a table where her mother had tried to shelter her from the bombing. Unknown to her colleagues, for six years Senior had been conducting an affair with Tom Kendrick himself, fourteen years older than her and married. She wanted a baby; Kendrick did not, but she was determined, in spite of the scandal that would have ensued. Sally was handed into the care of her doting grandmother and aunt in East Dean in Sussex, where she had in fact been born.[9]

★

At Westminster Abbey, the first incendiary bombs descended at 11.25 in the evening, including one which penetrated the nave roof directly over the grave of the Unknown Warrior. The Deanery, Cloisters and Little Cloisters were set alight, in an attack quite unlike those which the Abbey had suffered over the previous nine months. The lantern over the central crossing caught fire, with 'flames leaping 30 or 40 feet into the air, thus awakening fears in all who witnessed it that the Abbey itself was likely to fall victim', recalled Charles Peers, its Surveyor of the Fabric who watched as the wooden lantern collapsed into the building.[10]

But all was not lost. At the start of the war, the seventy-year-old Peers had made extensive arrangements for the protection of its contents. Tombs, monuments and glass had been protected with 16,200 sandbags; the marvellous medieval tiles of the Chapter House floor and the Cosmati pavement before the High Altar sheeted over with thick layers of felt, then rubber, then planking, fit for even the most pea-sensitive princess; the crypt and Pyx Chapel converted into storage spaces; and an extensive ARP operation set up.[11] Some of the Abbey's most precious moveables, including selected bronze gates and grilles, paintings, and the statues and wooden stalls from the Henry VII Chapel, had gone to Boughton House, to sit alongside the British Museum's collections there in Northamptonshire.[12]

This was no coincidence. Peers was a trustee of the Museum and also a member of the Standing Commission which had made those initial arrangements back in 1934.[13] However, things had not been entirely acceptable at first. While two of the Abbey's greatest medieval treasures, its portrait of Richard II and the Westminster Retable (the earliest-known English painted-panel altarpiece), were lodged 'somewhere' in the main house, the bronze tomb effigies of medieval

and Tudor kings and queens were in the empty stalls of the stables and no one was taking responsibility for their safety. 'This doesn't seem to me a very satisfactory arrangement,' Peers murmured to Forsdyke. 'I wonder whether you can make enquiries about this. I need not emphasise the national importance of our effigies.'[14]

This had an effect, and the Coins and Medals curator Stanley Robinson made arrangements to get them into the Little Hall at the house, or at least to a drier stall. But on opening some of the crates he panicked. Peers moved to reassure him: 'it is quite in order that Henry V should have no head and Anne of Bohemia no arms. His head disappeared in the 16th century, but I don't know that we know when the Queen was dismembered.' Charles Peers was up and down regularly to Boughton that first autumn to check on his treasures, armed with a packed lunch which he liked to eat in the open air beside the lake, the offerings on site being very frugal.[15] A photograph survives in the Westminster Abbey muniments of Peers posing with the bronze effigy of Henry III lying in a loose box at Boughton, surrounded by hay and looking for all the world as if he were a proud farmer overseeing a prize heifer in calf.

Ever since the Blitz began, notices on the pews in the Abbey had informed the public that it was not a safe place to take refuge. And it certainly looked very different with all the precautions in place. 'But nothing', H. V. Morton told his readers,

> can be done to safeguard the roof of the Henry VII Chapel, which is one of the most exquisite things in England, a roof of stone carved with such audacious certainty that it seems to hang robbed of all weight, like festoons of intricate, creamy lace . . . as I looked at the protection provided, the thought of the possible effect of a bomb upon

an old building, honeycombed with tombs, was present in my mind.

The Coronation Chair, he wrote, had been sent into the country, 'and will not be seen again until the war is over'.[16]

This medieval throne, on which all monarchs (with the exception of Mary II) had been crowned since 1300, was one of the most prized objects in the Abbey. It was the earliest piece of English medieval furniture with a named maker: Walter of Durham. On 24 August 1939, the first day of the other evacuations from London, it had left the precincts in a lorry heading to a secret destination. Two detectives accompanied the driver, who some hours later drew up at the South Porch of Gloucester Cathedral. One of the stonemasons on the staff, Henry Pearce, watched as they unloaded the seven-hundred-weight crate and the Dean and Cathedral Architect signed for them. 'The Scon [sic] Stone was not with it. We rolled it into the Nave and it remained there for the rest of the day.' The next morning a large load of pine planks arrived, along with five carpenters who began shoring up a vaulted recess in the ancient crypt, sufficient to withstand – they hoped – explosion and collapse.

The Cathedral's thirteenth-century bog-oak effigy of Robert Curthose, eldest son of William the Conqueror, also needed protection – so once the vault had been strengthened, Pearce and his colleagues 'rolled the chair into place and put Robert on top. In the bad light it looked very strange.' The Office of Works had supplied the Cathedral with 10,000 sandbags and the Clerk of Works had ordered 100 tons of sand to fill them. These and many more were used to wall in the recess and protect the other monuments at Gloucester, including the tomb of Edward II – the first King to use the Chair. Meanwhile the Coronation Chair of Mary II, a duplicate which had been made for her when she and her Dutch

husband William of Orange were crowned dual monarchs in 1689, had been shifted from its usual home in Westminster to Winchester Cathedral.[17]

Although the Cathedral Architect had given instruction that the Coronation Chair should be taken out and inspected every six months, there were so many other pressing things to do that this did not take place as scheduled. When they did finally get round to taking a look through a small squint left in the sandbag wall, something awful had gone wrong. 'I have never had such a shock in my life,' said Pearce. 'It was like a snow storm, everywhere was white, the whole place was covered with fungus, slabs of it all over everywhere.' This was dry rot, in the early stages of its sinister spread. It thrives in humid conditions where the air has stagnated; it would ultimately be fatal for both wood and stone if not checked. The entire Crypt was closed for a month and no one was allowed down. A special dispensation was obtained to get new timber outside rationing restrictions.

> We then got to work one night after the church was closed scraping all the fungus off wherever we could. We carried out all the affected timber and fungus and covered it with paraffin and set fire to it. The Archdeacon came up from his house because he thought the Cathedral was on fire. We washed the sides with Copperus [a fungicide] and dried them out with electric fires. The fungus had not touched the chair as it was well covered with roofing felt.

Harry Pearce was proud to help. One wonders if Charles Peers ever knew. 'After making a new case exactly as the old one, we put it back as if nothing had happened.'[18]

As Pearce had noticed, the Stone of Scone was missing. This was the block of sandstone around which the Chair had been designed, and which since the late Middle Ages had been one of the central elements of the most solemn,

sacral rite of English kingship: the coronation. Originally thought to be the pillow on which Jacob had slept as recounted in the Book of Genesis, the 'Stone of Destiny' had until the seventeenth century directly supported the royal posterior during the ceremony, until a wooden seat was built over it, enclosing it in the Chair's base. It had only once left the building since 1300, and that was for the ceremonial installation of Oliver Cromwell as Lord Protector across the road in Westminster Hall in 1657. The Abbey authorities had quickly recognised that the Stone of Destiny would be of huge propaganda – and perhaps mystical – value if it ever fell into the hands of the Nazis. This was somewhat ironic, since the Stone itself had been looted from Scone Abbey in 1296 by Edward I – the *Malleus Scotorum* himself – during his extensive military campaigns against that nation.

The Stone now lay secreted in a burial vault under Abbot Islip's Chapel, off the north ambulatory of Westminster Abbey.[19] Only a few people knew it was there, including Charles Peers and the Dean. So few in fact that extraordinary steps were taken to ensure that this knowledge would not be lost if the enemy invaded and killed them. Peers was a distinguished antiquary. He had retired in 1933 from the Ancient Monuments Department of the Office of Works, having radically changed the presentation of the buildings in their charge. It was he – a keen gardener at his family home of Chiselhampton House in Oxfordshire – aided by the invention of the motor lawnmower, who had introduced the characteristic Ancient Monuments 'look' to sites such as Tintern and Rievaulx abbeys, with their walls stripped of overgrown greenery and neatly manicured lawns all around.[20] The resulting destruction wrought to later medieval additions had not been without its critics, but Peers now saw this as a chance to save another great medieval relic.

Peers carefully drew up three plans of the Chapel and its vault with the location of the Stone of Destiny (behind a pile of ancient lead coffins) marked with a circled cross. He folded two of the plans up and slipped each into envelopes which were then heavily sealed. The first was sent to the Canadian Prime Minister, W. L. Mackenzie King, who deposited the envelope in the Bank of Canada's vaults in Ottawa. The second went to the King's representative in Canada, the Lieutenant Governor, via the Canadian High Commission, who placed his sealed packet in the Bank of Montreal in Toronto. Peers kept the final copy at his bank until he had had confirmation that the two other plans were safe across the ocean, and then destroyed it.

But it wasn't just the Nazis who Peers was worried about. The Office of Works forwarded a suggestion sent to the Scottish Office that the Stone – an ancient bone of contention nearly as gnawed as that of the British Museum and the Parthenon Marbles – should be transferred to north of the border. 'It is in an exceedingly safe and secret place,' snapped back Peers.

> I trust the Office of Works will not lend itself to this attempt by the Scotch to get hold of the Stone by a side wind. You cannot be so simple as not to know that this acquisitive nation have ever since the reign of Edward I been attempting, by fair means or foul, to get possession of the Stone, and during my time at Westminster we have received warnings from the Police that Scottish emissaries were loose in London, intending to steal the Stone and that we had better lock up the Confessor's Chapel, where it is normally kept.

'I suppose', sighed the Dean, 'the Scotch will never learn to keep their fingers off the Coronation Stone.'[21]

★

For Peers' colleague, Lawrence Tanner, it was an equally 'terrible night'. As Keeper of the Muniments at the Abbey, he was in charge of its extensive archives. But he had also taught history at Westminster School in the neighbouring buildings, where his father had been a housemaster, so loved the place as if it were his home. During the Munich Crisis, Tanner had driven the most important of the Abbey's muniments to Oxford, destined for the tunnels under the Radcliffe Camera, or for Peers' home in nearby Chiselhampton. Inside four tin boxes were the *Liber Regalis* (source of the fourteenth-century coronation liturgy), four Abbey cartularies and the 1383 Litlington Missal. But when war broke out the following year, Tanner had made alternative arrangements, no doubt influenced by Peers, to evacuate them to Boughton.

Tanner's house at Westminster had been damaged in an early air raid, so he had followed his remaining evacuated collections to Hampshire where a number were scattered in various country houses. He rented a property near Stockbridge, from where he could make regular inspections of them to check for damp as well as being able to get up to London when needed. At Stockbridge he had joined the Romsey Home Guard and fished for trout in the Test. Indeed, the reason he chose that area was because he had loved fly-fishing on the river before the war and it had been a favourite haunt. As the fear of invasion began to fade he felt confident in gathering some of the archives back to his cottage.

> It seemed to me that they were safer there than in large country houses standing in their own grounds which might well be a target for the bombs of a solitary daylight raider. It was a great relief to have them under my immediate care again, and to be able to distract my mind for an hour or two daily by retiring into the Middle Ages in order to work on a box of medieval documents.

And indeed, what antiquary would not seek escape into the past when the present was so perilous?[22]

The precincts and school 'suffered grievously. A large part of the Deanery was completely burnt out', and the damage to the School Tanner found 'simply heartbreaking'. Of his immediate reaction to the bombing of that night, he recorded:

> all that really matters is that no one was injured and that at present the Abbey is safe and very little damaged . . . It is distressing to look up at a great square of sky over the Lantern. But it was the *only* place where the roof could fall in without doing much harm. The whole burning mass fell in a heap in the central space between the Choir and the Altar steps and burnt itself out. The Choir stalls a bit singed and the 17th-century pulpit a little damaged, but as far as I could see nothing else – hardly a chip. *Laus Deo.*

However, outside things were different. He and Peers surveyed the damage together, picking their way through the devastated landscape:

> The Deanery and the lovely houses round the Little Cloister are just heaps of bricks. I could not have believed such utter desolation. The curious thing is that the monastic buildings have been laid bare. The medieval stone walls stand out everywhere in the ruins and all the Tudor and later work grafted onto them have disappeared . . . the whole place was alive with antiquarian discoveries – what an irony![23]

The work of patching up and evacuating even more items began in the wake of the damage. 'We must hope', Peers reported to the Chapter, 'to emerge from the present relapse into barbarism with some of our ancient splendours intact.'[24]

There was no doubt in Lawrence Tanner's mind that the Luftwaffe's aim at Westminster 'was a concentrated attack

on the Houses of Parliament (dear Big Ben with the dirtiest face you ever saw!) and we unluckily were near enough to catch it too'.[25] That night, two of the Palace's police and the Staff Superintendent had been killed; the House of Commons chamber had been destroyed; a UXB was buried in the floor of the House of Lords; and the scaffolding around the Victoria Tower, the great citadel of the Palace of Westminster and the location of Parliament's archives, had caught fire.[26] Fortunately, the most precious constitutional records of the country were safe in the Bodleian Library at Oxford.

At the time of Munich the Librarian of the House of Lords had asked Bodley's Librarian, Edmund Craster, to consider the 'hypothetical' possibility of storing some records from Parliament. Accordingly, in an echo of Tanner's journey to Oxford during the crisis, four anonymous tin boxes of what was coyly described as 'first grade material' had been transported by the Office of Works up the A40 on the outbreak of war. In the boxes were a selection of some of the country's most important historic records, including the Death Warrant of Charles I, the Bill of Rights and the Great Reform Act.[27] Some of Parliament's other archives, including all the original parchment acts of Parliament – 'the vellums' – and early records of the House of Lords were transferred to the unheated outbuildings of Laverstoke Park in Hampshire, the home of Lord Portal, a member of the House of Lords and, from 1942, Minister of Works. Their stay at Laverstoke proved to be less than happy. They returned back after the war covered in mould and mildew, which caused considerable difficulty for decades after.

For a number of London institutions, the city of dreaming spires seemed a safe haven. It was sixty miles from the capital, still in largely rural countryside, and the Bodleian had a new and, like the National Library of Wales, largely

empty library building in Broad Street, designed by Giles Gilbert Scott, who later got the commission to rebuild the House of Commons chamber. There was a strange sense among some curators that Oxford would be spared the effects of the war. Perhaps this was sentimentality on the part of many of those who had been educated there. But those in residence were not so sure. When Leslie Bradley of the IWM was desperately looking for a home for his museum's library earlier that year, the Master of Pembroke had warned him that the College's

> unique treasures, which could never be replaced, have been sent away into the country. The treasures which are not unique, have mostly been retained here . . . I should be inclined to agree with you that it had better be sent into the country, if suitable conditions for keeping it can be provided. No one can tell how long Oxford's immunity from bombing will last.[28]

Persistent post-war rumours that Oxford was saved from bombing because it was intended as Hitler's English capital overlooked the sinister interest shown in the city and university in the *Informationsheft G.B.*, which makes specific mention not only of colleges and museums of note there but also of various academics who were on the Gestapo death list. If it were true that Oxford was intended to become a Nazi capital then it would have been purged not only of its intellectuals and other undesirables but also its art, literary and historical treasures – including those sent there for safety from London.

In fact, despite appearances, the New Bodleian was not complete and instead the main location for evacuated materials was initially in the basements of the Camera, where a series of tunnels under the cobbles of Radcliffe Square

linked James Gibbs' glorious rotunda to the Old Bodleian Library complex. Sandbagged redoubts containing specially purchased safes for the London evacuees were installed (not without difficulty in some cases), but wet sand began to affect the refugees; within a month or two the New Bodleian swung into action, supplied with a hastily constructed 'Brick Room', two floors below street level, on Deck K. Eventually the New Bodleian held some 60,000 manuscripts and books, over multiple floors, below ground and above, sent for safe-keeping not only by Oxford colleges but by many institutions in London. These arrived in waves, after the fall of France and increasingly as the Blitz intensified, and included items from the libraries of the V&A, the Science Museum, the House of Commons and the House of Lords. In all, the Bodleian gave sanctuary to the book collections of eighty-seven institutions.[29]

But the most iconic constitutional record of all was not in Oxford at all. Of the four surviving 1215 originals of Magna Carta, two were underground in the British Museum's section of the ARP cave at Aberystwyth; Salisbury Cathedral's copy had been removed from their library to the Diocesan Registrar's strongroom in the Cathedral Close, locked inside a rough wooden box along with other treasures;[30] and the fourth one, belonging to Lincoln Cathedral, was on holiday in the United States. It had been lent for display at the World's Fair in New York City which opened in April 1939 and was still in the British Pavilion when war in Europe broke out. At that point it was sent to the Library of Congress in Washington DC for safekeeping, but reappeared again at the World's Fair for a while in 1940. When Congress passed the Lend–Lease Act in March 1941 to provide food, fuel and materiel for the UK war effort, someone in the Foreign Office decided that an appropriate

thank you to Roosevelt would be to present Lincoln's copy of the great charter to America. It would be, wrote one civil servant,

> at once the most precious of gifts and the most gracious of acts in American eyes; it would represent the only really adequate gesture which it is in our power to make in return for the means to preserve our country.

Churchill was extremely interested, and a draft gift tag of sorts was drawn up:

> You are giving us aid on a scale which makes it almost impossible for us materially to repay . . . May we give you – as least as a token of our feelings – something of no intrinsic value whatever: a bit of parchment, more than seven hundred years old, rather the worse for wear. You know what it means to us; we believe it means as much to you.

The plan was for Churchill to announce the gift in a radio broadcast on 15 June 1941 – the anniversary of the sealing of the charter at Runnymede. But no one had consulted the Dean and Chapter of Lincoln Cathedral whose treasure it was, and they were having none of it. The plan came to a juddering halt, and when the USA entered the war six months later the Library of Congress despatched the Lincoln Magna Carta to lie alongside the Declaration of Independence and the Bill of Rights in heavily armoured security at Fort Knox, Kentucky until 1946.[31]

Emerging from his shelter, dazed and tired, on the morning of Sunday 11 May, Jock Colville walked to the Sunday morning service at Westminster Abbey in the smoke-filled air, with fluttering sheets of burnt paper 'falling like leaves on an autumn day' around him. He was turned away by a policeman: 'There will not be any services in the Abbey

today, Sir.' At the Houses of Parliament the Clock Tower was pocked and scarred but Big Ben was still ringing on the hour with its quarter chimes. Standing on Westminster Bridge, he saw fires all along the Embankment and thought that 'after no previous raid has London looked so wounded the next day.'

He phoned Churchill at Ditchley Park, the Prime Minister's secret wartime retreat in west Oxfordshire, to tell him of the devastation. There he heard the news that emerged over the next day that, as well as the forty-five German bombers shot down that night, Hitler's deputy Rudolf Hess had been captured in Scotland after his bizarre one-man mission to seek a peace treaty with an unsuspecting Duke of Hamilton had ended in a crash-landing. Once untangled from his parachute and his alias uncovered, Hess was arrested and briefly sent to the Tower before being moved on. 'There never has been such a fantastic occurrence,' Colville wrote in his diary.[32]

The Tower of London too suffered major damage in the bombings, being so close to the Docklands and so easy to identify from the air. But life went on for the Yeoman Warders and their families in the precincts. They continued to feed the ravens and dug up the moat to grow vegetables. The Tower itself, divested of its armoury collections and the Crown Jewels, had reverted to its ancient origins as a prison. Not only the place of Hess' captivity, it also became a Prisoner of War Collection Centre and processed 180 German submarine crew and Luftwaffe officers before the unit was moved to Cockfosters. And there was one execution: Josef Jakobs, a German spy executed by firing squad in August 1941.[33]

'Alas, poor London,' Queen Elizabeth wrote to her mother-in-law at Badminton,

an even more violent & cruel raid on Saturday night. Our beautiful national shrines and monuments – It seems such sacrilege that they should be destroyed by such wicked lying people as the Germans.[34]

PART III

Finest Hour

12

Victory, However Long and Hard the Road

T HROUGHOUT THE BLITZ, the search had been on for a new home for the National Gallery. Kenneth Clark knew it would not be easy. Most viable underground possibilities had already been snapped up.[1] In July 1940, the Chairman of the Board of the Gallery had written to Rawlins, urging him to find a solution. He began a wide-ranging search for suitable quarries, narrow gorges capable of being roofed over with reinforced concrete, disused caves, the inevitable railway tunnels: anywhere which could provide deep shelter overhead. All were considered and rejected: too close to a bombing target; too likely to flood; too difficult to access; too likely to collapse. Ian Rawlins began to lose hope. But then he heard of a place near the slate-mining town of Blaenau Ffestiniog, deep in Snowdonia: 'the abode of Eagles', full of myth and history, a beautiful and windswept region home to ospreys, pine martens and wild goats.

He and Martin Davies drove to inspect it on 17 September 1940. It was Manod Mawr, a mountain in the Moelwyns, rising 1,700 feet above sea level and some 600 feet high. By Snowdonia standards it was pretty modest and from the road below it looked rather like a wide, upturned pudding bowl. They wound almost four miles up a single-track road, cut through the green moorland, dotted with sheep and cattle grids, and the odd farm. Water ran down from the mountain streams above as the way rose to a one-in-six gradient. At the top was a slate mine, their destination, and as Rawlins got out of the

car he immediately noticed that the adit – the passage leading into the mine – was only six feet high. He had to bend to walk along it, dressed in his habitual macintosh and clutching his briefcase, and it was less than half the height that was needed for the pictures to be moved inside. Once through, though, there was a spectacular surprise.

Rawlins found that it suddenly opened into 'several vast chambers, offering adequate accommodation, electric power, and water available, and from the technical aspect most vital of all, the natural temperature was low (47° F) and fairly constant – according to local tradition – winter and summer.' Doing a rough calculation on the spot, Rawlins realised that it would be possible to control the environment inside the caves by heating alone, without the need for dehumidification.[2] When Clark saw the mine for himself he was astonished: 'it must have supplied half the roofs of Liverpool, and contained a cave called "The Cathedral", which was on the scale of Karnak.'[3]

Davies was equally impressed. The attitude of the owner Mr Matthews was cordial. And unlike the other places which they had inspected, Manod had the ultimate prize: a tarmac road right to it, albeit a mountain one. Every other quarry they had looked at had been accessed by rough tracks which were fine for the transport of slate but which had 'filled Mr Rawlins and myself with despair when we thought of the National Gallery pictures'.[4] Four days later, the Office of Works men took a tour, were cautious, but the deal was sealed. The Gallery could install its collections in the very heart of the mountain. But there was still a seemingly overwhelming series of obstacles to overcome.

To begin with, if the paintings were even to get into the caves, the adit needed to be doubled in size to allow free passage. Here is where another Welshman came to the rescue: Mr Vaughan, the quarry manager. He oversaw its enlargement from six square feet to thirteen and a half by ten. As

soon as Vaughan's men had finished the blasting, the Ministry of Works took over the adaptation of the caves themselves. Inside them, widening works were also needed, and the rubble and boulders cleared away, so that the floor could be levelled. Just for once in the story of these evacuations, high explosive became a friend and not an enemy. In total 5,000 tons of slate were dynamited out and removed before any work on the art storage could start. The several hundred layers of granite and slate above were impregnable, even in the very unlikely event that the refuge's obscure location was attacked by planes flying overhead.

The preparation took months. Rawlins was anxious. 'Everything was a race against time,' he later wrote, 'the approach of winter on the one hand, and on the other the knowledge that the pictures could not be considered wholly safe by any means in their surface quarters near the coast.'[5] Thick snow and ice did its best to add further delay over Christmas. At the turn of 1941, Davies was dismayed by a security leak. A small clipping from an unidentified local paper – thought perhaps to be the *Liverpool Echo* – was dropped in the street at Blaenau Ffestiniog and came to his attention. 'Cave is Nation's Treasure Store', the headline trumpeted. 'A tiny stone quarry "somewhere in Britain" is soon to be filled with priceless art treasures belonging to the nation . . . Workmen who are preparing the cave in the heart of the mountain have been sworn to secrecy.' With so many labouring on the conversion it was impossible to avoid something slipping out. Davies shuddered. But at least absolutely no mention had been made of a location.[6]

Rawlins described his storage scheme as 'a complete model village to serve as a picture sanctuary'. Six brick sheds were erected inside each rock chamber, each with self-contained, controlled environments with their own ventilation and heating. It took time to temper the new buildings and they

had to be dried out safely before any art could be sent there. Fearful of mould in still air with over 68 per cent humidity, Rawlins required that the plant could change the air up to four times an hour. Tests were carried out on worthless canvases and wooden panels to see what would happen if left outside the sheds in the bare caves. They all grew mould: some within two and a half weeks. To prevent the darkening of oil and tempera paintings as a result of being stored in complete darkness, Rawlins specified low-level lighting to run twenty-four hours a day and ordered a 140-horsepower emergency generator, powered by diesel, which would take over the workings of the apparatus if the North Wales Power Company electrical supply failed.[7] Pairs of engineers would need to work eight-hour shifts throughout the Gallery's time at Manod to ensure conditions did not deteriorate.

Back at the Tate headquarters at Eastington, John Rothenstein was still itching to get the Tate's paintings out of there and Hellens. Ostensibly, he was exercised about their safety. 'The case for a move is entirely based on the vulnerability of the present accommodation,' he told the Office of Works, protesting just a bit too much about Eastington. Its timber framing; the fact that Mlle de Montgeon would only allow one attendant permanently in the house; the crowding of paintings in too small a space for them; the fact that the rest of the staff billets were a seven-minutes cycle ride away; as well as the costs incurred by him and Ironside motoring to and fro each day from four miles away: all this led him to believe that Sudeley Castle would be better.

Stone-built, with willing owners and in the middle of Winchcombe, Sudeley Castle was about twenty miles from the village outside Stroud where William Rothenstein lived. There, billets would be much closer and walkable. It was no surprise that Lord Lee's house, Old Quarries at Avening, a

similar distance away, was also in Rothenstein's sights for the Tate – if only the National Gallery would vacate it. 'You are, I believe, already aware that I have never felt confidence in Eastington, with the choice of which I had nothing to do, and have long been on the lookout for a suitable candidate.' Hellens was 'an exceedingly flimsy structure, in the immediate vicinity of which ten high explosive bombs were once dropped, with the result that several windows were broken and tiles fell off the roof'. Notice was given to both chatelaines that they would be freed of their evacuees by May 1941.[8]

But when May came round there was a problem. Rawlins reported that the temperature on the floors in at least one of the sheds at Manod was not the same as the ceiling temperature, and so it was not possible for the Ministry to give the Tate a date for its consequential move: 'it is very depressing.' Meanwhile, Whitehall was aware that Lady Helena and Mlle de Montgeon needed to be handled carefully and that the storage space could be of use in future.

> We will not write officially to our hostesses but, when the Tate pictures are on the point of going, we will consider writing semi-official letters saying we are retaining the house ear-marked for us and hope that the owners will be prepared to let us use them again if suitable requirements come along.[9]

*

By the summer of 1941, after nine months of extraordinary effort and several months after what had turned out to be not only the most devastating, but also the final, night of the London Blitz, 'The Cathedral' was ready for its new occupiers. Clark was quite clear that the success was down to one man: 'the indispensable Rawlins who saved the situation'.[10] This time, only the pictures at Old Quarries were re-evacuated by rail. The collections already in Wales were transported

onwards by road. All six locations – Penrhyn, Bangor, Caernarfon, Crosswood, Bontnewydd and Aberystwyth – were emptied of their precious freight. Railway containers on lorries (LMS from the Bangor properties, GWR from the Aberystwyth ones) were packed with the paintings and driven carefully to their destination.

The trickiest point of the journey came when they were tantalisingly close. Just outside Ffestiniog, there was the Hen Capel bridge. Here a low clearance of eleven feet where the railway to Bala went overhead, combined with a very sharp turn once through, made this an impossible obstacle to negotiate with the Van Dyck equestrian portrait of Charles and other paintings packed into elephant cases. Impossible, that is, without the determination of Rawlins. He arranged in advance of the move for the road under the bridge to be dug out by two and a half feet, new footings put in on either side of the lowered carriageway to support the bridge and test runs with an empty case to take place. Skid plates were put down.[11]

Clark, with his eye for a good anecdote, described how Rawlins

> had miscalculated by half an inch, and the case containing *Charles I on Horseback* and Sebastiano del Piombo's *Raising of Lazarus* was stuck, irrevocably as it seemed, under the bridge. We all stood silent, and I was reminded of the moment in Ranke's *History of the Popes*, when the ropes lifting the great obelisk in St Peter's Square began to fray. The crowd had been sworn to silence, but one sailor from Bordighera could not restrain himself. 'Acque alle tende' he shouted. Silence was broken. 'Let the air out of the tyres' we all said in chorus. It was done and grinding under, scraping over, the huge packing case passed through.[12]

Ever the romantic, Clark embroidered this story in his biography; he was present to observe operations with a film crew

to record the journeys up the mountain for the Ministry of Information. Rawlins, both more literal and more truthful, simply noted: 'the load passed with ¾ inch to spare . . . arrangements had been made to deflate the tyres if necessary but this was not called for. The time taken to negotiate this bridge was about ½ an hour.'[13]

The vehicles then had to be able to cope with the gradient from Ffestiniog, while being buffeted by high winds which caused Davies and Rawlins no little anxiety. On arrival at the top of the road, those loaded with all but the largest pictures then drove down the widened adit into the heart of Manod Mawr. They pulled up right inside the sheds so that the paintings could be unpacked without being affected too much by the unregulated conditions outside in the caves. It was a precision operation. The clearances which the lorries encountered, Rawlins was proud to record, 'were only a matter of inches. Skilful driving was essential.'

As the mountain road was single track, timing of consignments was critical so that an empty lorry did not meet a full one coming the other way. This Rawlins arranged again, with clockwork precision. The first pictures disembarked on 12 August 1941, just eleven months after Manod Mawr had first been identified. Space constraints inside the mine meant that only one container could be emptied at a time. Three containers a day, six days a week, were delivered on schedule for five weeks, each day bringing some 700 pictures to be unloaded, stacked and then cleared to make way for the next load. Some of them weighed up to half a ton and had to be disembarked at the entrance to the adit. Without lifting gear, it took two hours. It was an enormous effort. Finally, the paintings were hung against the racks on the shed walls so that they could be individually viewed without being moved, 'not indeed in a pleasing way,' admitted Davies, 'but well enough for inspecting how they behaved underground. In point of fact, they

behaved admirably, and gave far less trouble in cracking and blistering than had ever been the case at Trafalgar Square.'[14]

The National Gallery's accommodation stretched a quarter of a mile from end to end inside the mine. Included on site was a library building, where the Gallery's reference books had been transferred from Aberystwyth. Davies spent many happy and productive hours on new catalogues of the Gallery's holdings. The conservators Holder and Ruhemann had the use of a purpose-built studio constructed at the entrance and thus with natural light to help their work. Fourteen men in total were employed there: guarding, monitoring conditions, moving pictures as needed and cleaning. The distances between the studio and the storage was too great to allow the pictures to be carried between them. Not only were they heavy, they would also suffer from the uncontrolled atmosphere outside the sheds. So three closed wagons running on narrow gauge rails were commissioned by Rawlins from the LMS railway works at Derby. Lined with the 'Sorbo' shock-absorbing rubber sheeting, they could be pushed by hand across the site, and became the method of manoeuvring not just pictures, but also large frames, supplies, stores, furniture and engineering equipment around for the next four years.[15] One still survives today at Amberley Museum in Sussex.

The Tate pictures also transferred to their new homes that summer and Rothenstein considered himself at last free of the daunting women who had caused him so much irritation. With Old Quarries emptied of the National Gallery pictures, the Tate was finally able to shift from Hellens, and its Great Hall was offered to the Science Museum for book storage.[16] Into the space vacated by the National Gallery at the National Library arrived the historical section of the War Cabinet Secretariat, the Air Ministry historical branch and the Royal Canadian Air Force historical section, all working to record for posterity official histories of the conflict.[17]

Gabrielle de Montgeon was anxious that Eastington should carry on being earmarked for national art storage, 'to avoid any arguments should anything else be suggested', and the Ministry confirmed that the local council was aware of this. She had heard through local gossip that her home had been, 'put on the list of houses for refugees if any are sent this way later on', and she had been discussing independently with the Soane Museum whether it might like to take up the storage for some of its library and manuscript collection.[18]

The Soane idea came to nothing, but later on in the war, Mlle Montgeon was able to weaponise the Science Museum's interest in using the Hall for book storage in order to fend off attempts by the Women's Land Army to use it as a hostel.

> I think it would be very unfair to me – after having had the Tate Gallery here for two years entirely free of charge (which I was very pleased to do) . . . it is quite unsuitable for Land Girls – every room (some panelled) is furnished with very valuable furniture – which I could not replace added to which I have no servants left and have to use my kitchen as my own dining room so there would be no cooking arrangements possible for them – my water supply is very limited and the sanitary arrangements would not stand a number of additional people.

Why couldn't the land girls look for billets in the many big farmhouses round about instead, she asked?[19]

That December, the USA entered the war. By the end of the year, Rothenstein was rid of Fincham too, who left Muncaster Castle and transferred to the Ministry of Labour where he apparently proved quite satisfactory. From then on the picture billets proved untroublesome, and Rothenstein was able to devote himself to hobnobbing with his fellow gallery directors and artists in London during the week, and spending the weekend with Elizabeth in Winchcombe.[20]

Back at Manod, Davies settled into a manor farmhouse four miles away called Pengwern, obtained by the Ministry of Works. Originally he had planned for Rawlins to join him, and Rawlins hoped it would be 'a little bit of civilisation in that lovely but desolate region' but it came to nothing.[21] First, Rawlins wanted his housekeeper to come too and look after them, but there wasn't room. Then he became worried about the amount of rent he would have to pay, so in the end he found alternative accommodation in Ffestiniog. Davies found Pengwern 'charming'. It was nestled in the bend of moorland, down a steep slope, surrounded by sycamores and firs, the Moelwyns behind. He lived there from the summer of 1941, with other rooms occupied as offices during the day by Rawlins, the Gallery accountant and an administrator.[22]

Clark thought the property was ideal for Davies:

> He had always been a solitary character, and was said by his contemporaries in Cambridge to have emerged from his rooms only after dark; so this sunless exile was not as painful to him as it would have been to a less unusual man. In the morning he would emerge, thin and colourless as a ghost, and would be driven up to the caves, carrying with him a strong torch and several magnifying glasses.[23]

Twice a day Davies made the journey to the mine and back: for a morning and afternoon stint with lunch back at Pengwern in between. As the days got shorter and winter drew on, Davies found the trips less congenial. 'Some of these were in the dark, with war-time headlamps on the cars, snow on the ground and fog in the air.' He was pathetically grateful to Baldwin, a Gallery attendant turned 'most devoted chauffeur', and photographs of the time show him in the depths of winter in wellington boots and with a hefty sou'wester on his head.[24]

Davies found some peace of mind at Manod. With unlimited close-up access to the Gallery's paintings, he was able to research and catalogue them to a level never achieved before or since. Armed with his trusty torch and magnifiers, Clark noticed that Davies

> would examine every square millimetre of a few pictures. In twelve years I hardly ever saw him look at a picture as a whole, but at a series of small areas of paint, which he usually found to be more or less damaged. These reveal to him how insecure was the evidence for all attributions in early art, and for the very existence of certain painters . . . perhaps only someone as passionately sceptical and as isolated as Martin Davies could have exposed so many convenient fallacies.[25]

For Rawlins, Manod was a way of showing that science, especially applied physics and engineering, was not always used for ghastly ends in war and that its 'part is not wholly to undo. To save for posterity becomes an overwhelming urge.' Friends remembered him as a kind but deeply hesitant man, utterly without malice or guile.[26]

Kenneth Clark admitted he went to Snowdonia more often than was strictly necessary. It became his escape from wartime London and his many commitments as a cultural panjandrum. In 1940 he had added the Council for the Encouragement of Music and the Arts (CEMA), the forerunner of the Arts Council, to his portfolio of committee work, chairing its Arts Panel, which included John Rothenstein. He fell in love with the local landscape. At night he began to 'dream repeatedly of a wide Welsh valley, twisting its way up to distant mountains, and wake in an ecstasy'. But where to stay? He regarded industrial Blaenau Ffestiniog as a 'hellish town', and putting up at Pengwern with Davies was out of the question too. Sometimes he and Jane would stay with their friend Christabel Aberconway, owner of Bodnant Gardens.[27] What in fact he liked best

was to lodge at Portmeirion, Clough Williams-Ellis' pastiche Portofino on the coast but still within easy striking distance of Manod; sometimes with his family and sometimes without. It was a very select holiday camp for fashionable London society and the celebrities of the day – artists, actors, musicians, minor European royalty and glamorous airmen recovering from injuries. Williams-Ellis found it awkward to explain to staff and 'jealous would-be clients' just why Clark and some of the Manod staff were among the civilians there, without giving the game away.[28]

However, for some others staying, it was an open secret. The Jewish artist Fred Uhlman, who had fled first Germany then Paris for England, was one of the guests in 1942:

> I can still see Kenneth Clark solemnly entering the dining room followed by one of his faithful wine bottles. He had brought parts of his wine cellar with him and I remember how much we, who hadn't tasted wine for years, envied him. And how disappointed I felt when he, who had the keys to Aladdin's cave, the fabulous mine near Ffestiniog, where the National Gallery pictures were stored, never asked me, a painter, to see them but showed them only to a few of his carefully selected friends.

The composer William Walton was often at Portmeirion, and Jane was having a long and intense affair with him (Clark's lover at the time was the artist Mary Kessell). Favoured visitors and family friends would be driven over to Manod for a showing: so much for security.[29]

Williams-Ellis found these trips a fascinating and unintentionally humorous experience, the arrangement of the canvases being far from an exhibition hang, and on one occasion encountering a portrait of Gladstone at the end of one long aisle, 'glaring down its length as though in deep disapproval of some of his less decently clad neighbours'.[30] For Clark, the

pictures, detached from the surroundings of the Gallery, lost their allure. Despite many posed photographic shots of him studying the paintings and chatting with staff in the sheds, 'I did not enjoy looking at them. Out of their frames, crammed close together, in no order except that imposed by the necessities of size they seemed to be dishonoured.' According to John Rothenstein, Clark dismissed Davies' style of 'scholarship for scholarship's sake' as mere 'knitting'. He tried to adopt a scholarly approach and analyse them minutely with a flashlight as Martin Davies did, 'but I could learn nothing, and realised I am an incurable aesthete. Unless I enjoy a thing, I cannot understand it.'[31]

Yet Manod was not without its risks. Slate dust was causing problems for a start. Tramped in by the men from the tunnel outside, it thickly powdered the pictures near the door, which worried Davies with their alarming appearance. But it was only cosmetic. Rawlins had to keep reassuring him all was well; that it was 'very good dust, and could do no harm settling on the pictures except to render them temporarily invisible'. The power lines running across the Welsh hills sometimes cut out, especially with all the snow and heavy rain, so the emergency generator was kept busy keeping the sheds' atmospheres stable, kicking in only two or three minutes after a power cut was detected. Then there were the roofs in the mine. 'Manod roofs are safer than most; nevertheless the pictures could not walk away like a gang of quarrymen from any doubtful section,' Dry Martini noted. Each storage building was protected from stones falling from above by wire mesh over their asbestos concrete roofs. The Mines Inspectorate did quarterly inspections and Mr Vaughan, the mine manager, kept a close eye on the situation. It seemed precaution enough.[32]

Life at Manod settled into a comfortable routine for Davies, Rawlins and the other men there. By the early summer of

1942, the site was proving so successful that Clark, with his Surveyor of the King's Pictures hat on (probably an elegant trilby from Lock's of St James's), decided that forty of the most important paintings in the Royal Collection should be moved from Windsor Castle – including those originally at Buckingham Palace – for their greater safety. By the late summer they had been despatched and suffered 'no ill effects from the journey'. The remaining paintings left behind at Windsor were moved to safer areas in the basement and ground-floor stores in the Castle.[33] In London he would regularly meet up with John Rothenstein, even though both had set up domestic bases in Gloucestershire. At one lunch they discussed the novel idea of dividing the Tate Gallery into two after the war: a British art museum and a Modern art one.[34] It came to nothing.

Clark's genius for popular communication had another opportunity to flourish when the Gallery acquired Rembrandt's *Portrait of Margaretha Trip* from the Earl of Crawford in lieu of death duties. In response to a letter to *The Times* from Mortimer Wheeler, Director of the London Museum, Clark put the painting on display in the empty gallery for three weeks and then alighted on the idea of having a 'Picture of the Month' brought back from Manod. The public were encouraged to send in suggestions to him on postcards, but it was Davies who had the final say on which should be released from the mountain. Accordingly, nearly forty masterpieces made the journey back to London over the next three years: Tintoretto's *St George and the Dragon*; Constable's *Hay Wain*, Velázquez's *'Rokeby' Venus*, Botticelli's *Venus and Mars*, El Greco's *Christ driving the Traders from the Temple* and Titian's *Noli me Tangere* among them. There, they were viewed by over six hundred people a day, the art historian Herbert Read describing it as 'a defiant outpost of culture right in the middle of a bombed and shattered metropolis'. Each night the painting would be taken down and placed in the air-raid shelter in the

basement to protect it.[35] Some requests such as Michelangelo's *Entombment* and Piero della Francesca's *Nativity* were turned down because of the paintings' extreme value and fragility; on other occasions choices were made by Davies, as when Holbein's *Christina, Duchess of Milan*, a glorious evocation of black silk and squirrel fur, was put on display in November 1943 to mark the 400th anniversary of the artist's death.[36]

The men were rightly proud of what they had achieved. Davies was, as usual, cautious and shied away from the limelight, despising it, but Clark could not resist making the most of it. Arranged by him, the *Daily Telegraph* published a story, 'I Visit the National Gallery in its Mountain Cave'. The reporter Stewart Sale had been given access to the unnamed site.

> The men who worked there were cautious of tongue, but news runs mysteriously in country places, and now everyone in the nearest village knows the secret. But they are a people who mind their own business, and it must be seldom that a whisper reaches the next valley ... When they are off duty they hardly see a strange face – unless it is a sheep's.[37]

Later that year Clark invited a Fleet Street Press Agency to take photographs of the arrangements at Manod. These then ran in the *Picture Post* of 7 November 1942 under the headline 'Britain at War Guards Her Art Treasures'. The four-page spread showed the anonymous entrance to the adit, wagons manoeuvring pictures around the site on rails, the storage arrangements and, of course, Clark himself sagely admiring the pictures and watching Holder at work cleaning. Other photographs, not published, but which now form a fascinating record of everyday life inside the mountain included shots of the men in their day- and night-quarters, making tea, logging hygrometer readings and checking shed keys in and out.

As for Rawlins, it is clear from the newspaper stories that he had been interviewed by journalists, anonymously, on

the technical aspects. Yet he also felt that the academic and museological world should be made aware of the achievements at Manod to develop the professional practice of conservation and preservation science, and to help other museums and galleries as the war progressed. In July 1942 and January 1943 he published papers in the international journal *Nature*, one of which was reprinted in the February 1943 issue of the *Museums Journal*. That was how the story hit the newspapers a few days later, with journalists then often scouring specialist publications for newsworthy mainstream stories. Suddenly 'National Gallery Art Treasures Safe in 300 ft Caves' was once again splashed all over the national papers – including the *Daily Mirror* and *Evening Standard*.[38] No mention was made of Wales as the location, but it was, at the least, tempting fate.

There had been warnings. In the autumn of 1942, water had been spotted seeping in from a disused dam above the quarry into chambers No. 2 and No. 5. At the end of November, there was a rockfall of fifty tons at the back of No. 2 through a known fault in the roof – but it stopped well clear of the nearest storage building. A few months later, more water began seeping through, but still far from the sheds.[39] Finally, in March 1943, disaster struck. Clark happened to be on a brief visit to Portmeirion, where he received a hysterical phone call from Vaughan, summoning him at once to the mountain. 'It's a crisis, it's a crisis.' At 4 o'clock that morning, 9 March, some rocks had sheared away from the roof and fallen to the cave floor in chamber No. 2. Although they missed the storage shed, a large piece had bounced away and badly damaged the end of it. Davies telegraphed Gibson in London: 'one Poussin torn but repairable stop one Ruisdael slightly damaged stop trivial scratches on three others stop building now being cleared of its contents stop Vaughan

is here stop'. A complete collapse was imminent, and even the normally suave Clark was terrified that 'the whole of the National Gallery might at any moment be buried under an avalanche of slate.' Vaughan instructed that the western half of the shed should be evacuated immediately and a new partition wall constructed to close off the safe half. But before that could be done, there was another fall thirty-six hours later which collapsed the north wall of the shed and fifteen feet of its south wall. All the paintings had to be evacuated from No. 2 shed at speed.

Clark put it down to the way the additional heating required for the buildings in Manod had changed the wider environment and made the rock conditions more unstable. And it was indeed true that the temperature in the caves outside the sheds had risen by 5° F since their occupation, due to the heat leaking from the brick walls and the floodlighting in the adit.[40] The Mines Inspectorate arrived the day after to work out what had happened and whether it would happen again. They concluded that the roof falls were in fact a result of the percolating water from the stopped-up dam on the surface of the mountain, which had made the rock strata more mobile. But they were also satisfied the event (taking the second and third falls together) was a one-off and that, apart from needing more frequent inspections, Shed No. 2 should be repaired to half its original size and the paintings returned.[41]

Steel scaffolding was erected to allow for regular tests of the ceiling, and suspect parts of the rock were chained. Clark thought it 'a miracle there were no more falls of any consequence'.[42] The Ministry of Works were less sanguine. Eric de Normann wrote to Clark explaining that

while we are anxious and willing to do all in our power to guarantee the safety of your collection in this Quarry, I must repeat what I told you in my letter of 25 September, 1940, that

as this place was selected without any prior consultation with us, we naturally could not accept any responsibility for the choice of it or for any disabilities which these Quarries might eventually disclose as repositories for pictures.

Clark had charged ahead in 1941 without getting Whitehall completely on his side.

The original scheme was based on dispersal and whilst I appreciate that wide-spread air attack tended to reduce the margin of safety, the alternative of concentrating all the pictures in the heart of a mountain naturally introduces other types of risk inherent in the configuration and physical properties of the repository.

Clark noted in the margin, 'this is a very serious statement. Will you please see how the matter stands.'[43] Fortunately for him, his gamble, based on Rawlins' assurances, proved to be the right one.

Davies' view of the Gallery's evacuations and the wanderings of its collections was that 'the trouble taken was rewarded.' One only had to look at the Gallery's bombed-out Raphael Room to see what might have happened if the pictures had been left on the walls in London.[44] There was also no doubt in Clark's mind as to who the hero of the hour was, and for once, it wasn't him.

The man was F. I. G. Rawlins. He received inadequate thanks from me and, as far as I know, no official recognition, not even an OBE. This was partly due to his diffidence, and partly because he was the most relentless bore I have ever known, and the kind of people who distribute honours fled from his approach.[45]

13

Victory, in Spite of All Terror

IN JUNE 1941 John Forsdyke warned the Duke of Buccleuch not to moan too much to the Ministry of Works about the burden of having the British Museum and other collections billeted at Boughton. The Museum was, after all, supplying constant security, ARP protection, fire-fighting equipment and a generous £440 a year to house just eight men. 'Not even a Duke can expect to get through the war without suffering and he recognises that he suffers at Boughton a good deal less from us than he could do from anyone else,' Forsdyke told de Normann. 'The real fact is that his house-keeper is not up to this work: he told me so.'[1] More objects continued to arrive at Boughton, including some panel paint-ings from the House of Commons and rare printed books in oriental languages from the Museum's library; both moves prompted by the devastation wrought the previous month on that final terrible night of the Blitz.[2] Meanwhile, Forsdyke's attempts to obtain a subterranean store for the Museum's col-lections elsewhere was finally beginning to gain traction.

It was through a chance encounter with the Librarian of the University of Bristol, a Mr W. L. Cooper, the year before that Forsdyke had discovered the existence of a possible site in the Mendips. This was Westwood Quarry, part of a gigantic but failing scheme by the Ministry of Air Production to requisition all the underground stone quarries within a twenty-mile radius of Corsham in Wiltshire for use as aircraft production factories.

Cooper knew of it because he had sent the University's top library treasures to one of those disused quarries at the start of the war.[3] Ironically, it was the very attacks on the centres of British aircraft industry such as Yeovil, and the military aerodromes being built, such as the one near Boughton and Drayton, which simultaneously put those locations in jeopardy but also offered the seeds of a solution for both the V&A and the British Museum.

The need to construct safe underground factories which would turn out engines and other components for fighters and bombers free of the danger of attack during the Blitz had resulted in a series of multi-million-pound schemes in the limestone hills near Bath which by the end of 1941 had still not been put into operation. Of the 2.2 million square feet occupied by the quarry developments, 720,000 had so far been reluctantly occupied by the Royal Enfield motorcycle company, evacuated from Solihull, whose machine tools and male and female operators had been redirected to making bombsights. Of the remaining space, 25,000 square feet was available to the British Museum at the most far flung of the Corsham requisitions, a hillside called Westwood above the village of Avoncliff.[4]

As soon as Forsdyke had got even a sniff of a possibility at Westwood in 1940, he was set on his quarry. But it was a slow business persuading the Ministry. And he was also having to deal with fusillades of advice from Queen Mary, who was a regular correspondent and had her own very distinctive thoughts on the operations of the Museum. After a lengthy series of negotiations with the government, he and Maclagan, who had joined forces, became enraged that the National Gallery's scheme at Manod had received Ministry backing (they did not know how reluctantly) whilst theirs remained on hold.

Three months before the end of the Blitz, while military requisitioning continued apace all over the country, Forsdyke

wrote a stinging letter in defence of his and Maclagan's collections, demanding to be taken seriously:

> What we want now is not priority but a moment of parity with the Service Departments. I should not be surprised to hear that nothing can be done but in that event my letter will have served to ensure . . . that if we have to announce major disasters among the national collections the news will not be received by the government with surprise.[5]

Those were strong words within Whitehall, and they finally did the trick. The Ministry of Works scheduled a survey for suitability but before it could begin, the Air Ministry stepped in and the site was requisitioned for military use.[6]

At much the same time as Forsdyke was thwarted, Hilary Jenkinson at the PRO began negotiations with properties which could accommodate yet more of the national archives. The Oxford Diocesan Teacher Training College at Culham was one destination; Grittleton Park, near Badminton, was another; Clandon Park in Surrey a third. Each house was allocated an assistant keeper who would take continuous custody of the records there. In one of his regular Whitehall scuffles, Jenkinson had rejected the idea of moving the public records to underground storage at Westwood, prompting a Treasury civil servant to describe him as 'nearly as empty of sound judgement as he is full of words'. But in 1943 the office did consider moving the records to the deep salt mines at Winsford in Cheshire (which Fordyke had rejected as being too inaccessible), a move which only came to pass at the beginning of the twenty-first century when a commercial records store with virtually perfect, naturally occurring paper and parchment storage conditions opened there.[7]

Noel Blakiston was thirty-four, handsome and charming, setting the hearts of susceptible readers aflutter when he did his regular shift in the Round Room of the Public Record Office

in Chancery Lane in the years before the war.[8] In the late summer of 1941 he was sent to Clandon, the country seat of the Earl of Onslow, who was a personal friend. Clandon was a gorgeous red-brick Palladian mansion with an extraordinarily beautiful white marble entrance hall imitating the villas of the Veneto, with a delicious plasterwork ceiling. The Onslows had offered it for storage rent free, providing the heating bills were paid, and had moved out to a smaller property near Farnham to make way for the 300 tons of records which would fill the ground floor – including the Marble Hall – and basement of the house.[9]

The risk of an incendiary bomb on the roof at Clandon was that 'it would pierce the tiles and ceiling below but it would then stop and ignite. The best course, upon this argument, is to clear the top rooms of inflammabilities.'[10] The contents of the upper floors were cleared and furniture on the lower floors was accordingly stacked in the centre of each room. Fire-fighting equipment was installed on the roof.[11] One of the lorries leaked water through its roof on the way over but after drying the cartons in front of an electric fire, all was well and the boxes were stacked as usual.[12] Four hundred and fifty more tons of public records were sent to the Oxford Diocesan Training College at Culham in 1941; its principal Dr Alfred Guillaume was made an honorary Assistant Keeper as the Duke of Rutland had been at Belvoir in 1939.[13]

In the autumn of 1941 Blakiston was reunited with his wife Giana, as clever and glamorous as he, who had moved from their comfortable Chelsea home with their two daughters so that the family could be together. This was a policy which the PRO applied to all its married assistant keepers looking after evacuated collections. Blakiston's office was in the morning room, and the family sometimes lived in some grand rooms on the first floor, retreating to the basement surrounded by records where there was a bedroom, sitting room and kitchen, during

air raids. When the children's friends visited, rather than sit in the cold and uncomfortable accommodation at the bottom of the house, they played hide-and-seek between the towering stacks of crates of archives in the Marble Hall.[14] The Ministry of Food intended to supply him with enough emergency rations to keep twelve people going for forty-eight hours in the event of emergency: nine pounds of biscuits, twelve pounds of tinned meat roll, six pounds of chocolate and two tins of margarine. But that was for staff, not families. In the end Blakiston's pack consisted of just six tins of iron-enriched chocolate: three days' supply for one person. The family and records battled on, surviving burst pipes in the basement and leaks from the roof.[15]

Back at the British Museum, John Forsdyke was far from giving up on Westwood. He had now persuaded his trustees to appeal directly to Churchill, an ex-officio trustee of the Museum. The Prime Minister sliced through the Gordian knot with a single sweep of his pen, and instructed Westwood to be handed over to Forsdyke and Maclagan.[16] But as with Manod, at first sight Westwood was not promising. In the 1920s the disused quarry had been a mushroom farm, not too appropriate for collections which needed to be protected from mould; and some of the floors had a steep gradient which would make storing the V&A's furniture difficult.[17] Over the course of the next six months the site at Westwood was a hive of activity, with the Ministry of Works clearing and cleaning, levelling the floors, reinforcing the ceiling, waterproofing, adding heating, air-conditioning and other systems. It then took more time than expected to dry out and stabilise the atmosphere, and the winter caused further delay as more daylight was required to effect an efficient move. Thus it was only in February 1942 that the first collections were shifted. Both preparation and evacuation were each a 'herculean operation', in Forsdyke's estimation.[18] For Harold Plenderleith, as ever in attendance,

the storage arrangements at Westwood needed to be 'perfection or nothing'.

The storage of furniture, textiles and museum objects required far more space than paintings, and avenues of clothes rails hung with textiles in cellophane envelopes did the trick. Plywood boxes of museum objects were stacked on duckboards to protect from damp or leaks. Illuminated by fluorescent lighting and with compressed air on hand to aid spraying against moths and other insects, the various areas of the repository were kept at Plenderleith's favoured 60:60 temperature–humidity ratio. The conditions were remote controlled from a plant room where the engineer could change the environment as required if the readings before him showed it necessary.[19] It was cutting-edge stuff. 'The British Museum and V&A, with the Ministry of Works,' Plenderleith announced in a technical journal (without disclosing any location), 'have jointly brought into actuality a museum in the bowels of the earth, which, from the point of view of conservation, is as fine as anything known above ground, either in this country or elsewhere.'[20]

The British Museum's collections took six weeks to evacuate to the Mendips. For some it was their third wartime home in as many years and Forsdyke sincerely hoped it would be their last. First, the Boughton collections left for Westwood by train between 24 February and 31 March 1942. Later that year a camp for German prisoners of war was built in the grounds of the house. All that remains today of the British Museum's stay at Boughton are the tell-tale rust marks on the flagstones in the Great Hall and Egyptian Hall from the rivets of the No-Nails boxes.[21] Antiquities arrived by road from Compton Wynyates, and then the Drayton collections rolled up at the start of April.[22] Stanley Robinson stayed on at Compton Wynyates, caring for the Boughton coins and medals and a few ethnographic collections to the end of the war. With the departure of the Drayton collections to Wiltshire, young Adrian Digby

was transferred to Naval Intelligence in Cambridge where his knowledge of the Pacific Islands, acquired at the Museum, was put to good use.[23]

In view of the 'thousand to one chance of a lucky hit' on the ARP Tunnel at Aberystwyth some of the British Museum's most precious books and manuscripts there were also transported over by van to Westwood in a four-day operation at the beginning of July.[24] This in turn made way in the Tunnel, where conditions remained excellently stable, for further collections sent from Bloomsbury. The Bodleian in Oxford also took another 65,000 new refugees from Bloomsbury. 'But', admitted Forsdyke,

> these later clearances made little difference to the great mass of books that had to be kept in London, and it is not possible to say that if the additional accommodation had been available earlier, we should have been spared any part of the disaster that fell upon the Library in the night of 10 May 1941.[25]

In return, the Bodleian itself was assigned space for 2,000 of its own most precious treasures at Westwood, so that the Library was in the curious situation of being considered a haven for vast quantities of others' most valuable items while its own moved out to a place Bodley's Librarian, Edmund Craster, believed was a place of even greater safety.[26]

Simultaneously, William Llewelyn Davies found himself harried by petty bureaucrats on top of trying to run operations at Aberystwyth. On one occasion he was told to burn the gorse on the slopes below the National Library building. In the view of the Borough Surveyor and the War Emergency Sub-Committee, the Town Clerk told him, it

> might constitute a danger . . . I am to remind you that any burning should be done in the daytime and all fires should

be extinguished before black-out time. I am also to remind you of the necessity of doing the work at once so as to avoid unnecessary cruelty to nesting birds.

The Chief Librarian was unlikely to have agreed that the gorse be removed from over the very ARP Tunnel it helped to conceal from the air. The nesting birds were saved from roasting for another season.

In any case, Llewelyn Davies had already arranged for extra sandbagging of the roof in case of incendiaries, and the ARP squads were rearranged, with Scholderer and Leveen assigned to the salvage teams. Later in the year the Town Clerk was back, this time with an order for Llewelyn Davies and his staff to undertake compulsory ARP duties in the town. The mild-mannered librarian rarely lost his temper, but he was sorely tempted on this occasion. 'I would like to point out that all of us have been engaged in fire-watching at the National Library of Wales,' he wrote back,

and, as we have, in addition to our own valuable material, many collections which have been evacuated here from other institutions, government bodies etc. from London and elsewhere, I submit that our first obligation is to the Library and its contents.

The local fire brigade was more helpful, providing a trailer pump which would suck up the 80,000 gallons of the University's swimming pool in case of any incendiary attack on the Library.[27] For his efforts and the visionary leadership shown by him in the previous five years, in 1944 William Llewelyn Davies received a knighthood.

Muriel Clayton oversaw the transfer of the V&A collections from Somerset to Wiltshire in the spring of 1942 where 15,000 square feet had been set aside for the Museum. That included over 1,000 square feet of free floor space which would enable

its biggest rugs to be unrolled and scrutinised for lurking lepidoptera. It was something of a relief, as the strength and safety of the roof over the Long Gallery was in doubt in the event of incendiary bombs, about which she had been long engaged in discussions with the Yeovil ARP and its Montacute officer, Stuart Keep. A large consignment of books from the National Art Library at the V&A were sent down following the bombing of the art collections in the British Museum library stacks, as they had now become significantly rarer.[28]

Adding to the pressure, American troops were stationed nearby and using the park at Montacute on a regular basis, some even asking for tours of the house. But not everything went to Westwood. Left behind were many shelves and boxes of books, solanders full of prints, ten Japanese screens, fifteen boxes of textiles, sixty rolls of loose carpets and tapestries, a large quantity of the V&A's own records and collection inventories, some chairs and other furniture which had been returned from Westwood, and a large Chippendale organ case. Having seen the most important items installed at the quarry safely, Muriel continued to supervise matters at Montacute, making visits every few weeks to check on the staff and deal with curatorial queries.

In April 1944, bombs were dropped nearby, and later that year she began asking the Director if she could stay for longer periods at the House to complete various jobs. After D-Day she wrote, 'I am still finding plenty to do here and I think I shall be able to get everything in order for the return to London.'[29] Muriel's professional concern was of course for the objects in her care. But there was a personal benefit to her staying on. The V&A building back in London was not very comfortable, being occupied by, among others, Royal Engineers engaged in what Muriel called 'hush-hush' work, schoolchildren from Gibraltar and, most unlikely of all, a large RAF canteen.[30] But also, Muriel had fallen in love.

The object of her affection was dashing Captain Keep, who early in 1943 had divorced his wife on the grounds of adultery. His wife Marjorie, explained the divorce petition, was fond of dancing, but with a double-amputee husband it was impossible. For fifteen years this had rankled and when war broke out she had moved to London, ostensibly to do VAD work but in fact to join a man she had grown close to, whom she had met at a dance. The scandal culminated in the Keeps' divorce and was rapidly followed by Marjorie Keep's remarriage.[31]

Thrown together by circumstance, Muriel and Keep's relationship blossomed thereafter and, having seen the V&A's collections safely back to London, in August 1945 they too got married. Muriel was forty-six and retired from the V&A shortly before the wedding, looking forward to making a new life with her husband and her stepdaughter, Ann.

The creation of Westwood led to a major relocation of other collections in the last three years of the war. The National Portrait Gallery also took advantage of Westwood. Two hundred of the top paintings at Mentmore were shipped over to the Mendips that summer. Rearranged on fresh shelving, some strange new acquaintances lay together: Charlotte Brontë with Cardinal Newman; James I and Charles Barry; Mary I side by side with Mrs Siddons; and the Duke of Wellington next to Isaak Walton. But someone had clearly made a sentimental decision to put Henry VII beside his mother Lady Margaret Beaufort, and Robert Browning next to Elizabeth Barrett Browning.[32]

Mentmore had by then became a veritable bazaar of storage. When Lord's Rosebery's sister, the Marchioness of Crewe, visited she found the central hall 'filled with historic ceilings from Greenwich and Marlborough House and the floor of the Billiards Room covered with recumbent figures of kings and queens from Westminster Abbey'. There were other delights as well:

I used to walk outdoors past the Maze, flanked by huge bushes of sweet-smelling syringa, till I came to the summit of a slope and there, gazing over the view of the orchards that lay below, was the romantic equestrian figure of Charles I by Le Sueur, removed from London for safety.[33]

Mentmore had also taken on the bronze effigies of Westminster Abbey previously held at Boughton; and Charles Peers had agreed with James Mann, his friend and fellow member of the Cocked Hats (a dining club of the Society of Antiquaries), that the Westminster Retable and Richard II portrait would transfer from Boughton to Hall Barn to join Mann's evacuees from the Wallace Collection.[34] Peers also had at his home in the hamlet of Chiselhampton, a few miles from Oxford, some other treasures, just as his friend and archivist at the Abbey, Lawrence Tanner, had moved collections back to his rented cottage in the Hampshire countryside.[35] For these men, nothing could be safer than to have their collections in their own homes as if they were their own children or grandchildren.

In 1941, Sir Lionel Faudel-Phillips had died and Balls Park in Hertford, where some of the Wallace Collection had been sheltering, was put up for sale. Over that summer James Mann decided to transfer its museum occupants not to Sir Lionel's cousins, the Lawsons at Hall Barn, but instead to nearby West Wycombe Park, country home of the Dashwoods (the same family who had let the V&A down so badly on the outbreak of war), which was just eight miles from Hall Barn and where the rest of the Wallace Collection was housed.[36] The paintings and crates of decorative arts occupied the Brown Room, the ballroom (in which two warders slept at night), and two rooms in the Old Wing. The Wallace Collection also took over a kitchen there and a four-bedroom cottage for its transferred staff.[37]

Sharing the chilly Brown Room at West Wycombe with the Collection was James Lees-Milne, Secretary of the Country Houses Committee of the National Trust, which had been

headquartered there just a few months before. A maternity hospital was also billeted at the house and in the spring of 1942 a number of aristocratic guests were in residence, including Nancy Mitford, who liked to call the freezing upstairs lavatory 'the Beardmore' (after the glacier in Antarctica), much to the annoyance of Helen 'Hellbags' Dashwood, their hostess. One day in March 1942, after lunch, Lees-Milne and his friends were treated to a spectacle.

> The guardian of the Wallace Collection (its pictures are stored in the house for the war) got out some of the Watteaus and Fragonards for us to look at. He arranged them in a row in the saloon. We had a perfect view of the lady incising a large S on a tree and the *scènes champêtres*, all of which suit the particular elegance of this house and park.

Lees-Milne then drove to Eton for tea – which consisted of baps with jam and cream made from soya beans, followed by an ersatz sachertorte, 'which tasted of straw rolled in dung'. At dinner that evening, Nancy told the now infamous story of an American millionaire's wife who on meeting a parson's daughter wearing a small necklace of lapis lazuli remarked, 'I have a staircase made of those.' It was quite a day.[38]

Indiscriminate air attacks and Baedeker raids continued across the country. As at Manod, the rock above Westwood Quarry was some ninety feet thick and impenetrable even to the bombers going to or from the strategic targets of Bristol and Cardiff. Eventually, thirty-one other London institutions joined the British Museum, NPG and V&A there, including some of the Imperial War Museum and Westminster Abbey, nestling alongside treasures and glass from Salisbury, Winchester and Hereford cathedrals, Oxford and Cambridge colleges and many others.

It was romantically rumoured that the quarry air-conditioning was a refrigeration plant seized from a captured German

merchant ship. Humidity problems plagued the experimental conditions at Westwood and levels proved unreliably high throughout 1942. But the collections were at last securely underground. Queen Mary came to inspect from Badminton and declared herself fascinated and satisfied by the arrangements.[39] The curators holed up at the Old Court Hotel in Avoncliff, under the watchful eye of Cyril Gadd, Keeper of Egyptian and Assyrian Antiquities, while the maintenance workers shared the wooden huts of the Royal Enfield workers. And there the myriad collections remained, having finally come to rest after three years of wandering, until their eventual return to the capital in 1945.

Yet the danger was not over in London. A fortnight after D-Day, the city was subjected to the first attacks by deadly pilotless V1 bombers, flying at 400 mph across the Channel, their arrival heralded by a deep, macabre roaring noise that earned them the nickname buzzbombs. They caused massive damage and death in built-up areas. The Doodlebugs' flight path frequently took them directly over Westminster and Buckingham Palace. Slightly ruffled, Morshead, the Royal Librarian, wrote to his old friend Kenneth Clark that 'Five minutes ago the queen rang me up to say that she had for some time been concerned lest we had not got too great a concentration of pictures here in the castle.' Queen Elizabeth wanted them to be moved to join the others at Manod. Morshead tried to persuade her that it was not worth it so late in the war and that the store was pretty full; to which she replied, 'well, if they can't take them, that's an end of it . . . but I think it might be worth trying.' Which was really a way of saying *I want this done*.

Eventually Clark deflected her by pointing out that the Hampton Court pictures were at much greater risk; wood for packing was in short supply; and that alternative venues might be Balmoral or the Henry VIII Wine Cellar at Hampton Court.[40]

The V1s caused devastation of a kind not seen since the Blitz. Windows were blown out at the front of the British Museum and the same month its east wall was hit by an anti-aircraft shell, damaging Plenderleith's research laboratory again.[41] The buzzbombs also caused the worst damage the Natural History Museum had experienced, in July 1944, when all the western galleries were blown out and many exhibits destroyed. Only seven out of 162 cases of the famous Nesting Series of British Birds survived and 130 tons of broken glass had to be cleared away. Up until then, the main damage had occurred in the autumn of 1940 when the east roof, the Coral and Shell galleries and about 10 per cent of the herbarium specimens had been badly affected.[42]

Canon Quirk, the Chapter Librarian at Salisbury Cathedral, recalled visiting Westwood to retrieve his 1215 Magna Carta at the end of the war:

> An official led us into a rock-hewn tunnel floored with cement and lit by electric light . . . Two hundred and fifty paces into the hill they passed through a door and into a storage chamber, cool and clean and dry with a temperature of 63 degrees Fahrenheit. Fire detection was provided by a system of blue lights which would set off alarms if the beam between them were interrupted by smoke. Shelves filled the space as far as the eye could see.

Inside the Duty Curator's office he saw some words on the wall in Greek which he instantly translated as: 'Fearing a sudden stroke from heaven above, I hastened hither to the gods below.'[43]

They had been placed there by one of the superintendents, Harold Mattingley, Assistant Keeper of Coins and Medals, but were in fact a classicist's version of another piece of graffiti by Cyril Gadd, who had occupied himself over several shifts by composing and then carving an inscription into the wall in

Babylonian cuneiform. Gadd carefully coloured in his epigraph with the ends of burned matchsticks:

> In the year of our Lord 1942 the sixth year of George King of all Lands
> In that year everything precious, the works of all the craftsmen which from palaces and temples were sent out
> In order that by fire or attack by an evil enemy they might not be lost
> Into this cave under the earth, a place of security, an abode of peace, we brought them down and set them.[44]

It is still there today, in the darkness.

14

The Broad Sunlit Uplands

ALL THE EVACUATED collections survived intact to June 1945, but they and their curators returned to a changed world as the war ended. The damage and destruction done to London's national museums and gallery buildings alone was calculated at £1,294,000. 'Considering the damage inflicted upon London generally the nation can be thankful that the destruction was not greater still,' declared the official report from the Standing Commission on Museums and Galleries about the wartime experience of London's treasure houses. 'Throughout these difficult and dangerous times the depleted staffs from Directors down to Warders rendered devoted and gallant service in caring for those portions of the buildings left to them and in maintaining the evacuated material.'[1]

For many years after, the British Museum staff who had spent the war at the National Library of Wales retained warm memories of their time in Aberystwyth. Jacob Leveen described it as 'one of the most beautifully situated and appointed libraries in the world, with its spacious and sunny rooms, and with books made available from its shelves promptly and with the minimum of formality'. In return, the National Library staff had had the opportunity to study the BM's collections, including those in the Welsh language, while Flower and Scholderer in particular had done research into and provided advice on the Aberystwyth collections in their areas of expertise. In April 1941, the USA company University Microfilms had sent a cutting-edge microfilm camera, the Recordak, to

Bloomsbury-on-Sea where the British Museum staff set it up in the Print Room. There it microfilmed many of the Museum's manuscript treasures, and the National Library of Wales acquired a copy of those from the Welsh collections for its own use. Many friendships were forged between Aberystwyth and Bloomsbury in those years, as dedications in books by Scholderer and Popham made clear. 'The National Library of Wales will long retain', wrote Leveen afterwards, 'an affectionate place in the hearts and memories of those Saeson [Englishmen] who met with so much kindness and hospitality from their Celtic colleagues and friends.'[2]

VE Day in Aberystwyth was celebrated with tea parties in every street and games for the children, 'the friendliness and absence of snobbery' of the Welsh reminding Scholderer of a Renaissance painting. That month, the ARP Tunnel was cleared and the British Museum book and manuscript treasures moved uphill to the main Library. On 24 May 1945 the air-conditioning in the Tunnel was switched off and never used again. Scholderer retired at the end of the war, but was very happy to stay on with his wife Frida in the town for a further year while their house in Wimbledon was repaired after being hit by a VI in the closing stages of the war: 'so in the end we passed some seven years in Wales, and lucky to do so.' His former colleague and Llewelyn Davies' friend, Idris Bell, retired to Aberystwyth at the end of the war too, so altogether it was a genial circle. All ninety tons of British Museum book and manuscript collections at Aberystwyth were sent back to London a year later, filling twenty-five railway containers.[3] The delay was due to the repairs needed in London. There were a few strays. Two manuscripts and a printed book belonging to the British Museum were sent back to London from Aberystwyth in October 1946, to the embarrassment of Leveen, who took possession of them:

I had thought we had cleaned out the Print Room pretty thoroughly. It is a chastening experience to find that we had overlooked some of the Museum material. With kind regards and best wishes to you and Lady Davies and Melun, and kind remembrances to the staff.[4]

It was therefore a slap in the face for Llewelyn Davies that when he asked the British Museum trustees to consider leaving their Welsh manuscripts at the Library on deposit they refused. Much use had been made of them by the Aberystwyth librarians and more would have occurred if it had been publicly known they were there, he explained. The implication that it might have been an appropriate gesture of gratitude from one national library to another was left hanging in the air between him and Forsdyke. The move of the Welsh material was delayed until the final tranche of the Museum's collection was due to leave in November 1945, but eventually, leave it did.[5] Sir William continued as Chief Librarian of the National Library of Wales until his death in 1952, aged sixty-five. His ashes were scattered in the grounds.[6]

On his return home, Scholderer found the British Museum building 'a terrible sight'. Robin Flower compared it to a bankrupt department store. But it could be repaired.

All the same, Hitler came too close to blunting the point of the tale that in the long ago days a Keeper of Printed Books asked a junior assistant to lunch in the residence and kept him in talk over coffee until he grew restless and hinted that perhaps he ought to be back at work – whereupon the Keeper took him to the window, pointed to the Museum, and said: 'It'll be there tomorrow.'[7]

All the British Museum's books, manuscripts and the museum objects above ground returned by the end of 1946. The Reading Room reopened that summer, its dome repaired.

Gallery repairs continued but were only fully completed in the 1960s when the whole of the Museum could once again be accessed by the public. Unpacked objects stored in the Underground were not returned until galleries were repaired.[8] In 1973, the British Museum split into two separate organisations, its vast book and manuscript collections becoming 'The British Library', but remaining on site at Bloomsbury operating out of the Reading Room until 1997, when it moved to a splendid new building built on the old St Pancras railway goods yard. John Forsdyke had two daughters in his sixties with Dea Gombrich and retired in 1950. He had travelled a long way and died aged ninety-six in 1979.

Philip Pouncey, the National Gallery's curator at Aberystwyth until 1941, had found his time so congenial among the Prints and Drawings specialists from the British Museum that at the end of the war he took up a job at the Museum as Deputy Keeper to Arthur Popham, who had been promoted to Keeper. He went on to be a director of Sotheby's. Adrian Digby of the British Museum became its Keeper of Ethnography in 1953. He remained in post until he retired in 1969 with a CBE. He became a world expert in ancient South and Central American pottery, and, in 2000 at the age of ninety-one, patented his design for a walking stick with a pick-up device.[9]

For Martin Davies, it had become 'abundantly clear that the pictures enjoyed life at Manod Quarry far more than they previously had in London'. They had received a respite from the wild fluctuations of temperature and humidity in the Gallery and from the breath and heat of the general public which added to the mix. 'Manod Quarry seemed therefore likely to preserve the National Collection indefinitely; except indeed in its function of a picture gallery.' During the first week of June 1945, pictures started to trickle back to Trafalgar Square. On the Saturday following VE Day, fifty of the gallery's top masterpieces were on display. They knocked fifteen minutes

off the time taken to negotiate the treacherous bend at the Hen Capel bridge at Ffestiniog, as a result of all the practice they had had three and a half years previously. One container a day, five days a week, followed until all the pictures and the library had left Manod, to be loaded with meticulous care onto wagons at Blaenau Ffestiniog. By the end of 1945 they had all left their mountain sanctuary.[10]

Once the Germans had fled Paris, Kenneth Clark and John Rothenstein headed over the Channel to visit Picasso and see if they could pick up bargains on the art market. Instead they discovered they had made a 'ludicrous error of judgement': sales were booming and Paris in the late summer of 1944 both looked and felt far more prosperous, bright and cheery than London.[11]

Of the National Gallery's wartime adventures, Clark took the view that

> now that every exhibited picture in the Gallery has been cleaned I am sorry I did not carry my cleaning activities even further. The whole effect is incomparably more exhilarating than it was before the war . . . Cleaning is a battle won, and I can claim to have made, during the war, the first timid steps.

His evacuees travelled back to London as soon as peace broke out, and were put on display in undamaged rooms. The poet Louis MacNeice – like Muriel Clayton, from Ulster – wrote some celebratory verses, beginning 'The kings who slept in the caves are awake and out/The pictures are back in the Gallery.'

On Sunday 10 June 1945, Kenneth Clark broadcast a talk on the BBC Home Service, 'Pictures Come Back to the National Gallery', announcing where the paintings had been and how they had got there and back. The public deluged him with appreciative letters. 'I should like to tell you', wrote one Jewish lady straight after, from her home in Hampstead,

what the return of this 'first load' had meant to me – and, I
am sure, to many others like me. I came to this country in
July 1939, but it was not until many months after the out-
break of the war that I first came to London. I had come
from Germany, a Germany in which, apart from many other
things, even the right to go into a Gallery and look at paint-
ings had been taken from me. And then I came to London
and again I had to stand outside the National and the Tate
Galleries, longing to go in and yet knowing that, although
no one would forbid me to enter, I should not be able to
see what I had waited to see so long . . . There will be many
like me, many who will see old paintings for the first time
and they will all take with them a lasting memory, happy and
grateful that they have not had to miss this chance. I am one
of the lucky ones.[12]

Clark resigned as Director of the National Gallery at the end
of 1945, and took up the position of Slade Professor of Art at
Oxford for a few years, intending to combine it with writing
and broadcasting. He continued to add public appointments to
his ever-increasing list of accomplishments but became most
famous as the presenter of the BBC's 1969 landmark televi-
sion series, *Civilisation*. His friend Johannes Wilde was released
from internment in Canada in 1941 and after the war became
Deputy Director and Professor of Art at the Courtauld Insti-
tute, in the opinion of Clark: 'the most beloved and influential
teacher of art history of his time'. Clark became a Companion
of Honour in 1959, a life peer in 1969 and was granted the
Order of Merit in 1976. For the rest of his life he continued
to dream of Snowdonia. 'I dream of it even more often than
food or girls, and it seems to play the dominating part in my
unconscious mind.'[13]

The environmental controls had proved so successful at
Manod that the National Gallery replicated them in the rebuild
of its post-war galleries housing the most vulnerable paintings.[14]

The man behind their extraordinary wartime achievement, Ian Rawlins, remained active in the new field of conservation science after the war, publishing many technical papers, becoming Secretary General of the International Institute for Conservation, editor of its journal, and finally its vice-president and an honorary fellow in 1964. He was also Technical Director of the Central Council for the Care of Churches, and joined the Cathedrals Advisory Committee and the Council of the National Buildings Record as well as many other conservation bodies. Interspersed with this were visiting fellowships and lecture tours to the USA, and his chairmanship of Liddon House, the Anglo-Catholic foundation in London supporting the Anglican priesthood, of which he had been a governor since 1934. He was awarded a CBE in 1960. He spent his last years at Danny House, a home for retired civil servants in West Sussex. He had friends who loved him, but remained a deeply introverted loner. On 3 May 1969, he was found dead there, having taken an overdose of sleeping tablets.[15] He left much of his estate to Fitzwilliam College Cambridge, where it funded a chapel and a scholarship in natural sciences.

'Ian never was an ordinary fellow,' declared Harold Plenderleith, his long-time collaborator at the British Museum.[16] Plenderleith too was under no illusion about the importance of their work during the war. As far as he was concerned, at Westwood 'much valuable experience had been gained', and he fully expected that 'this knowledge will be applied in the remodelling of our museums after the war, so that the national treasures can be adequately housed and suitably displayed.'[17] He rose to be one of the world's most distinguished conservation scientists. After the war he was made Keeper of the British Museum's Research Lab, then from 1959 to 1970 he was Director (its first) of UNESCO's International Centre for the Study of the Preservation and Restoration of Cultural Property in Rome, set up in response to the cultural

devastation of the Second World War.[18] He died in 1997 in his hundredth year. His dream that the environmental storage conditions which he had established before the war, and that he and Rawlins had tested during the war in their respective repositories at Westwood and Manod, could be of use to heritage organisations came true. They became the basis – now much refined – for today's internationally recognised building standards for the preservation of museum, gallery, archive and library materials.[19]

The Royal Collection pictures returned from Manod to Windsor and Buckingham Palace in October and November 1945.[20] Clark's erstwhile deputy at the Royal Collection, Ben Nicolson, survived the war and took up the editorship of the *Burlington Magazine* in 1947 until his death. In his hands the magazine became the most well-respected history of art journal in the world. The Rubens ceiling was removed from Hall Barn in July 1945, taken to Kensington Palace where the panels were restored, and reinstalled at the Banqueting House in Whitehall in 1950.[21]

The Tower of London had been damaged in the war, and the Jewel Tower was to be re-presented to the public as part of the restoration. So the Crown Jewels were transferred from Windsor, in thirty-four cases under armed escort, to a strongroom in the Bank of England until the Tower was ready.[22] Thoroughly cleaned and with the most precious stones reinstated in their settings by Garrard's, they reinstated in the Tower in October 1947 and were put on public display a week later. Nearly six years later they glittered in the lights of the first televised coronation, at Westminster Abbey; some 277 million people across the world watched the ceremony.[23]

A group of Scottish students succeeded in stealing the Stone of Destiny from the Coronation Chair in Westminster in 1950, returning it the following year. In 1996, the UK government ordered the removal of the stone from the

Chair, and it was transferred to Edinburgh Castle to sit beside the Honours of Scotland between coronations. At the end of the war, Lawrence Tanner married Joan Curzon, great-niece of the former Viceroy. He had met her while evacuated to Houghton in Hampshire with the Westminster Abbey muniments and they had discovered a shared love of antiquities, local history and each other. 'Westminster was a somewhat desolate place when we returned to it after peace had been declared,' he recalled in his memoirs. Much was rebuilt, 'but for some of us the wounds inflicted on that terrible night, when so much that I had known and loved all my life was destroyed, have never completely healed.'[24] His ashes are buried in the Islip Chapel in the Abbey, where the Stone of Destiny was secreted during the war. Those of Sir Charles Peers were also interred in the Chapel.

Domesday Book and the other treasure items of the Public Record Office returned to Chancery Lane on 26 July 1945, with the remainder of the items from Shepton Mallet following six months later.[25] Like the British Museum Library, the Public Record Office also made technological advances during the war as a result of the evacuation: a Kodak microfilm camera from the USA was put into operation at Shepton Mallet, making surrogate copies of its holdings, a practice which was continued until photography went digital at the end of the century.[26] Hilary Jenkinson did not take part in the Domesday return. That was because in 1943 he had joined MFA&A, better known by its nickname of 'the Monuments Men'. The (second) A – for 'Archives' – in its name was largely due to him, and his insistence that archives should be protected not only for historic reasons, but also as legal evidence, influenced the operations of the Allied forces, as he accompanied them as they liberated Italy. He also went on Allied operations in western Germany and Austria between 1944 and 1945, and advised on the record keeping of

the Nuremberg Tribunal in 1946.[27] He became Deputy Keeper of Public Records in 1947 and was knighted in 1949.

Noel and Giana Blakiston returned to their house in Chelsea after leaving Clandon. He continued as an archivist at the Public Record Office after the war, but also became a successful journalist and historian of the Risorgimento. She in turn wrote a distinguished biography of her ancestors, the Russells of Woburn. Their eldest daughter Caroline, who lived with them in the basement at Clandon during the war, became an actress and a familiar face on TV in Britain from the 1970s onwards. She would become known around the world, however, for a small but memorable part in *The Return of the Jedi* and also starred, in 2015, as Aunt Agatha in the BBC's adaptation of *Poldark*.

John Rothenstein was devastated by the death of his beloved father in 1945. The post-war years at the Tate saw the building repaired and reopened under his directorship and the acquisition of a number of significant works for the collection. He was knighted in 1952. His most infamous post-war moment came when he punched the art historian and collector Douglas Cooper, knocking his glasses off, during an exhibition opening at the height of the 'Tate Affair' scandal in 1954. Ten years later he retired to Oxfordshire, and proceeded to write three volumes of autobiography: surely enough for anyone, even someone who liked the sound of their own prose.[28]

Gabrielle de Montgeon died at Eastington Hall in the summer of 1944, eleven days after her companion Donnie Donisthorpe, aged sixty-eight.[29] That other couple, their friends Helena Gleichen and Nina Hollings, moved from Hellens when their perennial shortage of money finally caught up with them in June 1943: 'not that either of us wants to sell Hellens, it makes us <u>very sad</u> but needs must when the devil drives.'[30] The manor was bought by Hilda

Pennington-Mellor, a cousin of Helena's and a descendant of its original owners, the Walwyn family. Helena and Nina bought 'a nice little house (if anything is nice after Hellens) near Malmesbury 7 bedrooms and 3 sitting rooms'. Helena hoped to make an artist's studio there using some labourers 'out of the pigstyes'.[31] Her death at a nursing home in Gloucestershire, from a heart attack aged seventy-five, in 1947, was notified to the Registrar by her nephew Roger, who had convalesced at Hellens surrounded by the Tate pictures in the summer of 1940. Nina died the following summer, aged eighty-six. Hilda was the wife of the physician and author Axel Munthe, and the family set up a trust to run Hellens, which was opened to the public.

Muriel and Stuart Keep had a few years of happiness together. They did not move far from Montacute after the wedding, settling for an idyllic two-bedroomed thatched cottage in nearby Long Sutton with a large garden, inglenook fireplaces and wooden beams. Stuart died there from a heart attack in 1952. Muriel outlived her husband, but two years before his death she had been admitted to the Tone Vale Mental Hospital near Taunton with early onset dementia. From being 'intelligent, bright and cheerful', she had become 'a rather simple childish woman' with significant memory loss, and was unable to care for herself or her husband. The various muscle and back problems she had had before and during the war were, in addition, finally diagnosed as multiple sclerosis. She died of pneumonia, a complication of the MS, in the summer of 1956 aged fifty-seven.[32] A friend completed a final article on her behalf for the *Burlington Magazine*.[33]

As with the evacuated children leaving their rural homes, some partings were sad. The National Portrait Gallery collections left Mentmore, after their very pleasant sojourn there, straight after VE Day. 'Six years is a long time,' wrote Charles Edmunds, the land agent, to Henry Hake.

At the commencement of the stay we were all strangers to one another; the end of it was the parting of real friends; the whole parish will join in this. You will all be missed. I want you to thank your side not only for their friendship but also for what friendship implies; the willingness to help one another in so many ways and you fitted in so well with our village life. Any of you will always be welcome if ever they pay us a visit. The stay here of the NPG was one of the bright spots in a time of universal sorrow and trouble.[34]

Henry Hake was knighted in the New Year's Honours of 1947, while his counterpart at the Wallace Collection, James Mann, followed him the year after, and became Surveyor of the King's Works of Art after Kenneth Clark, a post which he also held under Elizabeth II until his death in 1962.

Tom Kendrick, the Keeper of British and Medieval Antiquities, succeeded Sir John Forsdyke as the British Museum's Director in 1950. The year before, he published his long-awaited *Late Saxon and Viking Art*, which his friends noticed had been unaccountably delayed. In it, he acknowledged

an irredeemable debt to my colleague Elizabeth Senior, who was killed in 1941, for she gave me invaluable assistance with her camera and her sketch-book, and I know well that her sensible suggestions and courageous opinions have brightened and improved almost every chapter I have written.

Colleagues remembered him as a sociable and witty man, a courteous and encouraging leader, but also complex and private, prone to 'despondencies'. Sally Senior only found out once she had children of her own that her mother's old friend, 'Uncle Tom', was in fact her father. He had written letters to her throughout her childhood; 'they were wonderful . . . and so funny,' and 'he was brilliant' with her children, his grandchildren. In 1962 he wrote a semi-autobiographical

novel featuring 'a beautiful young bluestocking', who was a thinly disguised version of Betty. He died in 1979. 'All my life I have been taking trains to the wrong destinations,' he said in a final speech to an archaeological conference, 'but oh, my dears, how enchanting have been the views out of the window.'[35]

Epilogue

IN 1943, THE War Cabinet Office had the bright idea of commissioning an account of the experiences of the national museums and galleries over the previous five years. The editor was to be Professor Keith Hancock of the University of Birmingham, who was undertaking with a team of researchers the work of producing a civil series of official war histories, which would eventually run to thirty volumes. That would be one of them. At the V&A they had the ideal person on hand to write their report. Although Muriel Clayton had been 'crippled with sciatica for the last few weeks', she had written what Eric Maclagan described as 'a rather voluminous and I think extremely interesting report on our war activities', which he would supply after she had made some revisions. When the reports came in (not all of them did), one mandarin was distinctly unimpressed:

> I have read most of this History and my general comment is that is quite unsuitable for publication. It is much too long and detailed . . . which may be of interest to the author's successors but cannot possibly be of any interest to anyone else.

In 1945 Professor Hancock's own views were reported back:

> Most of the material in the histories will be of no interest to the public and need hardly be published . . . certain items will be of interest, such as the preservation of important objects, and if a collective history as between the different museums could be made by some writer, then he thought the public would

read it with interest. The problem would be to get a writer . . .
no one at work in the museums could possibly find time to
write this history as immediately after the war the pressure on
the museums' staffs will be very heavy . . . Professor Hancock
feels that at some time someone . . . may be able to make
a readable story out of the experiences of the Museums &
Galleries. But the time has not come for this, and meanwhile
no action is required.

The project was abandoned.[1]

Acknowledgements

I AM MOST grateful to a range of friends, contacts and new acquaintances for their input into this book, including Gareth Hughes, Nick Kingsley and Adrian Tinniswood, and Jeremy Musson for country house information. To Karey Draper for her thoughts (and thesis) on Boughton in wartime, my thanks. Sylvia Valentine, Simon Fowler and Chris Paton provided genealogical pointers and the Ulster Historical Foundation enabled me to find the crucial missing part of the jigsaw in Muriel Clayton's life. At the National Library of Wales, I was generously aided by Martin Robson Riley and Lorena Troughton; and to Christopher Catling my great appreciation for arranging a visit to the ARP Tunnel there. Justine Peberdy and Kieran Terry kindly showed me round Hellens, including a viewing of Lady Helena's shooting brake.

Others to whom I am indebted are Crispin Powell, Archivist at Boughton; Morwenna Blewitt; Sarah MacDougall; Jessamy Carlson and Melinda Haunton at The National Archives; Francis Knights; Mike Overend; Chris Green; Francis O'Gorman; Jane Spooner and Tom Drysdale at Historic Royal Palaces; Matthew Payne at Westminster Abbey Muniments; Bill Stockting at the Royal Archives; Morwenna Roche at the Wallace Collection library; Clare Wichbold; Arnold Hunt; Katie Birkwood; Liam Sims; Elizabeth Hallam Smith; Christopher Marsden at the V&A archive; Francesca Hillier and Myriam Upton at the British Museum central archives; Jane Kennedy at the Tate archive; Zara Moran at the National Gallery archive; Emily Naish at Salisbury Cathedral archives;

and Marjorie Caygill and Christopher Date for information about Charles Waterhouse. My gratitude also to David Adshead who generously read parts of the text. Andrew Oddy very kindly passed on a range of references to Harold Plenderleith's work and granted me permission to use a transcript of his oral history interview with the great man.

My thanks also to colleagues in the Senior Common Room at Girton College Cambridge for providing such a congenial place to work and think, and to Gladstone's Library for making me a Political Writer in Residence in 2017.

Extracts from the records of the British Museum are by kind permission of the Trustees of the British Museum.

Extracts from the records of the National Library of Wales are by kind permission of the Board of Trustees of the National Library of Wales.

Extracts from the records of Westminster Abbey Muniments are by kind permission of the Dean and Chapter of Westminster.

The extracts from Evelyn Waugh, *Men at Arms* published by Penguin Classics. Copyright © The Estate of Evelyn Waugh 1952. Reproduced by permission of the Penguin Random House Group.

The extracts from James Lees-Milne, *Ancestral Voices and Prophesying Peace: Diaries, 1942–1945* (London: John Murray, 1995) and *Holy Dread: Diaries, 1982–1984* (ed. Michael Bloch) (John Murray, 2001) are reproduced courtesy of Michael Bloch and David Higham Associates.

Every reasonable effort has been made to trace copyright holders, but if there are any errors or omissions, John Murray will be pleased to insert the appropriate acknowledgement in any subsequent printings or editions.

I apologise to all those London institutions who have not found a place in this book: the stories I uncovered could have filled another entire volume and there just wasn't space.

As a proud graduate of Scotland's oldest university, I am, of course, aware that Edinburgh and Glasgow are full of national treasures, and I hope that at least the inclusion of some Scottish characters here is recompense for not including more about evacuations north of the border.

I was very fortunate to receive a Lambarde Travel Grant from the Society of Antiquaries and a Minor Research Grant from the Bibliographical Society of London to support a crucial research trip to Aberystwyth and Bangor in 2019. They made all the difference. The Society of Authors also very generously gave me a work-in-progress grant from the Authors' Foundation, greatly boosting the writing time and energy of its author, which proved to be even more welcome when the 2020 Coronavirus pandemic hit a few months later.

This book could not have been completed without the extraordinary efforts of the staff of Cambridge University Library to supply online resources and hard-copy books in safety to its users during three English COVID-19 lockdowns.

I am, as ever, hugely privileged to have Bill Hamilton as my agent, and now Joe Zigmond as my editor at John Murray. I thank them both for their enthusiasm and tactful encouragement at various stages of the creation of this book.

And finally Mark Purcell knows what I think about his willingness to discuss, proofread and comment on this book at all its stages; and for the regular supply of shepherd's pie and glasses of claret during its creation, when he himself was working flat out.

Picture Credits

Notes

Abbreviations

1939 Register	1939 Register, 29 September 1939 via www.findmypast.co.uk
BM	British Museum central archives, London
Bodleian	Bodleian Library archives, Oxford
Boughton	Boughton House archives, Kettering
IWM	Imperial War Museum archives, London
NG	National Gallery archives, London
NLW	National Library of Wales, Aberystwyth
NPG	National Portrait Gallery archives, London
ODNB	*Oxford Dictionary of National Biography*
PA	Parliamentary Archives, London
RA	Royal Archives, Windsor
Tate	Tate archives, London
TNA	National Archives, London
V&A	Victoria & Albert archives, London
WAM	Westminster Abbey Muniments, London
WCA	Wallace Collection archives, London

Chapter 1: The Abyss of a New Dark Age

1. NLW, Corporate Archives XI/17, 7 October 1939.
2. Daniel Todman, *Britain's War: Into Battle, 1937–1941* (London: Penguin, 2017), 258–63.
3. NLW, *Printed Minutes of the Court of Governors*, 14 June 1945, no. 14; William Llewelyn Davies, 'War-Time Evacuation to the National Library of Wales', *Transactions of the Honourable Society*

of Cymmrodorion, 1945 (London: Honourable Society of Cymmrodorion, 1946), 176–8.

4. TNA, AR 1/480, 6 September 1933.
5. TNA, WORK 17/118, ff.10–12, December 1934.
6. Quoted in Thad Parsons III, 'The Science Museum and the Second World War', in *Science for the Nation: Perspectives on the History of the Science Museum* (ed. Peter J. T. Morris) (Basingstoke: Palgrave Macmillan, 2013), 62, 86 n4.
7. Lynn H. Nicholas, *The Rape of Europa* (London: Macmillan, 1994), 50, 52.
8. Stephanie Barron, *'Degenerate Art': The Fate of the Avant-Garde in Nazi Germany* (New York: Harry N. Abrams, 1991), 9.
9. Ines Schlenker, 'Defining National Socialist Art. The First "Grosse Deutsche Kunstausstellung" in 1937', in Olaf Peters (ed.), *Degenerate Art: The Attack on Modern Art in Nazi Germany, 1937* (Munich, London and New York: Prestel, 2014), 98–9.
10. Ibid., 91 and *passim*.
11. Olaf Peters, 'Genesis, Conception, and Consequences: The "Entartete Kunst" Exhibition in Munich in 1937', in *Degenerate Art: The Attack on Modern Art in Nazi Germany, 1937* (Munich, London and New York: Prestel, 2014), 106–25 (106).
12. Barron, *'Degenerate Art': The Fate of the Avant-Garde*, 13.
13. Nicholas, *Rape of Europa*, 23–5.
14. Ibid., 37–44.
15. TNA, T 162/1000, part 3, Permanent Secretary of the Office of Works to the Permanent Secretary of the Treasury, 30 October 1937.
16. TNA, EB 3/9, 6 April 1938.
17. *Air Raid Precautions in Museums, Picture Galleries and Libraries* (London: British Museum, 1939), 7, 16, 23; additional biographical information on Plenderleith kindly supplied by Andrew Oddy.
18. Helen Little, 'Picasso in Britain, 1937–1939', in *Picasso & Modern British Art* (ed. James Beechey and Chris Stephens) (London: Tate Publishing, 2012), 163.
19. Ibid.
20. *Daily Telegraph*, 30 September 1938; TNA, EB 3/9.
21. WCA, AR2 53/I, 5.

22. TNA, EB 3/9, Forsdyke to Beresford, 26 November 1938.
23. TNA, EB 3/9, Appendix 1, Eric de Normann.
24. TNA, T 162/1000, part 3, Beresford to Tribe, 4 January 1939.
25. Ibid., 7 January 1939.
26. TNA, EB 3/9, Standing Commission on Museums and Galleries, memorandum of interview, 15 February 1939.

Chapter 2: Before Us an Ordeal of the Most Grievous Kind

1. A. van Schendel and H. J. Plenderleith, 'Ian Rawlins: I.I.C. Honorary Fellow', *Studies in Conservation*, 9.4 (1964), 123–5; Garry Thomson, 'F. I. G. Rawlins', *Physics Bulletin*, 20 (1969), 336.
2. I am grateful to Louise Slater at London Metropolitan University special collections and Adam Green at Trinity College Cambridge archives for supplying me with the respective details of Ian Rawlins' academic record.
3. *Who's Who*. I am grateful to Louise Clarke at Cambridge University Library for identifying the title of Rawlins' MSc (CUL MSc.b.5).
4. Kenneth Clark, *Another Part of the Wood: A Self-Portrait* (London: John Murray, 1974), 275. I am grateful to Professor Francis O'Gorman for the information from the Athenaeum members' website, that Rawlins joined the club in 1922.
5. James Lees-Milne, *Holy Dread: Diaries, 1982–1984* (ed. Michael Bloch) (London: John Murray, 2001), 94–5.
6. Kenneth Clark, *Another Part of the Wood*, 275.
7. Ibid., 270, 273–4.
8. Charles Saumarez Smith, *The National Gallery: A Short History* (London: Frances Lincoln, 2009), 128.
9. Jonathan Conlin, *The Nation's Mantelpiece: A History of the National Gallery* (London: Pallas Athene, 2006), 156.
10. Saumarez Smith, *The National Gallery*, 143.
11. Conlin, 158.
12. Kenneth Clark, *The Other Half: A Self-Portrait* (London: John Murray, 1977), 1.

13. Martin Davies and F. Ian G. Rawlins, 'The War-Time Storage in Wales of Pictures from the National Gallery, London. I The Course of Events. II Some Technical Problems', *Transactions of the Honourable Society of Cymmrodorion, 1945* (London: Honourable Society of Cymmrodorion, 1946), 179.

14. John Martin Robinson, *Requisitioned: The British Country House in the Second World War* (London: Aurum Press, 2014), 8, 10; Julie Summers, *Our Uninvited Guests: The Secret Lives of Britain's Country Houses 1939–45* (London: Simon & Schuster, 2018), 7.

15. TNA, T 162/1000, part 3, correspondence 27 February 1939, 13–30 March 1939.

16. Caroline Seebohm, *The Country House: A Wartime History, 1939–45* (London: Weidenfeld & Nicolson, 1989), 8.

17. Summers, 49.

18. NG, NG 16/20. See also Suzanne Bosman, *The National Gallery in Wartime* (London: National Gallery, 2008), 19.

19. NG, NG 16/20; Davies and Rawlins, 180.

20. Kenneth Clark, *Another Part of the Wood*, 276.

21. Robinson, *Requisitioned*, 138.

22. Davies and Rawlins, 179; Kenneth Clark, *Another Part of the Wood*, 275.

23. van Schendel and Plenderleith, 125.

24. Robinson, *Requisitioned*, 138; Kenneth Clark, *Another Part of the Wood*, 275. MacLaren was later loaned by Clark to help with arrangements for the protection of private collections and some local museums, from November 1941 to May 1942 (*Standing Commission on Museums and Galleries, Third Report. The National Museums and Galleries: The War Years and After* (London: HMSO, 1948), 5–6).

25. TNA, EB 3/9, Beresford to Charteris, 15 December 1938, Appendix 1.

26. Ibid., Beresford to Young.

27. Nicholas J. McCamley, *Saving Britain's Art Treasures* (Barnsley: Leo Cooper, 2003), 12.

28. Kenneth Clark, *Another Part of the Wood*, 276–7.

29. Davies and Rawlins, 179.

30. TNA, T 162/1000, part 3, 25 February 1939.

31. *Who's Who.*

32. NG, NG 16/20.

33. Davies and Rawlins, 185–6.

34. Kenneth Clark, *Another Part of the Wood*, 276–7.

35. *ODNB*; James Stourton, *Kenneth Clark: Life, Art and Civilisation* (London: William Collins, 2016), 87–8, 160.

36. Kenneth Clark, *Another Part of the Wood*, 276–7; Kenneth Clark, *The Other Half*, 31.

37. Alan Clark, *A Good Innings: The Private Papers of Viscount Lee of Fareham* (London: John Murray, 1974), 348.

38. Ibid., 349–50.

39. Bosman, 22; McCamley, 1; Davies and Rawlins, 185.

40. For the full story of the *Equestrian Portrait's* travels see Margaret Goldsmith, *The Wandering Portrait* (London: Weidenfeld & Nicolson, 1954).

41. Stourton, *Kenneth Clark*, 158.

42. Davies and Rawlins, 179.

43. Kenneth Clark, *Another Part of the Wood*, 277.

44. 1939 Register; *Crockford's Clerical Directory*, 1939.

Chapter 3: We Shall Defend Our Island

1. Victor Scholderer, *Reminiscences* (Amsterdam: Van Gandt, 1970), 30, 41–2.

2. Bernard Ashmole, *Bernard Ashmole 1894–1988: An Autobiography* (ed. Donna Kurtz) (Oxford and Oakville: Oxbow Books, 1994), 68–70; *Cleaning and Controversy: The Parthenon Sculptures 1811–1939*, British Museum Occasional Paper, no. 146 (London: British Museum, 2001), 20–1; *ODNB*.

3. *ODNB*.

4. 1939 Register, Amersham sub-district.

5. John Forsdyke, 'The Museum in War-Time', *British Museum Quarterly*, 15 (1941–50), 1.

6. NLW, Corporate Archives, G4/8: ARP – Quotations for Boxes.
7. David M. Wilson, *The British Museum: A History* (London: British Museum Press, 2002), 249; Marjorie Caygill, '1939: Evacuating the BM's Treasures', *British Museum Society Bulletin*, 62 (1989), 18.
8. Forsdyke, 1; Wilson, 249.
9. Forsdyke, 1; TNA, WORK 17/118, 28 March 1939.
10. TNA, WORK 17/118, 28 March 1939.
11. Alice, Duchess of Gloucester, *The Memoirs of Princess Alice, Duchess of Gloucester* (London: HarperCollins, 1983), 34.
12. Seebohm, 147.
13. TNA, WORK 17/118, f. 5, 17 January 1934.
14. Ibid., 6 March 1934.
15. Forsdyke, 2.
16. TNA, WORK 17/239, ff. 9, 32.
17. NLW, Corporate Archives, XI/98.
18. Ibid., G4/5, 19 and 23 January 1934.
19. *ODNB*.
20. David Jenkins, *A Refuge in Peace and War: The National Library of Wales to 1952* (Aberystwyth: National Library of Wales, 2002), 256–60.
21. Ibid., 255–6.
22. NLW, Corporate Archives, G4/5: ARP Correspondence, 17 January 1938, 18 February 1938, 22 February 1938, [n.d.] March 1938, 10 May 1938, 16 July 1938; TNA, T 162/1000, part 3, 22 June 1938, 8 July 1938.
23. W. Andrew Oddy, 'The Three Wise Men and the 60:60 Rule', *Past Practice – Future Prospects*, British Museum Occasional Paper, no. 145 (London: British Museum, 2001), 169–70.
24. TNA, T 162/1000, part 3, Plenderleith to Usher, 15 June 1938.
25. Ibid.
26. Ibid., 25 September 1938, 27 September 1938.
27. *ODNB*; *Welsh Dictionary of National Biography*.
28. NLW, Corporate Archives, G4/5: ARP Correspondence, 20 October 1938.
29. Ibid., 22 October 1938, 26 October 1938, 31 October 1938, 16 November 1938.

30. Forsdyke, 2.

31. BM, Second World War Records, Box 1, 'Adrian Digby Memoir', 1–5.

32. Ibid., 6–8, 17; Wilson, 249.

33. Ashmole, 73; Forsdyke, 2.

34. Forsdyke, 2.

35. BM, 'Adrian Digby Memoir', 9–10a; Forsdyke, 2.

36. Caygill, '1939: Evacuating the BM's Treasures', 17.

37. BM, 'Adrian Digby Memoir', 11–12, 15.

38. Ashmole, 73.

39. Scholderer, 42.

40. NLW, Corporate Archives, G4/5: ARP Correspondence, 25 October 1938, 6 February 1939.

41. Ibid., 24 August 1939.

42. Caygill, '1939: Evacuating the BM's Treasures', 20–1; Seebohm, 149.

43. *British Museum Standing Committee Minutes*, 14 October 1939, 5,594; Forsdyke, 2.

44. BM, 'Adrian Digby Memoir', 19–20.

45. John Colville, *The Fringes of Power: Downing Street Diaries 1939–1955*, rev. edn (London: Weidenfeld & Nicolson, 2004), 4–5.

46. TNA, WORK 17/118, 4 July 1939, f. 76. The memo from the Office of Works reads: 'we are having to face the position that the two houses near Kettering selected for the B.M. treasures are not sufficiently outside vulnerable areas, and we are advised to seek houses in Wales, away from the Swansea area, as has been done by the National Gallery.'

Chapter 4: You Ask What is Our Aim? It is Victory

1. Stourton, *Kenneth Clark*, 129; Adrian Clark, *Fighting on All Fronts: John Rothenstein in the Art World* (Norwich: Unicorn, 2018), 95; Kenneth Clark, *Another Part of the Wood*, 234–5.

2. Adrian Clark, 129.

3. Adrian Clark, 13, 17.

4. John Rothenstein, *Summer's Lease: Autobiography 1901–1938* (London: Hamish Hamilton, 1965), 34.

5. Adrian Clark, 28.
6. Ibid., 30.
7. Ibid., 14–15, 20–3, 95.
8. John Rothenstein, *Brave Day Hideous Night: Autobiography 1939–1965* (London: Hamish Hamilton, 1966), 54.
9. TNA, WORK 17/238, 29 October 1940.
10. Tate, TG 2/7/1/21, Fincham to de Normann, 21 September 1939.
11. TNA, WORK 17/197, September 1940; TNA, CAB 103/237 (Tate), 1.
12. Ethel Smyth, *As Time Went On . . .* (London: Longmans, Green & Co., 1936), 27, 29; *Who's Who*.
13. Smyth, *As Time Went On*, 27–8.
14. Ethel Smyth, *What Happened Next* (London: Longmans, Green & Co., 1940), 259.
15. The account of their exploits during the war occupies much of Helena Gleichen, *Contacts and Contrasts* (London: John Murray, 1940; reprinted Kilkerran: Mansion Field, 2013); Olinka Koster, 'The Mother Who Went to War in 1916 after Learning Her Son Had Been Killed in the Trenches', *Daily Mail*, 21 March 2008.
16. Virginia Nicholson, *Singled Out: How Two Million Women Survived Without Men After the First World War* (London: Viking, 2007), 201.
17. Gleichen, 41, 306, 324; Smyth, *What Happened Next*, 120.
18. Val Brown, *Toupie Lowther: Her Life* (Kibworth Beauchamp: Matador, 2017), 92; Hugh Neems, *The Giant's Children* (n.p., 2016), 56–7.
19. Neems, 57; Brown, 93–5.
20. Rothenstein, *Brave Day*, 54.
21. Tate, TG 2/7/1/21, Fincham to de Normann, 21 September 1939; Rothenstein, *Brave Day*, 57.
22. Tate, TG 2/7/1/21, 21 September 1939, 29 September 1939.
23. Kenneth Clark, *Another Part of the Wood*, 232–3.
24. Rothenstein, *Brave Day*, 106–7.
25. Anthony Burton, *Vision & Accident: The Story of the Victoria and Albert Museum* (London: V&A Publications, 1999), 195.
26. Nicholson, 22–3.

27. Ibid., 25.
28. Ibid., 119, 288–91.
29. John D. Cantwell, *The Public Record Office 1838–1958* (London: TSO, 1991), 398.
30. Information from Muriel Clayton's student records in Manuscripts and Archives Research Library, Trinity College Dublin, and Senate House Library archives, University of London; birth, family and other information gathered from findmypast. com and ancestry.com.
31. Muriel Clayton, *A Gust of Wind and Other Stories* (London: A. H. Stockwell, 1925).
32. Burton, 181.
33. Muriel Clayton, *The Print Collector* (London: Herbert Jenkins, 1929), viii.
34. TNA, CAB 102/473 (V&A), 1–3.
35. Ibid., 3.
36. Ibid., 8–9, 11.

Chapter 5: For Without Victory There is No Survival

1. Obituary, *The Times*, 30 January 1969, 8.
2. *ODNB*; 'A National War Museum: What France has done', *The Times*, 20 February 1917, 11.
3. *ODNB*.
4. TNA, CAB 102/473 (IWM), 1.
5. Ibid., 3. The other two paintings were probably Sargent's *Surrender of the German Fleet* and Hughes-Stanton's *St Quentin Canal*, which were prepared for a move during the Munich Crisis, though this did not occur (see IWM, EN/1/COB/48/3, Standing Committee minutes, 11 October 1938).
6. TNA, CAB 102/473 (IWM), 6–7, 14.
7. TNA, AR 1/480, 20 April 1934.
8. WCA, AR2 53/I, 1.
9. TNA, WORK 17/250, 13 January 1940; WCA, AR2 53/I, 3, 5.
10. *ODNB*; WCA, AR2 53/I, 2.

11. Robert C. Woosnam-Savage, 'Olivier's *Henry V* (1944): How a Movie Defined the Image of the Battle of Agincourt for Generations', in *The Battle of Agincourt* (ed. Anne Curry and Malcolm Mercer) (New Haven and London: Yale University Press, 2015), 254–5.

12. WCA, AR2 53 F/1, 28 September 1938; WCA, AR2 53/I, 7.

13. Lucia Lawson, *Of Old I Hold: My Life in a Newspaper Family* (Dublin: Linden, 2008), 81–2, 84.

14. Cantwell, 425–7.

15. Elizabeth M. Hallam, *Domesday Book Through Nine Centuries* (London: Thames & Hudson, 1986), 168–9.

16. Cantwell, 428; C. T. Flower, 'Manuscripts and the War', *Transactions of the Royal Historical Society*, 25 (1943), 17.

17. Flower, 17.

18. Cantwell, 428.

19. Ibid., 429.

20. TNA, CAB 103/237, 31 December 1943 for this, and what follows. Hake's memoir is transcribed in full, though unreferenced, in John Martin Robinson, *The Country House at War* (London: Bodley Head, 1989), 89–93, and also partly reproduced in Robinson, *Requisitioned*, 128–9. Edmunds' domestic arrangements from 1939 Register.

Chapter 6: We Shall Fight in the Fields and in the Streets

1. I am grateful to Chris Green for drawing this episode to my attention.

2. James Lees-Milne, *Ancestral Voices and Prophesying Peace: Diaries, 1942–1945* (London: John Murray, 1995), 74.

3. 1939 Register.

4. Karey L. Draper, 'The English Country Estate: Contributions and Consequences of Requisition in the Second World War' (unpublished M.St thesis in Building History, Cambridge, 2013), 22. The arrangements were recorded by Charles Waterhouse, the Museum's in-house illustrator, in 1941 when

he was despatched to Boughton to sketch them before they headed off once again to a new home.

5. Boughton, WW2 Box, Bennit to Wycherley, 2 April 1942.

6. Draper, 23.

7. Boughton, WW2 Box, 'Notes re behaviour of Museum Staff at Boughton House', 1–2; and 'Boughton House – British Museum', 6; 1939 Register, for household members.

8. BM, 'Adrian Digby Memoir', 22–7.

9. Ibid., 29–35, 38, 41; W. Andrew Oddy, 'Harold Plenderleith's Reminiscences of the Second World War at the British Museum', oral interview transcript (Dundee: 11 June 1987), n. 18. The interview took place at Plenderleith's home in Dundee. I am most grateful to Andrew Oddy for sharing this transcription with me.

10. BM, 'Adrian Digby Memoir', 34, 38–40, 45–6.

11. W. Andrew Oddy, 'ARP at the British Museum in the Second World War', *The Staircase*, 13.3 (2008), nn. 51–3; 'Harold Plenderleith's Reminiscences', n. 14.

12. BM, 'Adrian Digby Memoir', 48–53.

13. Todman, 271.

14. BM, 'Adrian Digby Memoir', 29.

15. Marjorie Caygill, 'The British Museum at War', *British Museum Magazine* (1990), 37.

16. BM, 'Adrian Digby Memoir', 55–9.

17. Ibid., 59–61.

18. Jacob Leveen, 'The British Museum Collections in Aberystwyth', *Transactions of the Honourable Society of Cymmrodorion, 1945* (London: Honourable Society of Cymmrodorion, 1946), 194–5.

19. Ibid., 194–7.

20. Scholderer, 42–5.

21. Leveen, 197.

22. Scholderer, 45.

23. NLW, Corporate Archives, G4/14.

24. Ibid., G4/5: ARP Correspondence, 31 October 1939, 8 November 1939, 20 November 1939; ibid., G4/14: ARP construction of tunnel, heating and ventilation [n.d].

25. Ibid., G4/5: ARP Correspondence, 12 January 1940.
26. Forsdyke, 3.
27. *British Museum Standing Committee Minutes*, 14 October 1939, 5,597.
28. Rupert Bruce-Mitford, 'Thomas Downing Kendrick', in *Interpreters of Early Medieval Britain* (ed. Michael Lapidge) (Oxford: British Academy, 2002), 415.
29. Ibid., 401–2.
30. H. V. Morton, 'London in Wartime: Your Buried Treasure', *Daily Herald*, 17 April 1940, 6.
31. Ibid.

Chapter 7: We Shall Fight in the Hills

1. Davies and Rawlins, 180–1; NG, NG Martin Davies 1939, Registry File 59.1, 27 September 1939; NLW, Corporate Archives, XI/85 (General File), 7 September 1939.
2. Kenneth Clark, *The Other Half*, 2.
3. *ODNB*; Stourton, *Kenneth Clark*, 114.
4. Kenneth Clark, *The Other Half*, 2.
5. Morwenna Blewitt, 'A Safe Haven: Refugee Restorers and the National Gallery, London', in *ICOM-CC 17th Triennial Conference Preprints, Melbourne, 15–19 September 2014* (ed. J. Bridgland) (Paris: International Council of Museums, 2014), 1–4; Ulrik Runeberg, 'Immigrant Picture Restorers of the German-Speaking World in England from the 1930s to the Postwar Era', in *Arts in Exile in Britain 1933–1945: Politics and Cultural Identity* (ed. Shulamith Behr and Marian Malet), *Yearbook of the Research Centre for German and Austrian Exile Studies*, 6 (2005), 341, 350, 354.
6. Florence Hallett, 'David Bomberg: Better Late Than Never', *New European*, 7 November 2017. See also Stourton, *Kenneth Clark*, 193, though Stourton omits the racial slur.
7. Nicholson, 152; *ODNB*; Kenneth Clark, *The Other Half*, 27–30; Bosman, 35–52.

8. V&A, ED 84/27, Clayton to Maclagan, 31 July 1940.
9. The Clayton family history and what follows has been constructed from searches on findmypast.com and ancestry.com.
10. Susan Parkes (ed.), *A Danger to the Men? A History of Women in Trinity College Dublin 1904–2004* (Dublin: Lilliput Press, 2008), 90–1, 95.
11. Karolyn Shindler, 'Natural History Museum: A Natural Wartime Effort that Bugged Owners of Period Homes', *Daily Telegraph*, 28 September 2010.
12. TNA, WORK 17/180, 12 September 1939, [n.d.] June 1940, 18 March 1941.
13. *ODNB*; 1939 Register.
14. Cecil Beaton, *The Book of Beauty* (London: Duckworth, 1930), 28; National Portrait Gallery, image NPGx199921; Obituary, *The Times,* 11 September 1962, 17; 1939 Register.
15. TNA, CAB 102/473 (IWM), 2.
16. TNA, WORK 17/180, 31 August 1939.
17. NG, NG Martin Davies 1939, Registry File 59.1, 7 September 1939, 21 October 1939, November 1939.
18. Davies and Rawlins, 186.
19. Ibid., 186–7.
20. NPG, NPG66/6/2/2, 5 September 1940.
21. TNA, CAB 103/237 (Tate), 31 December 1943; NPG, NPG66/6/2/2, 23–4 February 1940.
22. Adrian Clark, 106.
23. Adrian Clark, 109.
24. TNA, WORK 17/195, 9 November 1939, 29 November 1939.
25. Malcolm Munthe, *Hellens: The Story of a Herefordshire Manor*, 2nd edn (London: Sickle Moon, 2012), 154.
26. Gleichen, 335, 337.
27. Tate, TG 2/7/1/43, February 1940; Gleichen, 337.
28. Tate, TG 2/7/1/43, 21 March 1940.
29. Kenneth Clark, *The Other Half*, 3.
30. Stourton, 158.
31. Runeberg, 351; Kenneth Clark, 'Johannes Wilde', *Burlington Magazine*, CIII.699 (1961), 205; *ODNB*.

32. Stourton, 158.
33. NG, NG Martin Davies 1939, Registry File 59.2, 4 January 1940.
34. Davies and Rawlins, 181.

Chapter 8: We Shall Fight on the Beaches

1. Midge Gillies, *Waiting for Hitler: Voices from Britain on the Brink of Invasion* (London: Hodder & Stoughton, 2006), 150–1, 156–7.
2. Todman, 377; Rothenstein, *Brave Day*, 49–50.
3. Adrian Clark, 106.
4. Todman, 375, 377.
5. BM, Second World War, Box 3, File: 'Political Credentials of Temporary Staff, 1940'.
6. Rothenstein, *Brave Day*, 61.
7. Gillies, 56.
8. Ibid., 120.
9. Scholderer, 44.
10. Ashmole, 74.
11. TNA, CAB 103/237, 31 December 1943.
12. Tate, TG 2/7/1/43, 23 May 1940; Gillies, 56.
13. Tate, TG 2/7/1/43, Chappin to Rothenstein [May 1940].
14. Ibid., 29 May 1940, 28 June 1940.
15. Stourton, 158.
16. NG, NG Registry File 4.2, ARP Precautions 1939–41, Bevir to Clark, 1 June 1940 and Clark to Gibson, 4 June 1940; Colville, 117, 678. A more poetic account is given in Kenneth Clark, *The Other Half*, 5: 'When pressure was put on me to export the pictures I sent a short memorandum to Mr Churchill. It came back the same day, with a note in red ink "Bury them in the bowels of the earth, but not a picture shall leave this island, W.S.C." Like a fool I never had this document photographed. I took it to the Treasury and the Office of Works, and they authorised me to look for a suitable hiding place.'
17. NG, NG Martin Davies 1940, Registry File 59.2, 5 June 1940.

18. Cantwell, 427; TNA, PRO 1/416, 17.

19. TNA, CAB 102/473 (V&A), 14–15; V&A, ED 84/267, Holmes to Maclagan, Board of Education, 21 June 1940.

20. BM, 'Adrian Digby Memoir', 62.

21. Draper, 27.

22. Ibid., 28.

23. BM, 'Adrian Digby Memoir', 62–3.

24. Walter Schellenberg, *Invasion 1940: The Nazi Invasion Plan for Britain* (ed. John Erickson) (London: St Ermin's, 2000), 29–30.

25. Ibid., 25–6.

26. Ibid., 97–9, 107, 222, 238.

27. Lawson, 320.

28. Scholderer, 42.

29. Schellenberg, 148.

30. Stourton, 214.

31. Carola Hicks, *The Bayeux Tapestry: The Life Story of a Masterpiece* (London: Chatto & Windus, 2006), 206–12.

32. Ibid., 218–25.

33. Ibid.; *The Times*, 27 October 1941, 5.

34. Hicks, 240–2.

35. Hilary Jenkinson, 'British Archives and the War', *American Archivist*, 7.1 (1944), 17.

36. TNA, CAB 102/473 (IWM), 12.

37. V&A, ED 84/267, 14 July 1940.

38. Davies and Rawlins, 181.

39. Ibid., 187.

40. NLW, Corporate Archives, ARP Arrangements, XI/17, 24 June 1940.

41. Kenneth Clark, *The Other Half*, 4; Kenneth Clark, 'Johannes Wilde', 205; *ODNB*.

42. Leveen, 198.

43. Scholderer, 44–5.

44. Davies and Rawlins, 181.

45. Ibid., 188.

46. NG, Registry File 4.2, ARP Precautions 1939–41, Clark to Gibson, 4 June 1940.

47. Alan Clark, 350.
48. Davies and Rawlins, 181, 188.

Chapter 9: Blood, Toil, Tears and Sweat

1. Christian Wolmar, *The Subterranean Railway: How the London Underground Was Built and How It Changed the City Forever* (London: Atlantic, 2012), 288.
2. Rothenstein, *Brave Day*, 81–2.
3. Ibid., 81–3.
4. Cantwell, 431.
5. TNA, PRO 1/416, 2, 7, 12.
6. NPG, NPG66/1/7, 3 November 1943.
7. Forsdyke, 3; Caygill, 'The British Museum at War', 37. For detailed statistics and an analysis of what was lost, see Adrian S. Edwards, 'Destroyed, Damaged and Replaced: The Legacy of World War II Bomb Damage in the King's Library', *EBLJ* Article 8 (2013), 1–31.
8. Oddy, 'ARP at the British Museum in the Second World War', nn. 57–9.
9. Forsdyke, 3–4.
10. BM, 'Adrian Digby Memoir', 68–71.
11. Ibid., 63–5, 71.
12. Draper, 28–9.
13. *ODNB*.
14. Rothenstein, *Brave Day*, 85, 88–9; TNA, WORK 17/196, 19 September 1940, 8 October 1940, 18 October 1940, 8 November 1940.
15. TNA, WORK 17/197, 29 January 1941.
16. Rothenstein, *Brave Day*, 125.
17. Colville, 226. Beresford's body was discovered on 26 October 1940; he had perished in the attack mentioned by Churchill's private secretary, Jock Colville, on 17 October. Colville described 'the complete destruction of a large part of the Treasury' and the death of four members of the Treasury ARP in it. Beresford was either one of these four, as his death certificate records the cause

as 'war operations', or he may have remained at his desk during the raid.

18. Stourton, 175; Bosman, 65.
19. TNA, WORK/17/196, 29 October 1940.
20. TNA, CAB 102/473 (V&A), 389.
21. 1939 Register.
22. *Flight & Aircraft Engineer*, lxiii, 2 January 1953, 11 and xvi, 15 May 1924, 280.
23. Munthe, 155; Tate, TG 2/7/1/43, 27 November 1940; Herefordshire Archives and Records Centre, E69/453, Gleichen to Constance Radcliffe Cooke, 27 September 1946.
24. Tate, TG 2/7/1/43, 27 November 1940.
25. TNA, CAB 103/237, 31 December 1943.
26. NPG, NPG66/6/2/2, 16 January 1941.
27. RA, LC/LCO/AR/1941, Chapels.
28. Robinson, *Requisitioned*, 128; NPG, NPG66/6/2/2, 12 March 1941, 13 March 1941.
29. TNA, CAB 103/237, 31 December 1943.
30. TNA, WORK 17/195, 26 January 1941, 3 March 1941, 17 March 1941.
31. TNA, WORK 17/196, 21 March 1941; TNA, WORK 17/195, 23 April 1941.
32. Ibid., 22 November 1940, 3 December 1940, 16 December 1940.
33. Ibid., 6 December 1940.
34. TNA, CAB 103/237 (Tate), 1.
35. Forsdyke, 5.
36. Seebohm, 150–1.
37. W. Andrew Oddy, 'ARP at the British Museum', 3–18.
38. Draper, 33; Seebohm, 151.
39. Norman Longmate, *How We Lived Then: A History of Everyday Life During the Second World War* (London: Hutchinson, 1971), 226.
40. H. V. Morton, 'Wardens for Wild Animals', *Daily Herald*, 6 April 1940, 6.
41. Ibid., 6.

42. Longmate, 225.
43. Morton, 'Wardens', 6; Longmate, 226–7.
44. Seebohm, 21, 123.
45. *ODNB*; Seebohm, 121.
46. Seebohm, 147–8; D. M. S. Watson, 'Clive Forster-Cooper (1880–1947)', *Obituary Notices of Fellows of the Royal Society*, 30 November 1950, 7:19.
47. Lees-Milne, *Ancestral Voices*, 35.
48. TNA, CAB 102/473 (IWM), 9; TNA, WORK 17/180, 29 June 1940, 2 July 1940, 9 July 1940, 11 July 1940 and *passim*, 9 September 1940.
49. TNA, WORK 17/180, 29 September 1939, 23 October 1940, [n.d.] 1941.
50. Parsons, 63, 66, 72–4.
51. IWM, EN2/1/ACC/4/7, 1 February 1941.
52. Ibid., 5 February 1941.
53. IWM, EN2/1/ACC/4/1–25 and *passim*; IWM, EN2/1/ACC/4/25, 19 February 1941.
54. TNA, CAB 102/473 (IWM), 25.
55. IWM, EN2/1/ACC/4/28, 5 March 1941, 26 June 1941, 10 May 1946.
56. TNA, CAB 102/473 (IWM), 12.

Chapter 10: All That We Have Loved and Cared For

1. TNA, HO 205/376, 5 September 1939.
2. William Shawcross, *Queen Elizabeth the Queen Mother: The Official Biography* (London: Macmillan, 2009), 522–3.
3. Andrew Stewart, *The King's Private Army: Protecting the British Royal Family During the Second World War* (Solihull: Helion, 2016), 16–17.
4. Ibid., 19–20, 101–3.
5. Ibid., 108, 110.
6. Ibid., 127.
7. Shawcross, 493.

8. James Pope-Hennessy, *Queen Mary 1867–1953* (London: Allen & Unwin, 1959), 596.
9. James Pope-Hennessy, *The Quest for Queen Mary* (ed. Hugo Vickers) (London: Hodder & Stoughton, 2018), 300–1.
10. Shawcross, 496; Stewart, 18.
11. Pope-Hennessy, *The Quest for Queen Mary*, 302.
12. James Lees-Milne, *Through Wood and Dale: Diaries, 1975–1978* (London: John Murray, 1998), 75.
13. Pope-Hennessy, *Queen Mary*, 599–603; Pope-Hennessy, *The Quest for Queen Mary*, 306.
14. Marion Crawford, *The Little Princesses* (London: Duckworth, 1993), 73.
15. TNA, WORK 28/20, 22 September 1938, 14 October 1938, 25 October 1938, 16 November 1938, 29 December 1938.
16. Ibid., 29 August 1939.
17. H. V. Morton, 'The Crown Jewels Are Evacuated', *Daily Herald*, 18 April 1940, 6.
18. Ibid.
19. RA, QM/PRIV/CC48/969, 12 June 1941.
20. RA, LC/LCO/AR/1939, Miscellaneous.
21. RA, LC/LCO/AR/1940.
22. RA, QM/PRIV/CC48/863, 28 August 1939.
23. Pope-Hennessy, *Queen Mary*, 604.
24. *ODNB*; Shawcross, 515; Stourton, 76, 88.
25. RA, RC/PIC/MAIN/Evacuation of Pictures 1939–1948, 9 August 1939, 11 August 1939, 26 August 1939. Today the 'Van Dyck Room' is known as the Queen's Ballroom, and 'Charles II's Dining Room' as the King's Dining Room.
26. RA, QM/PRIV/CC48/865, 21 September 1939.
27. Stewart, chapter 1.
28. Shawcross, 239, 516–17.
29. Gregory Martin, *Rubens: The Ceiling Decoration of the Banqueting Hall* (ed. Arnout Balis), *Corpus Rubenianum of Ludwig Burchard, Part 15*, 2 vols (London and Turnhout: Harvey Miller/Brepols, 2005), I, 127.
30. TNA, WORK 14/2374.
31. Ibid.

32. Ibid.
33. See also RA, LC/LCO/MAIN/502/1941, 15 May 1941.
34. TNA, WORK 14/2374.
35. WCA, AR2 53/I, 9; Lawson, 84.
36. Lawson, 84.
37. TNA, WORK 14/2374, Mann to Bennett, 16 December 1940.
38. TNA, WORK 17/250, 23 January 1940.
39. RA, LC/LCO/AR/1941, Works of Art.
40. RA, QM/PRIV/CC48/951, 7 January 1941
41. Crawford, 73.
42. RA, QM/PRIV/CC48/969, 12 June 1941.
43. Ibid.
44. Stourton, 194; Shawcross, 544 also attributes this comment to the King; Steven Brindle (ed.), *Windsor Castle: A Thousand Years of a Royal Palace* (London: Royal Collection, 2018), 447–9.
45. Pope-Hennessy, *Queen Mary*, 604.

Chapter 11: The Whole Fury and Might of the Enemy

1. Colville, 333–4;. Gavin Mortimer, *The Longest Night: Voices from the London Blitz* (London: Weidenfeld & Nicolson, 2005), 119.
2. RA, LC/LCO/AR/194, Palaces.
3. T. D. Kendrick, 'Foreword', *British Museum Quarterly*, 5 (1941), v–vi.
4. Forsdyke, 7–8; Caygill, 'The British Museum at War', 38.
5. Forsdyke, 8; A. F. Johnstone-Wilson, 'The Library's Losses from Bombardment', *British Museum Quarterly*, 15 (1941), 9–11.
6. Caygill, 'The British Museum at War', 39; Parsons, 71; W. Andrew Oddy, 'The 1941 Bombing of the Book Stacks', *The Staircase*, 14.3 (2009), 13–14.
7. Elizabeth Southworth, 'A Life in Pictures: Looking for Elizabeth Senior', *Women: A Cultural Review*, 27.2 (2016), 153–76; Wilson, 216, 231.
8. *ODNB*.

9. Southworth, 169–76.
10. WAM, Peers files, file 37* War Protection/bombing/reconstruction (Report of Surveyor of the Fabric, February 1940), 18–21.
11. Ibid.
12. WAM, Peers files, file 4; Lawrence Tanner, *Recollections of a Westminster Antiquary* (London: John Baker, 1969), 103.
13. *Who's Who.*
14. WAM, Peers files, file 4, Peers to Forsdyke, 8 September 1939.
15. Ibid., Peers/Robinson, 22 September 1939, 4 October 1939.
16. H. V. Morton, 'Our Sandbagged Queens', *Daily Herald*, 8 April 1940, 6.
17. Warwick Rodwell, *The Coronation Chair and Stone of Scone: History, Archaeology and Conservation* (Oxford and Oakville: Oxbow Books, 2013), 184.
18. Ibid.
19. Ibid.
20. Simon Thurley, *Men from the Ministry: How Britain Saved Its Heritage* (New Haven and London: Yale University Press, 2013), 141–7; see also Peers' entry in the *ODNB*.
21. Rodwell, 185–6, 285 nn. 38, 40.
22. Tanner, 186–7.
23. Ibid., 104–6.
24. WAM, Peers files, file 37* War Protection/bombing/reconstruction (Report of Surveyor of the Fabric, March 1942), 24.
25. Tanner, 105.
26. Caroline Shenton, *Mr Barry's War: Rebuilding the Houses of Parliament After the Great Fire of 1834* (Oxford: Oxford University Press, 2016), 1–2.
27. Robert J. Bruce, 'Deposits in the New Bodleian During the Second World War', *Bodleian Library Record*, 2009, 61. Charles I's Death Warrant was not, as stated in Nicholas McCamley's *Saving Britain's Art Treasures* (133), part of the Public Record Office's holdings.
28. IWM, EN2/1/ACC/4/7, 27 February 1941.
29. Bruce, 60, 66–70, 78–9.

30. Salisbury Cathedral Archives, CH/1/34, 290. My thanks to the Cathedral archivist, Emily Naish, for this reference.
31. Claire Breay and Julian Harrison (eds), *Magna Carta: Law, Liberty, Legacy* (London: British Library, 2015), 246–9.
32. Colville, 333–4.
33. Kenneth J. Mears, *The Tower of London: 900 Years of English History* (Oxford: Oxford University Press, 1988), 115–16.
34. Shawcross, 537–8.

Chapter 12: Victory, However Long and Hard the Road

1. Kenneth Clark, *The Other Half*, 5.
2. Davies and Rawlins, 188–9.
3. Kenneth Clark, *The Other Half*, 5.
4. Davies and Rawlins, 181–2.
5. Ibid., 182, 189.
6. NG, Registry File 59.3, Martin Davies 1941, 25 January 1941, 28 January 1941.
7. Davies and Rawlins, 182, 189–90.
8. TNA, CAB 103/237 (Tate Gallery), 1.
9. TNA, WORK 17/195, 17 May 1941.
10. Kenneth Clark, *The Other Half*, 5.
11. Davies and Rawlins, 191.
12. Kenneth Clark, *The Other Half*, 6.
13. Davies and Rawlins, 191.
14. Ibid., 182, 191–2.
15. Ibid., 183.
16. TNA, WORK 17/195, 2 October 1941.
17. Jenkins, 269.
18. TNA, WORK 17/196, 19 November 1941, 24 November 1941.
19. Ibid., 16 April 1943, 27 September 1944. The Science Museum books had been in storage at Maenan Abbey, Llanrwst, and were moved to Eastington in July 1943.

20. Adrian Clark, 114, 118–19.
21. NG, Registry File 185.1, Rawlins FIG, 15 November 1940.
22. Davies and Rawlins, 183.
23. Kenneth Clark, *The Other Half*, 7.
24. Davies and Rawlins, 183.
25. Kenneth Clark, *The Other Half*, 7.
26. F. Ian G. Rawlins, 'The National Gallery in War-Time', *Nature*, 151 (30 January 1943), 123; Thomson, 336.
27. Kenneth Clark, *The Other Half*, 5, 8; Stourton, 205.
28. Clough Williams-Ellis, *Architect Errant* (London: Constable, 1971), 235.
29. Clough Williams-Ellis, *Portmeirion: The Place and Its Meaning*, rev. edn (Portmeirion: Blackie, 1973), 27, 66–7; Stourton, 205.
30. Williams-Ellis, *Architect Errant*, 235.
31. Kenneth Clark, *The Other Half*, 8; Adrian Clark, 223.
32. Davies and Rawlins, 183–4, 190.
33. RA, RC/PIC/MAIN/Picture movements 1934–1947, Clark to Bennett, May 1942; RA, LC/LCO/AR/1942, Works of Art.
34. Adrian Clark, 115.
35. Stourton, 170–1; Bosman, 99.
36. Stourton, 170; NG, Registry File 185.2, Rawlins FIG 1942–1943, 24 September 1943, 28 September 1943.
37. NG, NG24/1942/20.
38. Press clippings survive in NG, NG24/1943/10, 13 and 14.
39. NG, Registry File 257.3, Ministry of Works 1943, Moore – Report on Manod Quarry, 22 March 1943.
40. Davies and Rawlins, 183; Kenneth Clark, *The Other Half*, 8; Bosman, 83.
41. NG, Registry File 257.3, Ministry of Works 1943, Moore – Report on Manod Quarry, 22 March 1943.
42. McCamley, 110–11; Kenneth Clark, *The Other Half*, 8.
43. NG, Registry File 257.3, Ministry of Works 1943, de Normann to Clark, 21 May 1943.
44. Davies and Rawlins, 184.
45. Kenneth Clark, *The Other Half*, 6.

Chapter 13: Victory, in Spite of All Terror

1. TNA, WORK 17/118, Forsdyke to de Normann, 27 June 1941.
2. Draper, 24.
3. McCamley, 46–7.
4. Ibid., 48–50.
5. Quoted in ibid., 51.
6. Forsdyke, 5.
7. Cantwell, 428–9.
8. *ODNB;* Cantwell, 429.
9. TNA, PRO 18/2; Cantwell, 429; Robinson, *The Country House at War*, 101.
10. TNA, PRO 18/2, Jenkinson to Onslow, 27 September 1941.
11. Ibid., 1 September 1941.
12. Ibid., 12 August 1941.
13. Cantwell, 428.
14. TNA, PRO 18/2; Louise Jebb, 'Obituary: Georgiana Blakiston', *Independent*, 29 November 1995; Teresa Waugh, 'My Childhood Aladdin's Cave Has Gone', *Sunday Times*, 2 May 2015; Robinson, *The Country House at War*, 101.
15. TNA, PRO 18/2, 17 September 1942, 19 October 1942, 22 October 1942.
16. Forsdyke, 5.
17. McCamley, 53, 55.
18. Forsdyke, 5.
19. H. J. Plenderleith, 'The Preservation of Museum Objects in War-Time', *Proceedings of the Royal Institution of Great Britain*, XXXII (1941), 546–7.
20. Ibid.
21. Draper, 23, 34.
22. Caygill, 'The British Museum at War', 38.
23. BM, 'Adrian Digby Memoir', 71.
24. Leveen, 198–9.
25. Forsdyke, 7.
26. Bruce, 69.

27. NLW, Corporate Archives, XI/17, ARP Arrangements (Fire Precautions), 5 March 1941, 22 September 1941, 22 October 1941; NLW, Corporate Archives, XI/17, ARP Arrangements (Guard Duty), 15 February 1941.
28. TNA, CAB 102/473 (V&A), 16–17, 19–20.
29. V&A, ED 84/267, 6 May 1942, 20 December 1942, 30 April 1943, 16 September 1944.
30. TNA, CAB 102/473 (V&A), 31–4.
31. *Western Morning News*, 19 January 1943, 5.
32. TNA, CAB 103/237, 31 December 1943; NPG, NPG66/6/2/1.
33. Seebohm, 146. Other statues from around Parliament Square found their way to Berkhamsted Castle.
34. WCA, AR2 53/N, 22 October 1941, 25 October 1941, 17 November 1941.
35. Tanner, 103.
36. WCA, AR2 53/I, 5.
37. Ibid., 7.
38. Lees-Milne, *Ancestral Voices*, 27; Michael Bloch, *James Lees-Milne: The Life* (London: John Murray, 2009), 134–5.
39. McCamley, 80.
40. RA, RC/PIC/MAIN/Picture Movements/1934–1947, 20 June 1944; Shawcross, 582–4.
41. Caygill, 'The British Museum at War', 39; Oddy, 'ARP at the British Museum in the Second World War', n. 60.
42. *Standing Commission on Museums and Galleries*, 9.
43. Friends of Salisbury Cathedral Annual Report (1946), 3. My thanks to the Cathedral archivist, Emily Naish, for this reference.
44. Caygill, 'The British Museum at War', 39; Oddy, 'Harold Plenderleith's Reminiscences of the Second World War', nn. 9, 11, 13; BM, 'Adrian Digby Memoir', 74.

Chapter 14: The Broad Sunlit Uplands

1. *Standing Commission on Museums and Galleries*, 6.
2. Jenkins, 268; Leveen, 199–200.

3. Scholderer, 46; Leveen, 199.

4. NLW, Corporate Archives, G4/11 'ARP, British Museum correspondence', 8 October 1946, 11 October 1946.

5. Ibid., 10 July 1945, 10 November 1945.

6. *ODNB.*

7. Scholderer, 46.

8. Caygill, 'The British Museum at War', 39; *Standing Commission on Museums and Galleries*, 8.

9. *ODNB.*

10. Davies and Rawlins, 184, 191.

11. Kenneth Clark, *The Other Half*, 71–3.

12. NG, NG Registry File 268.6, Kenneth Clark 1945–48, Margot Simmons to Kenneth Clark, 10 June 1945.

13. Kenneth Clark, *The Other Half*, 3, 4, 8; Runeberg, 354.

14. Sarah Staniforth (ed.), *Historical Perspectives on Preventive Conservation* (Los Angeles: Getty Publications, 2013), 139.

15. *Who Was Who*; Colin Brent and Judith Brent, *Danny House: A Sussex Mansion Through Seven Centuries* (Andover: Phillimore, 2013), 144; Death certificate.

16. van Schendel and Plenderleith, 125.

17. Plenderleith, 'The Preservation of Museum Objects', 547.

18. *Who Was Who.*

19. Currently known as British Standard BS EN 16893.

20. RA, RC/PIC/MAIN/Picture Movements/1934–1947, 20 June 1944; Shawcross, 582–4.

21. TNA, WORK 14/2374, 30 January 1946; Martin, *Rubens*, 128.

22. RA, LC/LCO/AR/45.

23. RA, LC/LCO/AR/47.

24. Tanner, 187–8, 105.

25. Hallam, 169.

26. Cantwell, 433.

27. *Who's Who.*

28. Adrian Clark, 120, 123, 172; *ODNB.*

29. Brown, 95.

30. Herefordshire Archives and Records Centre, E69/453, Gleichen to Constance Radcliffe Cooke, [n.d. (1942)], 22 January 1943,

6 June 1943. I am most grateful to Clare Wichbold for this and the following reference.

31. Ibid., Gleichen to Constance Radcliffe Cooke, 6 June 1943.

32. Taunton, Somerset Archives and Local Studies Centre, D/H/MEN/19/3/9; Death certificate, 16 August 1956.

33. Muriel Keep and Alma Oakes, 'Early Calico Printers Around London', *Burlington Magazine*, XCVI.614 (1 May 1954), 135–9

34. Robinson, *The Country House at War*, 95.

35. Southworth, 161; *ODNB*; Bruce-Mitford, 411–12 (Bruce-Mitford discreetly does not name this contributor but clearly it is Sally (Senior) Mellersh, who is acknowledged at the end of the article (423)), 415–19, 422–3.

Epilogue

1. TNA, CAB 103/237, 4 January 1944, 24 January 1945, 31 January 1945.

Bibliography

Air Raid Precautions in Museums, Picture Galleries and Libraries (London: British Museum, 1939)

Ashmole, Bernard, *Bernard Ashmole 1894–1988: An Autobiography* (ed. Donna Kurtz) (Oxford and Oakville: Oxbow Books, 1994)

Barron, Stephanie, *'Degenerate Art': The Fate of the Avant-Garde in Nazi Germany* (New York: Harry N. Abrams, 1991)

Beaton, Cecil, *The Book of Beauty* (London: Duckworth, 1930)

Beevor, Antony, *The Second World War* (London: Weidenfeld & Nicolson, 2012)

Bell, Amy, 'Landscapes of Fear: Wartime London, 1939–1945', *Journal of British Studies*, 48.1 (2009), 153–75

Bell, H. E., 'Archivist Itinerant: Jenkinson in Wartime Italy', in *Essays in Memory of Sir Hilary Jenkinson* (ed. A. E. J. Hollaender) (London: Society of Archivists, 1962), 167–77

Blewitt, Morwenna, 'A Safe Haven: Refugee Restorers and the National Gallery, London', in *ICOM-CC 17th Triennial Conference Preprints, Melbourne, 15–19 September 2014* (ed. J. Bridgland) (Paris: International Council of Museums, 2014), 1–8

Bloch, Michael, *James Lees-Milne: The Life* (London: John Murray, 2009)

Bohm-Duchen, Monica, *Art and the Second World War* (Farnham: Lund Humphries, 2013)

Bosman, Suzanne, *The National Gallery in Wartime* (London: National Gallery, 2008)

Breay, Claire, and Julian Harrison (eds), *Magna Carta: Law, Liberty, Legacy* (London: British Library, 2015)

Brent, Colin, and Judith Brent, *Danny House: A Sussex Mansion Through Seven Centuries* (Andover: Phillimore, 2013)

Brindle, Steven (ed.), *Windsor Castle: A Thousand Years of a Royal Palace* (London: Royal Collection, 2018)

Brown, Val, *Toupie Lowther: Her Life* (Kibworth Beauchamp: Matador, 2017)

Bruce, Robert J., 'Deposits in the New Bodleian During the Second World War', *Bodleian Library Record* (2009), 59–82

Bruce-Mitford, Rupert, 'Thomas Downing Kendrick', in *Interpreters of Early Medieval Britain* (ed. Michael Lapidge) (Oxford: British Academy, 2002), 399–426

Burton, Anthony, *Vision & Accident: The Story of the Victoria and Albert Museum* (London: V&A Publications, 1999)

Cantwell, John D., *The Public Record Office 1838–1958* (London: TSO, 1991)

Caygill, Marjorie, '1939: Evacuating the BM's Treasures', *British Museum Society Bulletin*, 62 (1989), 17–21

———, 'The British Museum at War', *British Museum Magazine*, 1990, 35–9

Chanel, Gerri, *Saving Mona Lisa: The Battle to Protect the Louvre and Its Treasures from the Nazis*, 2nd edn (London: Icon, 2018)

Clark, Adrian, *Fighting on All Fronts: John Rothenstein in the Art World* (Norwich: Unicorn, 2018)

Clark, Alan, *A Good Innings: The Private Papers of Viscount Lee of Fareham* (London: John Murray, 1974)

Clark, Kenneth, 'Johannes Wilde', *Burlington Magazine*, CIII.699 (1961), 205

———, *Another Part of the Wood: A Self-Portrait* (London: John Murray, 1974)

———, *The Other Half: A Self-Portrait* (London: John Murray, 1977)

Clayton, Muriel, *A Gust of Wind and Other Stories* (London: A. H. Stockwell, 1925)

————, *Brief Guide to the Western Painted, Dyed and Printed Textiles* (London: Victoria & Albert Museum, 1938)

————, *Catalogue of Rubbings of Brasses and Incised Slabs*, 2nd edn (London: Victoria & Albert Museum, 1929)

————, *The Print Collector* (London: Herbert Jenkins, 1929)

Colville, John, *The Fringes of Power: Downing Street Diaries 1939–1955*, rev. edn (London: Weidenfeld & Nicolson, 2004)

Condell, Diana, 'The History and the Role of the Imperial War Museum as an Institution', in *War and the Cultural Construction of Identities in Britain* (ed. Barbara Korte and Ralf Schneider) (Amsterdam: Editions Rodopi, 2000), 25–38

Conlin, Jonathan, *The Nation's Mantelpiece: A History of the National Gallery* (London: Pallas Athene, 2006)

Conway Davies, J., 'Memoir of Sir Hilary Jenkinson', in *Studies Presented to Sir Hilary Jenkinson* (ed. J. Conway Davies) (Oxford: Oxford University Press, 1957), xiii–xxx

Crawford, Marion, *The Little Princesses* (London: Duckworth, 1993)

Davies, Martin, and F. Ian G. Rawlins, 'The War-Time Storage in Wales of Pictures from the National Gallery, London. I The Course of Events. II Some Technical Problems', *Transactions of the Honourable Society of Cymmrodorion, 1945* (London: Honourable Society of Cymmrodorion, 1946), 179–93

Draper, Karey L., 'The English Country Estate: Contributions and Consequences of Requisition in the Second World War' (unpublished M.St thesis in Building History, University of Cambridge, 2013)

Duchess of Gloucester, Alice, *The Memoirs of Princess Alice, Duchess of Gloucester* (London: HarperCollins, 1983)

Edwards, Adrian S., 'Destroyed, Damaged and Replaced: The Legacy of World War II Bomb Damage in the King's Library', *EBLJ* Article 8 (2013), 1–31

Ellis, Roger H., 'Recollections of Sir Hilary Jenkinson', *Journal of the Society of Archivists*, 4.4 (1971), 261–75

Flower, C. T., 'Manuscripts and the War', *Transactions of the Royal Historical Society*, 25 (1943), 15–33

Forsdyke, John, 'The Museum in War-Time', *British Museum Quarterly*, 15 (1941–50), 1–9

Gardiner, Juliet, *Wartime: Britain 1939–1945* (London: Headline, 2005)

Gillies, Midge, *Waiting for Hitler: Voices from Britain on the Brink of Invasion* (London: Hodder & Stoughton, 2006)

Gleichen, Helena, *Contacts and Contrasts* (London: John Murray, 1940; reprinted Kilkerran: Mansion Field, 2013)

Goldsmith, Margaret, *The Wandering Portrait* (London: Weidenfeld & Nicolson, 1954)

Goodman, Jean, *The Mond Legacy: A Family Saga* (London: Weidenfeld & Nicolson, 1982)

Hallam, Elizabeth M., *Domesday Book Through Nine Centuries* (London: Thames & Hudson, 1986)

Harris, P. R., *A History of the British Museum Library 1753–1973* (London: British Library, 1998)

Hicks, Carola, *The Bayeux Tapestry: The Life Story of a Masterpiece* (London: Chatto & Windus, 2006)

Huws, Daniel, *The National Library of Wales: A History of the Building* (Aberystwyth: National Library of Wales, 1994)

Jenkins, David, *A Refuge in Peace and War: The National Library of Wales to 1952* (Aberystwyth: National Library of Wales, 2002)

Jenkins, Ian, *Cleaning and Controversy: The Parthenon Sculptures 1811–1939*, British Museum Occasional Paper, no. 146 (London: British Museum, 2001)

Jenkinson, Hilary, 'British Archives and the War', *American Archivist*, 7.1 (1944), 1–17

Johnstone-Wilson, A. F., 'The Library's Losses from Bombardment', *British Museum Quarterly*, 15 (1941), 9–11

Kendrick, T. D., 'Foreword', *British Museum Quarterly*, 5 (1941), v–vi

Koster, Olinka, 'The Mother Who Went to War in 1916 after Learning Her Son Had Been Killed in the Trenches', *Daily Mail*, 21 March 2008 https://www.dailymail.co.uk/news/article-532069/The-mother-went-war-1916-learning-son-killed-trenches.html

Lampe, David, *The Last Ditch* (London: Cassell, 1968)

Lawson, Lucia, *Of Old I Hold: My Life in a Newspaper Family* (Dublin: Linden, 2008)

Lees-Milne, James, *Ancestral Voices and Prophesying Peace: Diaries, 1942–1945* (London: John Murray, 1995)

———, *Through Wood and Dale: Diaries, 1975–1978* (London: John Murray, 1998)

———, *Holy Dread: Diaries, 1982–1984* (ed. Michael Bloch) (London: John Murray, 2001)

Leveen, Jacob, 'The British Museum Collections in Aberystwyth', *Transactions of the Honourable Society of Cymmrodorion, 1945* (London: Honourable Society of Cymmrodorion, 1946), 194–200

Little, Helen, 'Picasso in Britain, 1937–1939', in *Picasso & Modern British Art* (ed. James Beechey and Chris Stephens) (London: Tate Publishing, 2012), 162–4

Llewelyn Davies, William, 'War-Time Evacuation to the National Library of Wales', *Transactions of the Honourable Society of Cymmrodorion, 1945* (London: Honourable Society of Cymmrodorion, 1946), 171–8

Longmate, Norman, *How We Lived Then: A History of Everyday Life During the Second World War* (London: Hutchinson, 1971)

Martin, Gregory, *Rubens: The Ceiling Decoration of the Banqueting Hall* (ed. Arnout Balis), *Corpus Rubenianum of Ludwig Burchard, Part 15*, 2 vols (London and Turnhout: Harvey Miller/Brepols, 2005), I

Mattern, Eleanor, 'World War II Archivists: In the Field and on the Home Front', *Library & Archival Security*, 24.2 (2011), 61–81

McCamley, Nicholas J., *Saving Britain's Art Treasures* (Barnsley: Leo Cooper, 2003)

McKinstry, Leo, *Operation Sealion* (London: John Murray, 2014)

Mears, Kenneth J., *The Tower of London: 900 Years of English History* (Oxford: Oxford University Press, 1988)

Morshead, Owen, *Windsor Castle* (London: Phaidon, 1957)

Mortimer, Gavin, *The Longest Night: Voices from the London Blitz* (London: Weidenfeld & Nicolson, 2005)

Munthe, Malcolm, *Hellens: The Story of a Herefordshire Manor*, 2nd edn (London: Sickle Moon, 2012)

Murdoch, Tessa (ed.), *Boughton House: The English Versailles* (London: Faber & Faber, 1992)

Neems, Hugh, *The Giant's Children* (n.p., 2016)

Nicholas, Lynn H., *The Rape of Europa* (London: Macmillan, 1994)

Nicholson, Virginia, *Singled Out: How Two Million Women Survived Without Men After the First World War* (London: Viking, 2007)

Oddy, W. Andrew, 'Harold Plenderleith's Reminiscences of the Second World War at the British Museum', oral interview transcript (Dundee: 11 June 1987)

——, 'The Three Wise Men and the 60:60 Rule', *Past Practice – Future Prospects*, British Museum Occasional Paper, no. 145 (London: British Museum, 2001), 167–70

——, 'ARP at the British Museum in the Second World War', *The Staircase*, 13.3 (2008), 3–18

——, '[Harold] James Plenderleith: A Brief Biography', *The Staircase*, 14.2 (2009), 14–22

——, 'The 1941 Bombing of the Book Stacks', *The Staircase*, 14.3 (2009), 13–21

Oxford Dictionary of National Biography (Oxford, 2000–4)

Parkes, Susan M. (ed.), *A Danger to the Men? A History of Women in Trinity College Dublin 1904–2004* (Dublin: Lilliput Press, 2004)

Parsons III, Thad, 'The Science Museum and the Second World War', in *Science for the Nation: Perspectives on the History of the Science Museum* (ed. Peter J. T. Morris) (Basingstoke: Palgrave Macmillan, 2013), 61–89

Peters, Olaf (ed.), *Degenerate Art: The Attack on Modern Art in Nazi Germany, 1937* (Munich, London and New York: Prestel, 2014)

Plenderleith, H. J., 'The Preservation of Museum Objects in War-Time', *Proceedings of the Royal Institution of Great Britain*, XXXII (1941), 538–48

Pope-Hennessy, James, *Queen Mary 1867–1953* (London: Allen & Unwin, 1959)

———, *The Quest for Queen Mary* (ed. Hugo Vickers) (London: Hodder & Stoughton, 2018)

'Profile: F. I. G. Rawlins. A Scientist among the Old Masters', *New Scientist*, 17 September 1959, 456–57

Rawlins, F. Ian G., *From the National Gallery Laboratory* (London: National Gallery, 1940)

———, 'Care of Works of Art in Wartime', *Museums Journal*, 42 (1943), 269–72

———, 'The National Gallery in War-Time', *Nature*, 151 (30 January 1943), 123–37

Rhodes, Denis E. (ed.), *Essays in Honour of Victor Scholderer* (Mainz: Karl Pressler, 1970)

Roberts, David, *Bangor University 1884–2009* (Cardiff: University of Wales Press, 2009)

Robinson, John Martin, *The Country House at War* (London: Bodley Head, 1989)

———, *Requisitioned: The British Country House in the Second World War* (London: Aurum Press, 2014)

Rodwell, Warwick, *The Coronation Chair and Stone of Scone: History, Archaeology and Conservation* (Oxford and Oakville: Oxbow Books, 2013)

Rose, Sonya O., *Which People's War? National Identity and Citizenship in Britain 1939–1945* (Oxford: Oxford University Press, 2003)

Rothenstein, John, *Summer's Lease: Autobiography 1901–1938* (London: Hamish Hamilton, 1965)

———, *Brave Day Hideous Night: Autobiography 1939–1965* (London: Hamish Hamilton, 1966)

Runeberg, Ulrik, 'Immigrant Picture Restorers of the German-Speaking World in England from the 1930s to the Post-war Era', in *Arts in Exile in Britain 1933–1945: Politics and Cultural Identity* (ed. Shulamith Behr and Marian Malet), *Yearbook of the Research Centre for German and Austrian Exile Studies*, 6 (London: Brill, 2005), 339–72

Saumarez Smith, Charles, *National Portrait Gallery*, 2nd rev. edn (London: NPG Publications, 2010)

———, *The National Gallery: A Short History* (London: Frances Lincoln, 2009)

Schellenberg, Walter, *Invasion 1940: The Nazi Invasion Plan for Britain* (ed. John Erickson) (London: St Ermin's, 2000)

van Schendel, A., and H. J. Plenderleith, 'Ian Rawlins: I.I.C. Honorary Fellow', *Studies in Conservation*, 9.4 (1964), 123–5

Scholderer, Victor, *Reminiscences* (Amsterdam: Van Gandt, 1970)

Seebohm, Caroline, *The Country House: A Wartime History, 1939–45* (London: Weidenfeld & Nicolson, 1989)

Shawcross, William, *Queen Elizabeth the Queen Mother: The Official Biography* (London: Macmillan, 2009)

Shenton, Caroline, *Mr Barry's War: Rebuilding the Houses of Parliament After the Great Fire of 1834* (Oxford: Oxford University Press, 2016)

Smyth, Ethel, *As Time Went On . . .* (London: Longmans, Green & Co., 1936)

————, *What Happened Next* (London: Longmans, Green & Co., 1940)

Southworth, Elizabeth, 'A Life in Pictures: Looking for Elizabeth Senior', *Women: A Cultural Review*, 27.2 (2016), 153–76

Standing Commission on Museums and Galleries, Third Report. The National Museums and Galleries: The War Years and After (London: HMSO, 1948)

Staniforth, Sarah (ed.), *Historical Perspectives on Preventive Conservation* (Los Angeles: Getty Publications, 2013)

Stewart, Andrew, *The King's Private Army: Protecting the British Royal Family During the Second World War* (Solihull: Helion, 2015)

Stourton, James, *Kenneth Clark: Life, Art and Civilisation* (London: William Collins, 2016)

Summers, Julie, *Our Uninvited Guests: The Secret Lives of Britain's Country Houses 1939–45* (London: Simon & Schuster, 2018)

Tanner, Lawrence E., *Recollections of a Westminster Antiquary* (London: John Baker, 1969)

Thomson, Garry, 'F. I. G. Rawlins', *Physics Bulletin*, 20 (1969), 336

Thurley, Simon, *Men From the Ministry: How Britain Saved Its Heritage* (New Haven and London: Yale University Press, 2013)

Todman, Daniel, *Britain's War: Into Battle, 1937–1941* (London: Penguin, 2017)

Waugh, Teresa, 'My Childhood Aladdin's Cave Has Gone', *Sunday Times*, 2 May 2015

Who's Who 2019 and Who Was Who (London and New York: Bloomsbury, 2018)

Williams-Ellis, Clough, *Architect Errant* (London: Constable, 1971)

————, *Portmeirion: The Place and Its Meaning*, 2nd edn (Portmeirion: Blackie, 1973)

Wilson, David M., *The British Museum: A History* (London: British Museum Press, 2002)

Wolmar, Christian, *The Subterranean Railway: How the London Underground Was Built and How It Changed the City Forever* (London: Atlantic, 2012)

Woosnam-Savage, Robert C., 'Olivier's *Henry V* (1944): How a Movie Defined the Image of the Battle of Agincourt for Generations', in *The Battle of Agincourt* (ed. Anne Curry and Malcolm Mercer) (New Haven and London: Yale University Press, 2015), 254–5

Index

INDEX

Llewelyn Davies, Sir William (*cont.*)
death 250
inter-institutional camaraderie 111
knighthood 240
NLW, camouflaging 145–6
NLW directorship 56–7
NLW, heritage saved at 9
opening of central hall 57
Town Clerk's demands 239–40
see also National Library of Wales,
Aberystwyth
London, Midland & Scottish Railway
(LMS) 38, 52, 63, 220, 222
London Underground 11, 17, 20–1,
54–5, 59, 62, 78, 86, 151, 180
see also Aldwych Underground
station/tunnel; Balham;
Brompton Road; Green Park;
Knightsbridge
London Zoo 164–6
Longford Castle, Wilts. 85
Louvre, Paris 69, 142–3
Lowther, Toupie 77, 78
Luxembourg 131

Machell, Valda and Roger 134
MacKenzie family 121
Mackenzie King, W. L. 204
Maclagan, Sir Eric 80, 138, 234, 237, 261
MacLaren, Neil 35
McLeod, Donaldina Gunn 103, 104
MacNaghten, Colonel G. W. 31–2
MacNeice, Louis 252
Madresfield Court, Worcs. 175
Magna Carta 9, 209–10
Mann, James 91–2, 180, 181–2, 189,
190, 193, 243, 259
Mann, Mary 92–3
Manod Mawr, Gwynedd 215–18,
219–22, 224–5, 226–32, 251–2
Manson, James Bolivar 69
Margaret, Princess 173, 176, 177,
185–6, 192

Market Harborough workhouse,
Leics. 94, 95
Mary, Queen Mother 176–7, 178–9,
182–3, 185, 194, 234, 245
Mattingley, Harold 246
Melchett, Sir Alfred Mond, 1st Baron
87–8
Melchett, Henry Mond, 2nd Baron
88, 140–1
Men at Arms (Waugh) 101–2
Menace (Pollard) 12
Mentmore Towers, Bucks. 30, 96–8, 125,
134, 161–2, 166, 242–3, 258–9
microfilm cameras 248–9, 256
mildew 124, 147, 192, 207
Mines Inspectorate 227, 231
Ministry of Works *see* Office/
Ministry of Works
Mitford, Nancy 244
Molotov–Ribbentrop Pact 38, 61
Mond, Henry (2nd Baron Melchett)
88, 140–1
Mond, Sir Alfred (1st Baron
Melchett) 87–8
Montacute House, Somerset 85, 86,
119–20, 137–8, 145, 159, 240–1
Montagu House, London 53
Montaudon Smith, Madame 177
Montgeon, Gabrielle de 73, 76–8,
156, 160–1, 162–3, 218, 219, 223,
257
Monuments, Fine Arts and Archives
(MFA&A) unit (Monuments
Men) 143, 256
Morshead, Sir Owen 182, 183, 185,
186, 191, 192–4, 245
Morton, H.V. (Henry Vollum) 113–15,
165, 180, 181, 200–1
mould 32–3, 124, 147, 164, 207, 218
Muncaster Castle, Ravenglass,
Cumberland 73, 156–7
Munich Agreement 19, 36
Munich Crisis 19, 51

INDEX